FRIEZE ART FAIR

Yearbook
2005–6

Published in 2005 by Frieze Art Fair
5–9 Hatton Wall, London EC1N 8HX
Tel +44 20 7025 3970
Fax +44 20 7025 3971
Email admin@frieze.com
www.friezeartfair.com

Frieze Art Fair is an imprint of Frieze Events Ltd,
registered in England number 4429032

Frieze Art Fair Yearbook 2005–6 and Art Yearbook 3
© Frieze Art Fair, 2005
All images © the artists
All texts © Frieze Art Fair and the authors

ISBN 0 9527414 7 4

A catalogue record of this book is available from the British Library

Editor: Melissa Gronlund
Commissioning Editors: Amanda Sharp and Anna Starling
Editorial Assistant: Kate Fisher
Copy-editor: Matthew Taylor
Advertising Sales: Michael Benevento and Mareike Dittmer
Advertising Sales and Production: Claudia Garuti

Art Direction: Graphic Thought Facility, London
Printed by: Graphicom, Vicenza, Italy

Distributed outside North America by
Thames & Hudson Distributors Ltd
44 Clockhouse Rd
Farnborough
Hampshire
GU14 7QZ
United Kingdom
Tel +44 (0) 1252 541602
Fax +44 (0) 1252 377380
Email customerservices@thameshudson.co.uk

Additional Distribution in Germany
by Vice Versa Vertrieb
Immanuelkirchstr. 12
10405 Berlin
Germany
Tel +49 30 6160 9236
Fax +49 30 6160 9238
Email info@vice-versa-vertrieb.de

Contents

Participating galleries

1301PE
303 Gallery
ACME.
Air de Paris
Galería Juana de Aizpuru
The Approach
Arndt & Partner
Art & Public – Cabinet P.H.
Art : Concept
Galerie Catherine Bastide
Guido W. Baudach
Bernier/Eliades
Blum & Poe
Marianne Boesky Gallery
Tanya Bonakdar Gallery
Niels Borch Jensen Gallery
Gavin Brown's enterprise
Galerie Daniel Buchholz
Cabinet
Rebecca Camhi
Luis Campaña Galerie
Galerie Gisela Capitain
carlier | gebauer
Galleria Massimo de Carlo
China Art Objects Galleries
Galería Pepe Cobo
James Cohan Gallery
Sadie Coles HQ
John Connelly Presents
Corvi-Mora
Counter Gallery
CourtYard Gallery
CRG Gallery
Galerie Chantal Crousel
D'Amelio Terras
Sorcha Dallas
Thomas Dane

doggerfisher
Galerie EIGEN + ART Leipzig/Berlin
Foksal Gallery Foundation
Galeria Fortes Vilaça
Marc Foxx
Stephen Friedman Gallery
Frith Street Gallery
Gagosian Gallery
Galerist
Klemens Gasser & Tanja Grunert, Inc.
Gladstone Gallery
Marian Goodman Gallery
Greene Naftali
greengrassi
Galerie Karin Guenther
Nina Borgmann
Studio Guenzani
Galería Enrique Guerrero
Jack Hanley Gallery
Haunch of Venison
Galerie Hauser & Wirth
Zürich London
Herald St
Hotel
Taka Ishii Gallery
Jablonka Galerie
Jablonka Lühn
Alison Jacques Gallery
Galerie Martin Janda
Johnen + Schöttle
Annely Juda Fine Art
Iris Kadel
Georg Kargl
Galleri Magnus Karlsson
Paul Kasmin Gallery
galleria francesca kaufmann
Kerlin Gallery
Anton Kern Gallery
Peter Kilchmann
Nicole Klagsbrun Gallery
Klosterfelde
Leo Koenig Inc.

Johann König
Tomio Koyama Gallery
Gallery Koyanagi
Andrew Kreps Gallery
Galerie Krinzinger
Galerie Krobath Wimmer
kurimanzutto
Yvon Lambert
Galerie Gebr. Lehmann
Lehmann Maupin
Lisson Gallery
Luhring Augustine
maccarone inc.
Kate MacGarry
Mai 36 Galerie
Galerie Maisonneuve
Giò Marconi
Matthew Marks Gallery
Galerie Meyer Kainer
Meyer Riegger
Massimo Minini
Victoria Miro Gallery
The Modern Institute /
Toby Webster Ltd
Jan Mot
Galerie Michael Neff
Galerie Neu
Galleria Franco Noero
Galerie Giti Nourbakhsch
Galerie Nathalie Obadia
galerie bob van orsouw
Patrick Painter, Inc.
Maureen Paley
Paragon Press
Parkett Editions
Peres Projects Los Angeles Berlin
Galerie Emmanuel Perrotin
Galerie Francesca Pia
pkm Gallery
Postmasters Gallery
Galerie Eva Presenhuber
Produzentengalerie Hamburg

Projectile Gallery
Raucci/Santamaria Gallery
Galerie Almine Rech
Daniel Reich Gallery
Anthony Reynolds Gallery
Galerie Thaddaeus Ropac
Andrea Rosen Gallery
Galleria Sonia Rosso
Salon 94
Galerie Aurel Scheibler
Esther Schipper
Anna Schwartz Gallery
Gabriele Senn Galerie
Stuart Shave | Modern Art
Galeria Filomena Soares,
Sommer Contemporary Art
Galerie Pietro Spartà
Sperone Westwater
Sprüth Magers Lee
Diana Stigter
Galeria Luisa Strina
Sutton Lane
Galerie Micheline Szwajcer
Timothy Taylor Gallery
Emily Tsingou Gallery
Two Palms
Galerie Anne de Villepoix
Vilma Gold
Waddington Galleries
Galleri Nicolai Wallner
Galerie Barbara Weiss
Galerie Fons Welters
White Cube/Jay Jopling
Galerie Barbara Wien
Max Wigram Gallery
Wilkinson Gallery
Galleri Christina Wilson
The Wrong Gallery
XL Gallery
Donald Young Gallery
Zero
David Zwirner

Art Fair Staff

Amanda Sharp, Director
Matthew Slotover, Director
Stephanie Dieckvoss, Fair Manager
Kate Fisher, Assistant Fair Manager
Polly Staple, Curator
Kitty Anderson, Curatorial Assistant
Camilla Nicholls, Head of Communications
Claire Hewitt, Marketing Manager
Marc Bättig, Head of Business Development
Victoria Siddall, Head of Sponsorship
Daisy Shields, VIP Manager
Cristina Raviolo, VIP Consultant

Introduction

We are delighted to welcome you to the 2005 Frieze Art Fair. This year 160 of today's most dynamic contemporary art galleries are participating in what has become one of the major international meeting places for the contemporary art world.

There are several elements that make Frieze Art Fair different. For the third year, architect David Adjaye is designing the fair. David has undoubtedly succeeded in creating a dramatic environment while preserving the clean elegance that best suits contemporary art.

One of the aims of the fair is to place art in an exciting and critical context. Polly Staple's curated programme of artists' projects has enlivened the fair over the past two years, and this year, large-scale projects by Andrea Zittel and Germaine Kruip, amongst others, follow previous highlights such as Paola Pivi's *Untitled (Slope)* (2003) and Roman Ondák's queue (*Good Feelings in Good Times*, 2003/4). For the first time, we have commissioned films from artists that are being shown on-site in The Artists Cinema. In addition Frieze Talks presents wide-ranging contributors that include art historian Thomas Crow, architect Zaha Hadid and philosopher Jacques Rancière, and Frieze Music features a concert by the pioneer of electronic music Karlheinz Stockhausen.

We are grateful to our main sponsor Deutsche Bank for their continued support, and to our new associate sponsor Cartier for their involvement with the artists' projects. For both companies their commitment to contemporary art is long standing and extensive.

Amanda Sharp
Matthew Slotover

Sponsor's Foreword

Deutsche Bank is proud to be associated with the third annual Frieze Art Fair, an event that has already made a significant impact on the international art world.

Our sponsorship of this event for the second year running is part of our continued commitment to the arts. Deutsche Bank's own Art Collection – comprising some 50,000 works – is widely acknowledged as the leading corporate art collection in the world. We were also one of the first major institutions to embrace the idea of art in the workplace, highlighted by the recent exhibition at the Deutsche Guggenheim to celebrate 25 years of the Deutsche Bank Art Collection.

Art has a prominent role at Deutsche Bank. Recently, our twin aims of creating a stimulating work environment for staff and supporting new art have led to the sponsorship of events such as the Das MOMA in Berlin 2004, the involvement with Christo's Gates in New York and the sponsorship of the current Lucian Freud exhibition in Museo Correr in Venice.

With 66,000 employees in more than 70 countries and major offices in Frankfurt, London, New York, Singapore and Hong Kong, Deutsche Bank is an excellent partner for a major international art event such as the Frieze Art Fair 2005. I feel certain it will again be a resounding success and, like last year, will challenge, excite and inspire its visitors.

Josef Ackermann
Chairman of the Group Executive Committee
Deutsche Bank AG

A Passion to Perform. Deutsche Bank ◢

Frieze Art Fair wishes to acknowledge the generous support
of the following companies and organizations:

Main Sponsor

Deutsche Bank

Associate Sponsor

Cartier

Media Sponsor

The **Guardian**

Sponsors and Partners

Simmons & Simmons

The Frieze Art Fair Special Acquisitions Fund

The collaboration between Frieze Art Fair and Tate began with the inaugural fair, in 2003. It was an immediate success. The partnership was the first of its kind, and through the generosity of a group of London collectors it enabled Tate to buy important works by emerging artists at the fair for the national collection. Over the last two years, with a fund of over £250,000, works by 15 significant international artists have been collected: Fikret Atay, Pawel Althamer, Martin Boyce, Jeremy Deller and Alan Kane, Olafur Eliasson, Jesper Just, Mark Leckey, Scott Myles, Frank Nitsche, Henrik Olesen, Roman Ondák, The Atlas Group/Walid Raad, Anri Sala, Yutaka Sone and Pae White.

This year we are delighted to announce a fund of £125,000, which we hope will ensure that some of the best works of art in the fair will find a home in the Tate Collection. The works will be selected by Suzanne Pagé (Director, Musée d'Art moderne de la Ville de Paris) and Paul Schimmel (Chief Curator, Museum of Contemporary Art, Los Angeles) following guidelines provided by Jan Debbaut, Director, Tate Collection.

The list of acquisitions will be announced at 9.45am on 21 October at Tate Modern. These works will remain on display at Frieze Art Fair, and will be presented to the Tate Trustees in November.

The fund is organized by London collectors and Tate Patrons Candida Gertler and Yana Peel. The donors all have a particular interest in supporting the Tate's acquisition of international contemporary art, and we are very grateful to all the participants for their generosity and support.

Sir Nicholas Serota, Director, Tate
Amanda Sharp, Director, Frieze Art Fair
Matthew Slotover, Director, Frieze Art Fair

FRIEZE ART FAIR

Frieze Projects

Frieze Projects 2005
Introduction

Building on the success of the past two years, Frieze
Art Fair again features a curatorial programme
of artists' commissions, a series of talks and an
education day for young people, distinct from the
fair's commercial trajectory.

Frieze Projects, a high-profile public-arts
commissioning opportunity for artists, is expanding
this year to encompass physically ambitious
sculptural installations, film and video commissions
(screened in The Artists Cinema), a daily tour
programme and an off-site performance event.

Artists invited to work on Frieze Projects are
interested both in the inherent contradictions of
an art fair and the particular dynamics of the
event itself. Ranging from site-specific installations
to impromptu performances and publications
distributed free to fair visitors, many of the artists'
projects are event-based and involve the audience
directly.

Earlier this year Frieze Projects successfully secured
funding from European Union Culture 2000 and
Arts Council England (both 2005–7) which will
allow the programme to develop in fresh and
varied directions. We are pleased to be forging links
this year with our European partner institutions,
Stedelijk Museum Bureau Amsterdam and the
International Artists Studio Program in Sweden, and
here in London with London Underground's art
initiative Platform for Art and Delfina Studios, both
of whom Frieze Projects have worked with since the
first year.

With new Frieze Art Fair associate sponsors Cartier
and partners Arts & Business we are happy to
announce the Cartier Award, an open submissions

competition that will enable a young artist to
realize a project at the fair in 2006, following a
three month residency at Delfina Studios. This
continues Cartier's long-standing involvement
with contemporary art, manifested primarily in the
fondation Cartier pour l'art contemporain in Paris.

We are also pleased to establish a new collaboration
with LUX, London. This is a major initiative for
Frieze Projects, facilitating the committed and
enthusiastic representation of artists' film and video
in the fair environment and also, crucially, allowing
the development and distribution of the commissions
beyond, and independently of, the limited confines
of the fair itself.

Polly Staple
Frieze Projects Curator

Kitty Anderson
Frieze Projects Curatorial Assistant

Frieze Projects, Talks and Education are curated by Polly Staple and commissioned under the auspices of Frieze Foundation, which is generously supported by Arts Council England and the Culture 2000 programme of the European Union (2005–7), in association with: the International Artists Studio Program in Sweden (Iaspis), Stockholm; Stedelijk Museum Bureau Amsterdam (SMBA); Project, Dublin; Platform Garanti Art Center, Istanbul; and Sala Rekalde, Bilbao. Frieze Projects are presented in association with Cartier.

Participating artists and organizations

Michael Beutler
Jay Chung and Q Takeki Maeda
Henrik Håkansson
Roger Hiorns
Matthieu Laurette
Martha Rosler
Donald Urquhart
Richard Wentworth
Cathy Wilkes
Ian Wilson
Andrea Zittel
Iaspis: epipc & abäke
SMBA: Germaine Kruip
The Artists Cinema
Resonance 104.4fm

Michael Beutler
central avenue
2005
Installation view, Bonner
Kunstverein / Neue Kunsthalle
St Gallen
Courtesy Galerie Michael Neff

Michael Beutler
next to center

Michael Beutler's expansive sculptures are usually created on-site in relation to given architectural arrangements. In an idiosyncratic experimental process Beutler employs conventional building materials to question standardization, using DIY strategies and creating machines that facilitate the construction of the piece.

Beutler presents *next to center* (2005), a site-specific sculptural installation that responds to the ordered formality of the fair's internal grid. Beutler has proposed constructing a social space that makes use of lo-fi resources found in and around the fair environs. Treating the peculiar architectural conditions of Frieze Art Fair as his own workshop, Beutler explores alternative ways of inhabiting this very particular landscape, resulting in a playful interrogation of form and function, private and public space.

Jay Chung and Q Takeki Maeda
The Nickel Tour

'Tour guides will ask for attention and a certain degree of docility, but they also allow for passivity, graciously leaving one to rest easy in the security of a predetermined course. Given the opportunity to indulge in abstraction, one might drift off to find the personification of one's interests and motivations in such a guide. Certainly the idea of this figure – a version of which one is more or less discreetly following at all times in one's life, otherwise nothing would get done at all – becomes more distinct at times; yet it never becomes so concrete that it stops being an apparition. One isn't being so much led as projecting something ahead of oneself to follow. Who does it resemble? How and in which direction does it move?

At the outset, nothing, apathy. But ambivalence should be taken as a blessing; with nothing to resist against anything, one is free to plunge whole-heartedly into whatever might come one's way, substituting a benign good-naturedness for anomie. So we propose a tour with no information, something that could be filled with ... something that would play out the continual exchange of one interest for another, perhaps even evince a faint delight in interest per se. Who would be leading such a tour, and why would one be taking it?'

Jay Chung and Q Takeki Maeda

The tour takes place on Monday 24 October and is accessible to art fair visitors. Details of the schedule and location are available at the Frieze Art Fair Information Desk.

Henrik Håkansson
Birdconcert (Part 1)
Oct. 23, 2005

'A set to consist of a single bird performing its natural voice live onstage. The full set is with audience and 16mm film production focusing on the bird's performance and the full aspect of the surroundings. The set should be open to the public at a venue directed toward musical performances.'

Henrik Håkansson, London, July 2005

Håkansson uses the distinct cultural environment and the event of the fair to facilitate the production of this off-site event, while also employing the format of performance and the scenario of filmmaking. A concert hall more regularly used for classical recitals is the site of a solo performance of a bird. In this synthetic environment a native British songbird becomes a fragile, exotic spectacle. The observation of nature results in the production of culture. The audience themselves become players and, in turn, the process of art-making becomes the subject of the piece. We invite all Frieze Art Fair visitors to take part.

The concert takes place on the evening of Sunday 23 October at the Royal Academy of Music, London, and is open to art fair visitors. Details are available at the Frieze Art Fair Information Desk. The performance will be recorded and produced after the event as a film work.

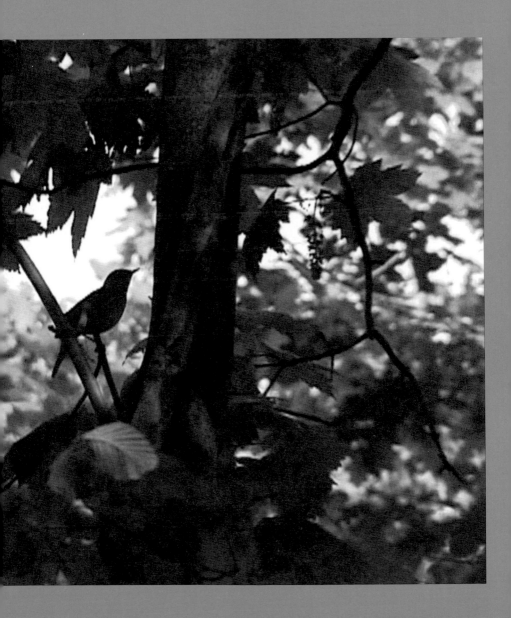

Roger Hiorns
Fleet St
2005
Black and white photograph
Courtesy Corvi-Mora

Roger Hiorns
BENIGN

'The simple act of a group against an individual and the realization of ignored prayer. Leave them with an empty reliance on a benign ceremony and a benign belief.
A film of a play and a song.
2005'

Roger Hiorns, London, June 2005

Roger Hiorns has been invited to make a short film that premieres at the fair in The Artists Cinema. Hiorns has taken the opportunity to develop his sculptural work in a new direction, choosing to focus here on the simple narrative potential of the time-based medium of film. Crafted to a modest degree and as self-sufficient as possible, *BENIGN* (2005) is minimally shot and features a play written by Hiorns, which a single actor delivers as a monologue directly to the camera.

Circling around a central narrative conceit, the play draws on intimation and description to present a collective who perform a pointless symbolic act. The passive subjects have absorbed the idea of progress to such a degree of pacified banality that they cease to comprehend any notion of challenge or disruption. The piece explores ideas of ceremony, consumption, design, acceptance and criticality.

Roger Hiorns' BENIGN is being shown during the fair in The Artists Cinema. Screenings are accessible to art fair visitors; schedule and location details are available at the Frieze Art Fair Information Desk.

Matthieu Laurette presents

WHAT DO THEY WEAR AT FRIEZE ART FAIR?
21–24 October 2005
Daily guided tours of Frieze Art Fair led by international fashion experts

Matthieu Laurette has been invited to make a project at the fair responding to the idea of the tour format. Laurette has asked a selection of the world's leading fashion experts to conduct tours of Frieze Art Fair. Instead of commenting on the art works on display, the experts focus on the visitors and their fashion styles. The experts become both guides and performers; their distinct personalities and abilities create a special atmosphere through fashion's highly specific vocabulary and a sense of occasion that shapes the artistic vision of the artwork.

The fashion experts include Peter Saville, Isabella Blow, Bay Garnett and Kira Jolliffe.

Laurette's daily tours led by international fashion experts are accessible to art fair vistors; schedule and location details are available at the Frieze Art Fair Information Desk.

03.06.05

Dear ███████████████

I am writing on behalf of the artist Matthieu Laurette. Matthieu is one of France's leading contemporary artists with an internationally recognized reputation.

As a long time admirer of your work Matthieu would like to invite you to participate as an artistic collaborator on a project he will realise at Frieze Art Fair, London, 20–24 October 2005.

Matthieu himself was invited to propose a special project at the fair following the format of the guided tour. With a unique twist Matthieu has proposed to invite four of the world's leading fashion experts to conduct guided tours of the art fair. Instead of commenting on the artworks on display the fashion experts are encouraged to focus on the visitors and their fashion styles.

The intention is that the tour winds its way through the fair stopping when someone or something of interest transpires. The success of this project of course lies in the concept catching your imagination. Your role as an innovative arbiter of taste would shape the artistic vision of the artwork. Of course the exact development of the project would be discussed and planned in advance with Matthieu.

Please find enclosed further details on the project and supporting material on Frieze Art Fair.

We would of course be thrilled if you would be able to consider participating in this project. An enthusiastic audience is certainly guaranteed. If you have any queries about the art fair and in particular the pitch of Matthieu's project I would of course be happy to explain further.

I look forward to hearing from you.

Yours sincerely,

Polly Staple
Frieze Art Fair Curator

Martha Rosler
surface/support

'An enterprise on the scale of the art fair, in
operation for a short while in a public park, requires
a great effort of production, construction, support
and maintenance. Martha Rosler provides a look
at some of the processes and services – whether
celebrated, taken for granted or ignored – that all
would acknowledge are critical to the successful
execution of the fair and the comfort and happiness
of exhibitors, guests and attendees.'

Martha Rosler, New York, June 2005

Martha Rosler works in video, photo-text,
installation and performance, and writes criticism.
Her work addresses the mythologies of everyday life
and the public sphere, as well as the construction of
space. Major projects have centred on war; cooking,
housing and domesticity; and airports, roads and
subways.

Rosler has been invited to make a project at the fair
responding to the idea of the tour format. She has
chosen to focus on the support structures that make
the site workable, behind the scenes and in plain
view – the cafés, toilets and cloakrooms, and the site
construction, security system and park maintenance
... as well as the people who work there.

*Martha Rosler's tour is accessible to art fair visitors; schedule
and location details are available at the Frieze Art Fair
Information Desk.*

Donald Urquhart
L'Entr'acte

Donald Urquhart
L'Entr'acte
Ink on paper
2005
Courtesy Herald St and
Maureen Paley

'*L'Entr'acte* takes place entirely backstage in a theatre. The curtain has just come down on Act One of a play (a dream ballet scene), and the cast are leaving the stage for their dressing rooms. One ballerina is in agony and some stagehands rush to assist her. An actress strides off-stage seething, seemingly outraged. Another breaks down in tears. The cast and crew busy themselves with preparations for Act Two. Make-up, costume and scenery changes take place; people drink, gossip, repair costumes, helping each other to dress. It seems as though no one will be ready in time…

… The backstage area appears to be an infinite warren of long, narrow corridors and stairwells. Visual motifs repeat and resonate: rows or ropes, water pipes, banisters, needles and thread, underlined passages of script, make-up brushes and pencils, shoes. The set is crammed with signage … Backstage movies all somehow have a similar look, from *All About Eve* through *Opening Night* and *A Chorus Line*. This film has the atmosphere of a damp, clammy, claustrophobic dream and should look considerably more sinister.'

Donald Urquhart, London, June 2005

Donald Urquhart has been invited to make a short film that premieres at the fair in The Artists Cinema. *L'Entr'acte* (2005) is shot in black and white on high-definition video and features an original screenplay and sets created by Urquhart as well as a cast and crew assembled from a glamorous assortment of friends and associates.

Screenings are accessible to art fair visitors; schedule and location details are available at the Frieze Art Fair Information Desk.

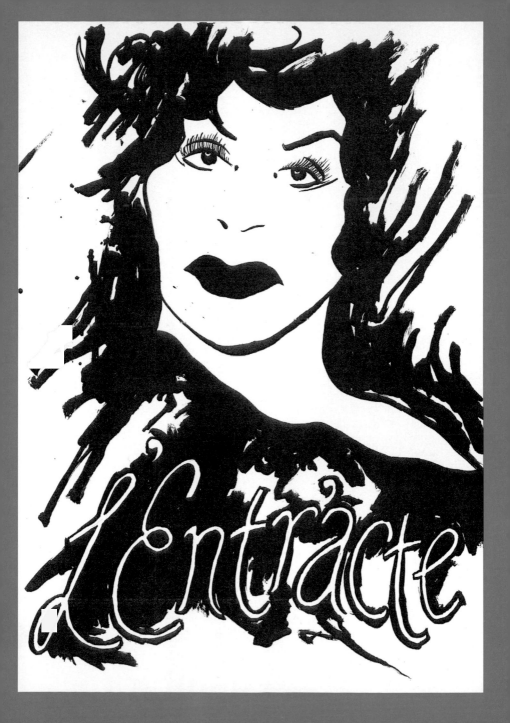

Richard Wentworth
If London Looked in the Mirror

Richard Wentworth
Time and Place
2004
Book with working watches
Courtesy the artist and Lisson
Gallery

'When is a Londoner not a Londoner? When does a long-term visitor become a Londoner? What makes people into Londoners? What must you know to be a Londoner? How long does it last?'

Richard Wentworth, London, June 2005

If London Looked in the Mirror (2005), by Richard Wentworth, is a print project to be distributed on the London Underground network. The work prompts a consideration of how London has evolved and proposes a scheme for re-acquainting Londoners with their city. The naming (and renaming) of London's parts has a contradictory history. Through a rearrangement of names on a rethought map of the city and a proposal for twinning its many boroughs, destinations, villages and landmarks, Wentworth's project aims to ensure that London's inhabitants become thoroughly familiarized with places previously unknown to them.

To accompany *If London Looked in the Mirror*, Wentworth has been commissioned to devise a unique tour originating at Frieze Art Fair, winding its way out into the local environs of Regent's Park and beyond. Wentworth offers commentary on the immediate surroundings and expands on ideas proposed in *If London Looked in the Mirror*.

If London Looked in the Mirror, by Richard Wentworth, is commissioned by London Underground's 'Platform for Art' and Frieze Projects. The tour is accessible to the art fair audience; schedule and location details are available at the Frieze Art Fair Information Desk.

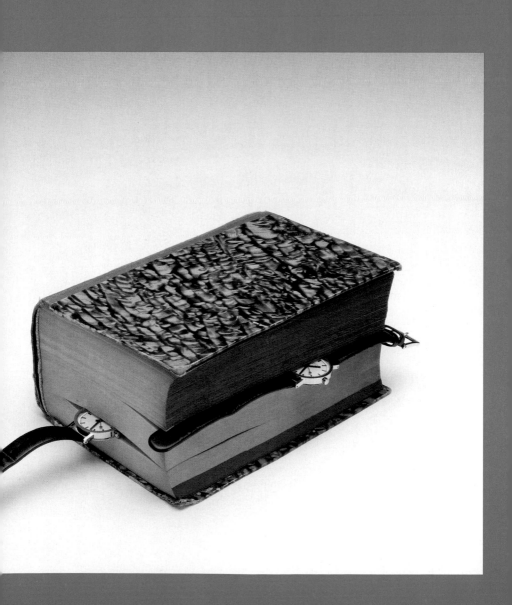

Photo by Cathy Wilkes
2005

Cathy Wilkes
Most Women Never Experience

'In relation to intellectual life in the midst of time and the mechanical. Even this (the mechanical) reaches out beyond what I thought possible and bearable, and returns to a point of splitting within me. So each is not an alternative to the other.'

Cathy Wilkes, Glasgow, July 2005

Cathy Wilkes has been invited to make a short film that premieres at the fair in The Artists Cinema. Wilkes combines sculpture, painting and writing to create detailed and immersive installations. Here she explores the narrative potential of film's duration: atmosphere, presence, loss, fabrication, bodily politics, art-historical posturing and economic analysis are all displayed and discarded with a tough precision that resists easy interpretation.

Cathy Wilkes' film is being shown during the fair in The Artists Cinema. Screenings are accessible to art fair visitors; schedule and location details are available at the Frieze Art Fair Information Desk.

Ian Wilson
A Discussion

In 1968 Ian Wilson made his final sculpture.
Since then he has used the unseen abstractions of
language as his art form. Today Wilson's ideas are
expressed as a series of philosophical discussions with
the audience. These 'Discussions' are an extended
work in progress about the possibilities of knowledge
and allow the audience the opportunity to present
their own views, and to question, propose, interject
and debate.

Over the years Wilson has had 'Discussions' in
museums, galleries and the homes of private
collectors. The event is never recorded or published,
beyond the certificates registering the date, time and
location.

Wilson's 'Discussions' exist as a 'fact', yet their
presentation utilizes the dynamic of myth, and
they in turn become mythologized. Within
the current glut of debate on 'social relational
practice', Wilson's insistence on clear parameters
of articulation is crucial. The works open up ideas
about perception and reality but also about what
is permissible; the sub-text is about freedom of
speech and the importance of communication, and
– within the context of the art fair – the need for a
conceptually critical rather than consumer-driven
experience.

**A Discussion with Ian Wilson will be
held on October 23, 2005, at 5p.m.
in the Frieze Art Fair auditorium.**

Andrea Zittel
Interlopers HC

'All of my friends in California seem to "do things"
– bake cakes, write 'zines, bicycle in the nude, ski in
costumes, build metal boats, identify bugs or grow
vegetables. And sometimes we do things together
– like getting dressed up and going for hikes...

The Interlopers HC is a formalization of a loosely
knit hiking club that began as The Feral Spaniels
in Los Angeles in 1998, founded by Lisa Anne
Auerbach and Andrea Zittel for the purpose of
pancake hikes in the Los Angeles Foothills of
the San Gabriel Mountains. In the early 2000s,
the group migrated to the high desert region of
A–Z West, where Giovanni Jance joined in as an
organizer. It was in the isolation of these high hills
that the hiking club's hiking apparel transformed
into a combination of utility and fashion, dazzling
the tortoises, snakes and other desert creatures.
Combining costumes and sport was the perfect
antidote to a practice of desert walking ... when
in costume, we looked as odd as joshua trees and
blooming cacti, and our iconoclastic attire brought
us closer to the desert's alien environment.

In October of 2005 The Interlopers HC will be at
Frieze Art Fair to trample some turf and to distribute
advice and assistance to other wayward walkers.'

Andrea Zittel and Lisa Anne Auerbach, California,
June 2005

**International Artists
Studio Program in
Sweden (Iaspis) presents**
European Cultural Policies
2015: A Report with
Scenarios on the Future
of Public Funding for
Contemporary Art in Europe

A collaboration among eipcp, åbäke and Iaspis.

At Frieze Art Fair the report is distributed free
of charge from the Iaspis booth situated in the
publications area. In November 2005 a workshop
will be held at Iaspis in Stockholm in which tactics
and strategies for concrete actions based on the
report will be discussed. The workshop in Stockholm
will later be followed by workshops in Vienna and
elsewhere.

eipcp (The European Institute for Progressive
Cultural Policies) is an independent institute based
in Vienna and Linz, which is concerned with the
links between philosophy, cultural theory and social
sciences as well as artistic production, political
activism and cultural policy. www.eipcp.net

åbäke is a partnership of four graphic designers
trained in Paris, London, New York, Helsinki,
Brighton and Gothenburg. Patrick Lacey, Benjamin
Reichen, Kajsa Ståhl and Maki Suzuki formed the
partnership in July 2000, after graduating from
the Royal College of Art. Previous projects have
included working with Belgian and British fashion
designers (Maison Martin Margiela and Hussein
Chalayan) as well as the FILMSHOP, Apolonija
Sustersic, Johanna Billing, Ella Gibbs & Amy
Plant, their local rental video shop ('mostly good
ones'), Channel 4, RIBA and the British Council.
They also co-edit *Sexymachinery*, a self-published
magazine and run their own music label (Kitsuné).

Iaspis (International Artists Studio Program in
Sweden) is a Swedish exchange program, whose
main purpose is to facilitate creative dialogues
between visual artists in Sweden and international
contemporary art. Iaspis encompasses an
international studio program in Sweden, a support
structure for exhibitions and residencies abroad
for artists based in Sweden, and a program of
seminars, exhibitions and publications. Iaspis is the
international program of the Visual Arts Fund, a
branch of the Arts Grants Committee.

Commissioned by Maria Lind, Director of Iaspis.

For more information please visit: www.iaspis.com

Shadow of a passing cloud, near
Bunavoneadar, Harris, Scotland
2005
Photo by John MacLean

Stedelijk Museum Bureau Amsterdam (SMBA) presents Germaine Kruip
The Wavering Skies

In Germaine Kruip's work the position of the spectator is always under scrutiny. Kruip stages temporary situations that guide the spectator's gaze, transforming his role into that of participant. Subtle interventions in the existing surroundings of the exhibition space – making use of special lighting, for example, or the introduction of actors – result in a heightened sense of self-awareness for the now active visitor.

At Frieze Art Fair Kruip creates a site-specific light piece for the monumental entry corridor. Titled *The Wavering Skies* (2005), the work creates a shadow that slowly moves through the corridor, drawing attention to the spatial co-ordinates of the structure, enhancing the viewer's sense of time and resulting in an almost ritual experience of passage.

The Wavering Skies is co-curated and commissioned by Martijn van Nieuwenhuyzen, Director of Stedelijk Museum Bureau Amsterdam, in collaboration with Frieze Projects. The project was also made possible by the support of the Mondriaan Foundation, Amsterdam, and The Netherlands Foundation for Visual Arts, Design and Architecture, Amsterdam.

A booth representing Stedelijk Museum Bureau Amsterdam can be found in the publications area of the art fair. For more information please visit: www.smba.nl

The Artists Cinema in collaboration with LUX

The Artists Cinema is a Frieze Projects/LUX collaboration to construct, programme and run a cinema for artists' film and video works within Frieze Art Fair.

The Artists Cinema programme focuses on new artists' film and video works that premiere at the art fair. Frieze Projects' film and video commissions, by Roger Hiorns, Donald Urquhart and Cathy Wilkes, will be shown daily alongside recent LUX/Spacex 'amovie' commissions by Mark Leckey, Daria Martin, Jimmy Robert, Imogen Stidworthy, Mika Tannila and Yang Fudong.

The commissions will be accompanied by an invited programme selected by eight curators: Bernadette Corporation, Chrissie Iles, Marta Kuzma, Philippe-Alain Michaud, Berta Sichel, Catherine Wood, Cerith Wyn Evans and Tirdad Zolghadr.

For a full programme and listings please see The Artists Cinema publication available at the cinema and the Frieze Art Fair Information Desk.

The Artists Cinema is a Frieze Projects/LUX collaboration. The programme is co-ordinated by Ian White. Programme highlights will tour to Arnolfini, Bristol; Baltic, Gateshead; and FACT, Liverpool, in Spring 2006. For more information please visit: www.lux.org.uk

Resonance 104.4fm

London's art radio station Resonance 104.4fm are
setting up their radio station and broadcasting live
from the fair. Resonance transmits Frieze Talks
alongside specially commissioned radio art projects,
and features interviews with artists and art profes-
sionals in and around the fair. Fair visitors are
able to watch the Resonance team at work and
contribute to the debate.

*Log on to www.resonancefm.com worldwide. Tune in on
104.4 FM in central London.*

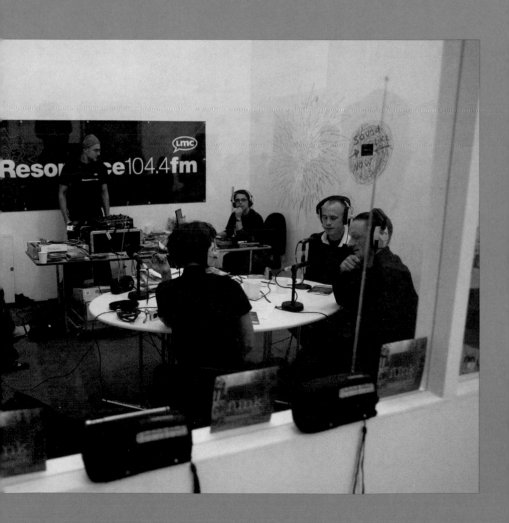

Selected Bibliography

2005 *Daysleepers*, Tresor im Kunstforum, Vienna

2004 *Adam Adach*, Patricia Falguières, Jean Brolly and Robert Fleck, Centre d'Art Contemporain, Château des Adhemar, Montelimar

2002 *Urgent Painting*, Patricia Falguières, Sandra Antelo-Suarez et al., Musée d'Art Moderne de la Ville de Paris

Adam **Adach**

Born 1962
Lives Paris

Working with images culled from the pages of newspapers, journals and found photo albums, Adam Adach takes snapshots and personalizes them, using a painterly technique to add an intriguing, evocative dimension. Emotionally charged, his paintings prompt us to engage imaginatively with these discarded, forgotten or simply lost stories. His canvases are large and gestural, executed in layers of wash, over which textures are carefully built up. This process creates images whose slick finish is offset by the deliberate nonchalance of drips, scrapes and splashes, producing disturbingly vague intimations of romance, disaster and loss. (DJ)

Shown by Arndt & Partner D21, D'Amelio Terras G14

Selected Exhibitions

2005 'Daysleepers', Ba-Ca Kunstforum, Vienna

2005 'Adam Adach: Paintings', D'Amelio Terras, New York

2005 'Gabi Hamm, Susan Turcot, Adam Adach', Arndt & Partner, Berlin

2004 Centre d'Art Contemporain, Château des Adhemar, Montelimar

2004 'Nouvelles Acquisitions', Centre Georges Pompidou, Paris

2004 'Voir en Peinture', Centre d'Art Contemporain–Zamek Ujazdowski, Warsaw

2004 'Sztuka Wspolczesna dla wszystkich dzieci', National Gallery of Art–Zacheta, Warsaw

2002 'Urgent Painting', Musée d'Art Moderne de la Ville de Paris

Come to Me
2004
DVD
Edition of 6+1AP
Three-screen version
Courtesy Galerist

Selected Bibliography

2005 'The Shifting Nature of Reality', Reena Jana, *tema celeste*

2004 'Out of Time: Haluk Akakçe', Alex Farquharson, *frieze* 81

2004 'Haluk Akakçe', Andrew Marsh, *Flash Art*

2004 'Haluk Akakçe', Martin Herbert, *Time Out London*

2004 'Haluk Akakçe', Eliza Williams, *Art Monthly*

Selected Exhibitions

2005 'Tomorrow Is Another Day', Max Hetzler, Berlin

2004 'Abstract Emotions/ Transmental World', Galerist, Istanbul

2004 'Missing Piece', The Approach, London

2004 'Art Now', Tate Britain, London

2004 'Blind Date', Nogueras Blanchard, Barcelona

2003 Cosmic Gallery, Paris

2002 'Illusion of the First Time', Whitney Museum of American Art at Phillip Morris, New York

2002 'A Delicate Balance', Centro Nazionale per le Arti Contemporanee, Rome

2001 'Still Life', Bernier/Eliades, Athens

2001 'Blood Pressure', Galerist, Istanbul

Haluk **Akakçe**

Born 1970
Lives London/New York

With state-of-the-art digital animation, drawings and wall paintings, Haluk Akakçe builds a visual environment of uncertain, mutating architecture and spatial elasticity. Abstract forms glide in perpetual motion across the flat plane of the projected image, suggesting that the screen is but a small window giving access to a virtual dimension extending in infinite directions – a fluid shadow world of reverie as redolent of computer games as it is of the modular Islamic and Ottoman aesthetics of his native Turkey. (DF)

Shown by The Approach G3, Bernier/Eliades F17, Galleria Massimo de Carlo E10, Galerist G18

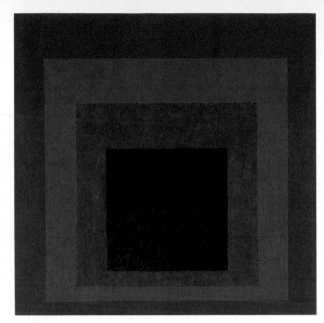

Selected Bibliography

2005 *Josef Albers*, Peter Weiermair, Giusi Vecchi and Nicholas Fox Weber, Silvana Editoriale Spa, Milan

1988 *Josef Albers: A Retrospective*, Nicholas Fox Weber, Mary Emma Harris, Charles Rickart and Neal Benezra, Guggenheim Foundation, New York

1988 *Josef Albers*, Getulio Alviani, L'Arcaedizioni, Milan

1972 *Josef Albers*, Eugen Gomringer, Dessain et Tolra, Paris

1963 *Interaction of Color*, Josef Albers, Yale University Press, New Haven

Selected Exhibitions

2005 Museo Morandi, Bologna

2004–5 'Josef and Anni Albers: Designs for Living', Cooper-Hewitt, National Design Museum, New York

1998 'Josef Albers: Works on Paper', Kunstmuseum, Bonn

1995 'Josef Albers: Glass, Color, and Light', Guggenheim Museum, New York

1994 National Gallery of Modern Art, Dublin

1988 Guggenheim Museum, New York

1971 The Metropolitan Museum of Art, New York

1968 Westfälisches Landesmuseum für Kunst und Kulturgeschichte, Münster

1964 'Josef Albers: Homage to the Square', International Council of the Museum of Modern Art, Caracas

Josef **Albers**

Born 1888
Died 1976

An artist, teacher, designer and writer, Josef Albers' work was essentially an exploration of the nature of perception. Having taught at the Bauhaus school until its closure in the 1930s, he subsequently moved to the USA, where he lectured at Black Mountain College until taking a position at Yale in 1950. That year he began his magnum opus, 'Homage to the Square', a series of paintings that occupied him until his death. Despite its title, the core concern of the series was a sustained study of the contingent characteristics of colour. For Albers, as Michael Craig-Martin has written, 'the essential and irreducible subject of painting should be colour, only colour'. (DF)

Shown by Waddington Galleries F3

Under Discussion
2005
Single channel video projection
Courtesy Lisson Gallery

Selected Bibliography

2005 'Allora & Calzadilla: The Monstrous Dimension of Art', Yates McKee, *Flash Art*

2005 'Talk About Three Pieces in Vieques', Jennifer Allora and Guillermo Calzadilla, *Artforum*

2004 'Allora & Calzadilla', Francesco Manacorda, *Flash Art*

2003 *Common Wealth*, ed. Jessica Morgan, Tate Publishing, London

2003 *When Latitudes Become Form: Art in a Global Age*, ed. Michelle Piranio, Walker Art Center, Minneapolis

Selected Exhibitions

2005 'Always a Little Further', Arsenale, Venice Biennale

2005 'Material Time / Work Time / Life Time', Reykjavik Arts Festival

2004 Institute of Contemporary Art, Boston

2004 Walker Art Center, Minneapolis

2004 'Unstable Atmospheres', Lisson Gallery, London

2003 'Puerto Rican Light', The Americas Society, New York

2003 'Common Wealth', Tate Modern, London

2002 Institute of Visual Arts at the University of Wisconsin, Milwaukee

2001 Museo de Arte de Puerto Rico, Santurce

Allora & Calzadilla

Born 1974/1971
Live San Juan

Jennifer Allora and Guillermo Calzadilla have written that 'we deal with globalization because it's impossible not to'. In *Charcoal Dancefloor* (1997) a drawing of human figures was blurred into abstraction by gallerygoers' feet until nothing but their Nike-branded footprints remained. While in this work the mobility of people, capital and ideas intimated violence, in their recent video *Under Discussion* (2005) it is perhaps a more benign force. Here the son of a Puerto Rican civil disobedience movement leader travels to the disputed territory of Vieques in a boat made from an upturned conference table, bringing with him the hope, however absurd, of profitable debate. (TM)

Shown by Galerie Chantal Crousel D10, Lisson Gallery D8

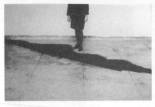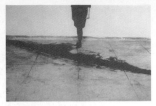

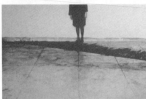

A Onda
(The Wave)
1997
Four black and white
photographs
126×185cm
Courtesy Galeria Filomena
Soares

Selected Bibliography

2004 *Impossible Seduction*, Moacir
dos Anjos, Anamnese

2004 *Helena Almeida: Feet on the
Ground, Head in the Sky*, Delfim
Sardo, Centro Cultural de
Belém, Lisbon

2001 *Helena Almeida*, Rosa
Martinez and Alexandre Melo,
Galeria Filomena Soares, Lisbon

1999 *Helena Almeida*, Maria de
Corral, Isabel Carlos and Carlos
Vidal, CGAC, Santiago de
Compostela

1997 *Helena Almeida in From Here
to There*, Michael Tarantino,
CAMJAP, Lisbon; Centro
Português da Fotografia, Porto

Helena **Almeida**

Born 1934
Lives Lisbon

Since the 1970s Helena Almeida has created works
that intertwine drawing, performance, sculpture
and photography, involving such tactics as
repetition and seriality, but with her own complex
motivations. She draws on eclectic influences,
including works by Marcel Duchamp and Lucio
Fontana and choreography by Pina Bausch.
Cinema is another reference point, evident in her
practice of making video 'studies' for photographs.
During the 1990s Almeida launched an extensive
series of investigations into the relationship
between her body and the space of her studio –
a relationship especially complex in recent works
incorporating mirrors that threaten to swallow
up her limbs and perforate the two-dimensional
surface. (KJ)

Shown by Galeria Filomena Soares E1

Selected Exhibitions

2005 'Recent Works', Centre
d'Art Santa Monica, Barcelona

2005 Portuguese Pavilion,
Venice Biennale

2004 'On Reason and Emotion',
Sydney Biennial

2001 Galeria Filomena Soares,
Lisbon

1995 'Dramatis Persona',
Fundação de Serralves, Porto

1991 'Europália', Musée de
Charleroi

1985 'Livres d'Artistes', Centre
Georges Pompidou, Paris

1982 Portuguese Pavilion,
Venice Biennale

1979 'Photography as Art',
Institute of Contemporary Arts,
London

1977 'Alternativa Zero', Galeria
de Belém, Lisbon

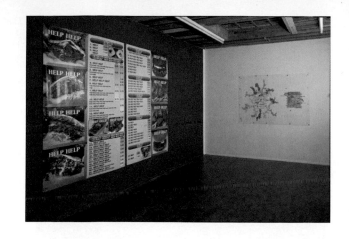

HELP
2002
Mixed media
Dimensions variable
Installation view, Cabinet
Courtesy Cabinet

Selected Bibliography

2000 *Provisional Acts*, Jean
Fisher, Whitechapel Art Gallery,
London

1998 *Fresh Cream: Contemporary
Art in Culture*, Phaidon Press,
London

1998 *From the Corner of the Eye*,
Stedelijk Museum, Amsterdam

1996 *Mothership Connection*,
Stedelijk Museum Bulletin,
Amsterdam

Selected Exhibitions

2005 'Capp Street Project', CCA
Wattis Institute, San Francisco

2004 Shanghai Biennial

2004 'Homeland', Spacex, Exeter

2002 'HELP', Cabinet, London

2000 'Temporary
Accommodation', Whitechapel
Art Gallery, London

2000 Gate Foundation,
Amsterdam

1998 'From the Corner of
the Eye', Stedelijk Museum,
Amsterdam

1996 'The Mothership
Connection', Stedelijk Bureau,
Amsterdam

Tariq **Alvi**

Born 1965
Lives London

Recycling and recontextualizing promise-tinged
printed ephemera – club flyers, porn mags,
jewellery catalogues and classified ads – Tariq
Alvi's early work comprised delicate collages
and installations that operated at the threshold of
private wants and wider public life. More recently
the artist has explored more painful aspects of
(especially gay) experience, covering a wheelchair
with cake icing and burnt-out 40th birthday
candles, and juxtaposing a gigantic 'bug chasing'
T-shirt, emblazoned with the phrase 'I ♥ SUPER
HIV', with video footage of an emaciated male
AIDS sufferer. This is work that knows that, while
our specific values may shift with the wind, what
underpins them is an ineffable yearning. (TM)

Shown by Cabinet E12, Diana Stigter H14

Dark Mirror
2002
Two channel video projection
over floating screen
Photo Fernando Maquieira
Courtesy kurimanzutto

Selected Bibliography

2005 'Carlos Amorales',
Jennifer Allen, *Artforum*

2005 'Carlos Amorales o el
tudo-vale', Fernando Castro
Flórez, *ABC*

2004 'Carlos Amorales', Siebe
Tettero, *Contemporary*

2003 'Wrestling with Identity',
Fiachra Gibbons, *The Guardian*

2003 'Carlos Amorales: "Le
Diable, c'est Bush"', Nicolas
Thely, *Le Monde*

Selected Exhibitions

2005 'Why Fear The Future',
Casa de America, Madrid

2005 'In Gold We Trust', Nuevos
Ricos winter tour, New York,
Madrid, Barcelona, Geneva and
Mexico City

2005 'In the Air: Projections of
Mexico', Guggenheim Museum,
New York

2004 'The Nightlife of a
Shadow', Annet Gelink Gallery,
Amsterdam

2004 'The Forest', Creative
Time, Times Square, New York

2004 'Don't Call It
Performance', Centro Andaluz
de Arte Contemporáneo, Seville;
Museo del Barrio, New York

2004 'Localismos', downtown
area, Mexico City

2003 'Devil Dance', Museum
Boijmans Van Beuningen,
Rotterdam

2003 Dutch Pavilion,
Venice Biennale

2003 'Independence', South
London Gallery

Carlos **Amorales**

Born 1970
Lives Mexico City/Amsterdam

Carlos Amorales is probably best known for his
Mexican *lucha libre* wrestling performances, where
his alter-ego characters, fitted out with elaborate
costumes and 'Amorales' masks, compete against
each other. For a project last year the artist
digitized and abstracted his personal archive
of hundreds of collected images and had tarot
readers interpret them. With installations, videos,
photography, graphic art and music performances
organized under his Nuevos Ricos record label,
Amorales animates the themes at the heart of these
events: the play between private, personal meaning
and larger cultural symbols and rituals. (PE)

Shown by kurimanzutto B11, Yvon Lambert F6

*Invocation of My Demon Brother
(Eye with Crowley's Star)*
1969/2004
Ultrachrome archival
photograph
48×64cm
Courtesy Stuart Shave |
Modern Art

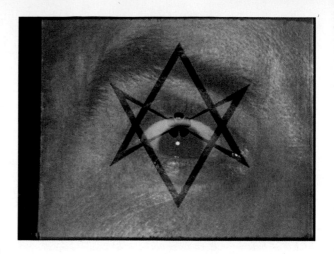

Selected Bibliography

2004 *Kenneth Anger: A Demonic
Visionary*, Alice L. Hutchinson,
Black Dog Publishing, London

2003 'Courting Anger', Alice
L. Hutchinson, *Afterall*

1998 *Material and Immaterial
Light: Brakhage and Anger, First
Light*, Fred Camper, Anthology
Film Archives, New York

1989 *Into The Pleasure Dome:
The Films of Kenneth Anger*, eds.
Jayne Pilling and Mike O'Pray,
British Film Institute, London

1971 *The American Independent
Film*, P. Adams Sitney, Museum
of Fine Arts, Boston

Selected Exhibitions

2004 'Invocation of My Demon
Brother (New Film Stills)',
Modern Art, London

2002 'Kenneth Anger's Icons',
The Bathhouse, Shiraishi
Contemporary Art Inc., Tokyo

2002 Film Forum, Tokyo

2001 'Beau Monde: Towards a
Redeemed Cosmopolitanism',
SITE Santa Fe

1995 Institut Français, Vienna

1986 'Hollywood: Legend and
Reality', Smithsonian Institution
Travelling Exhibition

1980 'Lucifer Rising',
Whitney Museum of American
Art, New York

1980 The Walker Center
for Art/Film in the Cities,
Minneapolis

1980 'The Pleasure Dome',
Moderna Museet, Stockholm

Kenneth **Anger**

Born 1927
Lives Los Angeles

Kenneth Anger holds a unique position in the
development of avant-garde cinema. From his
first significant work, *Fireworks*, made in 1947, he
has had a profound influence on 20th-century
experimental film. Sumptuous and mythopoeic,
Anger's hallucinatory and often homoerotic
narratives are shaped by the opulent symbolism
of occult 'magick' practices, while simultaneously
mining the darker, ritualized excesses of popular
culture. If 1962's *Scorpio Rising* has become a
byword for underground film (some say it single-
handedly invented the music video), then Anger's
name is synonymous with reinventing cinema as a
cabbalistic sacrament for the imagination. (DF)

Shown by Stuart Shave | Modern Art D13

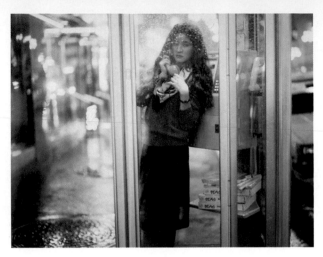

Tokyo Nostalgia
1998
C-print
Courtesy Taka Ishii Gallery

Selected Bibliography

2003 *ARAKI by ARAKI*, Nobuyoshi Araki, Kodansha International, Tokyo

1992 *AKT–TOKYO 1971–1991* (Tokyo Nudes 1971–1991), Nobuyoshi Araki, Camera Austria, Graz

1989 *Tokyo Nude*, Nobuyoshi Araki, Ohta Publishing, Tokyo

1971 *Sentimental Journey*, Nobuyoshi Araki, Self-published, Tokyo

Nobuyoshi **Araki**

Born 1940
Lives Tokyo

Intense eroticism tinged with violence has been Nobuyoshi Araki's calling card for decades. In obsessive, sometimes diaristic works – depicting young women, flowers, cats and other subjects – he captures photography's deathlike nature as much as what is in front of the lens. Scratched-out images of genitalia, he has said, were meant to suggest that 'it's the act of hiding them that's obscene'. In 1990 Araki recorded his wife's death from cancer. In his recent series 'From Winter to Spring' he created monochrome images of flowers and the poet Minori Miyata, who had lost a breast to cancer; she answered the photographs with poems. (KJ)

Shown by Rebecca Camhi E22, Studio Guenzani E13, Taka Ishii Gallery F4, Jablonka Galerie C16, galerie bob van orsouw D19, Galerie Almine Rech G1, White Cube/Jay Jopling F8

Selected Exhibitions

2005 'Self, Life, Death', Barbican Art Gallery, London

2003 'Hana-Jinsei', Tokyo Metropolitan Museum of Photography

2003 'Tokyo Still Life', Tampere Art Museum

2002 'Suicide in Tokyo', Italian Pavilion, Venice

2000 'Viaggio Sentimentale', Centro per l'Arte Contemporanea Luigi Pecci, Prato

2000 Stedeljik Museum voor Actuele Kunst, Ghent

1999 'Arakinema: A's Paradise', Museum of Contemporary Art, Tokyo

1999 'ARAKI Nobuyoshi Sentimental Photography, Sentimental Life', Museum of Contemporary Art, Tokyo

1998 'Tokyo Shijyo', Diechtorhallen, Hamburg

1997 'Tokyo Comedy', Secession, Vienna

Sabine/Brunilde
2003
Video installation
Courtesy Galeria Filomena
Soares

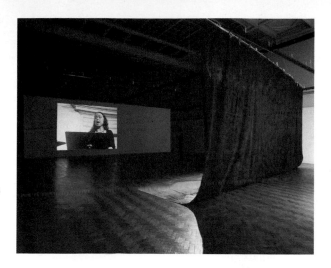

Selected Bibliography

2004 'Other Alternatives',
Alexandre Melo, *Artforum*

2004 'Vasco Araújo', Marie
Brugerolle, *Flash Art*

2003 'The Iberian Front: Spain
and Portugal', *Art in Europe
1990–2000*, Rosa Martinez

2003 *O Forro das Coisas: Prémio
EDP, Novos Artistas* (The Lining
of Things: EDP Prize, New
Artists), Isabel Carlos, EDP,
Lisbon

2003 *Hippolytus, Pardon and
Desire*, Mark Gisbourne,
Anamnese, Berlin

Selected Exhibitions

2005 'Dilemma', S.M.A.K,
Ghent

2005 Moscow Biennial

2005 'The Experience of Art',
Italian Pavilion, Venice Biennale

2004 'O Amante', Galeria
Filomena Soares, Lisbon

2004 'Amalgama',
Contemporary Art Museum,
Houston

2003 'Europe Exists',
Macedonian Museum of
Contemporary Art, Thessaloniki

2003 Center for Curatorial
Studies, Bard College,
Annandale-on-Hudson

2002 'The World May Be
Fantastic', Sydney Biennial

2002 'Melodrama, Atrium',
Centro–Museo Vasco de Arte
Contemporáneo, Vitoria-Gasteiz

2001 'Trans-Sexual Express:
A Classic for the Third
Millennium', Centre d'Art Santa
Monica, Barcelona

Vasco **Araújo**

Born 1975
Lives Lisbon

In his photographic and video work Vasco Araújo
presents intimate identity as in conflict with
social codes. 'Dilemma' (2004) is a series of oval,
faux classical portraits of courtiers wielding fans,
engaged in curious games of social and cultural
masquerade. Each portrait is given an emotive
yet oddly formal title, implying that the singular
gesture of concealment and display might bear
some internal logic of expression, illuminating
obscure rituals of cultural play. By extension,
through his mimicry of historical forms such as
opera, Araújo also questions the architectural
spaces of culture as places in which roles and codes
of behaviour are shaped and privileged. (DJ)

Shown by Galeria Filomena Soares E1

Selected Bibliography

2005 *Art & Language: Writings*,
Michael Baldwin, Charles
Harrison and Mel Ramsden,
Lisson Gallery, London

2002 *Too Dark to Read: Motifs
Rétrospectifs 2002–1965*, Michel
Gauthier et al., Musée de Lille
Métropole, Villeneuve d'Ascq

2001 *Essays on Art & Language*,
Charles Harrison, MIT Press,
Cambridge

2000 *Art-Language, Volumes 1–5,
1969–1985*, Fascimile edition

1999 *Art & Language in Practice:
Volumes 1 & 2*, Michael
Baldwin, Charles Harrison and
Mel Ramsden, Fundació Antoni
Tapies, Barcelona

Art & Language

Founded 1968
Live Middleton Cheney

The name Art & Language was given in 1968 to
the collaborative activities of a fluctuating number
of artists that eventually coalesced around the
core trio of Michael Baldwin, Mel Ramsden and
the art historian Charles Harrison. With its basis
in discussion, their work is wide-ranging in form,
embracing sculpture, painting, writing, music,
performance and installation, developing manifold
methods of production in order to create a
critically reflexive and often wilfully unpredictable
approach to understanding visual cognition and
context. (DF)

Shown by Galería Juana de Aizpuru C17, Lisson
Gallery D8, Galeria Filomena Soares E1

Selected Exhibitions

2003 Migros Museum, Zurich

2002 'Too Dark to Read:
Motifs Rétrospectifs 2002–1965',
Musée de Lille Métropole,
Villeneuve d'Ascq

1999 'The Artist out of Work,
PS1 Contemporary Art Center,
New York

1999 'Art & Language in
Practice', Fundació Antoni
Tapies, Barcelona

1993 Jeu de Paume, Paris

1987 'The Paintings', Palais des
Beaux-Arts, Brussels

1980 'Portrait of V.I. Lenin in
the Style of Jackson Pollock', Van
Abbe Museum, Eindhoven

1976 Venice Biennale

1972 Documenta, Kassel

1970 'Information', Museum of
Modern Art, New York

Mindfall
2004
Tarnished glasses, electrical
engines, electrical wires and
apparatus, nafta, smoke
Dimensions variable
Courtesy Johann König and
Zero

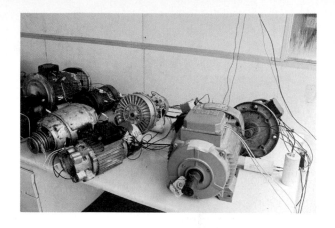

Selected Bibliography

2005 'Russian Front', John
Kelsey, *Artforum*

2004 'First Take', Carolyn
Christov-Bakargiev, *Artforum*

2004 'Micol Assaël', Andrea
Viliani, *Boiler*

2004 'Manifesta 5', Thomas
Wullfen, *Kunstforum*

2003 'Occhio alla Biennale:
Una scultura fatta di angoscia'
(Be Wary of the Biennale: A
Sculpture Made of Anxiety),
Francesco Bonami, *La Stampa*

Selected Exhibitions

2005 Zero, Milan

2005 Moscow Biennial

2005 'Material Time/Work
Time/Life Time', Reykjavik
Art Festival

2005 'Always a Little Further',
Arsenale, Venice Biennale

2004 'D-Segni', Fondazione
Sandretto Re Rebaudengo,
Turin

2004 'Non Toccare la Donna
Bianca', Fondazione Sandretto
Re Rebaudengo, Turin

2004 Manifesta, San Sebastian

2003 'Great Expectations', Fuori
Uso – Ferrotel, Pescara

2003 'Dreams and Conflicts:
The Dictatorship of the
Spectator', Arsenale, Venice
Biennale

2002 'Exit', Fondazione
Sandretto Re Rebaudengo,
Turin

Micol **Assaël**

Born 1979
Lives Rome

If the mind is a machine, then the body is a factory
and society the industry that puts mind and body
to work. So what happens when society falls apart,
leaving the mind machine whirring aimlessly
in a post-industrial wasteland? Micol Assaël's
work thrives on such physical symbolism. Her
installations stage dystopian scenarios – engines
in a derelict workshop that hum at full throttle but
have no apparent function (*Untitled*, 2004) or a
cell equipped with high-voltage generators that
produce sparks from wires and bulbs (*The Theory of
Homogenous Turbulence*, 2002). Assaël conjures the
spectre of heavy industry to haunt the sanitized
image of the information age. (JV)

Shown by Johann König D2, Zero A11

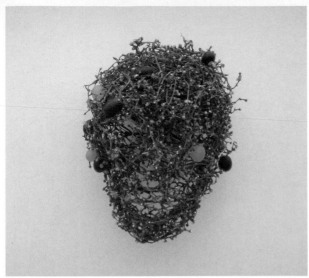

Skull Grapes
2004
Grapes and gold sparkles
15×20×15cm
Courtesy Galeria Luisa Strina

Selected Bibliography

2004 'Oddball Charm of The Beck's Futures Show', Waldemar Januszczak, *Sunday Times*

2004 *Beck's Futures 2004*, Institute of Contemporary Arts, London

2003 *Tonico Lemos Auad*, Galeria Luisa Strina, São Paulo

2003 *White Meat & Sunlite*, Galerie Wiensowik & Harbord, Berlin

2000 *ZigZag*, Galeria Thomas Cohn, São Paulo

Tonico Lemos **Auad**

Born 1968
Lives London

Tonico Lemos Auad practises a sort of bourgeois, office- or living-room-based *Arte Povera*. The images he pricks into unpeeled bananas have a dull–civil–servant–doodling–during–his–lunch–break quality, while the menagerie of animals he conjures from carpet fluff are as offensively inoffensive as any found on a Hallmark greetings card. Given that his materials articulate the fragility of the physical world in the face of time, there's something horrifying about the fact that what he does with them is so wilfully inconsequential. This, however, is Auad's point. Fiddling while Rome burns has seldom felt so wrong, and yet so oddly right. (TM)

Shown by Galeria Luisa Strina G7

Selected Exhibitions

2005 'Material Matters', Herbert Johnson Museum, Ithaca

2005 'EV+A', Limerick City Gallery

2005 'The British Art Show', Hayward Gallery, London and touring

2005 Yokohama Triennial

2004 'Beck's Futures', Institute of Contemporary Arts, London

2004 'Adaptive Behaviors', The New Museum, New York

2004 'Instinctive', Andrea Rosen Gallery, New York

2003 'Tonico Lemos Auad', Galeria Luisa Strina, São Paulo

2003 'Project Gallery', Dublin

2002 'Lyric Underground, Launch', Gasworks Gallery, London

Tree
2004
Oil and charcoal on flax canvas
168×168cm
Courtesy Anthony Reynolds
Gallery

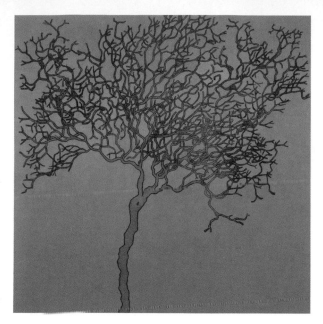

Selected Bibliography

2004 'David Austen', Morgan Falconer, *Modern Painters*

2003 'Bible Lessons', Joanna Pitman, *The Times*

2003 'The Sands of Time', Sue Hubbard, *The Independent*

2003 'Exodus', Sotiris Kyriacou, *Contemporary*

2003 'Austen in the Desert', Craig Burnett, *Modern Painters*

Selected Exhibitions

2004 Peer, London

2003 'Hard Times', Ingleby Gallery, Edinburgh

2001 'Objects and Images from the Edge of the World', Wolsey Art Gallery, Christchurch Mansion, Ipswich

1999 Galerie Marianne Hollenbach, Stuttgart

1999 Commission for British Embassy, Cairo

1998 Slewe Gallery, Amsterdam

1997 'Antechamber', Whitechapel Art Gallery, London

1997 'Marks and Traces', Sandra Gering Gallery, New York

1996 'About Vision: New British Painting in the 1990s', Museum of Modern Art, Oxford

1995 'Made in L.A.', Los Angeles County Museum

David **Austen**

Born 1960
Lives London

For David Austen a motif is a means to explore its own realization in paint. A word, a tree, a woman's back or an abstract network of lines is steadily inscribed in oil or watercolour, its innate meaning and its inter-subjective connections to the other elements in the work playing second fiddle to the array of techniques used and elegant solutions found. There is a sense that Austen scours the visual world for interestingness, selecting gems that suggest new ways of embedding accurate detail within a convincing whole – the crux of picture-making itself. (SO'R)

Shown by Anthony Reynolds Gallery D18

CONFIDENT

John **Baldessari**

Born 1931
Lives Los Angeles

Since he sang Sol LeWitt's 1969 text 'Sentences on Conceptual Art' (*Baldessari Sings LeWitt*, 1972), John Baldessari's Conceptualism has exerted a sagaciously droll influence. Moving freely between text-based pieces, video and photography, his work has consistently sought to disrupt the integrity and veracity of photographic space. His technique of juxtaposing, cropping, overpainting and overlapping seemingly disparate images, often culled from cinematic or art-historical sources, creates what he calls 'colliding imaginary zones', meridians of hybrid meaning where visual languages are invigorated with new and unexpected narrative possibilities. (DF)

Shown by 1301PE B8, Bernier/Eliades F17, Galería Pepe Cobo E24, Marian Goodman Gallery F9, Lisson Gallery D8, Mai 36 Galerie D19, Sprüth Magers Lee B13

Selected Bibliography

2005 *John Baldessari: A Different Kind of Order (Works 1962–1984)*, Rainer Fuchs, Museum of Modern Art, Vienna

2005 *John Baldessari: Life's Balance*, Peter Pakesch, Verlag Walther König, Cologne

2004 *John Baldessari: Somewhere Between Almost Right and Not Quite*, Deutsche Guggenheim, Berlin

2000 *While Something Is Happening Here ...*, Sprengel Museum Hanover; Verlag Walther König, Cologne

2000 *John Baldessari*, Skira, Milan

Selected Exhibitions

2005 'A Different Kind of Order', Museum of Modern Art, Vienna

2005 'Life's Balance', Kunsthaus, Graz

2004 'Somewhere Between Almost Right and Not Quite', Deutsche Guggenheim, Berlin

2003–4 'Vertical/Horizontal Series', Bernier/Eliades, Athens

2002 Monika Sprüth Philomene Magers Gallery, Cologne

2002 Marian Goodman Gallery, Paris, New York

2000–01 Museo d'Arte Moderna e Contemporanea di Trento e Rovereto

1999 'While Something Is Happening Here...', Sprengel Museum, Hanover

1993 Mai 36 Galerie, Zurich

A Sexy Little Pursed-Lipped Camouflaged Recidivist, Petrified and 'Colorless' (i.e. a Grimly-Determined Rampant Yin-Yang Rock Head, Looming Small); Alternately, an Interrupted Silhouette of Indeterminate Profile (Lucas Michael)
2000–04
Utah marble
22×12×15cm
Courtesy Salon 94

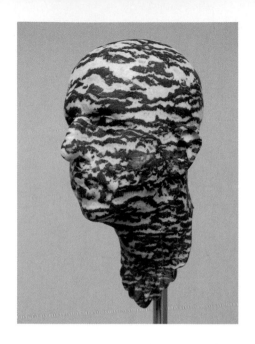

Selected Bibliography

2004 'Printemps de Septembre à Toulouse' (Springtime in September in Toulouse), Paul Ardenne, *L'Oeil*

2004 'Barry X Ball', Ann Wilson Lloyd, *Art in America*

2004 'Romanticism and the Works of Barry X Ball', Monroe Denton, *The Antiquer*

2003 *After the Observatory*, Louis Lawler and Bob Nickas, Paula Cooper Gallery, New York

2003 *American Art Today: Faces and Figures*, Roni Feinstein, The Art Museum at Florida International University, Miami

Selected Exhibitions

2004 PS1 Contemporary Art Center, New York

2004 'Printemps de Septembre', Eglise des Jacobins, Toulouse

2003 Mario Diacono Gallery, Boston

2003 'The Brownstone Collection', The Norton Museum of Art, Palm Beach

2002 'From the Observatory', Paula Cooper Gallery, New York

2002 'Le Stanza dell'Arte: Figure e immagini del XX secolo', Museo di Arte Moderna e Contemporanea di Trento e Rovereto

Barry X **Ball**

Born 1955
Lives New York

In 1997, after almost 20 years of producing abstract, Minimalist-influenced sculpture, Barry X Ball shifted gears and began working in a figurative mode, producing – very slowly – a series of ornate, elaborately finished three-dimensional portraits. Most recently he has exhibited a bust of Matthew Barney, the result of three years of labour. Rendered from a high-tech digital scan, carved in Mexican onyx, impaled on a gold-plated spike, it is an appropriately fetishistic object, something between a Mannerist sculpture and a kind of horror movie prop. Ball's excessive methods combine the cutting-edge and retrograde to create perversely beautiful objects. (SS)

Shown by Salon 94 B18

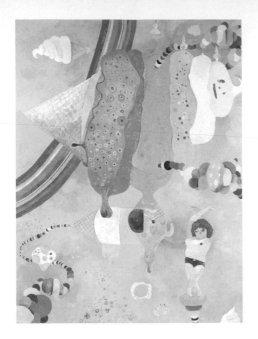

To You, Far Away to You, Far Away
2005
Acrylic on canvas
260×193cm
Courtesy Marianne Boesky
Gallery

Chinatsu **Ban**

Born 1973
Lives Tokyo

In Chinatsu Ban's candy-hued paintings and sculptures wilfully benign elephants stand on their heads, shine beams of light from their trunks or wear zebra-print panties. Girls levitate trance-like, and ice-cream cones or stars float in fields of colour. Even the scatological becomes saccharine, as if through Pop alchemy: pastel-coloured elephants leave lovely pastel-coloured turds. Ban's imagery draws heavily on *kawaii* (cute) culture, but when her paintings privilege composition and colour, they can also evoke the radiant, *faux* naive works by Paul Klee, in which all life forms seem connected. (KJ)

Shown by Marianne Boesky Gallery E5

Selected Bibliography

2005 'Chinatsu Ban', Roberta Smith, *The New York Times*

2005 Goings on About Town, *The New Yorker*

2005 'Takashi Murakami and His Protégés Invade New York: Little Boy Boom', Terry R. Myers, *Modern Painters*

2005 'The Murakami Method', Arthur Lubow, *The New York Times*

2005 'The Murakami Influence', Carol Vogel, *The New York Times*

Selected Exhibitions

2005 Marianne Boesky Gallery, New York

2005 'Doris C. Freedman Plaza Sculpture', Public Art Fund, New York

2005 'Little Boy', Japan Society, New York

2004 'Tokyo Girls Bravo', Marianne Boesky Gallery, New York

2003 Tomio Koyama Gallery, Tokyo

2003 'Hope: The Future Is in Our Hands', Laforet Harajuku, Tokyo

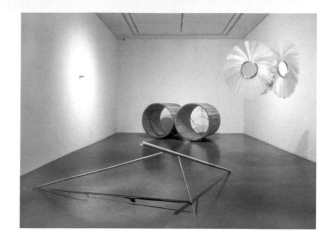

Half-Light
2004
Mixed media
Installation view,
'Art Now', Tate Britain
Courtesy doggerfisher

Selected Bibliography

2004 *Half-Light*, Lizzie
Carey-Thomas, Tate
Publishing, London

2003 'Dark Matter: Claire
Barclay', Tom Morton,
frieze 79

2003 *Claire Barclay: Ideal
Pursuits*, Penelope Curtis,
Dundee Contemporary Arts

2003 *Early One Morning*, ed.
Iwona Blazwick and Andrea
Tarsia, Whitechapel Art
Gallery, London

2001 *Here + Now, Scottish Art
1990–2001*, Katrina Brown,
Dundee Contemporary Arts

Selected Exhibitions

2005 Stephen Friedman Gallery,
London

2005 'Foul Play', doggerfisher,
Edinburgh

2004 'Art Now', Tate Britain,
London

2003 'Ideal Pursuits', Dundee
Contemporary Arts

2003 'Zenomap', Scottish
Pavilion, Venice Biennale

2002 'Some Reddish Work
Done at Night', doggerfisher,
Edinburgh

2002 'Howl', Canberra
Contemporary Art Space

2002 'Early One Morning',
Whitechapel Art Gallery,
London

2000 'Homemaking', Project
Space, Moderna Museet,
Stockholm

2000 'Take to the Ground', The
Showroom Gallery, London

Claire **Barclay**

Born 1968
Lives Glasgow

Claire Barclay creates hybrid sculptural terrains
out of disparate stuff: wood, clay, crystals, sail
fabric and hunting and interior design magazines.
Referencing Beuysian fetishism, the teasing
poetry of Eva Hesse and subcultural spaces such
as S&M clubs, Barclay's restrained handling of
her materials generates a spitting Catherine wheel
of associations. A number of her works resemble
looms or gibbets, a-functional machines that she
mucks up with mud or plugs with plastic, bringing
pricked fingers, broken necks and flourishing
microbes to mind. Textures speak of emotional
states and abstract forms are unwittingly
anthropomorphic, resulting in a constant testing
and re-testing of what objects are and what, with
a little thinking, they might become. (TM)

Shown by doggerfisher A10, Stephen Friedman
Gallery D11

Untitled (05.3)
2005
Mounted colour photographs
76×163cm
Courtesy Tanya Bonakdar
Gallery

Selected Bibliography

2004 *Uta Barth*, Uta Barth, Pamela Lee, Jeremy Gilbert-Rolfe and Matthew Higgs, Phaidon Press, London

2004 *white blind (bright red)*, Jan Tumlir, SITE Santa Fe

2000 *...and of time*, Timothy Martin, J. Paul Getty Museum, Los Angeles

2000 *Uta Barth: In Between Places*, Sheryl Conkelton, Timothy Martin and Russell Ferguson, Henry Art Gallery, Seattle; DAP, New York

2000 *At the Edge of the Decipherable*, Elizabeth Smith, Los Angeles Museum of Contemporary Art

Uta **Barth**

Born 1958
Lives Los Angeles

Uta Barth creates large-scale photographs that allude to Colour Field painting, counterpointing shaded or sunlit sections with grand swaths of monotone surface. In several series she has captured chance framings caused by the play of light against stretches of carpet, floor or wall, or used a gentle focus to create mottled surfaces. Blurry expanses of colour are often offset by sharply focused elements in the foreground, such as the edges of a piece of furniture or sprigs of leaves. Recent works frame groups of similar images in an expanse of complementary colour, as in the series 'White Blind (Bright Red)' (2002). (DJ)

Shown by ACME. D15, Tanya Bonakdar Gallery E5, Alison Jacques Gallery D17

Selected Exhibitions

2005 'Uta Barth: white blind (bright red), nowhere near, ...and of time, 1999–2002', SITE Santa Fe

2005 'Out There: Landscape in the New Millennium, Museum of Contemporary Art, Cleveland

2005 'In Focus: Themes in Photography', Albright-Knox Art Gallery, Buffalo

2004 'From House to Home: Picturing Domesticity', Museum of Contemporary Art, Los Angeles

2003 'Moving Pictures', Guggenheim Museum, New York

2002 'History/Memory/ Society', Tate Modern, London

2002 'Visions of America', Whitney Museum of American Art, New York

Untitled
2004
Stainless steel, water
85×60×33cm
Courtesy Galleria Massimo
de Carlo

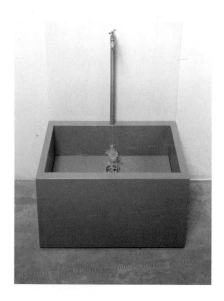

Selected Bibliography

2005 *Massimo Bartolini*,
Laura Cherubini, João
Fernandes and Joseph Rykwert,
Hopefulmonster, Turin

2004 *Spazi atti* (Fitting Spaces),
5 Continents Editions, Milan

2004 *Perception of Space*, Erik
Beenker, Museum Boijmans Van
Beuningen, Rotterdam

2004 'Massimo Bartolini: Nel
Deserto dei Miracoli' (From
the Desert of Miracles), Licia
Spagnesi, *Arte*

2002 *Light As a Bird Not As
a Feather*, Massimo Bartolini,
Onestar Press, Paris

Selected Exhibitions

2005 Galleria Civica d'Arte
Moderna e Contemporanea,
Turin

2004 'Spazi atti', PAC
Padiglione d'Arte
Contemporanea, Milan

2004 'Territorio Livre', São
Paulo Biennial

2004 'Perception of Space',
Museum Boijmans Van
Beuningen, Rotterdam

2003 'Desert Dance', Centro
per l'Arte Contemporanea Luigi
Pecci, Prato

2003 'Lounge', Museum
Abteiberg, Mönchengladbach

2001 'Untitled (Wave)',
PS1 Contemporary Art Center,
New York

2000 Forum Kunst Rottweil

1998 Casa Masaccio, San
Giovanni Valdarno

Massimo **Bartolini**

Born 1962
Lives Cecina

The contamination of human structures with
natural phenomena, and vice versa, is a key theme
in Massimo Bartolini's practice. In some cases he
punctures the architecture with a window or, in
the case of an Oscar Niemeyer building for the
São Paulo Biennial in 2002, he cut a short text
about an Amazonian wizard out of one of the
windowpanes, letting the weather and city sounds
in. Liquids become metaphors for the flow of
memory and energy of the imagination. In *Bedside
Wave* (2002), for example, the viewer discovered
a mechanized wave, like an escaped dream, next
to an unmade bed in the emptied gallery office.
(SO'R)

Shown by Galleria Massimo de Carlo E10, Frith
Street Gallery C1

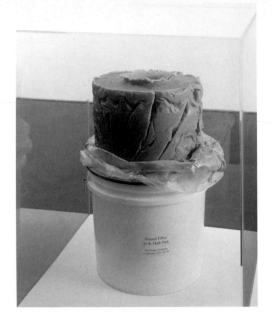

3/26/04 – Shot No.5
2004
Wound filler, plastic, paper
and metal
78×51×51cm
Courtesy Stephen Friedman
Gallery

Selected Bibliography

2004 'Robert Beck', Tory
Dent, *Parachute*

2004 'Robert Beck,' Jeffrey
Kastner, *Artforum*

2004 'Robert Beck', Jane
Harris, *Time Out New York*

2003 'Robert Beck: Once
across the Mason-Dixon', Ken
Johnson, *The New York Times*

2003 Alex Dodge, 'Shot On
Sight: A Conversation with
Robert Beck', *Swingset*

Selected Exhibitions

2005 Anthony Meier Fine Arts,
San Francisco

2005 'From Nature: The
Sportsmans Redux', Institute of
Contemporary Art, Portland

2005 'Heavenly or Slice of
White', The Bertha and Karl
Leubsdorf Art Gallery, Hunter
College, New York

2004 CRG Gallery, New York

2004 'Needful Things: Recent
Multiples', Cleveland Museum
of Art

2004 'Your Heart Is No Match
For My Love', Soap Factory,
Minneapolis

2003 'Once across the Mason-
Dixon', Susan Inglett Gallery,
New York

2003 'Somewhere Better
Than This Place: Alternative
Social Experiences in the
Spaces of Contemporary Art',
Contemporary Arts Center,
Cincinnati

2002 Anthony Meier Fine Arts,
San Francisco

Robert **Beck**

Born 1959
Lives New York

Everyday mysteries ripple through Robert Beck's investigations of masculinity, domestic life and national identity. His varied body of work includes drawings alluding to Sigmund Freud, Jacques Lacan and Bruno Bettelheim; large gelatin-silver prints depicting images of Christ partially obscured by reflected drapery; and vats of beige and pinkish wound-filler ripped open by gunshots. Recent violent manifestations of male adolescence in crisis in the USA have inspired such works as *Artwork by Kip Kinkel for His Parents, Bill and Faith* (2004), two silicone welcome mats littered with bullets shaped from mortician's wax. (KJ)

Shown by CRG Gallery C23, Stephen Friedman Gallery D11

Wild Boy
2004
Video still
Single channel video
Courtesy Postmasters Gallery

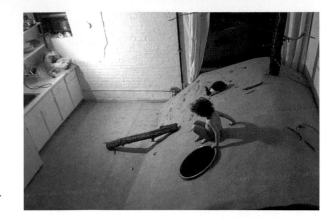

Selected Bibliography

2005 'At PS1, Few Artists Are Ready to Graduate', Blake Gopnik, *The Washington Post*

2005 'Guy Ben-Ner', Karen Rosenberg, *Artforum*

2005 'Central Park', Andrea Bellini, *Flash Art International*

2005 'Artists on the Verge of a Breakthrough', Karen Rosenberg, *New York Magazine*

2005 'It Takes a Video Project', Dean Daderko, *Gay City News*

Selected Exhibitions

2005 'Tree House', Israeli Pavilion, Venice Biennale

2005 'Wild Boy', Postmasters Gallery, New York

2005 'Greater New York', PS1 Contemporary Art Center, New York

2005 Cincinnati Art Center

2004 'Moby Dick', Museum of Modern Art, New York

2004 'Storytelling', George Eastman House, Center for Photography, Rochester

2004 'Becoming Father – Becoming Infant', The Bronx Museum, New York

2003 'Moby Dick', Postmasters Gallery, New York

2003 'Elia: A Story of an Ostrich Chick', Hertzeliya Museum

2002 'Enough about Me', Momenta Art, New York

Guy **Ben-Ner**

Born 1969
Lives New York

In making his video works and related sculptural installations Ben-Ner often gives his wife and children roles in the allegorical, gently pedagogical narratives. His video technique mimics home-movie and documentary aesthetics, coaxing his family members into various well-meaning but amusing ordeals. In *Wild Boy* (2004), for example, Ben-Ner's young son plays a child savage, put through a series of 'civilizing' processes in the artist's kitchen. Here and in other works Ben-Ner explores the relationship between play and mutual understanding, using childlike creativity to bridge real, and implicitly political, divides. (DJ)

Shown by Postmasters Gallery H12

Selected Bibliography

2005 *Documentary Heresy*, Jean-Pierre Rehm, Kunst Museum, Lucerne

2005 *Manon de Boer and Brussels*, Manon de Boer and Phillip van den Bossche, Van Abbe Museum, Eindhoven

2004 'Het Waarom Opgesloten Tussen Twee Vertellingen: Re-enactment als een Nieuw Verschijnsel' (The Why Nudged Between Two Tellings: Re-enactment as a New Phenomenon), Maxine Kopsa, *Metropolis M*

2003 'Manon de Boer. Where's Manon? Where's Al? Where's L.A.?', Phillip van den Bossche, *A Prior*

Manon **de Boer**

Born 1966
Lives Brussels

Artist and filmmaker Manon de Boer uses the camera like a distorted mirror for reflecting on the past. Her video installations and films are full of gaps, pregnant pauses and lapses of memory. In *Sylvia Kristel – Paris* (2003) the actress narrates two slightly different versions of the beginnings of her career in film, including landing a role in the film *Emmanuelle* (1974). One version dwells on cities and architecture, the other on her sexual relationships. Here and in other works De Boer probes the gap between image and speech. Her subjects' monologues and autobiographical anecdotes are the products of incomplete recollections and the staging of the self. (DE)

Shown by Galerie Martin Janda A13, Jan Mot B16

Selected Exhibitions

2005 Solar Gallery, Vila do Conde

2005 'Manon de Boer and Brussels', Van Abbe Museum, Eindhoven

2005 'Documentary Creations', Kunstmuseum, Lucerne

2005 'Inventaire contemporain III', Jeu de Paume, Paris

2005 E-flux video rental library, Manifesta Foundation, Amsterdam

2004 'Nederland niet Nederland', Van Abbe Museum, Eindhoven

2004 'Once upon a time...', MUHKA, Antwerp

2004 'Elders', Galerie Paul Andriesse, Amsterdam

2003 'Sylvia Kristel – Paris', Jan Mot, Brussels

L'Atelier Rouge
(The Red Studio)
2004
Mixed media
Courtesy John Connelly Presents

Selected Bibliography

2004 'Marco Boggio Sella',
Andrea Bellini, *Sculpture*

2003 'Thrills and Laughters',
Andrea Bellini, *Flash Art*

2002 'Marco Boggio Sella',
Guido Molinari, *Flash Art*

2002 'Oltre L'Eta del Dubbio'
(Beyond the Age of Doubt),
Chiara Leoni, *Flash Art*

2002 'Marco Boggio Sella',
Marinella Paderni, *tema celeste*

Selected Exhibitions

2004 'L'Atelier Rouge', John
Connelly Presents, New York

2004 'La Terra e la Notte',
Studio Guenzani, Milan

2003 'The Unity of the Real',
Cosmic Gallery, Paris

2003 'Today's Man', John
Connelly Presents, New York

2002 'Exit', Fondazione
Sandretto Re Rebaudengo,
Turin

2002 'A Big Brown Bag', Gavin
Brown's enterprise, New York

2001 'La Folie', Academia de
Francia, Villa Medici, Rome

2000 'Over the Edges',
S.M.A.K., Ghent

2000 Studio Guenzani, Milan

Marco **Boggio Sella**

Born 1972
Lives New York

A bright red compact Fiat with a malignancy
ballooning from its blind spot (*I Believe I Can Fly*,
1996), a greenhouse coated with black pigment
(*House of the Wood*, 2001), a Hummel-like ceramic
tableau of two adolescents squaring off in a toe-
to-toe mutual admiration contest (*I'll Love You
'til Suicide (Symmetric Love)*, 1998–9): this is the
sculpture of blithe dysfunction and wilful self-
delusion. Boggio Sella's objects pick and choose
their way through a litany of styles, scales and
sculptural conventions, finding in each instance
the appropriate means to express a certain shortfall
between the real and the wished-for. (JT)

Shown by John Connelly Presents A12

Henning **Bohl**

Born 1975
Lives Berlin

Henning Bohl's appropriationist strategies treat the histories of Modernism as a treasure trove of ideas and effects to be plundered. One work is inspired by a patchwork quilt made by Sonia Delaunay for her son (*Die Kubistische Tagesdecke*, The Cubist Quilt, 2003), which combines Cubism with handicraft, reinterpreted in a series of paintings that Bohl assembles from scraps of previous works. Bohl's approach is less concerned with analysis than with creative retelling, revealing the translation over time of formal aesthetics, while content wanes from the Utopian to the decorative. (KB)

Shown by Galerie Karin Guenther Nina Borgmann B7, Galerie Daniel Buchholz D14

Selected Bibliography

2005 'Henning Bohl', Nina Möntmann, *Artforum*

2004 *Henning Bohl*, Heiner Georgsdorf, Sparkassen Kulturstiftung Hessen-Thüringen, Willingshausen

2004 'Henning Bohl', Jens Asthoff, *Kunstbulletin*

2003 'Weiter machen' (Go Further), Michaela Eichwald, *Texte zur Kunst*

Selected Exhibitions

2005 Studio Galerie, Kunstverein Braunschweig

2005 Kunstverein für die Rheinlände und Westfalen, Dusseldorf

2005 'Videoskulpturen' (with Amelie von Wulffen), Rote Zelle, Munich

2005 'Therefore Beautiful', Ursula Blickle Stiftung, Kraichtal

2005 'POST-MoDERN', Greene Naftali, New York

2004 'Toward a Coffee Table Book', Galerie Karin Guenther Nina Borgmann, Hamburg

2004 'Müllberg', Galerie Daniel Buchholz, Cologne

2004 'Deutschland sucht...', Kunstverein, Cologne

2004 'The Studio' (with Michaela Meise and Shannon Bool), Galerie Karin Guenther Nina Borgmann, Hamburg

2004 'Heute und 10 Jahre danach', Kunst-Werke, Berlin

Untitled
2004
Oil on canvas
150×120cm
Courtesy Galleri Christina
Wilson

Selected Bibliography

2004 *Hjem Igen* (Back Home
Again), Galerie Mikael
Andersen, Copenhagen

2004 *Carnegie Art Award*, ed.
Ulrika Levén, Konstakademien,
Stockholm

2003 *Kaspar Bonnén*, Sibbe
Aggergaard, Kunstforeningen,
Copenhagen

Selected Exhibitions

2004 'Carnegie Art Award',
Konstakademien, Stockholm
and touring

2004 'Dänemark: Skulptur
und Installation 2004', Kiel
Stadtgallerie

2004 'Password', CCGA, Tokyo

2004 Mori Art Center, Tokyo

2003 'Home Again', Galerie
Mikael Andersen, Copenhagen;
The Danish Cultural Institute,
Edinburgh

2003 Kunstforeningen,
Copenhagen

Kaspar **Bonnén**

Born 1968
Lives Copenhagen

In Kaspar Bonnén's multimedia installation *Hjem Igen* (Back Home Again) (2004) the everyday is made strange. The still lifes and banal domestic interiors of his oil paintings are subjected to a schematic arrangement of colour, shifting their representational stability through an unsettling, abstract formula. A roughly formed papier mâché head, which from the back appears to be a disjointed model house projected with the face of a small child, blends exterior and mental space, while several short hallucinatory texts spread throughout the installation develop this to-and-fro between elusive fact and dream-like reality. (KB)

Shown by Galleri Christina Wilson B4

Drill 4 Chastity
2004
2-part cast, bronze and resin
10×15×9cm
Courtesy Parkett Editions

Selected Bibliography

2004 'Monica Bonvicini', Juliane Rebentisch, Lars Lerup, Jörg Heiser, *Parkett*

2003 *Anxiety Attack*, Modern Art Oxford

2003 *Monica Bonvicini / Sam Durant: Break It / Fix It*, Secession, Vienna

2002 *Scream & Shake*, Joshua Decter, Diedrich Diedrichsen and Doina Petrescu, Magasin-Centre National d'Art Contemporain, Grenoble

2000 *Bau* (Building), Dan Cameron, Susanne von Falkenhausen, Hopefulmonster, Turin

Monica **Bonvicini**

Born 1965
Lives Berlin/Los Angeles

In her 1998 work *Plastered*, Monica Bonvicini covered the floor of the Secession building in Vienna with plasterboard panels. Visitors found their steps were producing an alarming crunch, participating in a work about the cracks in their own composure. Then in 2002 she turned an advert for fences – 'add elegance to your property' – into a mocking graffito, *Add Elegance to Your Poverty*. And at this year's Venice Biennale her big black, randomly running drill dangled from the Italian Pavilion's ceiling as if about to run amok, but 'penetrating' nothing but air (*Blind Shot*). Bonvicini plays with Modernist claims of the sublime or the universal, shedding light on how they set power and gender roles in stone. (JöH)

Shown by Parkett Editions H6, Galerie Krobath Wimmer H7

Selected Exhibitions

2004 'Monica Bonvicini: Elmgreen & Dragset', Sprengel Museum, Hanover

2004 Emi Fontana Gallery, Milan

2003 'Shotgun', Tramway, Glasgow

2002 'Black', Kunstmuseum, Aarhus

2002 'Add Elegance to Your Poverty', Anton Kern Gallery, New York

2001 'Damaged', Galerie Krobath Wimmer, Vienna

2001 The Project, Los Angeles

2000 'You Better Watch Out', Forum Stadtpark, Graz

1999 'I Believe in the Skin of Things as in That of Woman', Anton Kern Gallery, New York

1999 'Bed Times Square', Emi Fontana Gallery, Milan

Hessian Ministry of Art and Science
2003
Pencil and acrylic on paper
collage, wood
Courtesy Iris Kadel

Selected Bibliography

2005 *Vitamin D*, Phaidon Press, London

2004 *Shannon Bool*, Lutz Becker and Sabine Oelze, Schnitt Raum, Cologne

2004 *Genealogies of Glamour*, Tom Holert and Heike Munder, Migros Museum, Zurich

2004 'Die blaue Blume haut ins Auge' (Blue Flowered Skin in the Eyes), Magdalena Kroener, *Die Tageszeitung*

2003 'Feuer unterm Dach' (Fire under the Roof), Christoph Schütte, *FAZ*

Selected Exhibitions

2005 'Deutsche Bank Collection', Deutsche Guggenheim, Berlin

2005 'Liquid Soft Lightning Touch', doggerfisher, Edinburgh

2004 'Geneologies of Glamour', Migros Museum, Zurich

2004 'It Takes a Year to Make a Day', Iris Kadel, Karlsruhe

2004 'Waxing the Sublime', Schnitt Raum, Cologne

2004 'The Studio', Galerie Karin Guenther Nina Borgmann, Hamburg

2004 'Let My Vinyl Lick Your Finger' (with Dani Gal), Pavilion am Main, Frankfurt

2004 'The Savoy', Collective Gallery, Edinburgh

2003 'Heute', Hessian Ministry of Art and Science, Wiesbaden

2003 'Fresh and Upcoming', Kunstverein, Frankfurt

Shannon **Bool**

Born 1972
Lives Frankfurt

Whether exploiting the discrepancies between two European Renaissance painters' rendering of the same oriental carpet, or sampling the tacky *trompe-l'oeil* wallpaper from a German pizzeria, Shannon Bool's wall drawings delight in a parallax view of perspective, pattern and place. In the latter work she conjured a wave effect into the bricks-and-ivy motif, meticulously collaging it onto the gallery wall. The imagery in Bool's ink and acrylic drawings offers a similarly disorienting mix of the graphically and ethnically displaced – Ryanair logo and designs are deployed alongside silhouetted armaments, arcane ornaments and a 'chopsticks' type font. (MA)

Shown by Iris Kadel A9

Selected Bibliography

2005 'Come Together: Carol
Bove', Tom Morton, *frieze* 89

2005 'Shelf Life', Barry
Schwabsky, *Artforum*

2004 '(Re) Making History:
Carol Bove and Andrea
Bowers', Brian Sholis, *Flash Art
International*

2003 'Carol Bove', Martha
Schwendener, *Artforum*

2003 'Carol Bove', Holland
Cotter, *The New York Times*

Selected Exhibitions

2005 'Greater New York',
PS1 Contemporary Art Center,
New York

2005 'Model Modernisms',
Artist's Space, New York

2005 'Ice Storm', Kunstverein,
Munich

2004 'A Pattern Language:
Intermacy Gradient', Hotel,
London

2004 'Momentum 1', Institute of
Contemporary Art, Boston

2004 Kunsthalle, Zurich

2004 'Formalism',
Kunstverein, Hamburg

2004 'Playlist', Palais de
Tokyo, Paris

2003 'The Science of Being and
the Art of Living', Kunstverein,
Hamburg

2003 'The Joy of Sex: Carol
Bove & Charles Raymond',
Cubitt, London

Carol **Bove**

Born 1971
Lives New York

Although steeped in the ideas, objects and moods
of the late 1960s and early 70s, Carol Bove's work
isn't so much about the cultural logic of that period
as about the ways in which that logic gets wrapped
around what we want from the past, and what
the past wants from us. In her Minimalist domestic
environments, carefully curated 'bookshelf'
pieces and cream-on-milk ink drawings of soft-
core, hippie-chick nudes, Bove explores the
impossibility of approaching our yesterdays with
the impartiality of an academic historian. Instead,
she offers an erotics of temporal recovery, a chance
to run our fingers through the past's hair. (TM)

Shown by Hotel H5, Georg Kargl G9, maccarone
inc. B3

Untitled
2005
Ink on paper
80×59cm
Courtesy the artist and Private
Collection, Boston

Selected Bibliography

2005 *Ulla von Brandenburg*,
Nina Möntmann, Musée d'Art
Moderne de la Ville de Paris

2005 'Ulla von Brandenburg',
Anna-Catharina Gebbers, *Artis*

2004 *Ulla von Brandenburg*,
Thomas Gann, Kunstverein,
Braunschweig

2004 'Unbedingt merken: Ulla
von Brandenburg' (Remember
for the Future), Katrin
Wittneven, *Monopol*

2000 *Neue Blicke, Neue Räume*
(New Views, New Spaces),
Schauspielhaus Hamburg

Selected Exhibitions

2005 'I Still Believe in Miracles',
Musée d'Art Moderne de la Ville
de Paris

2005 Produzentengalerie,
Hamburg

2004 'Ein Mensch ist keine
Nadel', Blaue Kugel, Hamburg

2004 'Deutschland sucht',
Kunstverein, Cologne

2003 'Den gelben in die
Ecke, Doublette in der Mitte',
Kunstverein, Braunschweig

2003 'Zimmer aufräumen,
Zupfgeigenhansel kommt',
Künstlerhaus, Stuttgart;
Kunstverein, Dresden

2003 'Feine Ware 3',
Kunstverein, Hamburg

2002 'Slow', Shedhalle, Zurich

Ulla **von Brandenburg**

Born 1974
Lives Hamburg

The translation of historical motives into a
contemporary time frame and the parallel
transformation involved in a shift in medium are
ongoing interests in Ulla von Brandenburg's films,
performances, drawings and installations. Her
mural *Untitled* (2003) reproduces a 19th-century
photograph of a dying girl, but its large scale and
graphically stylized execution lend it an estranged
and eerily indeterminate atmosphere. The three-
screen projection *Der Brief* (The Letter, 2004),
a black and white tableau vivant of a group of
people frozen in staged poses, has a similar graphic
clarity, but the individuals remain strangely
separate and the meaning of their dramatic
gestures is veiled in ambiguity. (KB)

Shown by Produzentengalerie Hamburg E18

V.S.
2003
Mixed media
Dimensions variable
Courtesy Esther Schipper

Selected Bibliography

2003 'Matti Braun: Showroom', Michael Archer, *Artforum*

2003 'Matti Braun', Catrin Lorch, *frieze* 78

2003 *S.R.*, Matti Braun, Dorothea Strauss et al., Kunstverein, Freiburg

2001 'Welcome to the Mystery Train', Hannula Mika, *nu: The Nordic ArtReview*

2000 *Ghor*, Matti Braun, Kunsthalle, St Gallen

Matti **Braun**

Born 1968
Lives Cologne

Matti Braun is interested in the misunderstandings, miscommunications and often undocumented connections that occur with the migration of ideas and people. His highly abstracted installations (usually announced by posters that act as thematic 'keys' to the show) have included a trilogy concerning an unmade science fiction film by Satyajit Ray (the script of which bore strong resemblances to Steven Spielberg's *ET*, which it pre-dated by 30 years), work by Japanese artist Yoruzu Tetsugoro (considered as the first Modernist painter in a culture already used to abstraction) and the Esperanto-related literature of Belgian writer Andreas Juste. Braun's art is a repository for secret histories of cultural cross-pollination. (DF)

Shown by Esther Schipper F5

Selected Exhibitions

2005 'The Alien', BQ, Cologne

2005 'The Alien (Sketch)', Project Arts Centre, Dublin

2003 'R.T.', The Showroom, London

2003 'S.R.', Kunstverein, Freiburg

2003 'V.S.', Schipper & Krome, Berlin

2002 'Bunta Garbo', Stedelijk Museum Bureau Amsterdam

2002 'Rajkot', BQ, Cologne

2000 'Ghor', Kunsthalle, St Gallen

1999 'Edo', Schipper & Krome, Berlin

1999 'German Open', Kunstmuseum, Wolfsburg

Die besten Jahre
(The Best Years)
2005
Mixed media
Courtesy Galerie EIGEN + ART
Leipzig/Berlin

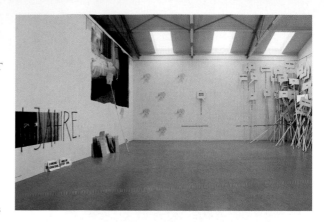

Selected Bibliography

2005 'Aus Leinwänden Gold spinnen' (Spinning Gold out of Canvases), Karin Schulze, *Financial Times Deutschland*

2004 'Kolekcja Wstydliwych Gestów', Agnieszka Maria Wasieczko, *Elle Poland*

2003 'Blicke in ein deformiertes Innenleben' (Glimpses into a Deformed Inner Life), Petra Kollros, *Südwestpresse Ulm*

2002 'Eine tiefgekühlte Sehnsucht' (A Deep-Frozen Longing), Hanno Rauterberg, *Die Zeit*

2001 'Der gerissene rote Faden' (The Torn Red Thread), Michaela Nolte, *Der Tagesspiegel*

Selected Exhibitions

2005 'Die besten Jahre', Galerie EIGEN + ART, Leipzig

2004 'Anna Baumgart. Birgit Brenner', Zacheta Gallery, Warsaw

2003 'Sie lacht oft ohne Grund', Stadthaus Ulm

2003 'Taktiken des Ego', Wilhelm Lehmbruck Museum, Duisburg

2003 'On Stage', Villa Merkel, Esslingen; Kunstverein, Hanover

2003 'Stories', Haus der Kunst, Munich

2003 'Berlino Nuova Città D'Arte', Opera Paese, Rome

2002 'Listen to New Voices', PS1 Contemporary Art Center, New York

2001 'Let's Talk about Sex', Kunsthaus, Dresden

2001 'Nicht neurotisch', Galerie EIGEN + ART, Leipzig

Birgit **Brenner**

Born 1964
Lives Berlin

The red threads running through Birgit Brenner's installations suggest metaphorical links to feminism. Works such as *Sie lacht oft ohne Grund* (She Often Laughs for No Reason, 2003) typically combine dark, moody or disturbing photography and rambling texts covering walls or printed on sculptural elements. Banners for a street demo, for instance, depict emotionally dysfunctional and verbally impoverished relationships from the perspective of troubled female protagonists. Installations such as *All This Started with Love* (2003) are often designed to unfold like scenes from a film with a plot that is candidly emotional, macabre, melancholy or fretful – an exorcism of disappointment and doubt. (DE)

Shown by Galerie EIGEN + ART Leipzig/ Berlin B17

Selected Bibliography

2004 'In Search of Lost Purpose', Marc-Olivier Wahler, Carissa Rodriguez, Gianni Jetzer, *Parkett*

2004 'Olaf Breuning', Daniele Perra, *tema celeste*

2004 *Olaf Breuning: Home*, Lionel Bovier, Ringier Kunstverlag, Zurich

2003 'The New Gothic', Michael Cohen, *Flash Art International*

2001 *Olaf Breuning: Ugly*, Christoph Doswald, Hatje Cantz Verlag, Ostfildern-Ruit

Olaf **Breuning**

Born 1970
Lives New York

Olaf Breuning's photographs, videos and installations feature a large and colourful cast, including leering bed-sheet spooks, red-nosed 20-something protesters, hordes of skeletons, cargo cult minstrels, surfing Vikings and fake black-bearded militia. His approach to the clash of global culture is irreverent and trashy – recycling characters from TV and film while revelling in bad taste, abrasive behaviour and the visually jarring. His recent off-the-wall, medium-length feature film *Home* (2004) took his main protagonist in a romp around the planet, among other things playing cowboy on a ranch, chasing llamas while dressed in Peruvian costume and vomiting the words 'I exist' into the snow. (DE)

Shown by Air de Paris A4, Arndt & Partner D21, Galerie Meyer Kainer G2

Selected Exhibitions

2005 Chisenhale Gallery, London

2005 Galerie Meyer Kainer, Vienna

2005 'First We Take Museums: Urban Art Now', Kiasma Museum of Contemporary Art, Helsinki

2005 'Burlesques contemporains', Jeu de Paume, Paris

2004 'Home', Metro Pictures Gallery, New York; The New Stedelijk Museum, Amsterdam

2004 'Boys Behaving Badly', Contemporary Arts Museum, Houston

2003 Magasin-Centre National d'Art Contemporain, Grenoble

2003 'Hello Darkness', Arndt & Partner, Berlin; Swiss Institute, New York

2003 Musée d'Art Moderne et Contemporain, Strasbourg

Holy Star
2005
Oil on linen
135×135cm
Courtesy Marc Foxx

Cris **Brodahl**

Born 1963
Lives Ghent

'Uncanny' is an overused word in art criticism. Cris Brodahl's work, however, truly deserves the label. Picking up where the original Surrealist painters left off, she explores the strangeness of the human body, producing fetish-like images that have the unsettling familiarity of dreams. Brodahl's canvases mimic the slick surfaces of black and white photography, and often seem to be assembled from mismatched scraps of portraits. The longer one looks, the more there is to see – animals emerge from the folds of faces, skulls lurk in shocks of hair. These paintings don't just evoke the unconscious mind, but seem to have an unconscious of their own. (SS)

Shown by Marc Foxx C18

Selected Bibliography

2004 'Focus: Belgium', Luk Lambrecht, *Flash Art International*

2004 'Interview with Raf Simons', *Flash Art International*

Selected Exhibitions

2004 'Cris Brodahl: Pink Floyds', Marc Foxx, Los Angeles

2004 'Michael Bauer, Cris Brodahl, Stef Driesen', Marc Foxx, Los Angeles

2002 Annette de Keyser, Antwerp

Untitled
2005
Monotype
86×119cm
Courtesy Two Palms

Cecily **Brown**

Born 1969
Lives New York

Swirling strokes of near-abstract imagery; a chaotic palette of hallucinogenic flesh beneath flambé skies; a restless anatomy fuelled by self-doubt and paint. Tangled bodies, fevered intentions and echoes of Pollock and De Kooning – restraint has no place in the paintings and works on paper of Cecily Brown. Reason disappears in the space between abstraction and figuration. Nothing is distilled – layers, limbs and colour pile up until the whole thing collapses, is scraped away and built anew. Brown is interested in what happens to your mind when it tries to make up for what is missing. Her stated aim is to make pictures that are tender, graspable and indescribable. (JH)

Shown by Gagosian Gallery D9, Two Palms H11

Selected Bibliography

2004 *Whitney Biennial*, Chrissie Iles, Shamin M. Momin and Debra Singer, Whitney Museum of American Art, New York

2003 *Cecily Brown*, Danilo Eccher, MACRO Museo d'Arte Contemporanea, Rome

2001 *Cecily Brown*, Stephan Schmidt-Wulffen, Verlag Walther König, Cologne; Contemporary Fine Arts, Berlin

Selected Exhibitions

2005 Modern Art Oxford

2005 'Cecily Brown: Recent Paintings', Gagosian Gallery, New York

2004 Contemporary Fine Arts, Berlin

2004 Museo National Centro de Arte Reina Sofia, Madrid

2003 MACRO Museo d'Arte Contemporanea, Rome

2003 Gagosian Gallery, Los Angeles

2002 'Directions: Cecily Brown', Hirshhorn Museum and Sculpture Garden, Washington, D.C.

Pornography
2005
Oil on panel
87×112cm
Courtesy Collection of Ivor
Braka, London, and Patrick
Painter, Inc.

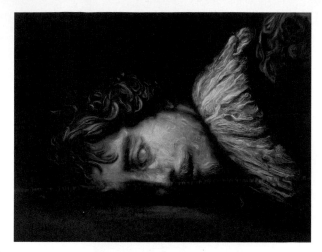

Selected Bibliography

2004 *Glenn Brown*, Alison M.
Gingeras; Julia Peyton-Jones;
Rochelle Steiner, Serpentine
Gallery, London

2004 'You Take My Place
in This Showdown', Ian
MacMillan, *Modern Painters*

2004 *Against Cliché: Glenn Brown
and the Possiblities of Painting*,
David Freedberg, Gagosian
Gallery, New York

2004 'Glenn Brown: The
Divine and the Dirty', Craig
Burnett, *Contemporary*

2004 'Glenn Brown: Classic
Contemporary', Pablo Lafuente,
Flash Art International

Selected Exhibitions

2005 'Ecstasy: In and about
Altered States', Museum of
Contemporary Art, Los Angeles

2005 Patrick Painter, Inc.,
Santa Monica

2004 Serpentine Gallery,
London

2004 Gagosian Gallery,
New York

2003 'Delays and Revolutions',
Italian Pavilion, Venice Biennale

2002 Galerie Max Hetzler,
Berlin

2002 'Liebe Maler, male mir',
Centre Georges Pompidou, Paris

2002 São Paulo Biennial

2002 'The World May Be
Fantastic', Sydney Biennial

2000 Turner Prize, Tate Britain,
London

Glenn **Brown**

Born 1966
Lives London

Glenn Brown's trademark is the flattened painterly gesture – Auerbach without the impastoed anguish, Rembrandt without the biographical gloom, Fragonard without the frivolity. Although his virtuoso handling of paint links the look of his paintings – hyperreal 'copies', or variations on a theme or detail of another painting – each one is different from the one that precedes it. Brown's technique, like all trademarks, only hints at the complexity of the finished product. These paintings are about the cyclical dreams of art history; the architecture of paint; the slippery relationship between time and the possibilities of representing it. There's no right way to look at or remember a painting, they seem to be saying. And they're right. (JH)

Shown by Gagosian Gallery D9, Patrick Painter, Inc. C2

Untitled
2004
Movable walls, photocopies,
computer printouts
210×250×150cm
Installation view, Klosterfelde
(detail)
Courtesy Klosterfelde

Tobias **Buche**

Born 1978
Lives Berlin

Tobias Buche wonders how we relate to imagery
– both as individuals and as members of society.
What does an image from a newspaper mean,
once the event it describes is long over and
absorbed into personal or cultural histories?
Buche's display boards installations of collected
photographs, computer print-outs and photocopies
have an institutional or educative feel, yet his
tenuously structured arrangements prompt us to
question associations and meanings we ascribe
to fragmentary scenes from public life. Violence,
political unrest and cultural oddities are not turned
into glossy, aestheticized pictures but remain
blurred scraps that demand our attention. (SO'R)

Shown by Klosterfelde A7

Selected Bibliography

2004 'Struktur ohne Ordnung'
(Structure without Order),
Meike Jansen, *Die Tageszeitung*

Selected Exhibitions

2005 'No Away Fans', Mary
Mary, Glasgow

2004 'Starship: Space Debris',
Büro DC, Cologne

2004 'Dischord', Klosterfelde,
Berlin

2004 Partners of Art, Berlin

2003 'Das grosse Fenster', Raum
Freie Klasse, Bikinihaus, Berlin

2003 Galerie Antik, Berlin

2001 'Sanierung des Palastes',
Palasseum Schöneberg, Berlin

2001 'Polter', Kunst-Werke
Ateliers, Berlin

Lumière 03.03
2001
Silkscreen on Perspex
190×270cm
Courtesy Galerie Thaddaeus
Ropac

Selected Bibliography

2004 *Jean-Marc Bustamante: Nouvelles Scènes*, Matthew Arnatt, Timothy Taylor Gallery, London

2003 *Bustamante*, Jean-Pierre Crioui, Michel Gauthier, Katy Siegal and Michel Poivert, Gallimard, Paris

2001 *Jean-Marc Bustamante: L.P.*, New Museum of Art, Lucerne

Selected Exhibitions

2003 'Nouvelles Scènes', Timothy Taylor Gallery, London

2003 'Jean-Marc Bustamante, Candida Höfer', Galerie Karlheinz Meyer, Karlsruhe

2003 'Recent Works', Galerie Thaddaeus Ropac, Salzburg

2003 French Pavilion, Venice Biennale

2003 'Private Crossing', CASA Centro de Arte de Salamanca

2002 Matthew Marks Gallery, New York

2001 'Long Playing', Deichtorhallen, Hamburg

2001 'Retrospective de l'oeuvre photographique', Centre National de la Photographie, Paris

Jean-Marc **Bustamante**

Born 1951
Lives Paris

In Jean-Marc Bustamante's photographs there is almost too much to see. Everything is perfectly in focus, all at once, and each detail gets added to the next, even if the whole thing doesn't quite add up. These monumentally scaled colour landscapes are often beautiful, but in their studied neutrality they avoid anything as grand as the Sublime. Bustamante usually exhibits his photographic work alongside hermetic sculptural objects, somewhere between furniture and Minimalist constructions. Part of his project, it seems, is to offer proposals about how a place is created in the mind: one piece at a time. (SS)

Shown by Galerie Thaddaeus Ropac F14, Timothy Taylor Gallery F2

Farewell to George Jackson (from 'Walking with the Panther')
2004
Lambda print
32×34cm
Courtesy Galleria Sonia Rosso

Massimiliano **Buvoli**

Born 1975
Lives Milan

Massimiliano Buvoli's installations set up a relationship between printed matter and sculptural objects that echoes the contested nature of his themes. Marginal figures and unresolved historical debates are often the focus for his work, as in the exhibition 'Paul Morphy, the Best American Chess Player' (2004). Buvoli's recent show 'It's About Time' (2005) featured collages of pictures and graphics from the magazine published by the Black Panthers between 1969 and 1971. Elsewhere a spare, structural five-metre-high pole, entitled *Oakland* (2005), shared space with a text-based work inscribed on the gallery wall, which described an episode from the disputed history of the Black Power movement. (SL)

Shown by Galleria Sonia Rosso A6

Selected Bibliography

2005 *Lima Buenos Aires Relazionale, anonimo amicale*, Christian Davide, Massimiliano Massimo, Patrick Riccardo and Andrea Viliani, DOJO, Milan

Selected Exhibitions

2005 'It's about Time', Galleria Sonia Rosso, Turin

2005 'DOJO', Via Ventura 5, Milan

2005 'Galleria in Galleria', Metropolitana, Milan

2004 'Paul Morphy, the Best American Chess Player', Galleria Sonia Rosso, Turin

2001 'Tune up/Clip on/Plug in', Teatro Studio di Scandicci

2000 'Emporio parte prima', Galleria Viafarini, Milan

Favourite Places #8
2005
Car paint on aluminium, MDF,
fluorescent lamps, electric cables
250×135×135cm
Courtesy Haunch of Venison

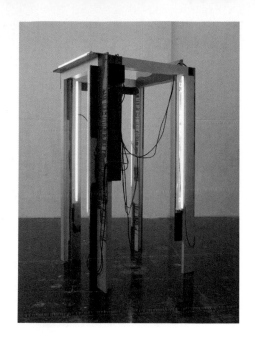

Selected Bibliography

2003 *Pedro Cabrita Reis*, Michael
Tarantino, Adrian Searle,
Jose Miranda Justo and João
Fernandes, Hatje Cantz Verlag,
Ostfildern-Ruit

2001 *Pedro Cabrita Reis: Giving
Heed to Silence*, Alessandra Pace,
Yehuda E. Safran and Doris von
Drathan, Hopefulmonster, Turin

2001 *Pedro Cabrita Reis: The
Silence Within*, Doris von
Drathen, Magasin 3 Konsthall,
Stockholm

2001 *Pedro Cabrita Reis*,
Lorand Hegyi, Bruno Cora,
Alexandre Melo and Denys
Zacharopoulos, Charta, Milan

Selected Exhibitions

2005 'A propos des lieux
d'origine #3', Giorgio Persano,
Turin

2005 Mai 36 Galerie, Zurich

2005 Galerie Nelson, Paris

2004 'Stillness', Camden Arts
Centre, London

2004 'Sometimes One Can
See the Clouds Passing By',
Kunsthalle, Bern

2004 'One Place and Another',
Tracy Williams Ltd, New York

2003 Portuguese Pavilion,
Venice Biennale

2002 'Serene Disturbance',
Kestner Gesellschaft, Hanover

2001 'The Silence Within',
Magasin 3 Konsthall, Stockholm

2000 'Il Silenzio in Ascolto',
Galleria Civica d'Arte Moderna
e Contemporanea, Turin

Pedro **Cabrita Reis**

Born 1956
Lives Lisbon

Using materials such as aluminium, plywood,
bricks and concrete, Pedro Cabrita Reis creates
installations that evoke temporary architecture or
half-remembered places. Although works such as
Blind Cities # 1 (1998) and *Longer Journeys* (2003)
have been interpreted as referring to *favelas*, the
artist rejects this reading as too specific. He prefers
to think of himself as 'a transporter of memory',
generating melancholic atmospheres. The poetic
aspect of Cabrita Reis' work largely stems from
details, such as a carefully placed jug of water or a
film of dirt smeared over a light. (SL)

Shown by Haunch of Venison F16, Mai 36
Galerie D19

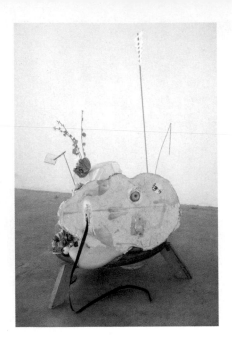

Animal Life
2004
Mixed media
140×91×91cm
Courtesy Galerie Nathalie
Obadia

Selected Bibliography

2005 'The Next Big Thing in LA', Christopher Knight, *Los Angeles Times*

2005 'Good Thing', Doug Harvey, *LA Weekly*

2005 'Object Lessons', Louise Roug, *Los Angeles Times*

2003 'Under the Sun', Nico Israel, *Artforum*

2002 'Eduardo Abaroa, Jedediah Caesar and Abraham Cruzvillegas', Holland Cotter, *The New York Times*

Selected Exhibitions

2005 'Sculpture New Spirit', Galerie Nathalie Obadia, Paris

2005 Group Show, D'Amelio Terras, New York

2005 'Thing', Armand Hammer Museum, Los Angeles

2004 'Done by the Forces of Nature', Black Dragon Society, Los Angeles

2004 'Strange Animal', Los Angeles Contemporary Exhibitions, Los Angeles

2004 'Surface Tension', Lombard-Fried Fine Arts, New York

2004 'Run for the Hills', Locust Projects, Miami

2003 'Jedediah Caesar and Brad Phillips', Andrew Kreps Gallery, New York

2002 Black Dragon Society, Los Angeles

2002 'New Sculpture', Roberts and Tilton Gallery, Los Angeles

Jedediah **Caesar**

Born 1973
Lives Los Angeles

Jedediah Caesar's sculptures look like the field findings of a down-on-his-luck geologist from the 25th century. Casting bundles of studio rubbish (magazines, wooden off-cuts, old cans) in clear resin, then sawing the resulting boulders into polished slices which are propped up against the gallery wall, Caesar creates objects that are peculiarly photographic and, in their resemblance to sparkling geodes, peculiarly beautiful. Part time capsule, part two-fingered salute to future history, these sculptures speak about what happens when nature (itself a cultural category) becomes overrun by the detritus of culture. (TM)

Shown by Galerie Nathalie Obadia E23

Untitled
2005
Oil on canvas
169×147cm
Courtesy galleria francesca
kaufmann

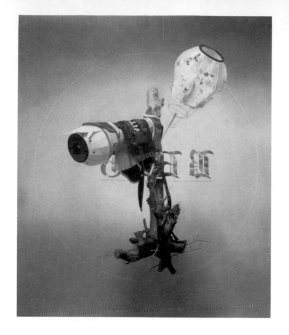

Selected Bibliography

2004 *Vernice* (Varnish),
Francesco Bonami, Villa Manin
Centro d'Arte Contemporanea,
Udine

2004 *Pierpaolo Campanini*,
Guido Molinari, Galleria d'Arte
Moderna di Bologna, Spazio
Aperto, Edizioni Pandragon

2003 *Fame: Premio Querini
Stampalia* (Hunger: Querini
Stampalia Award), Massimiliano
Gioni, Postmedia Books, Milan

2002 'Pierpaolo Campanini',
Guido Molinari, *Flash Art*

2002 *Exit*, ed. Oscar
Mondadori, Fondazione
Sandretto Re Rebaudengo,
Turin

Selected Exhibitions

2005 galleria francesca
kaufmann, Milan

2004 Galleria d' Arte Moderna,
Spazio Aperto, Bologna

2004 'Vernice', Villa Manin
Centro d'Arte Contemporanea,
Udine

2003 'Premio Furla', Fondazione
Querini Stampalia, Venice

2002 galleria francesca
kaufmann, Milan

2002 Corvi-Mora, London

2002 'Exit', Fondazione
Sandretto Re Rebaudengo,
Turin

1999 Claudia Gian Ferrari Arte
Contemporanea, Milan

Pierpaolo **Campanini**

Born 1964
Lives Cento

In Pierpaolo Campanini's sober canvases painting
has become an exercise in elaborate redundancy.
He depicts precarious constructions that hang in
proscenium arches, composed of wildly various
elements – stones, footballs, clothing fragments,
string, branches, wire and what seem to be leg
splints or harnesses. The structures resemble
prototypes for unusable bridges or, in his more
recent work, junk gibbets. Crudely lit against
sombre-coloured backdrops, each of these
assemblages is archived in paint 'through a slow
ritual', as the artist has recounted, 'a concatenation
of gestures' that produces a phlegmatically
precisionist, stillborn still life. (MA)

Shown by Corvi-Mora E7, galleria francesca
kaufmann C19

My Potential Future Based on Present Circumstances (09–02–03) (detail)
2003
Graphite on paper
97×64cm
Courtesy Nicole Klagsbrun Gallery

Selected Bibliography

2005 'Beth Campbell', Steven Zivadinovic, www.glasstire.com

2003 'Beth Campbell', Gregory Volk, *Art In America*

2003 'So Now Let's Talk about Me', Leah Ollman, *Los Angeles Times*

2002 'Repeat Performance', Jerry Saltz, *The Village Voice*

2001 'New York E-mail', David Humphrey, *Art Issues*

Selected Exhibitions

2005 'Make Belief', Sala Diaz, San Antonio

2005 Nicole Klagsbrun Gallery, New York

2005 'Dating Data', Josee Bienvenue Gallery, New York

2004 'Open House: Working In Brooklyn', Brooklyn Museum of Art, New York

2004 'Home Extension', University Art Museum, State University of New York at Albany

2002 'Same As Me', Roebling Hall, New York

2002 'Hello, My Name Is', Carnegie Museum of Art, Pittsburgh

2001 'Fresh: The Altoids Curiously Strong Collection', The New Museum of Contemporary Art, New York

2000 'Greater New York', PS1 Contemporary Art Center, New York

2000 'House (A Standardized Affectation for Telepresence)', Roebling Hall, New York

Beth **Campbell**

Born 1971
Lives New York

Entering into Beth Campbell's installations of simulated domestic interiors, the visitor is transformed into an intruder, a voyeur of its absent inhabitants' archly contrived lives. Campbell's mock-ups are often built around sprawling, handwritten flow charts, thickets of possibilities branching out from an apparently simple decision. Campbell implies that the future of a mundane choice entails a series of certain failures and missed experiences, but also happy encounters and resounding successes, all located within the volatile security of the domestic. Her uncanny, uninhabited installations mark the unlived yet hoped-for experiences that real homes presume – but often fail – to foster. (DJ)

Shown by Nicole Klagsbrun Gallery G17

A Mirage
2004
C-print
75×100cm
Courtesy CourtYard Gallery

Selected Bibliography

2005 *Moscow Biennale of Contemporary Art*, Joseph Backstein et al., Federal Agency for Culture and Film, Moscow

2005 'Cao Fei: A Mini-Manifesto of New Human Beings', Hou Hanru, *Flash Art International*

2004 *Do It*, Hans-Ulrich Obrist, e-flux and Revolver Verlag, Frankfurt

2004 *Past in Reverse: Contemporary Art of East Asia*, Betti-Sue Hertz et al., San Diego Museum of Art

2004 *Between Past and Future. New Photography and Video from China*, Chris Phillips et al., Smart Museum of Art, University of Chicago

Selected Exhibitions

2005 'Parallel Realities: Asian Art Now', Fukuoka Triennial

2005 'Follow Me! Contemporary Chinese Art at the Threshold of the Millennium', Mori Art Museum, Tokyo

2005 'Cosplayers', Lombard-Freid Gallery, New York; CourtYard Gallery, Beijing

2005 'I Still Believe in Miracles, Part II', Musée d'Art Moderne et Contemporain de la Ville de Paris

2005 'Emergency Biennale', Palais de Tokyo, Paris and Chechnya

2005 Moscow Biennial

2004 'Past in Reverse: Contemporary Art of East Asia', San Diego Museum of Art

2004 Shanghai Biennial

Cao Fei

Born 1978
Lives Guangzhou

Cao Fei stages forays into fantasy – she has asked Burberry-clad office workers to imitate dogs, for example, and youngsters to impersonate video-game heroes – and frames these as strategies that combat the numbing consolations of everyday life or respond to the uniformity of consumer-oriented lifestyles. The video work *Cosplayers* (2005) toys with the documentary form, with costumed teenager dressed as anime characters indulging in cartoonish skits. Here young kids from the provinces engage in a mode of subcultural play in order to suspend their routine concerns. (DJ)

Shown by CourtYard Gallery H13

Selected Bibliography

2001 'Maggie Cardelùs',
Jonathan Gilmore, *tema celeste*

2000 *Espresso:Art Now in Italy*,
Gianfranco Maraniello, Electa,
Milan

2000 *Schattenrisse, Silhouetten und
Cutouts*, Marion Ackermann,
Hatje Cantz Verlag, Ostfildern-
Ruit

1999 'FWD Italia, Passaggi
Invisibili' (FWD Italy, Invisible
Passages), Marco Senaldi,
Periodico del Palazzo delle Papesse

1998 *Maggie Cardelùs*, Sarah
Cardelùs, Gianfranco
Maraniello and Roee Rosen,
Galería Fucares, Madrid

Selected Exhibitions

2005 'Serene Obsession', Haim
Chanin Fine Arts, New York

2004 'Bird People', Galerie
Thaddaeus Ropac, Paris

2004 'Bambini nel tempo',
Palazzo Te, Mantova

2003 'Laura's Inheritance',
galleria francesca kaufmann,
Milan

2003 'Assenze Presenze', Centre
Culturel le Botanique, Brussels

2002 'Exit', Fondazione
Sandretto Re Rebaudengo,
Turin

2002 'Gótico ... pero Exótico',
Centro-Museo de Arte
Contemporánea, Vitoria-Gasteiz

2001 'Vanishing Points', Galerie
Thaddaeus Ropac, Paris

2001 'Circus', Deitch Projects,
New York

2000 'White Pieces', galleria
francesca kaufmann, Milan

Maggie **Cardelùs**

Born 1962
Lives Milan

The snapshot is a potent form of imagery: it encapsulates our scuppered desire to objectify memory and stem the flow of time. Maggie Cardelùs enlarges photographs of her family and friends and takes a scalpel to them, carving them into fine filigrees of flowers, birds or abstract patterns. They become ornamental – beguiling to the immediate senses, yet tragic when we realize the sacrifice made in creating them. Yet Cardelùs' surgery performs a reclamation of sorts, mutating the past into something that can be valued afresh, divested of mawkish sentimentality. (SO'R)

Shown by galleria francesca kaufmann C19,
Galerie Thaddaeus Ropac F14

Pergola
2001
Polystyrene, fibre, resin,
acrylic paint
350×350×225cm
Courtesy Galerie Eva
Presenhuber

Selected Bibliography

2004 'Valentin Carron', Lionel
Bovier and Christophe Cherix,
Flash Art International

2004 *Valentin Carron: Cahiers
d'Artistes*, Pro Helvetia Arts
Council of Switzerland, Bern

2002 'Les vertiges de la rétine'
(The Dizziness of the Retina),
Gauthier Huber, *Kunst Bulletin*

2001 'Valentin Carron', Maï-
Thu Perret', *frieze* 60

2000 *Accross/Art/Suisse/1975–
2000*, Lionel Bovier, Skira,
Milan/Geneva

Selected Exhibitions

2005 Centre d'Art
Contemporain, Geneva

2005 'OK/OKAY' Swiss
Institute / Grey Art Gallery,
New York

2004 'It's All an Illusion', Migros
Museum, Zurich

2003 'Kontext, Form, Troja',
Secession, Vienna

2001 'La conduite du Rucher',
Musée d'Art Moderne et
Contemporain, Geneva

Valentin **Carron**

Born 1977
Lives Paris

Saturated with references to traditional Alpine
imagery, Valentin Carron's works suggest
popular art's compulsion towards simulation and
replication as a means of cultural self-preservation.
He explores the visual stereotypes and social
pretensions maintained within such demotic
spaces of representation as bric-à-brac and kitsch
souvenirs. In *Château Synthèse* (Château Synthesis,
2000), for example, Carron manufactured a brand
of wine with no certificate of origin, blocking the
functions of regional pride and cultural identity,
and exposing the dubious strategies that come
disguised as 'authentic' tradition. (DJ)

Shown by Galerie Francesca Pia C20, Galerie
Eva Presenhuber C7

Selected Bibliography

2005 'Jota Castro', Jerome Sans, *Paris Musées*

2004 'Sooner or Later...', Jota Castro, *Janus*

2004 'Jota Castro: Mourir pour des idées, d'accord, mais ...' (Jota Castro: To Die for Ideas, okay, but ...), Amiel Grumberg, *L'Oeil*

2004 *Quick Sand*, De Appel Foundation, Amsterdam

2003 *50th International Art Exhibition: Venice Biennale*, Editions Marsilio, Venice

Jota **Castro**

Born 1965
Lives Brussels

The fact that Jota Castro was a diplomat for the UN and the European Union until the late 1990s provides an insight into his politically oriented work. Performances such as *Discrimination Day* (2005), which divided up the audience and subjected the 'whites' to the harassment usually reserved for the 'others', reflect his direct and provocative response to current affairs. His output is multifarious: from T-shirts bearing the slogan 'Kosovo Hope' to *Guantánamo* (2005), a recreation of a cell from the notorious US detention centre. The precariousness and hypocrisy of Western socio-political systems may be a well-rehearsed theme, but one articulated with a new urgency in Castro's unambiguous statements. (KB)

Shown by Massimo Minini E4

Selected Exhibitions

2005 'Exposition Universelle 1', Palais de Tokyo, Paris

2005 'Exposition Universelle 2', B.P.S. 22, Charleroi

2004 'Jota Castro ... Pour Amiel', La Criée, Rennes

2004 'Bouc-émissaire', Galerie Kamel Mennour, Paris

2004 'Quick Sand', De Appel, Amsterdam

2004 'Shake', O.K. Centrum für Gegenwartskunst, Linz

2004 Gwangju Biennial

2004 'Seven Sins', Museion Bolzano

2003 'Motherfuckers Never Die', Massimo Minini, Brescia

2003 'Zone of Urgency', Arsenale, Venice Biennale

Fruit Display
1996
Acrylic on canvas
193×193cm
Courtesy Waddington Galleries

Selected Bibliography

2005 *Patrick Caulfield: Paintings*, Marco Livingstone and Lund Humphries, London

2004 *Patrick Caulfield*, Waddington Galleries, London

1999 *Patrick Caulfield*, Marco Livingstone and Bryan Robertson, Hayward Gallery Publishing, London

1998–9 *Patrick Caulfield: The Complete Prints 1964–99*, Alan Cristea, Mel Gooding and Kathleen Dempsey, Alan Cristea Gallery, London

1992 *Patrick Caulfield: Paintings 1963–1992*, Andreas C. Papadakis, Academy Group, London

Selected Exhibitions

2002 'Patrick Caulfield: Paintings and Drawings 1985–2002', Waddington Galleries, London

1999 Hayward Gallery, London

1998 'Patrick Caulfield: Works on Board', Waddington Galleries, London

1997 'Patrick Caulfield: New Paintings', Waddington Galleries, London

1992–3 'Patrick Caulfield: Paintings 1963–1992', Serpentine Gallery, London

1989 Waddington Galleries, London

1985 Waddington Galleries, London

1981–2 'Patrick Caulfield: Paintings 1963–81', Walker Art Gallery, Liverpool

1976 Arnolfini Gallery, Bristol

1965 Robert Fraser Gallery, London

Patrick **Caulfield**

Born 1936
Lives London

Patrick Caulfield has written: 'I don't think my painting has moved in a straight line formally or progressed evenly. At different periods I've done simple things. Then I've complicated everything.' Over the past 40 years or so his high-key paintings have approached the still-life aspects of the modern world from an idiosyncratic Pop perspective. 'The spaces and interiors we see in real life are always more surprising than those we could invent', he has said. 'Since one can't actually compete with the unexpectedness of reality, I feel free to invent any contortions of space, as long as they work for me.' (JH)

Shown by Waddington Galleries F3

The Absent Presence
2005
C-Print
Edition of 6+1AP
59×42cm each
Courtesy Galerist

Selected Bibliography

2005 'Under the Skin',
November Paynter, ArtReview

2005 'Signe Chalayan',
Anaid Demir, Jalouse Art

2005 'Hussein Chalayan',
Suzie Menkes, International
Herald Tribune

2005 'Place and Passage',
Greg Hilty, Modern Painters

2004 'Hussein Chalayan',
Marco Tagliafierro, tema celeste

Hussein **Chalayan**

Born 1970
Lives London

While fashion has long been used – more or less explicitly – as a vehicle for ideas and ideologies, few designers have carried their conceptual bent as far as Hussein Chalayan. His innovations include clothes that transform into furniture and back, and clothes that function as protective pods and cocoons for the wearer. He has conjured ready-to-wear lines out of designs sketched while blindfolded, and brought traditional Muslim costume onto the catwalk. Chalayan practises a kind of intimate architecture, exploring the way clothing creates social interactions, and how these interactions in turn create novel spaces to contain them. (SS)

Shown by Galerist G18

Selected Exhibitions

2005 'The Absent Presence',
Pavilion of Turkey, Venice
Biennale

2005 'Hussein Chalayan:
Retrospective', Groninger
Museum, Groningen;
Kunstmuseum, Wolfsburg

2005 'Place to Passage',
Centraal Museum, Utrecht;
Proje4L, Istanbul; Centre d'Art
Contemporain, Geneva

2003 'Echoforms', Galerist,
Istanbul

2001 'Radical Fashion', Victoria
& Albert, London

Wave
2004
Acrylic on canvas
153×213cm
Courtesy Galerie Anne de
Villepoix

Changha Hwang

Born 1969
Lives New York

Selected Bibliography

2005 *Changha Hwang*, Pierre Sterckx, Galerie Anne de Villepoix, Paris; Galerie Boronian Francey, Brussels

Selected Exhibitions

2005 Martha Cervera, Madrid

2005 Galerie Baronian-Francey, Brussels

2004 Massimo Audiello Gallery, New York

2004 Galerie Anne de Villepoix, Paris

2004 'Surface Tension', Chelsea Art Museum, New York

2003 'City Mouse / Country Mouse', Space 101, New York

2002 'MFA Thesis Exhibition', Hunter College, New York

There is something both slow and electric about Changha Hwang's dizzyingly colourful paintings. While these painstaking and complex compositions emanate partly from a hyper-speed, digitalized culture, they are also informed by more traditional concerns, such as the depiction of space and the application of colour theory. Paintings such as *Adjust* (2004) set up an optical challenge for the viewer, as expressionist panels overlap and collide with floating grids and blocks of solid colour. Movement is often alluded to in the titles of paintings, such as *Zipper* (2004) and *Boomerang* (2004) – fittingly, as the eye is sent shuttling along various horizontals and clashing verticals. (SL)

Shown by Galerie Anne de Villepoix D1

Bat Opera
2005
Oil on canvas
15×20cm
Courtesy Herald St

Lali **Chetwynd**

Born 1973
Lives London

Lali Chetwynd studied history and anthropology before art, which may account for the way her practice links disparate examples of the grotesque. Her paintings, collages and performances have cited Michael Jackson's *Thriller* video, *Conan the Barbarian* and Hieronymus Bosch's *Garden of Earthly Delights*. Whatever the source, Chetwynd's reworkings are decidedly irreverent, as in her performance *An Evening with Jabba the Hutt* (2004). Clad in a hideous wig and garish bikini, Chetwynd made playful critique of Carrie Fisher's slave girl turn in *Return of the Jedi*. However, her deliberately amateurish approach often results, as in *Iron Age Pasta Jewellery* (2004), in work that is oddly beautiful. (SL)

Shown by Herald St A8

Selected Bibliography

2005 *Beck's Futures*, Rob Bowman, Institute of Contemporary Arts, London

2005 *Do Not Interrupt your Activities*, Sarah McCrory, Royal College of Art, London

2003 'Orchestrating Chaos', Kit Hammonds, *Untitled*

2003 'Lali Chetwynd', Neil Mulholland, *Flash Art International*

Selected Exhibitions

2005 'Bridge Freezes before Road', Gladstone Gallery, New York

2005 'Do Not Interrupt Your Activities', Royal College of Art, London

2005 'Beck's Futures', Institute of Contemporary Arts, London

2004 'Born Free', Gasworks, London

2004 'Bat Opera', Millers Terrace, London

2003 'The Golden Resistance', Tate Britain, London

www.tupacproject.it
2004
Height 178cm
Installation view, MARTa
Courtesy Massimo Minini

Selected Bibliography

2005 *(my private) HEROES*, Raimar Stange, MARTa, Herford

2003 'Paolo Rennt' (Paolo Runs), Raimar Stange, *Kunstbulletin*

2003 *Dangerous Liaisons*, Marcella Beccaria, S.M.A.K., Ghent

2003 'Overture', Chiara Leoni, *Flash Art*

2002 'Arte e video' (Art and Video), Maria Rosa Sossai, *Silvana Editoriale*

Selected Exhibitions

2005 '(my private) HEROES', MARTa, Herford

2005 'YDV', W139, Amsterdam

2005 'Behind the Ego', Moscow Biennial

2004 'ON-AIR: Video in onda dall' Italia', Museum of Contemporary Art, Monfalcone, Gorizia

2003 'Forse Italia', S.M.A.K., Ghent

2003 'Spazi Circoscritti', Galleria Massimo Minini, Brescia

2003 'Videoabende', MARTa, Herford

2003 'Focusis', Museo Nacional Centro de Arte Reina Sofia, Madrid

2002 '20° Livello', Museum of Modern Art, Turin

2002 'EXIT: Nuove geografie della creatività italiana', Fondazione Sandretto Re Rebaudengo, Turin

Paolo **Chiasera**

Born 1978
Lives Bologna

Although he produces mainly video works, Paolo Chiasera has stated that he is 'obsessed with the idea of painting as infinite time, analogous to the loop, with the picture as a kind of continuous space'. This line of thought informs works such as *The Wall* (2002), in which he runs incessantly against the backdrop of a detail from a Giorgio de Chirico painting. Similarly in other works the artist uses indices of the real – a protagonist, architecture, movement in space – along with digitally assisted illusions that result in an engaging blend of the everyday and the virtual. (DE)

Shown by Massimo Minini E4

Selected Bibliography

2005 'Jan de Cock', Jordan
Kantor, *Artforum*

2004 *Denkmal ISBN
9080842419*, Jan de Cock,
Atelier Jan de Cock, Brussels

2004 'Kunst und Welt flirten
miteinander' (Art and the World
Flirt with Each Other), Merten
Worthmann, *Die Zeit*

2004 'Jan de Cock', Douglas
Heingartner, *Flash Art
International*

2004 'Architektur der Grenze'
(The Architecture of Borders),
Gregor Jansen, *Die Tageszeitung*

Jan **de Cock**

Born 1976
Lives Brussels

Carefully constructed from chipboard, plywood
and cheap Formica, Jan de Cock's installations
occupy space without declaring themselves as
either sculpture or architecture. Interlocking
horizontal and vertical planes echo the forms of the
buildings they inhabit (be it a university library in
Ghent, a disused shipyard in the Basque country
or, this year, the galleries of Tate Modern) while
referencing the work of key Modernist architects
such as Adolf Loos or Frank Lloyd Wright. These
structures, mostly titled *Denkmal* (Monument),
operate under the guise of functionality – shelf,
bench, corridor – yet serve to highlight the myriad
strategies by which architects direct our use of
space. (DF)

Shown by Luis Campaña Galerie G16, Galerie
Fons Welters E19

Selected Exhibitions

2005 '2005 Denkmal 7', Schirn
Kunsthalle, Römerberg 7,
Frankfurt

2005 'Denkmal 1', Tate
Modern, London

2004 'Denkmal 23II', Palais des
Beaux-Arts, Brussels

2004 'Denkmal 2', Manifesta,
Donostia / San Sebastian

2004 'Denkmal 1a', Luis
Campaña Galerie, Cologne

2004 'Denkmal 9', Henry Van
de Velde University Library,
Ghent

2004 'Denkmal 4', Kunsthalle,
Dusseldorf, in co-operation with
'Mouse on Mars', Dusseldorf

2003 'Denkmal 10', De Appel,
Amsterdam

2003 'Denkmal 23', Palais
des Beaux-Arts, Jeune Peinture
Belge, Brussels

Work No. 340 A sheet of paper
folded up and unfolded
2004
Paper
29.7×21cm
Courtesy Hauser & Wirth
Zürich London

Selected Bibliography

2004 *Martin Creed*, Kunsthalle, Bern

2004 *Martin Creed: the whole world + the work = the whole world*, Centre for Contemporary Art, Ujazdowski Castle, Warsaw

2003 *Martin Creed Works*, Southampton City Art Gallery

Selected Exhibitions

2005 'The lights off', ACCA Melbourne

2005 Gavin Brown's enterprise, New York

2004 Galerie Jörg Johnen, Berlin

2004 Hauser & Wirth, London

2004 Galerie Emmanuel Perrotin, Paris

2004 Centre for Contemporary Art, Ujazdowski Castle, Warsaw

2003 'Work No. 300', permanent installation, Gavin Brown's enterprise, New York

2003 Kunsthalle, Bern

2003 'Beaucoup de bruit pour rien', Frac Languedoc-Roussillon, Montpellier

2003 'Work No. 289', The British School at Rome

Martin **Creed**

Born 1968
Lives London

Lights go on. Lights go off. Repeat. This is a full description of Martin Creed's *Work No. 127 The lights going on and off* (1995). Like all his works, it's aware that the universe is already full of things to look at and think about, and wishes to add to them only marginally, if at all. While some critics have identified Creed as a Conceptualist or Minimalist, he is rather an alchemist, transforming the stuff of daily life (Blu-Tack, A4 paper, floor tiles) into something that, while not extraordinary, has a parallel ordinariness that prickles our assumptions about the world. (TM)

Shown by Gavin Brown's enterprise D7, Marc Foxx C18, Hauser & Wirth Zürich London C9, Johnen + Schöttle D16

Untitled (house fire)
2004
Digital C-print
163×239cm
Courtesy Luhring Augustine

Gregory **Crewdson**

Born 1962
Lives New York

In each of Gregory Crewdson's lushly shot, elaborately staged photographs, something strange and unsettling has just happened, or is about to. We are presented with moments snipped from an occult narrative. The settings are familiar enough – the all-American vernacular of comfortable bedrooms, backyards and small-town streets – as are the people who occupy them. But here the typical suburban psychodramas are ramped up to fairy-tale weirdness. Some dam of normality has been broken, and all the latent menace and melancholy of domestic situations comes rushing in. Crewdson's cinematic tableaux offer glimpses of the dream world we always suspected was skulking behind our neighbours' doors. (SS)

Shown by Gagosian Gallery D9, Luhring Augustine B12, White Cube/Jay Jopling F8

Selected Bibliography

2005 'Director's Cut', Linda Yablonsky, *Time Out New York*

2005 'Gregory Crewdson', Martin Herbert, *Time Out London*

2005 'American Alienation in Smallsville', Andrew Graham-Dixon, *The Sunday Telegraph*

2005 'Hitchcock Meets Hopper', Laura Cumming, *The Observer*

Selected Exhibitions

2005 'Beneath the Roses', Luhring Augustine, New York; White Cube, London; Gagosian, Los Angeles

2002 'New Work 6: Gregory Crewdson, Twilight', Aspen Art Museum

2001 'Gregory Crewdson: Photographs', SITE Santa Fe

Untitled (Diptych)
2005
Oil, enamel and spray paint
on two canvases
250×326cm
Courtesy Galerie Nathalie
Obadia

Selected Bibliography

2004 'Rosson Crow', Ben La
Rocco, *The Brooklyn Rail*

Rosson **Crow**

Selected Exhibitions

2005 Galerie Nathalie
Obadia, Paris

2005 'Little Odysseys',
Marianne Boesky Gallery,
New York

2005 Art : Concept, Paris

2004 'Estate Between',
Canada, New York

2004 'Familiar Haunts', The
Happy Lion, Los Angeles

2004 'Majority Whip', White
Box, New York

2004 'Poets of Miniature', Office
Ops, New York

2004 'Mira, Mira, Look, Look',
Visual Arts Gallery, New York

2003 'K48 Klubhouse', Deitch
Projects, New York

Born 1982
Lives New Haven

At a distance Rosson Crow's baroque interior
paintings appear misleadingly sleek. Up close,
however, her layered combination of oil, enamel
and spray paint reveal a tactile edginess. Diffuse
aureoles of light, peeling areas and loose drips
contribute to the atmospherics of her paintings
of empty rooms, such as *Delaney House* (2004).
Other, more off-beat works, such as *Invitation to
a Beheading (Mordacity and His Ilk)* (2004), feature
lone figures in medieval costume. Crow's deft use
of motifs such as grids, reflections and windows
add to the sense of a virtual world, half digital, half
dreamt. (SL)

Shown by Galerie Nathalie Obadia E23

Carro Novo
(New Car)
2004
Metallic car paint on wood,
rubber, metal and mirror
160×130×340cm
Courtesy Galeria Luisa Strina

Selected Bibliography

2004 *Imagine Curating*,
Allan Phelan, Gandon Editions

2003 'It's a Bourgeois Feeling',
*The Wrong Times – The Wrong
Gallery*

2001 'Body Matters',
Paul Thek, *Welcome News*

2000 'On Emotional and Social
Interaction', Rosa Martinez,
EV+A Friends and Neighbors

2000 'Never the Twain Shall
Mate', Aidan Dunne, *The Irish
Times*

Alexandre **da Cunha**

Born 1969
Lives London

Mundane yet mysterious, Alexandre da Cunha's
sculptures transform culturally degraded objects
into formally suggestive assemblages that evoke
the human body. Plastic bottles, toilet plungers,
sports equipment and orthopaedic devices all
make appearances in his playful mix of metaphor
and metamorphosis. In *Climbing Frame* (2002) an
array of mops stand upright with their orange
brushes splayed on the floor; linked to horizontal
poles, their handles form part of a jungle-gym-like
structure. *Ebony Terracotta* (2002) is a dignified trio
of vaguely classical 'vases' made from black and
terracotta-coloured plungers. (KJ)

Shown by Galeria Luisa Strina G7, Vilma
Gold D20

Selected Exhibitions

2005 Museu de Arte da
Pampulha, Belo Horizonte

2005 Prague Biennial

2005 'Colorama', Vilma Gold,
London

2004 'Carro Novo', Galeria
Luisa Strina, São Paulo

2004 'Produciendo Realidad',
Prometeo Associazione
Culturale, Lucca

2004 'Imagine Limerick,
EV+A 2004', Limerick City
Gallery of Art

2003 'The Structure of Survival',
Arsenale, Venice Biennale

2002 Liverpool Biennial

2002 'Alexandre da Cunha +
Brian Griffiths', Galeria Luisa
Strina, São Paulo

2000 PICAF / Pusan
International Contemporary Art
Festival

Left: *AST036*
2003
Acrylic on canvas
250×400cm
Right: *AST037*
2003
Acrylic on canvas
250×250cm
Installation view, Air de Paris
Courtesy Air de Paris

Selected Bibliography

2004 'Stéphane Dafflon: Une Beauté séculière' (Dafflon: A Secular Beauty), Michel Gauthier, *Art Press*

2004 *Vitamin P: New Perspectives in Painting*, Phaidon Press, London

2002 *Kogler, Dafflon, Baudevin*, Eric Troncy, Villa Arson, Nice

2001 *Salon de Musique* (Music Room), Fabrice Stroun, Musée d'Art Moderne et Contemporain de Strasbourg

2001 'Easy Geometry', Judicaël Lavrador, *zérodeux*

Selected Exhibitions

2005 'Space Invaders', Kunsthaus Baselland, Muttenz/Basel

2005 'Les apparences sont souvent trompeuses', CAPC Musée d'Art Contemporain, Bordeaux

2004 'Pattern Recognition', Le Spot, Le Havre

2004 'Something More Abstract', Air de Paris

2004 'None of the Above', Swiss Institute, New York

2004 'La Lettre volée', Franche-Comté, Musée de Dole

2003 'Wall Walk', Musée d'Art Moderne et Contemporain, Geneva

2003 'Coollustre', Collection Lambert, Avignon

2002 Villa Arson, Nice

Stéphane **Dafflon**

Born 1972
Lives Paris

Stéphane Dafflon's geometric forms recall graphic design and advertising as much as art-historical modes of abstraction. Rendered in soft colours, his paintings exhibit a lean formal vocabulary, exemplified by the repetition of a star shape in both the series 'AST' (2001) and its sculptural counterpart, *PMGREENSTAR* (2001). Dafflon's abstract iconography shuns straight lines and right angles – style choices that derive from his embrace of computerized design. Painting is deployed to question its own relation to new technologies, and its trespass into the history of visual art. (DJ)

Shown by Air de Paris A4

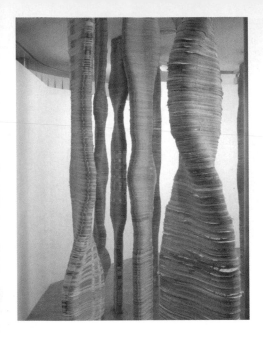

José **Damasceno**

Born 1968
Lives Rio de Janeiro

José Damasceno's drolly hermetic installations seem to be working out a poetics of accumulation. Commonplace objects – hammers, pencils, chess pieces, chalkboard erasers, glass microscope slides – are massed together, forming flowing structures, grids, networks of information. The effect is often disorienting, as the viewer tries to reconcile two different notions of scale at the same time. Puzzling out the implied order in the seemingly chaotic groupings is a bit like exploring another world. As Damasceno himself says of his work: 'There is an unknown system of cause and effect, somewhat frightening yet also seductive.' (SS)

Shown by Galeria Fortes Vilaça C15, Projectile Gallery E15

Selected Bibliography

2002 *José Damasceno*, Galeria Fortes Vilaça, São Paulo

1998 *José Damasceno:Trabalhos 1992–1998* (Works 1992–1998), Galeria Camargo Vilaça, São Paulo

Selected Exhibitions

2005 'The Experience of Art', Italian Pavilion, Venice Biennale

2004 'Observation Plan', Museum of Contemporary Art, Chicago

2003 Mercosul Biennial, Porto Alegre

2003 'Descubra as Diferenças', Culturgest, Porto

2003 'Living inside the Grid', New Museum of Contemporary Art, New York

2002 São Paulo Biennial

2001 'Squatters', Museu Serralves, Porto

2001 'El Final del Eclipse', Fundación Telefónica, Madrid

The Incredulity of Saint Thomas
2004
Oil on board
12×18cm
Courtesy Private Collection,
New York

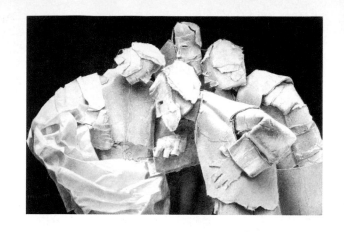

William **Daniels**

Selected Bibliography

2005 *Waste Material*, David Musgrave, The Drawing Room, London

Born 1976
Lives London

Selected Exhibitions

2005 Vilma Gold, London

2005 Marc Foxx, Los Angeles

2005 'Waste Material', The Drawing Room, London

2005 'The Darkest Hour', Leisure Club Mogadishni, Copenhagen

2005 'Young Masters', 148a St John Street, London

2004 'Death & Magic', Keith Talent Gallery, London

2004 'XS', fa projects, London

2004 'Project 1', Alma Enterprises, London

William Daniels' canvases are derived from torn paper tableaux of famous religious paintings from the past – the kind of thing that a Renaissance scholar might make out of paper napkins at a lonely bistro table. Painted in shades of light grey, they are graphically precise but also seem terribly, terminally frail, as though on the brink of fading into nothingness or of blowing away on the slightest breeze. Art history, here, has a very material death wish, which perhaps accounts for the melancholy in Daniels' work. His work is an act of preservation that knows that it's perfidious but which is unwilling to let the past slip out of sight. (TM)

Shown by Marc Foxx C18, Vilma Gold D20

Enrico **David**

Born 1966
Lives London

Enrico David's work endows interiors and functional objects with a particularly masculine charge. It refuses explicit interpretation, preferring instead the discreet nuances of aesthetic and intellectual allusion. Often echoing the sleek, geometric streamlining of Art Deco, David's paintings, sculpture, furniture and fabric designs together evoke a crypto-Masonic world of corporate boardrooms and clandestine ritual, where décor and decorum, design and desire are collapsed together in games of power, eroticism and intrigue. (DF)

Shown by Galerie Daniel Buchholz D14, Cabinet E12

Selected Bibliography

2004 'League of Gentlemen', Martin Herbert, *frieze* 80

2003 *The Best Book about Pessimism I Have Ever Read*, Neil Mulholland, Kunstverein Braunschweig, Verlag Walther König, Cologne

Selected Exhibitions

2005 'Wizard's Sleeve', Cabinet, London

2004 'Douche That Dwarf', Transmission Gallery, Glasgow

2004 'Flesh at War with Enigma', Kunsthalle, Basel

2004 'Teil 1 Mullberg', Galerie Buchholz, Cologne

2003 'David', Project Art Centre, Dublin

2003 'Madreperlage', Cabinet, London

2003 'Clandestines', Arsenale, Venice Biennale

Player (First Act)
2005
Framed etching and steering
wheel
54×49cm
Courtesy Sorcha Dallas

Selected Bibliography

2005 'Domestic Strangeness',
Sarah Lowndes, *frieze* 91

2005 'Participator', Coaimhin
MacGiollaleith, *The Map*

2005 'It's Truly an Education',
Moira Jeffrey, *The Herald*

2004 *Participant,* Anke Kempkes,
Sorcha Dallas, Glasgow

2004 'Glasgow Review',
Alexia Holt, *Contemporary*

Selected Exhibitions

2005 'Exile: New York is a
Good Hotel', Broadway 1602,
New York

2005 The Breeder Projects,
Athens

2004 'Participant', Sorcha
Dallas, Glasgow

2004 'Country Grammar', The
Gallery of Modern Art, Glasgow

2004 'Flesh at War with
Enigma', Kunsthalle, Basel

2004 'Like Beads on an Abacus
Designed to Calculate Infinity',
Rockwell, London

2004 'Spacemakers', Lothringer
Dreizehn, Munich

2003 'I Could be Happy',
Gagosian Gallery, London

2003 'Mother Nature', Vilma
Gold, London

2003 'Zenomap', Scottish
Pavilion, Venice Biennale

Kate **Davis**

Born 1977
Lives Glasgow

Literary and animate forms coalesce in the recent
practice of Kate Davis. She has a knack for the
metaphorical – her meticulous pencil studies
and art-historical collages generate an array of
unsettling almost-bodies. In *The Participant* (2004)
she drew bottles and glasses with swollen stomachs,
tiny arms and misshapen heels. Davis often
introduces sculptural elements, such as plinths or
a stage, to offer the viewer various vantage points
on her eerie, Surrealist drawings and collages. This
tactic was taken to an extreme in *The Player* (2005),
when she suspended a punchbag in front of a
drawing, leaving the spectator to duck and weave.
(SL)

Shown by Sorcha Dallas A14

The Skyride
2002
Oil and acrylic on canvas
81×163cm
Courtesy Tomio Koyama
Gallery

Jeremy **Dickinson**

Born 1963
Lives London

For more than a decade Jeremy Dickinson has been making meticulous oil paintings of toy cars, trucks and buses, paying careful attention to every dent and scratch. His compositions, such as *High Performance Stack* (2002), showing a tower of sports cars with a crane perched on top, all suggest a serious commitment to play. His Lilliputian junkyards and automotive arrangements are like Pop still lifes, which, while nostalgic for childhood and obsessive about collecting, also treat those subjects with a technical detachment that shows itself in the serious business of getting the right tone. (DE)

Shown by Tomio Koyama Gallery B6

Selected Bibliography

2004 'Jeremy Dickinson', Christian Rimestad, *Horsens Folkeblad*

2004 *Kathimerini*, Alexandra Korexenidis, Athens

2001 'Jeremy Dickinson', H. F. Debailleux, *Libération*

1999 John Judge, *Zing*

1998 'Jeremy Dickinson', Meghan Dailey, *Artforum*

Selected Exhibitions

2005 Galerie Xippas, Paris

2004 '1:76 Scale', Sara Meltzer Gallery, New York

2004 'Bus Park', Kunstmuseum, Horsens

2004 Galerie Xippas, Athens

2004 'New Paintings', Galleria Micia, Takamatsu

2003 'Bus Park', Angles Gallery, Santa Monica

2002 Tomio Koyama Gallery, Tokyo

2002 'Autojumble', Sara Meltzer Gallery, New York

2001 Anthony Meier Fine Arts, San Francisco

2000 Nils Staerk Contemporary Art, Copenhagen

Ike Cole; 38 years old; Los Angeles, California; $25
1990–92
Ektacolour print
Edition of 20
107×167cm
Courtesy Galerie Almine Rech

Selected Bibliography

2003 *A Storybook Life*, Philip-Lorca diCorcia, Twin Palms Publishers, Santa Fe

2003 *Philip-Lorca diCorcia*, Peter Galassi, Museum of Modern Art, New York

2001 *Heads*, Luc Sante, DAP, New York

2001 *Rencontres 6: Philip-Lorca diCorcia,* Jeff Rian, Galerie Almine Rech/Images Modernes, Paris

1998 *Philip-Lorca diCorcia, Streetwork*, Ediciones Universidad de Salamanca

Selected Exhibitions

2004 Kunsthall, Stockholm

2004 Centre National de la Photographie, Paris

2004 Carnegie International, Carnegie Museum of Art, Pittsburgh

2004 'Fashination', Moderna Museet, Stockholm

2004 'Fashioning Fiction in Photography since 1990', Museum of Modern Art, New York

2004 'Cruel and Tender: Photography and the Real', Museum Ludwig, Cologne

2001 'Open City: Street Photographs since 1950', Museum of Modern Art, Oxford

2000 Sprengel Museum, Hanover

1997 'Family and Friends', Museum of Contemporary Photography, Chicago

1993 'Strangers', Museum of Modern Art, New York

Philip-Lorca **diCorcia**

Born 1953
Lives New York

How much can we learn from photographs? What do we know about the world they present? The people and situations portrayed in Philip-Lorca diCorcia's work simultaneously invite interpretation and challenge it. Slipping between documentary and fiction, these images – sometimes staged or heightened, sometimes not – seem like fragments of a larger story. In cinematically lit street scenes diCorcia isolates harried passers-by, putting their introversions and preoccupations on display. His portraits seem 'psychological', but only in a vague, diffuse way. The essential bit of information is always withheld; the lost moments before and after the shutter click remain oblique. (SS)

Shown by Galerie Almine Rech G1

*Floor, Amstelveen, The Netherlands,
April 9, 1995*
1995
C-print
114×97cm
Courtesy Marian Goodman
Gallery

Selected Bibliography

2004 *Portraits*, Hripsimé Visser
and Urs Stahel, Schirmer/Mosel,
Munich

2002 *Beach Portraits*, Carol
Ehlers and James Rondeau, La
Salle Bank, Chicago

2001 *Portraits*, Katy Siegel and
Jessica Morgan, Institute of
Contemporary Art, Boston

2001 *Israel Portraits: Rineke
Dijkstra*, Herzliya Museum of
Art/Sommer Contemporary Art,
Tel Aviv

1999 *Die Berliner Zeit*, Rineke
Dijkstra and Bart Domberg,
DAAD, Berlin

Selected Exhibitions

2004–5 'Rineke Dijkstra:
Portraits', Jeu de Paume, Paris;
Fotomuseum, Winterthur;
Fundació la Caixa, Barcelona

2003 Marian Goodman Gallery,
New York

2001 'Rineke Dijkstra: The
Tiergarten and the French
Foreign Legion', Frans
Halsmuseum, Haarlem

2001 'Focus: Rineke Dijkstra',
The Art Institute of Chicago

2001 'Portraits', Institute of
Contemporary Art, Boston

2000 Marian Goodman Gallery,
New York

1999 'The Buzzclub, Liverpool,
England/Mysteryworld,
Zaandam', Museu d'Art
Contemporani de Barcelona

1999 'Israel Portraits', The
Herzliya Museum of Art

1998 Museum Boijmans Van
Beuningen, Rotterdam

Rineke **Dijkstra**

Born 1959
Lives Amsterdam

Using a subtly classical approach, Rineke Dijkstra
depicts people at transitional stages in their lives:
adolescents on the beach, women coping with
childbirth, young Israeli soldiers and a French
Foreign Legion officer undergoing training.
Facing the camera and appearing before bland
backgrounds, they project both strength and
fragility. In Dijkstra's words, 'I am interested in
the paradox between identity and uniformity, in
the power and vulnerability of each individual and
each group. It is this paradox that I try to visualize
by concentrating on poses, attitudes, and gestures.'
(KJ)

Shown by Marian Goodman Gallery F9, Jan Mot
B16, Sommer Contemporary Art A2

Untitled
2005
Oil on canvas
160×130cm
Courtesy Galerie Michael Neff

Selected Bibliography

2003 *Das Schwarze sind die Buchstaben* (The Black Are the Letters), Galerie Ben Kaufmann, Berlin

2001 'Besondere Kennzeichen Malerei' (Specific Distinguishing Marks of Painting), Kunsthalle Exnergasse, Vienna

Selected Exhibitions

2005 'Purple Valley', Galerie Michael Neff, Frankfurt

2005 'Favoriten', Kunstbau Lenbachhaus, Munich

2005 'Cthulhu', Kunstverein, Augsburg

2004 'Fantastic Voyage', Galerie Ben Kaufmann, Munich

2004 'im Mai', Ausstellungsraum Chausseestrasse, Berlin

2003 'The State of the Upper Floor: Panorama', Kunstverein, Munich

2002 'Malerei', Gist, Galerie voor hedendaagse Kunst, Brummen

Hansjörg **Dobliar**

Born 1970
Lives Munich/Berlin

In its title and schooled 'bad painting' style, Hansjörg Dobliar's *1981* (2003) – a depiction of a brown mountain range and a brightly striped radiant sky – recalls the work of an earlier generation, notably Albert Oehlen. In Dobliar's paintings pathos and romantic motifs such as darkness and the forest are interrupted by abstract elements with a vague whiff of mystic symbolism, and furiously nonchalant brushwork. No nostalgic yearning for the Sublime, however, echoes in the valleys of Dobliar's Alps. Rather, they suggest a fascination with their own painterly present. (DE)

Shown by Galerie Michael Neff A15

Lost and Found
2005
Oil on canvas
213×183cm
Courtesy CRG Gallery

Tomory **Dodge**

Born 1974
Lives Los Angeles

Tomory Dodge's favourite painters are probably those such as David Park, Philip Guston or Richard Diebenkorn, whose figuration was shaped by forays into and back out of abstraction. This young Los Angeles painter's gestural pastorals often depict detritus-strewn landscapes that, at their best, seem near enough to abstraction and to places we recognize to be mildly in danger of becoming both civilized and unrecognizable. It's as if places on the edge of chaos are the only things worth trying to look closely at. Dodge's tightly cool palette is consistent with this tightrope walk, affecting a vaguely sickening light that becomes just warm enough to play up his seductive touch. (PE)

Shown by ACME. D15, CRG Gallery C23

Selected Bibliography

2005 'The ArtReview 25: Emerging US Artists', Daniel Kunitz and João Ribas, *ArtReview*

2005 'Tomory Dodge', Christopher Miles, *Artforum*

2005 'Tomory Dodge', Sarah Douglas, *Flash Art International*

Selected Exhibitions

2004 ACME., Los Angeles

2004 Taxter and Spengermann, New York

2004 'A402 Gallery', California Institute of the Arts, Los Angeles

2004 'Super Sonic', Art Center College of Design, Pasadena

2004 'Singing My Song', ACME., Los Angeles

2004 'Surface Tension', Lombard Fried Fine Arts, New York

2004 'Field Trip', San Francisco Art Institute

2003 'Lordship and Bondage', LeRoy Neiman Gallery, Columbia University, New York

Fischköder
(Fishing Bait)
2003
Acrylic and enamel on canvas
60×120cm
Courtesy Galerie Gebr. Lehmann

Selected Bibliography

2005 *Doll*, Tatjana Doll,
Wim Peeters, Verbrecher Verlag,
Berlin

2005 'Platz da!' (Out of my
way!), Boris Hohmeyer, *Art
Kunstmagazin*

2004 'Seriously Sexed Up',
Peter Herbstreuth, *Kunstbulletin*

2003 'Disabled Parking',
Marcus Lütkemeyer, *Kunstforum*

Selected Exhibitions

2005 'Bier für Öl + ein blinder
Passagier', Kunstverein,
Bremerhaven

2005 'Ferrari', Galerie Jean
Brolly, Paris

2004 'Gr8-Show', Galerie
Gebr. Lehmann, Dresden

2004 'Visa for 13', PS1
Contemporary Art Center,
New York

2002 'Disabled Parking',
Städtische Galerie, Gladbeck

2002 'Urgent Painting', Musée
d'Art Moderne de la Ville de
Paris

2001 'The Big Show: Healing',
NICC Antwerp

Tatjana **Doll**

Born 1970
Lives Berlin

Sports cars, SUVs, trucks, ships and road signs
fill Tatjana Doll's huge canvases with a frontal,
in-your-face presence, as if conjuring the actual
life-size object. Echoes of Julian Opie's pristine
large-scale pictogram style are undercut with
a late 1970s' feel of quick, deadpan, anti-
perfectionist paint application. Doll, who in the
mid-1990s co-founded the Dusseldorf artists' group
hobbypopMUSEUM, allows her motifs to expand
to the extent that they cannot be contained by
the canvas – and often the canvas in turn can't
fit the space in which it is shown. The resulting
awkwardness is one of social friction: like pit bulls
gate-crashing a poodle party. (JöH)

Shown by Galerie Gebr. Lehmann G10

Here's Your Chance to Step out of Time
2005
Oil on canvas
49×61cm
Courtesy Yvonne Force
Villareal, New York, and
Maureen Paley

Kaye **Donachie**

Born 1970
Lives London

With their subdued pallor and luminescent light sources, Kaye Donachie's scenes evoke another place and time, which could be past, future or in some other dimension altogether. Quotations of the halcyon settings of cults and communes taken from film and reality depict youths with indistinct features and rangy limbs lounging in hammocks or against a tree in Elysian glades. Donachie's scenes of spiritual aspiration have distinctly dark undertones, though – her hazily impenetrable imagery conveys the double-edge of counterculture. At once alluring and treacherous, indoctrination could bring salvation or downfall. (SO'R)

Shown by John Connelly Presents A12, Maureen Paley C12, Peres Projects Los Angeles Berlin E21

Selected Bibliography

2004 'Die Nächste Generation' (The Next Generation), Ossian Ward, *Kunstmagazin*

2004 'Kaye Donachie', Peter Suchin, *frieze* 83

2004 'Kaye Donachie', Martin Herbert, *Time Out London*

2004 'Kaye Donachie', Kamini Vellodi, *Contemporary*

Selected Exhibitions

2005 Peres Projects, Los Angeles

2005 'Ideal Worlds: New Romanticism in Contemporary Art', Schirn Kunsthalle, Frankfurt

2005 Maureen Paley, London

2004 Artists Space, New York

2004 'Epiphany', Maureen Paley Interim Art, London

2004 'Sign of the Covenant', John Connelly Presents, New York

Zola's Daughter
2004
Charcoal, gouache on paper
175×121cm
Courtesy Diana Stigter

Selected Bibliography

2005 'Framed: Iris van Dongen', *Dazed and Confused*

2005 Critics' Picks, Jens Asthoff, www.artforum.com

2005 'Iris van Dongen', Robert Roos, *Kunstbeeld*

2005 'Ambivalent Entanglements', Jeannot Simmen, *BE magazine*

2004 'Expander', Neil Mulholland, *frieze* 88

Selected Exhibitions

2005 Diana Stigter, Amsterdam

2005 'Aurelia', Salon 94, New York

2005 'She's the Night', Kunstlerhaus Bethanien, Berlin

2005 'Nox noctis', GEM, The Hague

2005 'Spleen', The Breeder Projects, Athens

2005 'New Figuration', Galleri Christina Wilson, Copenhagen

2005 'Expanded Painting', Prague Biennial

2004 'Expander', Royal Academy of Arts, London

2004 'The Dutch Show', The Dutch Institute, Athens

2004 'Vixen', Diana Stigter, Amsterdam

Iris **van Dongen**

Born 1975
Lives Rotterdam

Single, white women with regular features and wide eyes, who like dabbling with the occult, skulls, Death Metal and tattoos, are the principal motifs in Iris van Dongen's large pastel and charcoal drawings. Works such as *Decomposition* (2003) would have a dark presence in any glossy fashion magazine, although van Dongen's photography-oriented realism is always soft-focus and sometimes fuzzy around the edges. As if aware of their existence in a state of limbo – as neither subjects nor mere impassive objects – her models respond to the viewer with a look of haughty, repressed aggression or with a melancholy gaze that seems tragically conscious of how it is mediated. (DE)

Shown by Salon 94 B18, Diana Stigter H14

Panopticon, Isla de Pinos / Isla de
la Juventud
2005
C-print mounted on honeycomb
aluminium
125×201×6cm
Courtesy David Zwirner

Selected Bibliography

2005 *Stan Douglas: Inconsolable
Memories*, Scott Watson, Sven
Lütticken and Philip Monk,
Joslyn Art Museum, Omaha;
Belkin Art Gallery, University
of British Columbia, Vancouver

2003 *Stan Douglas: Film
Installationen*, Kestner
Gesellschaft, Hanover

2002 *Journey into Fear*,
Serpentine Gallery, London

2002 *Stan Douglas: Every
Building on 100 West Hastings*,
Contemporary Art Gallery,
Vancouver

1998 *Stan Douglas*, Stan
Douglas, Diana Thater, Scott
Watson and Carol J. Clover,
Phaidon Press, London

Stan **Douglas**

Born 1960
Lives Vancouver

Like a movie camera rotating around its subject,
Stan Douglas' film and video work circles around
meaning to create multiple shifts in perspective.
Time slips and slides – scenes are replayed (often
across a number of scenes) in endless loops,
dialogue moves in and out of sync with action,
and restaged scenes from literary and cinematic
history are collapsed together to form scenarios
heavy with interpretative possibilities. Often
taking canonical novels and Hollywood classics as
sources of inspiration, Douglas turns the grammar
and syntax of the moving image upside down to
render transparent the mechanisms that keep their
orthodox narratives ticking. (DF)

Shown by David Zwirner C11

Selected Exhibitions

2005 Joslyn Art Museum,
Omaha

2005 'The Experience of Art',
Italian Pavilion, Venice Biennale

2002 The Serpentine Gallery,
London

2002 Documenta, Kassel

2001 'Le Detroit', Kunsthalle,
Basel

2000 'Between Cinema and
a Hard Place', Tate Modern,
London

2000 'Le Detroit', The Art
Institute of Chicago

1999 'Double Vision', Dia
Center for the Arts, New York

1994 Institute of Contemporary
Arts, London

1994 Centre Georges
Pompidou, Paris

Monument for May 68: History Doesn't Repeat Itself
2004
Fibreglass, mirror, steel
c. 220×175×160cm
Courtesy Blum & Poe

Selected Bibliography

2004 'Sam Durant', Jan Tumlir, *Artforum*

2004 'Speaking of Others', Mary Leclere, *Afterall*

2004 *Playlist*, Nicolas Bourriaud, Palais de Tokyo, Paris

2002 *Sam Durant's Riddling Zones*, Michael Darling, Museum of Contemporary Art, Los Angeles; Hatje Cantz Verlag, Ostfildern-Ruit

2002 *Sam Durant: Following the Signs*, Nicholas Baume, Wadsworth Atheneum, Hartford

Selected Exhibitions

2006 Gagosian Gallery, London

2005 'Proposal for White and Indian Dead Monuments Transposition, Washington D.C.', Paula Cooper Gallery, New York

2004–5 'Faces in the Crowd', Whitechapel Art Gallery, London; Castello di Rivoli, Turin

2004 'Involved', Blum & Poe, Los Angeles

2004 '12 Signs', S.M.A.K., Ghent

2004 Whitney Biennial, New York

2003 Garden Project, Walker Art Center, Minneapolis

2003 'Dreams and Conflicts: The Dictatorship of the Viewer', Arsenale, Venice Biennale

2003 The Wrong Gallery, New York

2002–3 Museum of Contemporary Art, Los Angeles; Kunstverein, Dusseldorf

Sam **Durant**

Born 1961
Lives Los Angeles

Sam Durant's kaleidoscopic matrix of references connects the faded glories of postwar Modernism with the battered, tarnished ideals of the civil-rights era. Robert Smithson, the Rolling Stones, Isamu Noguchi, Joseph Beuys, Huey Newton and Kurt Cobain, among others, are key protagonists in his drawings, sculptures and photographs. Durant's works bounce cultural signals off each other, like an echo chamber for late 20th-century protest and resistance. His work seeks to express something of the tension between individual action and social change – a chorus of historical dissent speaking to those disillusioned by today's political climate. (DF)

Shown by Blum & Poe G6, Tomio Koyama Gallery B6

Campus, Politische Mündigkeit
(Campus, Political
Responsibility)
2005
Newspaper
46×32cm
Courtesy Galerie Barbara Weiss

Maria **Eichhorn**

Born 1962
Lives Berlin

The autonomous art work is anathema to Maria Eichhorn's practice, which seeks to investigate the underlying exchange structures that define or make up an exhibition or that ascribe value to an art object. Whether founding a public company whose statutes restrict the accumulation of capital (for Documenta, 2002) or examining the politically dubious provenance of works in a German public art collection (Lenbachhaus, Munich, 2003), it is the process itself that constitutes the work, rather than the attainment of a definitive result or creation of a final product. (KB)

Shown by Galerie Eva Presenhuber C7, Galerie Barbara Weiss C20

Selected Bibliography

2004 *Maria Eichhorn: Bibliotheca*, Verlag Silke Schreiber, Munich

2003 *Maria Eichhorn: 1. Mai Film Medien Stadt*, Portikus, Frankfurt

2003 *Maria Eichhorn: Restitutionspolitik* (Maria Eichhorn: Politics of Restitution), Helmut Friedel, Städtische Galerie im Lenbachhaus und Kunstbau, Munich

2001–2 *Maria Eichhorn: Das Geld der Kunsthalle Bern, vols. 1 & 2* (Maria Eichhorn: Money at the Kunsthalle Bern, vols. 1 & 2), Kunsthalle, Bern

Selected Exhibitions

2005 Kunsthalle, Bern

2004 Centre d'Art Santa Monica, Barcelona

2004 Berlin Biennial

2003 'Restitutions-politik', Städtische Galerie im Lenbachhaus und Kunstbau, Munich

2002 Documenta, Kassel

2001 Galerie Barbara Weiss, Berlin

2001 'Das Geld der Kunsthalle Bern', Kunsthalle, Bern

1999 '1. Mai Film Medien Stadt', Portikus, Frankfurt

1998 'The Artist's Reserved Rights Transfer and Sale Agreement', Kunstverein, Salzburg

1997 'Arbeit/Freizeit', Generali Foundation, Vienna

Ring
2005
Chain of 260 silver rings
c. 4.4m
Courtesy Galerie Barbara Weiss

Selected Bibliography

2003 *Ayse Erkmen: Kuckuck* (Cuckoo), Konrad Bitterli and Roland Wäspe, Verlag für Moderne Kunst, Nuremberg, St Gallen

2002 *Kein Gutes Zeichen* (It Doesn't Look Good), Matthias Herrmann and Faith Özgüven, Secession, Vienna

2001 *Shipped Ships*, Ariane Grigoteit, Britta Färber and Friedhelm Hütte, Deutsche Bank, Frankfurt

1998 *An der Verbindungsstelle der Dinge* (At the Juncture of Things), Gregory Volk, Museum Fridericianum, Kassel

1997 *Ayse Erkmen: I-ma-ges*, Ferdinand Ullrich, Kunsthalle, Recklinghausen

Selected Exhibitions

2005 'Habseligkeiten', Galerie Barbara Weiss, Berlin

2005 'Under the Roof', Ikon Gallery, Birmingham

2004 'Durchnässt', Schirn Kunsthalle, Frankfurt

2003 'Kuckuck', Kunstmuseum, St Gallen

2003 'Tidvatten', Magasin 3 Konsthall, Stockholm

2002 'Kein Gutes Zeichen', Secession, Vienna

2001 'Shipped Ships', Public Space, Frankfurt

1999 'Choo Choo', Städtische Galerie Göppingen

1997 'Skulpturen Projekte 1997', Public Space, Münster

Ayse **Erkmen**

Born 1949
Lives Istanbul/Berlin

Ayse Erkmen looks at the process of displacement as a physical and symbolic process. For *Shipped Ships* (2001) she relocated boats – crews and all – from Venice, Shingu (Japan) and Istanbul to Frankfurt, where they operated as riverboats for five weeks. The crews, hosting local visitors in a twist on the logic of tourism, had an ambivalent status somewhere between that of guest workers and holidaymakers. In other works Erkmen has played with the displacement of the gallery architecture, using strategies such as slowly moving walls or perpetually flickering lights. Under scrutiny here is the rigid logic of exclusion and confinement that dominates modern society's understanding of space. (JV)

Shown by Galerist G18, Galerie Barbara Weiss C20

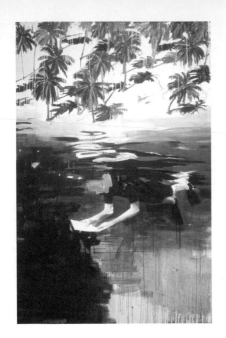

The Message
2003
Oil on canvas
250×160cm
Courtesy Galerie Catherine
Bastide

Selected Bibliography

2000 'Patrick Vanden Eynde',
Anne Pontegnie, *Artforum*

1998 'Bloed en Rozen, in
De Grote Parade', Edith Doove,
De Standaart

1989 'De beelden van
Patrick Vanden Eynde en
het besluiteloze slot van de
schilderkunst', Dirk Lauwaert,
De Witte Raaf

1989 'Patrick Vanden Eynde',
Alied Ottevanger, *Metropolis M*

Selected Exhibitions

2005 Museum Dhondt
Dhaenens, Deurle

2004 'Zie Tekening', Project
Voorkamer: Stedelijk Museum,
Lier

2003 'Once upon a Time',
Museum Van Hedendaagse
Kunst, Antwerp

2002 'Spervuur', Jonge
Beeldende Kunst in Vlaams
Brabant; Factor 44, Antwerp

1999 'La Consolation',
Magasin-Centre National d'Art
Contemporain, Grenoble

1997 'Trapped Reality', Centre
d'Art Santa Monica, Barcelona

1997 'Reality Revisited',
Fundació la Caixa, Barcelona

1995 'Call it Sleep', Witte de
With, Center for Contemporary
Art, Rotterdam

1992 'Lichtecht', Lokaal W 139,
Amsterdam

1992 'Close Encounters', Galerie
Paul Andriesse, Amsterdam

Patrick **Vanden Eynde**

Born 1964
Lives Antwerp

Patrick Vanden Eynde's paintings approach collage in their construction of imagery and meaning. Bringing together disparate elements – faces, masks, machines – and stranding them in the neutral non-space of the canvas, Vanden Eynde sets us adrift in a sea of associations, where a threatening unease floats just below the surface. A sketchy incompleteness suggests the ragged edges of memory and the possibilities of illusory space itself, while his evocative meld of archetypal and fantastic imagery is close to the language of film, where atmosphere is created by the dislocation of norms. (SO'R)

Shown by Galerie Catherine Bastide E16

Ars Gratia Artis
2005
Acrylic and glitter on canvas
305×243cm
Courtesy Leo Koenig Inc.

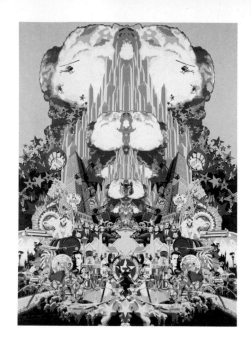

Selected Bibliography

2005 'System Overload', Jerry Saltz, *The Village Voice*

2005 'Pop Goes the Culture, Emblems and All', Holland Cotter, *The New York Times*

2005 Goings on about Town, *The New Yorker*

2005 'Justin Faunce: Thanks for All the Memories', Carly Berwick, *The Week*

2004 'Justin Faunce', Holland Cotter, *The New York Times*

Selected Exhibitions

2005 'Thanks for All the Memories', Leo Koenig Inc., New York

2005 'Greater New York', PS1 Contemporary Art Center, New York

2005 'Wasteland: 21st Century Landscapes', Roebling Hall, New York

Justin **Faunce**

Born 1980
Lives New York

Justin Faunce's paintings combine a meticulous attention to detail with a keen sense of cultural commentary. Faunce uses playful sloganeering, psychedelic colour combinations and multiple layers of reference to create works that critique, celebrate and reanimate his Pop heritage. *Emperor Tomato Ketchup* (2004) depicts Michael Jackson in a Che Guevara beret, beaming over strewn Campbell's soup cans, corporate logos and a banner that reads, 'Where there's dirt there's danger'. Subtle changes in the painting's mirrored halves highlight the piece's arch styling and seductive flair. (DJ)

Shown by Leo Koenig Inc. E25

IV
2005
Video
c. 10 minutes
Edition of 3+2AP
Courtesy Galerie Karin Guenther
Nina Borgmann

Jeanne **Faust**

Born 1968
Lives Hamburg

Jeanne Faust's photos and videos look as if they're taken from unmade films, loaded with a blend of cinematic clichés and new sentiments. An admitted fan of Fassbinder, the Hamburg-based artist pushes the cinéaste's 'double vision' to the limit: quite willing to empathize with the cinematic scenario, and yet completely aware of the conventions that produced it. In the context of artistic takes on cinema – Cindy Sherman, James Coleman, Sharon Lockhart, to name but a few – Faust clearly carves out her own approach. While her protagonists are locked in irritated gazes and muted interactions, the way cinema establishes a connection with the viewer – through shot and counter-shot, for example – becomes abstracted and juxtaposed with Baldessarian wit. (JöH)

Shown by Galerie Karin Guenther Nina Borgmann B7, Meyer Riegger C5

Selected Bibliography

2003 *Facing Footage*, Jeanne Faust and Omar Fast, BDI, Berlin

2003 *Jeanne Faust*, Tom Holert, Kunsthalle, Dusseldorf; Kunstverein, Heilbronn

Selected Exhibitions

2005 'Akademie', Kunstverein, Hamburg

2004 Meyer Riegger, Karlsruhe

2004 'Facing Footage', with Omer Fast, Pinakothek der Moderne, Munich

2004 Group Show, Museum of Contemporary Photography, Chicago

2004 'Deutschland sucht', Kunstverein, Cologne

2003 'Compilation 1', Kunsthalle, Dusseldorf

2003 'Hidden in a Daylight', curated by Foksal Gallery Foundation, Ciezyn

2003 'Groupshow', Galerie imTaxispalais, Innsbruck

2003 Museum Ludwig, Cologne

Autre Monde
(Other World)
2003
Ballpoint pen on paper
1 from a series of 5
34×25cm
Courtesy Galleria Franco Noero

Selected Bibliography

2005 'Lara Favaretto: Il
Futuro Ritrovato' (The Future
Rediscovered), Alessandro
Rabottini, *Flash Art*

2004 'Openings: Lara
Favaretto', Lisa Thompson,
Artforum

2003 *Why Donkeys Can Fly*,
Frank Maes, S.M.A.K., Ghent

2003 'Art Statements: Basel,
Andrea Viliani, *Flash Art*

2001 *Giovani Artisti Italiani*
(Young Italian Artists), Chiara
Bertola, Fondazione Querini
Stampalia, Venice

Selected Exhibitions

2005 'Ecstasy: Recent
Experiments in Altered
Perception', Museum of
Contemporary Art, Los Angeles

2005 Venetian Pavilion,
Venice Biennale

2005 'OK/OKAY', Swiss
Institute of Contemporary Art
and Grey Art Gallery, New York

2005 'XIV Quadriennale
d'Arte', Palazzo delle Esposizioni
di Roma, Rome

2005 Klosterfelde, Berlin

2004 Galleria Franco Noero,
Turin

2004 Swiss Institute of
Contemporary Art, New York

2002 'Treat or Trick, Project
Room Eldorado', Galleria d'Arte
Moderna e Contemporanea,
Bergamo

Lara **Favaretto**

Born 1973
Lives Turin

Lara Favaretto creates actions and installations in
a spirit of Utopian collaboration. For *Treat or Trick*
(2000–03) she shot footage of carnival in Cuba
and projected it onto a screen, which viewers had
to climb onto a silver stage to see. She also made
papier mâché heads inspired by carnival masks and
incorporated them into improvised processions.
Other interactive sculptures have included a felt
tree whose branches droop when someone sits
in its shade. She has said: 'The idea becomes the
protagonist. The idea is put on trial, and while
awaiting suitable partners who will develop it, it
becomes the pretext for the encounters'. (KJ)

Shown by Klosterfelde A7, Galleria Franco
Noero E8

Untitled
2003
Mixed media
c. 122×58×58cm
Courtesy D'Amelio Terras

Selected Bibliography

2004 *State of Play*, Rochelle Steiner, Serpentine Gallery, London

2001 *Tony Feher*, Claudine Ise, UCLA Hammer Museum, Los Angeles

2001 *Tony Feher*, Amada Cruz, Center for Curatorial Studies, Bard College, Annandale-on-Hudson

2001 'Lost and Found', Charles LaBelle, *frieze* 56

2000 'Tony Feher', Roberta Smith, *The New York Times*

Selected Exhibitions

2005 Chinati Foundation, Marfa, Texas

2005 'Material Matters', Herbert F. Johnson Museum of Art, Cornell University, Ithaca

2004 'The Wart on the Bosom of Mother Nature', D'Amelio Terras, New York

2004 'State of Play', Serpentine Gallery, London

2003 'Poetic Justice', Istanbul Biennial

2003 'Basic Instinct: Minimalism, Past, Present, and Future', Museum of Contemporary Art, Chicago

2002 'Provisional Worlds', Art Gallery of Ontario, Toronto

2001 'Red Room and More', UCLA Hammer Museum, Los Angeles; Center for Curatorial Studies, Bard College, Annandale-on-Hudson

Tony **Feher**

Born 1956
Lives New York

'The Wart on the Bosom of Mother Nature', the title of Tony Feher's 2004 solo exhibition, is an adequate description of the confluence of beauty and banality in his work. The discarded stuff of mechanized production and packaging – bottles, coins, crates and polystyrene buffers – becomes, through repetition and artful poise, a set of trim sculptural propositions. Feher's art objects may threaten to topple back at any moment into the realm of refuse, but they also remind us that they have the capacity to reappear from any junk-filled corner. (SO'R)

Shown by ACME. D15, D'Amelio Terras G14

Eva
2005
Enamel paint on mirror
105×78cm
Courtesy Marianne Boesky
Gallery

Selected Bibliography

2005 'Kinky Quicky Mops and Bewigged Geriatric Coquettes', Leslie Camhi, *The Village Voice*

2005 Goings on about Town, *The New Yorker*

2005 'Rachel Feinstein', Bill Powers, *Black Book*

2004 'D'Arte & D'Amore' (Of Art & of Love), Cristina Gabetti, *Elle Italia*

2003 'John Currin and Rachel Feinstein', Germano Celant, *Interview*

Selected Exhibitions

2005 Marianne Boesky Gallery, New York

2004 'Candyland', Herbert Read Gallery, Kent Institute of Art and Design, Canterbury

2003 'Self-Portraits', Deitch Projects, New York

2003 '3-D', Friedrich Petzel Gallery, New York

2003 'Peep Show', Comme Ça Art Gallery, Manchester

2002 Art in the Atrium at Sotheby's, New York

2002 Corvi-Mora, London

Rachel **Feinstein**

Born 1971
Lives New York

Feinstein makes many things, some of which are sculptural and some of which fit into the loose category of painting. Most have funny, enigmatic titles such as *Pequod in Denim and Diamonds* (1999), reference songs or plays and recall lifestyles varnished with the patina of old magazines. Happily mingling Rococo flourishes with Pop approximations of hallucinations, Feinstein's work looks as if she has plundered the contents of her bedroom and emptied a hardware store. The materials she uses include wood, plaster, denim, mirrors, velvet, rope, paint and rhinestones. Looking at these sculptures is like watching cartoons when you're over-tired, or letting your imagination fly in dusty museums. (JH)

Shown by Marianne Boesky Gallery E5, Corvi-Mora E7

Selected Bibliography

2005 'The Collector: Hans-Peter Feldmann', Dominic Eichler, *frieze* 91

2005 'Hans-Peter Feldmann in Conversation with Kasper König', Kasper König, *frieze* 91

2004–5 'Ask Me No Question and I'll Tell No Lies', Kirsty Bell, *ArtReview*

2003 'Bitte Knips Mir den Sound der Welt' (Please Take a Photo of the Sound of the World), Georg Imdahl, *FAZ*

2002 *272 Pages*, Hans-Peter Feldmann, Fundació Antoni Tapies, Barcelona

Hans-Peter **Feldmann**

Born 1941
Lives Dusseldorf

Although he also makes quirky sculpture from found objects, Hans-Peter Feldmann's main muse is the photographic image. Over many decades he has made many series, in limitless editions, of plain but striking photographs with motifs ranging from slept-in hotel beds and women's knees to the victims of the violent conflict between the German state and radical left-wing terrorist groups. An avid collector and collator of images – both his own snapshots and photographs taken from the mass media – Feldmann has published numerous artist's books, the most recent of which documents life in a women's prison. (DE)

Shown by 303 Gallery C13, Johnen + Schöttle D16, Galerie Francesca Pia C20, Galerie Barbara Wien C20

Selected Exhibitions

2005 Galerie Martine Aboucaya, Paris

2005 Galerie Barbara Wien, Berlin

2004 303 Gallery, New York

2002 Galerie Chouakri Brahms, Berlin

2002 Galerie Barbara Wien, Berlin

2002 303 Gallery, New York

2001–3 Fundació Antoni Tapies, Barcelona; Centre National de la Photographie, Paris; Fotomuseum, Winterthur; Museum Ludwig, Cologne

1993 Guggenheim Museum, New York

1972 Documenta, Kassel

Untitled
2005
PVC silver foil,
electroluminescent cables
240×140×65cm
Courtesy Galerie Giti
Nourbakhsch

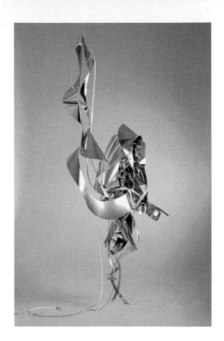

Selected Bibliography

2004 *Il Colore della Vita/Die Farben des Lebens: Hommage à Piero Siena* (The Colours of Life: Homage to Piero Sina), Paola Tognon, Museion, Bozen-Bolzano

2004 'Berta Fischer', Elena di Raddo, *tema celeste*

2004 'Berta Fischer', Silvia Margaroli, www.exibart.com

2002 *Der Zauber des Verlangens* (The Magic of Desire), NBK Neuer Berliner Kunstverein; Kunstverein, Göttingen

2002 ... *Ein Himmel wie blaues Porzellan* (A Sky Like Blue Porcelain), Claudia Spinelli, Villa Merkel, Esslingen

Selected Exhibitions

2005 'Waters and Watercolours', Georg Kargl, Vienna

2004 'It's All an Illusion', Migros Museum, Zurich

2004 Diana Stigter, Amsterdam

2004 Galleria Galica, Milan

2003 Galerie Giti Nourbakhsch, Berlin

2003 'Look Both Ways before You Cross', Galerie Gebr. Lehmann, Dresden

2002 Foksal Gallery Foundation, Warsaw

2002 'Ein Himmel wie blaues Porzellan', Villa Merkel, Esslingen

2002 'The Collective Unconsciousness', Migros Museum, Zurich

2001 Galerie Giti Nourbakhsch, Berlin

Berta **Fischer**

Born 1973
Lives Berlin

Berta Fischer's sculptures are characterized by a delicate insubstantiality coupled with a futuristic use of colour, light and material. Sheets of thin silver foil may hang from the ceiling in a flimsy, shimmering curtain, or small neon yellow structures covered with bits of taut plastic may approximate tiny UFOs. In recent works thin spidery lines of acrylic glass in luminescent colours are suspended on invisible threads, their faint but expansive gestures moving dynamically through space. Crooked spirals or tangled scrawls are like Cy Twombly-esque sketches in thin air, suggesting a spontaneous if fleeting creative impulse. (KB)

Shown by Galerie Giti Nourbakhsch D4, Diana Stigter H14

Morgan **Fisher**

Born 1942
Lives Santa Monica

Emerging from the experimental West Coast filmmaking scene of the late 1960s and '70s, Morgan Fisher is drawn to the intrinsic elements of cinema that somehow elude the rest of us. His subject, which he approaches through various media, is film itself – its conventions of structure and production, its standards and practices. His latest film, *()* (2005), is a montage of parenthetic cinematic filler, the Hollywood 'inserts' that are the unsung glue holding filmic narratives together. A roulette wheel spins, a key turns in a car's ignition, a railway station clock ticks. Extracted from any specific context, they float – maddeningly absurd but also intensely familiar and comforting. (JT)

Shown by Galerie Daniel Buchholz D14, China Art Objects Galleries F13

Selected Bibliography

2002 'Morgan Fisher', Catrin Backhaus, *frieze* 68

2002 'Finding Conceptual Pleasures in Monochromes', Christopher Knight, *Los Angeles Times*

2002 'Gemälde über Bücher' (Paintings over Books), Vanessa Joan Müller, *Texte zur Kunst*

1994 'Filmforum Tackles the "Beast"', Kristine McKenna, *Los Angeles Times*

Selected Exhibitions

2004 Galerie Daniel Buchholz, Cologne

2004 San Francisco Cinemathèque

2004 Filmforum, Los Angeles

2004 Greene Naftali, New York

2002 'To See Seeing: Paintings, Drawings, Films', Neuer Aachener Kunstverein, Aachen

2002 China Art Objects Galleries, Los Angeles

2002 Pacific Title and Art Studio presented by China Art Objects Galleries, Los Angeles

2000 Kunstverein, Hamburg

Yellow Girl
2005
Snapshot with paint
193×259cm
Courtesy Jack Hanley Gallery

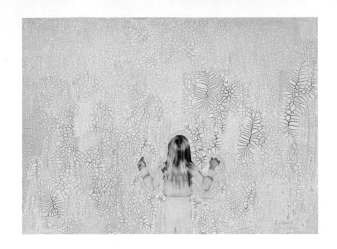

Selected Bibliography

2004 'Harrell Fletcher', Holland Cotter, *The New York Times*

2004 'Harrell Fletcher', Glen Helfand, *Artforum*

2004 'The Biennial That's Not at the Biennial', Mia Fineman, *The New York Times*

2004 'Everyday People', Kate Fowle, *a–n Magazine*

2004 'Ouverture', Brian Sholis, *Flash Art International*

Selected Exhibitions

2005 'Exercises in the Park', Laura Bartlett Gallery, London

2005 'With Our Own Little Hands', The Wrong Gallery, New York

2005 'Come Together', Apex Art, New York

2005 'Do Not Interrupt ', Royal College of Art Gallery, London

2004 'A Moment of Doubt', Christine Burgin, New York

2004 'Maintaining the Jazz', Jack Hanley Gallery, San Francisco

2004 Whitney Biennial, New York

2004 'Near and Far', Domaine de Kerguéhennec, Centre d'Art, Bignan

2004 'Street Selections', The Drawing Center, New York

2003 'Baja to Vancouver', Seattle Art Museum

Harrell **Fletcher**

Born 1967
Lives Portland

At the last Whitney Biennial a free newspaper offered a guide to some rather odd art exhibitions taking place all over the city – in libraries, cafés, restaurants and drugstores. This was Harrell Fletcher's contribution: a project that cheerfully led viewers away from his own work and away from the Whitney. Such is Fletcher's art: neighbourly and whimsical. His many collaborations all begin with an imaginative leap: an attempt to reconceive the art world as a more inclusive and less solemn place. As the Whitney hand-out proclaimed: 'It's a lot funner with friends and a bunch of fireworks.' (SS)

Shown by Jack Hanley Gallery E11, The Wrong Gallery H1

Ceal **Floyer**

Born 1968
Lives Berlin

The punch-line in Ceal Floyer's Conceptual works is often delivered by a new reading of the literal. *A Bucket* (1999), which appears at first to catch a drip in a gallery roof, is revealed to contain a tape-recorder playing a loop of a dripping sound. In the film *Downpour* (2000) Floyer twisted her camera in every direction to achieve an image of rain oriented southwards. Her antipathy towards standard interpretations was confirmed by her recent sound piece *Goldberg Variation* (2002), which simultaneously played every available version of Bach's Baroque keyboard exercise, resulting in a cacophony of adaptations. (SL)

Shown by 303 Gallery C13, Niels Borch Jensen Gallery H2, Lisson Gallery D8, Esther Schipper F5

Selected Bibliography

2002 *Tempo*, Paulo Herkenhoff, Miriam Basilio and Roxanna Marcoci, Museum of Modern Art, New York

2001 *Art Now*, ed. Uta Grosenick and Burkhard Riemschneider, Taschen, Cologne

1999 *Ceal Floyer*, Kunsthalle, Bern

1999 *Peace*, Migros Museum, Zurich

Selected Exhibitions

2004 Kabinett für Aktuelle Kunst, Bremerhaven

2003 'Plateau of Humankind', Italian Pavilion, Venice Biennale

2003 'Peel', Portikus, Frankfurt

2002 'X-rummet', Statens Museum for Kunst, Copenhagen

2002 Lisson Gallery, London

2001 'Ceal Floyer/MATRIX 192 37', Berkeley Art Museum and Pacific Film Archive

2001 'Massive Reduction: Peer', Shoreditch Town Hall, London

2001 'Inova', Institute of Visual Arts, Milwaukee

2001 Ikon Gallery, Birmingham

1999 Kunsthalle, Bern

Le Jardin
2005
Watercolour, gouache, pencil
and ink on paper
243×461cm
Courtesy Paul Kasmin Gallery

Selected Bibliography

2005 'America the Beautifully Absurd', Annette Grant, *The New York Times*

2005 'A Naturalist Painter Evokes Legends of the Past', James Prosek, *The New York Times*

2004 'Birds That Sing a Different Tune', Mary Haus, *ARTnews*

2003 *art:21:Art in the Twenty-First Century*, ed. Robert Storr and Thelma Golden, Abrams, New York

2002 *Tigers of Wrath: Horses of Instruction*, Abrams, New York

Selected Exhibitions

2005 Paul Kasmin Gallery, New York

2004 'Political Nature', Whitney Museum of American Art, New York

2004 'Bitter Gulfs', Paul Kasmin Gallery at 511, New York

2004 'For the Birds', Artspace, New Haven

2004 Michael Kohn Gallery, Los Angeles

2004 New Britain Museum of American Art, New Britain

2004 'Natural Histories: Realism Revisited', Scottsdale Museum of Contemporary Art

2004 'Animals & Us: The Animal in Contemporary Art', The Galerie St. Etienne, New York

2004 'Birdspace: A Post-Audubon Artists Aviary', Contemporary Art Center, New Orleans

Walton **Ford**

Born 1960
Lives Great Barrington

Walton Ford's paintings are social commentary disguised as natural history. His meticulously rendered works refract the legacy of Audubon through the satirical surrealism of Brueghel, Bosch and R. Crumb. A critique of colonialism and contemporary capitalism is apparent in many works, such as *Prodigy* (2004), a portrait of Fidel Castro as a wily-looking Cuban red macaw. *Falling Bough* (2002), one of Ford's most disturbing images, depicts a bough breaking under the weight of hundreds of carrier pigeons. These birds, once the most populous in America but now extinct, are shown fighting, copulating and eating their own young, oblivious to their imminent crash. (SL)

Shown by Paul Kasmin Gallery G12

Turning the corner. The flooded
Dry Creek, between One Tree
Hill-Jewtown and Clause Road
near Blacksoil just past Faith Peace
Lutheran Private Grammar School.
On a sunny summery hot afternoon
2004
Varnish and acrylic on linen
200×200cm
Courtesy Anna Schwartz Gallery

Selected Bibliography

2005 'Report from Australia:
Down Under No More',
Richard Kalina, *Art in America*

2004 'Dale Frank', Ashley
Crawford, *Art & Australia*

2004 'Ticket to Ride:
Dale Frank's Conceptual
Abstraction', Jane Rankin-Reid,
Art & Australia

2002 *Fieldwork: Australian Art
1968–2002*, Jason Smith and
Charles Green, The Ian Potter
Centre, National Gallery of
Victoria

2000 *Dale Frank: Ecstasy*,
Sue Cramer, Museum of
Contemporary Art, Sydney

Dale **Frank**

Born 1959
Lives Forest Hill

Although Dale Frank has worked in various media
since beginning his career as a Performance artist,
he still takes a performative stance toward art-
making, maintaining a dialogue with viewers'
desires. During the 1980s he created gestural
canvases, including odd, roiling seascapes. In the
1990s his projects included interactive 'sculptures'
such as a real-life pool hall and disco; he also
enlisted a couple to have sex on a painting, leaving
traces of paint. Other paintings incorporate objects
such as ashtrays, hubcaps and pool furniture.
Recently Frank has created large, radiant
'landscapes' with layers of glossy varnish. The titles
point to specific locations, but the paintings suggest
mental states. (KJ)

Shown by Anna Schwartz Gallery B1

Selected Exhibitions

2005 'Arthur Guy Memorial
Painting Prize 2005', Bendigo
Art Gallery

2004 'Swoon', Australian
Centre for Contemporary Art,
Melbourne

2003 Anna Schwartz Gallery,
Melbourne

2002 'Fieldwork: Australian
Art 1968–2002', The Ian
Potter Centre, NGV Australia,
Melbourne

2002 'Sublime: 25 Years of
the Westfarmers Collection of
Australian Art', Art Gallery of
Western Australia, Perth

2000 'Dale Frank: Ecstasy',
Museum of Contemporary Art,
Sydney

Strawberry Flavoured Mushroom
2004
Acrylic on canvas
91×100cm
Courtesy Tomio Koyama
Gallery

Selected Bibliography

2005 *Bijutsu Techo*, Yuri
Shirasaka, Bijutsu Shuppan-Sha

2004 *Roppongi Crossing: New
Vision in Contemporary Japanese
Art 2004*, Takashi Azumaya,
Mori Art Museum

2002 'Atsushi Fukui', Midori
Matsui, *Flash Art International*

2002 *Pacific Friend,* Yayoi
Kojima, Jijigahou-Sha

2001 *Bijutsu Techo*,
Noriko Miyamura, Bijutsu
Shuppan-Sha

Selected Exhibitions

2004 'Roppongi Crossing',
Mori Art Museum, Tokyo

2004 'teenage ghosts (and other
scary stories)', Tomio Koyama
Gallery, Tokyo

2003 'VOCA 2003: The Vision
of Contemporary Art', The Ueno
Royal Museum, Tokyo

2003 'New Generation Japanese
Painters', Hiroshima City
Museum of Contemporary Art

2002 'bedroom paintings',
Tomio Koyama Gallery, Tokyo

2001 'Morning Glory', Tomio
Koyama Gallery, Tokyo

1986 The Museum of Fine
Arts, Gifu

Atsushi Fukui

Born 1966
Lives Tokyo

The imagination is a great boon in moments of
boredom. Freely associative journeys are described
in Atsushi Fukui's careful depictions of banal
domestic surroundings. Scraps of white paper
littering a watery green carpet become sea serpents
rising from the ocean depths. The multicoloured
stripes of a rug in *Transport* (2001) zoom around
the perimeter of a room like some kind of futuristic
speedway. Fukui's paintings capture the interstitial
moments of inactivity that punctuate daily
routines, those points where the eye settles on an
object, the mind begins to drift and the subliminal
imagination breaks the surface. (DF)

Shown by Tomio Koyama Gallery B6

'*Time Is Our Choice of How to Love and Why*' (*Ash*)
2004
Bronze cast tree with
porcelain apples
Courtesy Thomas Dane

Anya **Gallaccio**

Born 1963
Lives London

Decay is at the core of Anya Gallaccio's art. In
her earlier pieces she painted walls with chocolate,
carpeted floors with fresh flowers, and erected
a seafront pillar of salt that was eaten away by
the encroaching tide. The works spoke of the
beauty, and the *memento mori* terror, of ephemeral
things. More recently, Gallaccio has introduced
an element of arrest into her entropic sculptural
systems. In *Because Nothing Has Changed* (2001),
400 real, rotting apples hung from a bronze tree
– suggesting that all objects eventually become
souvenirs of themselves, and that art flourishes best
in the fertile soil of memory. (TM)

Shown by Blum & Poe G6, Thomas Dane D23,
Lehmann Maupin F18

Selected Bibliography

2005 *Anya Gallaccio: The Look of Things*, Palazzo delle Papesse, Sienna

2003 *Anya Gallaccio*, Ikon Gallery, Birmingham

2003 *Blast to Freeze: British Art in the 20th Century*, Hatje Cantz Verlag, Ostfildern-Ruit

2002 *Anya Gallaccio: Beat*, Tate Publishing, London

1999 *Anya Gallaccio: Chasing Rainbows*, Tramway and Locus, Glasgow

Selected Exhibitions

2005 'The Look of Things', Palazzo delle Papesse, Sienna

2003 Turner Prize, Tate Britain, London

2003 Ikon Gallery, Birmingham

2002 'Beat', Duveen Sculpture Commission, Tate Britain, London

2001 Istanbul Biennial

Shot of Grace with Alighiero Boetti Hairstyle (Como)
2004
Series of 36 black and white slides
Courtesy Jan Mot

Selected Bibliography

2004 'What Did You Expect? Mario Garcia Torres', Elena Filipovic, *frieze* 86

2004 'Contract for a Never-to-Be-Seen-by-the-Patron Artwork', Luis Miguel Suro and Mario Garcia Torres, *Cabinet*

2004 'The Answer Is Never the Same', Raimundas Malasauskas, *Newspaper Jan Mot*

Selected Exhibitions

2005 'Today Is Just a Copy of Yesterday', Jan Mot, Brussels

2005 'Some Push, Some Hold and Some Don't Even Know How to Take a Picture', Jan Mot at Ravenstein Galleries, Brussels

2005 'Tracce di un Seminario', Via Farini, Milan

2005 'I Still Believe in Miracles', Musée d'Art Moderne de la Ville de Paris

2005 'Misunderstanding', Galería de Arte Mexicana, Mexico City

2005 'The Fragile Show', Analix Forever, Geneva

2004 '*Shot of Grace with Alighiero Boetti Hairstyle* and Other Works', Jan Mot, Brussels

2004 'Off the Record/Sound', Musée d'Art Moderne de la Ville de Paris

2003 '24/7', Contemporary Art Center, Vilnius

Mario **Garcia Torres**

Born 1975
Lives Los Angeles

Mario Garcia Torres' works favour the conceptual double bind, disrupting the systems of trust and exchange that are the foundation of the art industry. *Contract for a Never-to-Be-Seen-by-the-Patron Artwork* (2004), for instance, sets up a contract of absurd complexity whereby a patron commissions the artist to undertake a project but is forbidden to see it: if he does, it will cease to exist as an art object. Garcia Torres describes art as 'an endless negotiation', and seeks to highlight the frailty of the structures that determine a work's value and authenticity. (KB)

Shown by Jan Mot B16

Untitled (Grade 10)
2004
Pastel on gessoed paper
mounted on canvas
85×64cm
Courtesy 303 Gallery

Tim **Gardner**

Born 1973
Lives Victoria

Tim Gardner's project sounds simpler in theory than it looks in practice. With uncanny accuracy he copies snapshots borrowed from friends and family members, rendering them in obsessively detailed watercolours (and, more recently, pastels). The scenes depict a middle-class version of the Good Life: young men hiking in the mountains, fraternity types on drunken vacations, parties in suburban backyards. Yet the recontextualization of the images imbues them with a resonant and affecting psychological complexity. One cannot help but suspect that there is a subtle family drama here: a story of growing up, leaving home, changing ideals – and of looking back with the tender ambivalence of memory. (SS)

Shown by 303 Gallery C13, Stuart Shave | Modern Art D13

Selected Bibliography

2005 Goings on about Town, *The New Yorker*

2003 'Tim Gardner', Carol Kino, *Art in America*

2004 *Vitamin P: New Perspectives in Painting*, Phaidon Press, London

2002 'Tim Gardner', Vince Aletti, *Artforum*

1999 'Natural Selection: Tim Gardner', Jennifer Higgie, *frieze* 49

Selected Exhibitions

2005 National Gallery, London

2005 Indianapolis Museum of Contemporary Art

2005 303 Gallery, New York

2003 Modern Art, London

2003 303 Gallery, New York

2002 'Painting on the Move', Kunsthalle, Basel

2002 'Here Is There 2', Secession, Vienna

2002 'Some Options in Realism', Carpenter Center, Harvard University, Cambridge

2001 'Best of the Season', The Aldrich Museum of Contemporary Art, Ridgefield

2000 'Greater New York', PS1 Contemporary Art Center, New York

Little Nickita Loves the Cocteau Twins
2005
Ink on fluorescent paper
97×61cm
Courtesy Daniel Reich Gallery

Selected Bibliography

2005 'Hot Hands, Cold Heart', Roberta Smith, *The New York Times*

2004 'Fight or Flight', Ken Johnson, *The New York Times*

2004 'Summertime at PS1', Roberta Smith, *The New York Times*

2002 'Amy Gartrell', Michael Wilson, *frieze* 70

2002 'Amy Gartrell', Christopher Chambers, *Flash Art International*

Selected Exhibitions

2005 'Hot Hands, Cold Heart', Daniel Reich Gallery, New York

2004 'Fight or Flight', Whitney Museum at Altria, New York

2004 'Curious Crystals of Unusual Purity', PS1 Contemporary Art Center, New York

2004 'California Earthquakes', Daniel Reich Gallery, New York

2004 'Phiiliip: Divided by Lightning', Deitch Projects, New York

2003 'Karaoke Death Machine', Daniel Reich Gallery, New York

2002 'She's So Bright She's Dark', Greene Naftali, New York

2002 'Heaven Knows I Am Miserable Now', Low Gallery, Los Angeles

2001 'Flea Market', Gavin Brown's enterprise, New York

1998 'WWSD?', La Panadería, Mexico City

Amy **Gartrell**

Born 1974
Lives New York

As a member of the Performance group Actress in the late 1990s, Amy Gartrell, who also goes by the name of Crystal, focused on what could loosely be described as Conceptual Pop. She now makes drawings, paintings, the occasional sculpture, felt banners and pamphlets; her interests veer between stained glass, lace, comic books and melancholia, songs, wigs, ribbon and Punk. She is both nostalgic about the ways things once were and endlessly curious about the American preoccupation with happiness and bad taste. 'In the United States', she has written, 'mediocrity can be found everywhere (the ATM, the post office, TV, the grocery store; the President).' (JH)

Shown by Daniel Reich Gallery B5

Apparat-Dolly
2004
Cotton, wool
250×200cm
Courtesy Gallery Francesca Pia

Vidya **Gastaldon**

Born 1974
Lives Geneva

Vidya Gastaldon's drawings, films, sculptures and animations are like the products of hallucinations fuelled by psychedelia, science fiction, biology, ecology and cosmology. Her work is built up from fragments assembled from paper and drawing, knitting, embroidery, string and wool. Soft colours merge and mutate like faint memories or objects found washed up on the beach of a distant planet. A casual order binds the strands of her imagination; objects, images and ideas thoughtfully arranged seem only momentarily stilled in the midst of organic flux and change. (JH)

Shown by Art : Concept E2, Galerie Francesca Pia C20

Selected Bibliography

2005 *I Still Believe in Miracles*, Fabrice Stroun, Musée d'Art Moderne de la Ville de Paris

2004 'Interstella Vidya', Eric Sternberg, *Biscuit*

2001 'String Theory: Vidya Gastaldon', James Roberts, *frieze* 61

2000 'Future Perfect', Jennifer Higgie, *frieze* 55

Selected Exhibitions

2005 'Biolovarama', Musée d'Art Moderne et Contemporain, Geneva

2004 Galerie Cosmic, Paris

2004 'The Age of Optimism', Peter Kilchmann, Zurich

2004 'Apparat-Dolly', Galerie Francesca Pia, Bern

2003 Centre d'Art Contemporain, Geneva

2001 Magnani, London

2001 Kunsthaus, Glarus

2000 Galerie Mot & Van den Boogaard, Brussels

Money and Shit
1997
Mixed media
226×190cm
Courtesy Galerie Thaddaeus
Ropac

Selected Bibliography

2003 *Gilbert & George: Intimate Conversations with François Jonquet*, Phaidon Press, London

1998 *Gilbert & George: The Rudimentary Pictures*, David Sylvester and Michael Bracewell, Milton Keynes Gallery

1997 *The Art of Gilbert & George*, Wolf Jahn, Thames & Hudson, London

1986 *The Complete Pictures 1971–1985*, Schirmer/Mosel, Munich

1980 *Gilbert & George 1968 to 1980*, Carter Ratcliff, Van Abbe Museum, Eindhoven

Gilbert & George

Selected Exhibitions

2005 British Pavilion, Venice Biennale

2004 Musée d'Art Moderne de Saint Etienne; Kestnergesellschaft, Hanover

1997 'Art for All 1971–1996', Sezon Museum, Tokyo

1995–6 'The Naked Shit Pictures', South London Gallery; Stedelijk Museum, Amsterdam

1993 National Gallery, Beijing; Art Museum, Shanghai

1990 'Pictures 1983–1988: Central House of Artists', New Tretyakov Gallery, Moscow

1986–7 'Pictures 1982 to 1985', CAPC Musée d'Art Contemporain, Bordeaux and touring

1984–5 The Baltimore Museum of Art and touring

1980–01 'Photo-pieces 1971 to 1980', Van Abbe Museum, Eindhoven and touring

Born 1943/1942
Live London

Gilbert & George have been living and working together since 1967 as 'living sculptures'. Humorous, iconic and controversial, their performances, films and large-scale photographic works have made a lasting impression on the contemporary art landscape. From the early 'Magazine Sculptures' (photographs of the artists captioned 'GEORGE THE CUNT' and 'GILBERT THE SHIT', 1969) to the recent, more iconographic 'Gingko Pictures' series from this year's Venice Biennale the duo have striven to create an inclusive 'art for all' – an aesthetic leavened with a dry wit that reaches beyond the rarefied mores of art into a gritty world of ambiguous social commentary. (DF)

Shown by Bernier/Eliades F17, Lehmann Maupin F18, Galerie Thaddaeus Ropac F14, White Cube/ Jay Jopling F8

Kevin
2005
Silicone photograph under
Perspex
148×125cm
Courtesy Galería Juana de
Aizpuru

Selected Bibliography

2004 'El fotógrafo Pierre
Gonnord retrata la cultura
urbana japonesa' (The
Photographer Pierre Gonnord
Describes Japanese Urban
Culture), Susana Hidalgo,
El País

2003 'Pierre Gonnord', Javier
Montorria, *Lápiz*

2003 *Los lugares de lo real* (The
Places of the Real), Mónica
Álvarez Careaga, Fundación
Marcelino Botín, Santander

2000 *Pierre Gonnord: mirar
hacia adentro* (Pierre Gonnord:
Looking Inside), Manuel
Lorente, *ABC Cultural*

Pierre **Gonnord**

Born 1963
Lives Madrid

Pierre Gonnord's photographs play on the colour
and tone of classical portrait painting, stripping this
tradition down to the formal beauty of the body.
His portraiture is compositionally conventional,
but this is offset by his affinity for unusual faces and
bodies, whose architectural power he emphasizes
with painterly lighting and stark backgrounds.
Gonnord's subjects represent diverse age groups,
ethnicities and social statuses, and often bear
subcultural markings such as piercings, tattoos
and dreadlocks. The seduction and complexity
of the portrait form is redoubled here by each
unconventional sitter's accented self-styling. (DJ)

Shown by Galería Juana de Aizpuru C17

Selected Exhibitions

2005 'Photomeetings
Luxembourg 2005', Centre
Cultural de Rencontre Abbaye
de Neumunster, Luxembourg

2004 Maison Européene de la
Photographie, Paris

2003 'Como si Nada',
Fundación Foto Colectania,
Barcelona

2003 Fundación Centro
Ordoñez Falcón de Fotografía,
San Sebastian

2003 'Far East', Galería Juana
de Aizpuru, Madrid

2003 'Identidades Transitorias',
Centro Cultural Conde Duque,
Madrid

2002 'El bello género', Salas de
la Comunidad de Madrid

2000 'Regards', Galería Juana
de Aizpuru, Seville

Everafterallland
2004
C-print
32×40cm
Courtesy Gagosian Gallery

Selected Bibliography

2003 *Double Cross: The Hollywood Films of Douglas Gordon*, Philip Monk, Art Gallery of York University, Toronto

2002 *What Have I Done?*, Douglas Gordon, Cornerhouse Publications/Hayward Gallery Publishing, London

2001 *Douglas Gordon*, Russell Ferguson, MIT Press, Cambridge

2000 *Black Spot*, Mark Francis, Tate Publishing, London

1998 *Douglas Gordon*, Lynne Cooke and Ekhard Schneider, Kunstverein, Hanover

Selected Exhibitions

2003 'Douglas Gordon: Blind Star', Andy Warhol Museum, Pittsburgh

2002 'What Have I Done?', Hayward Gallery, London

2001 Museum of Contemporary Art, Los Angeles and touring

2000 'Black Spot', Tate Liverpool

1999 'Stan Douglas and Douglas Gordon: Double Vision', Dia Center for the Arts, New York

1998 Kunstverein, Hanover

1997 Lyon Biennial

1995 'Entr'Acte 3', Van Abbe Museum, Eindhoven

Douglas **Gordon**

Born 1966
Lives Glasgow/New York

Doubles and split personalities abound in Douglas Gordon's videos, photographs and text works; divine and demonic poles of human behaviour are invoked through memory games and fragments of popular culture. Gordon often takes classic films as his raw material, altering their duration in order to mine subconscious narratives – slowing down John Ford's *The Searchers*, for instance, to five years, the story's actual timespan. Where much art that deals with the 'big' themes – life, death and the passage of time – has a tendency to err towards melodrama and grandiosity, Gordon's art is spare and unsentimental. (DF)

Shown by Gagosian Gallery D9, Yvon Lambert F6, Lisson Gallery D8, Jan Mot B16, Galleri Nicolai Wallner A3

Selected Bibliography

2003 *Of Milk and Honey,*
Museum Folkwang, Essen

2002 *Seitlich aus der Requisite
kommen* (Coming out of the
Props Sideways), Galerie im
Taxispalais, Innsbruck

2001 *All I See I Cover,* Neue
Galerie, Steirischer Herbst, Graz

2001 *Kupferpfandl – und Darüber,*
Secession, Vienna

1998 *Martin Gostner,* Galerie
Giorgio Persano, Turin

Martin **Gostner**

Born 1957
Lives Innsbruck

Putting fake posters in public places announcing
events and courses – such as one from the series
'Festival of Fog' (2004) for Berlin, advertising
'Female-Dominated Yoga' led by the ghost of
Marlene Dietrich in the lotus position – is one of
Conceptual artist's Martin Gostner's favourite
ruses. Other recurrent media include sculptures and
installations using copious amounts of cotton wool
or furtive drapes, while his message often addresses
social and political sore points, past and present,
in his native Austria or Germany. Gostner's work
often combines whimsy, idealism and melancholy,
as in an installation of an open umbrella
occupying a corner at an imaginary gathering of
poets. (DE)

Shown by Gabriele Senn Galerie H4

Selected Exhibitions

2005 'Ein entspanntes Feld',
Galerie Museum Arge Kunst,
Bozen

2004 'Funky Lessons', Büro
Friedrich, Berlin; BAWAG
Foundation, Vienna

2003 'Of Milk and Honey',
Museum Folkwang, Essen

2003 'Karma Again', Gabriele
Senn Galerie, Vienna

2003 'Bankett', ZKM Centre for
Art and Media, Karlsruhe

2002 'Seitlich aus der
Requisite kommen', Galerie im
Taxispalais, Innsbruck

2001 'Kupferpfandl – und
Darüber', Secession, Vienna

2001 'All I See I Cover', Neue
Galerie, Steirischer Herbst, Graz

2000 'Apparat für Sonntag',
Rupertinum, Salzburg

1998 'Erinnerung weich',
Kunstverein, Cologne

Untitled
2004
Metal, varnish
65×150×21cm
Courtesy Galerie Daniel
Buchholz

Selected Bibliography

2005 'Julian Göthe', Tom
Holert, *Artforum*

2004 *The Future Has a Silver
Lining: Genealogies of Glamour*,
Tom Holert and Heike Munder,
Migros Museum, Zurich

2004 *Flesh at War with Enigma*,
Anke Kempkes, Kunsthalle,
Basel

2003 'Painted White in a Spirit
of Rebellion: Julian Göthe in
der Galerie Daniel Buchholz',
Dominic Eichler, *Texte zur Kunst*

2003 Gregor Jansen, *Kunst-
Bulletin*

Selected Exhibitions

2005 'Kontakt', Galerie
Meerrettich, Berlin

2005 'Kunstpreis der
Böttcherstraße in Bremen',
Kunsthalle, Bremen

2004 'Living with Design',
Cabinet, London

2004 Kunsthalle, Basel

2004 'Flesh at War with
Enigma', Kunsthalle, Basel

2004 'The Future Has a
Silver Lining: Genealogies of
Glamour', Migros Museum,
Zurich

2004 'Teil 1 Müllberg', Galerie
Daniel Buchholz, Cologne

2004 'Atomkrieg', Kunsthaus,
Dresden

2004 'Atelier Europa',
Kunstverein, Munich

2003 'Painted White in a Spirit
of Rebellion', Galerie Daniel
Buchholz, Cologne

Julian **Göthe**

Born 1966
Lives Berlin

Julian Göthe's spiky abstract sculptures, made
of combinations of welded metal frames clad
in cut and folded paper panels or crowned by
ostrich feathers, are ambivalent, hybrid creatures.
Formally aggressive and aloof, they strut their
brand of sophisticated stuff informed by influences
and references that include furniture designers from
the 1930s to the 1950s and set designs for film and
stage. This eclectic frame of reference is sometimes
given an explicitly homoerotic bent in Göthe's
works on paper, suggesting that his high-camp
parody of Modernist good taste is a response to the
social constraints implicit in the perfect surfaces of
designer objects, interiors and art. (DE)

Shown by Galerie Daniel Buchholz D14,
Cabinet E12

Dismembering the Leviathan
2005
Acrylic and graphite on canvas
213×305cm
Courtesy Peres Projects
Los Angeles Berlin

Selected Bibliography

2005 'Matt Greene: Dark Master of the New Gothic', Kim Dhillon, *i-D*

2005 'Matt Greene', Julian Myers, *frieze* 89

2004 *She Who Casts the Darkest Shadow on Our Dreams*, Matthew Greene, Peres Projects, Los Angeles

2004 'First Take: Dennis Cooper on Matthew Greene', Dennis Cooper, *Artforum*

2004 'Scream', Ken Johnson, *The New York Times*

Selected Exhibitions

2005 Peres Projects, Berlin

2005 'We Are the Dead', Modern Art, London

2004 'She Who Casts the Darkest Shadow on Our Dreams', Peres Projects, Los Angeles

2004 'JT Leroy: Origins of Harold', Deitch Projects and Art Production Fund, New York

2004 'Noctambule', D'Amelio Terras / Fondation Dosne-Bibliothèque Thiers, Paris

2004 'Obsession', Diana Stigter Gallery, Amsterdam

2004 'Axxxpresssunizm', Vilma Gold, London

2004 'Drunk vs. Stoned', Gavin Brown's enterprise at Passerby, New York

2004 'Matt Greene & Banks Violette: Lovesongs for Assholes/ The Sixty-edged Sword of the Androgyne', Peres Projects, Los Angeles

2004 'Scream', Anton Kern Gallery, New York

Matthew **Greene**

Born 1972
Lives Los Angeles

Matthew Greene's detailed paintings and drawings hallucinate a version of this world that depicts states of prelapsarian life, but wrought with a damaged romanticism that shifts them into a frenzy of psychedelic excess. Although Greene borrows a visual syntax from the genres of fantasy illustration and Heavy Metal album covers, the stains and washes of his canvases suggest the eye of a Modernist colourist. Their densely worked surfaces layer the fever dream of French Symbolism with the austere cool of 1960s British Pop, creating kaleidoscopic landscapes seen through a glass darkly. (DF)

Shown by Peres Projects Los Angeles Berlin E21, Stuart Shave | Modern Art D13

10 Discovery Channel Nature Documentaries
2004
Video projection
Dimensions variable
Courtesy Zero

Selected Bibliography

2004 'Sguardi sul Presente' (Gazes on the Present), Emanuela De Cecco, *Flash Art*

2004 'Massimo Grimaldi', Chiara Pilati, *Around Photography*

2003 'Massimo Grimaldi', Gyonata Bonvicini, *Flash Art*

2003 'Ritardi e Rivoluzioni' (Delays and Revolutions), Thomas Wulffen, *Kunstforum*

2002 Critics' Picks, Luca Cerizza, www.artforum.com

Selected Exhibitions

2005 'Dojo', via Ventura, Milan

2005 'No Manifesto', Galleria d'Arte Moderne e Contemporanea, Bergamo

2004 Zero, Milan

2004 'Prisma', Galerie Martin Janda, Vienna

2003 'Delays and Revolutions', Italian Pavilion, Venice Biennale

2003 'Premio Furla', Fondazione Querini Stampalia, Venice

2003 'Defrag', Suite 106, New York

2003 'Great Expectations!', Ferrotel, Pescara

2002 Zero, Piacenza

2002 'Exit', Fondazione Sandretto Re Rebaudengo, Turin

Massimo **Grimaldi**

Born 1974
Lives Milan

Massimo Grimaldi's Conceptual work examines how art functions, is perceived, valued and understood. It has taken the form of manipulated photographs (accompanied by such aphorisms as 'The possibility of an image has nothing to do with the image itself, nor with the person who is looking at it'), a digital playlist whose tracks are separated by ten minutes' silence so that they can be consecutively forgotten, and photographs of Afghanistan that can only be shown on the latest Apple computer. His texts suggest scepticism refracted through art: for instance, 'Things we attach importance to are only things we have attached importance to. Every type always leans to its stereotype.' (DE)

Shown by Zero A11

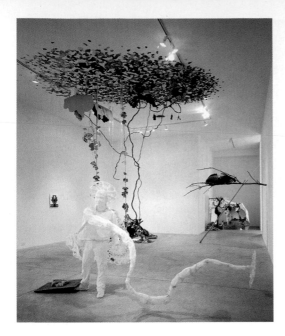

Selected Bibliography

2005 'Real World', James Hall, *Artforum*

2003 'Best of 2003', Bruce Hainley, *Artforum*

2003 'Katie Grinnan', Michael Duncan, *Art in America*

2003 'Katie Grinnan', Eugene Tsai, *Time Out New York*

2003 'Katie Grinnan', Bruce Hanley, *Artforum*

Selected Exhibitions

2005 'Treehugger-Now/ Romantic/Nature', MAMA: Showroom for Media and Moving Art, Rotterdam

2005 'House of Spirits', ACME., Los Angeles

2004 'Real World: The Dissolving Space of Experience', Modern Art Oxford

2004 Whitney Biennial, New York

2004 'Art on Paper', Weatherspoon Art Museum, University of North Carolina, Greensboro

2004 'Wit From Rainbow (Part 1)', The Project, Los Angeles

2003 'Adventures in Delusional Idealism', Whitney Museum of American Art at Altria, New York

2002 'Anti-Form', Society for Contemporary Photography, Kansas City

2001 'Snapshot', UCLA Hammer Museum, Los Angeles

2001 'Sharing Sunsets', Museum of Contemporary Art, Tucson

Katie **Grinnan**

Born 1970
Lives Los Angeles

Like a good ecologist, Katie Grinnan is a committed recycler, making sculpture out of whatever it takes: linoleum, wire, inkjet prints, second-hand stereo components and auto parts in one work; tree branches, photographs, magnets and the husk of a palm frond in another. But the sculptural use of photography – bent, twisted or folded – is her lodestar, upping the ante on how real space and its two-dimensional representation intersect. For Grinnan sculpture is a damaged and rickety business, an ad hoc reshuffling of what already exists. Her works often suggest trellises, follies and arts–and–craftsy tree houses made from carpet remnants and Photoshopped imagery manhandled like any other material. (JT)

Shown by ACME. D15

Magic Wands
2002
28 pieces of bamboo, cast
aluminium, chrome-plated
143×4×4cm
Courtesy Art & Public –
Cabinet P.H.

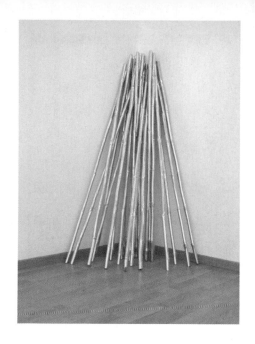

Selected Bibliography

2005 *Universal Experience: Art,
Life and the Tourist's Eye*, Museum
of Contemporary Art, Chicago;
DAP, New York

2003 *Video Art In India*, Apeejay
Media Gallery, New Delhi

2003 *Body/City*, Geeta Kabur,
The House of World Cultures,
Tulika Books, New Delhi

2003 *Post Production: Sampling
Programming Displaying*, Nicolas
Bourriaud, Galleria Continua,
San Gimignano

2002 *Sidewinder: Subodh Gupta*,
Peter Nagy, Cima Gallery,
Calcutta

Selected Exhibitions

2005 'Universal Experience:
Art, Life and the Tourist's Eye',
Museum of Contemporary Art,
Chicago

2004 'I Go Home Every Single
Day', The Showroom, London

2004 'Edge of Desire', Art
Gallery of Western Australia,
Perth

2004 'Vanitas Vanitatum',
Sakshi Gallery, Mumbai

2003 'This Side is the Other
Side', Art & Public – Cabinet
P.H., Geneva

2003 'Saat Samunder Paar',
Nature Morte, New Delhi

2003 'Body/City', House of
World Cultures, Berlin

2002 'Under Construction ',
Japan Foundation and Tokyo
Art Gallery

1999 'The Way Home', Gallery
Chemould, Mumbai

Subodh **Gupta**

Born 1963
Lives Haryana

Mapping the impact of globalization on the Indian
subcontinent, Subodh Gupta's sculptures and
installations have a prop-like feel, as though the
real-life objects they ape are themselves caught
up in a performance. Take *Untitled* (2003), an
installation of rope-bound consumer baubles that
refers to the conspicuous displays of wealth made
by homecoming Indian labourers after a spell
doing low-grade work in the Gulf states, or *Curry*
(2005), a gleaming rack of tiffin tins that wouldn't
look out of place in a Western lifestyle magazine
shoot. In Gupta's evocation of contemporary India
value is to be found in the appearance, not the
utility, of things. (TM)

Shown by Art & Public – Cabinet P.H. B20

Martin Kippenberger, „Kindliches Lächeln nach einer blöde...ort", 1960,
Foto Gerd Kippenberger

16

Wade **Guyton**

Born 1972
Lives New York

Wade Guyton's work often seem like a stab at grand Modernism. This native of Knoxville, Tennessee, is one of a number of young artists imbuing Minimalism's sculptural language with oblique humour. His pieces seem almost calculatedly clumsy, though their awkwardness makes Guyton's subtlety less obvious and its effects all the more surprising. A wood floor becomes an object that blocks out a room, but without filling it up; when he prints icons on top of images from art and design catalogues from the 1970s and '80s, it's difficult to tell whether he's embellishing his predecessors or declaring his independence from them. (PE)

Shown by Greene Naftali G5, Galerie Francesca Pia C20

Untitled (Kippenberger)
2005
Print, drawing
26×18cm
Courtesy Gallery Francesca Pia

Selected Bibliography

2005 'Formalismus', Diedrich Diederichsen, *Artforum*

2004 *Such Uneventful Events: the Works of Wade Guyton*, Johanna Burton, Kunstverein Hamburg

1999 Bill Arning, *BOMB*

Selected Exhibitions

2005 Galerie Francesca Pia, Bern

2005 'The Failever of Judgement, Part III, Guyton/ Walker', Greene Naftali, New York

2004 'Formalismus: Moderne Kunst, Heute', Kunstverein, Hamburg

2004 Whitney Biennial, New York

2004 'Real World: The Dissolving Space of Experience', Modern Art Oxford

2004 'Notes on New Appropiationisms', The Project, Los Angeles

2003 'Elements of Incomplete Map', Artists Space, New York

2003 'Le Rayon Noir', Circuit, Lausanne

2002 'Building Structures', PS1 Contemporary Art Center, New York

2001 'After the Diagram', Whitebox, New York

Aewan, Love #3
2004
C-print photograph of mixed
media sculpture
Photograph: 126×155cm
Sculpture: 1×1×1cm
Courtesy pkm Gallery

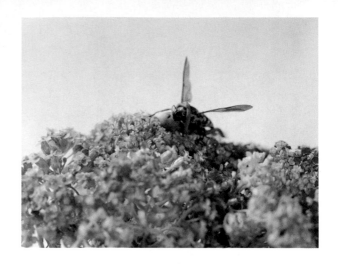

Selected Bibliography

2005 *The Elegance of Silence. Contemporary Art from East Asia*, Sunhee Kim, Mori Art Museum, Tokyo

2004 *Art Monthly*, Soo-mi Kang, Seoul

2003 'Ham Jin's Art Now', Fumio Nanjo, *Art Asia Pacific*

2001 *The Strange Dream of Pill Boy*, Ham Jin, Stone Pillow Kid, Seoul

1999 'Ham Jin's Art World', Sung-hee Kim, *Project Space Sarubia*, Seoul

Selected Exhibitions

2005 'Parallel Realities: Asian Art Now', Fukuoka Asian Art Triennial

2005 'J'en rêve', Fondation Cartier pour l'Art Contemporain, Paris

2005 'Secret Beyond the Door', Korean Pavilion, Venice Biennale

2005 'The Elegance of Silence', Mori Art Museum, Tokyo

2004 'Aewan', pkm Gallery, Seoul

2003 'Comic Release ', Carnegie Mellon University Art Gallery, Pittsburgh

2003 'Museum at a Playground 2', Artsonje Centre, Seoul

2001 'Pause', Gwangju Biennial

Ham Jin

Born 1978
Lives Seoul

Using polymer clay, wire, gum, bodily fluids, dead insects, fish bones, medicine caplets and other unexpected materials, Ham Jin crafts Lilliputian scenes with tiny, creepy-cute figures. Viewers often have to crouch on the floor to examine these surreal dioramas. Some works have depicted violent actions such as stabbings, but more saccharine ingredients in his recent installations and large-scale colour photographs include babies, flowers and pink pillows. Ham's microcosmic narratives, while quirkily evoking contemporary life, also echo Old Masters and medieval works that depict multiple events at once. (KJ)

Shown by pkm Gallery G4

Carl **Hammoud**

Born 1976
Lives Malmö/Stockholm

Carl Hammoud's oil paintings fuse the visual style of Edward Hopper with fantastical elements reminiscent of the *oeuvre* of Terry Gilliam. In Hammoud's depopulated 1940s' Manhattan galleons sail between skyscrapers, and unmanned candy-coloured biplanes coast over apartment buildings. Often there is a sense of menace, as in *Conquerors II* (2004), where a black plane is shown about to crash through a window into a brightly lit living-room. Consumer culture seems to be implicated as the cause of these surreal situations – a reading supported by *The Visionary* (2005), which shows an empty office with a desk piled high with levitating dollar bills. (SL)

Shown by Galleri Magnus Karlsson B2

Selected Bibliography

2005 'Den Sanna Känslans Ögonblick' (The Moment of True Feeling), Susanna Slöör, www.omkonst.com

2005 'Carl Hammoud', Anders Olofsson, www.konsten.net

2003 'Carl Hammouds drömska ödslighet ...' (The Dreamy desolation ...), Lars Hermansson, *Göteborgsposten*

Selected Exhibitions

2005 Galleri Magnus Karlsson, Stockholm

2004 'Drawing Exhibition', Galleri PS, Gothenburg

2004 'Graduates from Valand Academy of Fine Arts', Studio 44, Stockholm; Göteborgs Konsthall, Gothenburg

2003 'Återkastare', Galleri Rotor, Gothenburg

Moon of the Sun
1999
Pastel on paper
100×70cm
Courtesy Meyer Riegger

Selected Bibliography

2004 *Atomkrieg*, Antje Majewski and Ingo Niermann, Lukas & Sternberg, New York; Kunsthaus, Dresden

2003 *Deutschemalereizwei-tausenddrei* (German Painting 2003), Nicolaus Schaffhausen, Lukas & Sternberg, New York

2003 *Painting on the Roof*, Veit Loers, Städtisches Museum Abteiberg, Mönchengladbach

2002 'Rising Angels', Anke Kempkes, *Modern Painters*

2001 *Circles*, Christoph Keller, Revolver Verlag, Frankfurt

Selected Exhibitions

2004 'William Blake and Sons', Lewis Glucksman Gallery, Cork

2004 'Atomkrieg', Kunsthaus, Dresden

2004 'Strategies of Desire', Kunsthaus, Baselland

2004 'Untitled', Kerlin Gallery, Dublin

2003 'actionbutton', Hamburger Bahnhof, Berlin

2003 'Ländicken, Ländicken ...', Meyer Riegger, Karlsruhe

2003 'Deutschemalerei-zweitausenddrei', Kunstverein, Frankfurt

2003 'Painting on the Roof', Museum Abteiberg Mönchengladbach

2001 'Circles: Berlin–Montana Sacra', ZKM Centre for Art and Media, Karlsruhe

2001 'Moon White Future', hobbypopMUSEUM, Dusseldorf

Sebastian **Hammwöhner**

Born 1974
Lives Berlin

Sebastian Hammwöhner may at first seem like a hopelessly melancholic Romanticist, but one should not overlook his quirky sense of humour, or his carefully considered choice of medium. While his chalk drawings can resemble robust paintings – *Dusty* (2001) is a magnificent rendering of a cosmic nebula, done in expert sci-fi illustration style – his installations are as delicate and fragile as drawings: *Sweet Leaves* (2002), for example, with clothes and shoes scattered on the floor and a white egg dangling from a shrub, evokes the aftermath of a drug trip gone awry. Hammwöhner's images depict a pictorial world in constant flux between the beautiful and the grotesque. (JöH)

Shown by Meyer Riegger C5

Hail to Reason
2004
Wood, wire, polystyrene,
cement, acrylic, DVD player,
doilies
254×99×92cm
Courtesy Greene Naftali

Selected Bibliography

2005 'Two into One',
Brian Sholis, *Afterall*

2004 'The "Urmaterial"
Urge', Johanna Burton, *Parkett*

2004 'Rachel Harrison:
Latka/Latkas', Roberta Smith,
The New York Times

2002 'Blind Alleys',
Bruce Hainley, *Artforum*

2000 'The Harrison Effect',
Bill Arning, *TRANS*

Selected Exhibitions

2005 'Car Stereo Parkway',
Transmission Gallery, Glasgow

2005 'When Humor Becomes
Painful', Migros Museum, Zurich

2005 'Carnegie International',
Carnegie Museum of Art,
Pittsburgh

2004 'New Work', San
Francisco Musem of Modern Art

2004 'Posh Floored as Ali G
Tackles Becks', Camden Arts
Centre, London

2003 Kunsthalle, Bergen

2003 'The Structure of Survival',
Arsenale, Venice Biennale

2002 'Currents 30: Rachel
Harrison', Milwaukee Art
Museum

2002 Whitney Biennial,
New York

1998 'New Photography 14',
Museum of Modern Art,
New York

Rachel **Harrison**

Born 1966
Lives New York

Post-minimalism meets *The National Enquirer* in
Rachel Harrison's playful installations, where
cultural history is recast as wonkily assisted
ready-mades. *Cindy* (2004), for example, is a
precarious tower of rough-hewn wood and
polystyrene, topped with a blonde wig. *Perth Amboy*
(2001) brings together props and photographs
in a labyrinthine installation that is based on
a reported sighting of the Virgin Mary in New
Jersey. The work functions as a kind of microcosm
of contemporary culture, where acts of faith and
articles of Pop trash lead the viewer on a daisy trail
of consumption without enlightenment. (SL)

Shown by Arndt & Partner D21, Greene
Naftali G5

A Cup of Tea
2005
Oil on canvas
30×37cm
Courtesy Galerie Fons Welters

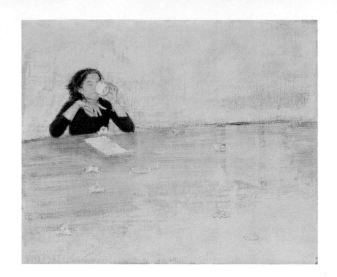

Selected Bibliography

2005 'Schooljuf uit een oud kinderboek' (Teacher in an Old Children's Book), Sandra Heerma van Voss, *NRC Handelsblad*

2005 'Versteende ogenblikken willen niet worden verstoord' (Petrified Moments Don't Want to Be Disturbed), Bianca Visser, *Tubelight*

2004 'Stick to What You Know. Art', Claire Harvey, *Tank Magazine*

2004 'Een onbetaalbare ervaring' (A Priceless Experience) Sandra Smallenburg, *NRC Handelsblad*

Selected Exhibitions

2005 'And It Looked Like This', Galerie Fons Welters, Amsterdam

2004–5 'A Molecular History of Everything', Australian Centre for Contemporary Art, Melbourne

2004 Store, London

2001 'Post-Graduate Diploma Show', Chelsea College of Art, London

Claire **Harvey**

Born 1976
Lives Amsterdam

Rendered on, among other things, transparent folios, glass slides and even Post-It notes, Claire Harvey's drawings and paintings echo their own ephemeral subjects. In *Doodle* (2004) a figure leans into the picture plane over a curly, scratched-in line. In other images poses, headshots, sideways glances and everyday scenes are also plucked from ordinary imaginary narratives. Seen together, as in her *Post-It I* (2003–4), comprising 259 glimpses into a shadowy world in shades of grey, these look like the storyboard for a film remake whose plot must be constructed in the mind of her viewer. (DE)

Shown by Galerie Fons Welters E19

*Variations on Vermeer's Girl with a
Pearl Earring*
2004
Photograph mounted
behind Perspex
49×64cm
Courtesy Anthony Reynolds
Gallery

Lucy **Harvey**

Born 1967
Lives Dusseldorf

Since 1997 Lucy Harvey has been collating
a multi-media 'Guide to Life'. Photographs,
videos and works on paper are categorized as
'Basic Philosophy', 'Necessary Knowledge',
'Productive Living', 'Autobiography' and 'Beauty',
and include a number of strategies that, if not
intended as advice, are more like illustrations
of attempts at productiveness. From the self-
deprecatory photograph of Harvey asleep next
to a pillow emblazoned with 'stupid and lazy', to
the valiant yet feeble attempt to sing Wagner, to
the systematic analysis of an El Lissitzky painting,
Harvey's 'Guide to Life' is a paean to fallibility
and potential. (SO'R)

Shown by Anthony Reynolds Gallery D18

Selected Bibliography

2003 'Lucy Harvey',
Kate Zamet, *Contemporary*

2003 'Lucy Harvey',
Sara Harrison, *Art Monthly*

2003 'Lucy Harvey', Sarah
Kent, *Time Out London*

2003 Picks of the Week,
The Guardian

Selected Exhibitions

2005 Kunsthalle, Dusseldorf

2005 Anthony Reynolds
Gallery, London

2005 'Truer than the Truth',
Anthony Reynolds Gallery,
London

2003 'Arbeiten aus dem
Lebensführer', Galerie M + R
Fricke, Dusseldorf

2003 'What We Saw When
We Got There', The Lab, San
Francisco

2002 'Carte Blanche de
Magdalena Jetelova', Galerie
Lab, Strasbourg

2001 'Gewöhnung an fremde
Räume', Kunstraum, Haus der
Kultur, Bonn

Stumps
2004
Acrylic and oil on linen
76×102cm
Courtesy Galerie Daniel
Buchholz

Selected Bibliography

2005 'Richard Hawkins',
Christopher Miles, *Artforum*

2004 'Richard Hawkins', Peter
Abs, *Flash Art*

2004 'Notizen aus dem
Zettelkasten' (Notes from
the Filing Cabinet), Michael
Krebber, *Texte zur Kunst*

2003 *Richard Hawkins*, ed.
Daniel Buchholz, Christopher
Müller, Cologne

2003 'A New Kind of Arty
Sex', *Art: A Sex Book*, John
Waters and Bruce Hainley,
Thames & Hudson, London

Selected Exhibitions

2005 'Three Day Weekend'
(curated by Dave Muller),
Central Park, New York

2004 'Powered by Emotions',
Kunstverein, Frankfurt

2003 Kunstverein, Heilbronn

2002 'L.A. on my Mind: Recent
Acquisitions from MOCA's
Collection', Museum of
Contemporary Art, Los Angeles

2002 'Mirror Image', UCLA
Hammer Museum, Los Angeles

2002 'Sammlung Schürmann',
K21 Kunstsammlung Nordrhein-
Westfalen, Dusseldorf

2000 Richard Telles Fine Art,
Los Angeles

2000 Galerie Daniel Buchholz,
Cologne

2000 Corvi-Mora, London

2000 'Unraveling Desire',
Center for Curatorial Studies,
Bard College, Annandale-on-
Hudson

Richard **Hawkins**

Born 1961
Lives Los Angeles

Nuanced allusions to 19th-century dandyism,
Symbolism, American postwar abstraction, Native
American traditions and Hollywood celebrity
pull at the skin of Richard Hawkins' paintings
and collages, giving shape to his homoerotically
charged studies of the raw politics of male sexual
desire. Recent figurative paintings such as *Closing
Time 2* (2004) and *Options, Not Solutions* (2004)
describe a gay underworld inhabited by beautiful
boys and Philip Guston–esque grotesques, zones
of pastel-hued sexual ambiguity and vividly
toned libidinous need. As critic Bruce Hainley has
written, 'Hawkins' work often defaces or trashes
something beautiful to get at how it might be that
it became beautiful in the first place'. (DF)

Shown by Galerie Daniel Buchholz D14, Corvi-
Mora E7

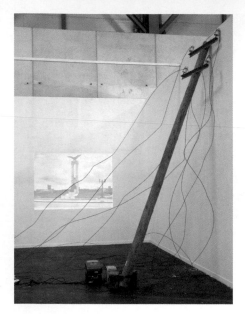

Palabras
(Words)
2005
Wooden and electrical poles,
wire, video projection and sound
Dimensions variable
Courtesy Galería Pepe Cobo

Selected Bibliography

2001 *Art Cuba : The New Generation*, Holly Block, Abrams, New York

2001 'El Ojo Breve: Una isla cada vez mas isla' (A Brief Look at an Increasingly Isolated Island), Cuauhtemoc Medina, *Reforma*

1999 'Thinking Aloud', Ian Hunt, *Art Monthly*

1997 *Utopian Territories: New Art from Cuba,* Scott Watson et al., Morris and Helen Belkin Gallery, University of British Columbia, Vancouver

1996 'Ordo Amoris: Hacia un diseño pragmatico' (Order of Love: Towards a Pragmatic Design), Juan Antonio Molina, *La Gaceta de Cuba*

Diango **Hernández**

Born 1970
Lives Dusseldorf

From 1994 to 2003, Diango Hernández was part of the Havana-based artist team fittingly called Ordo Amoris (the 'Order of Love') – an enterprise that, in one of its projects, collected the odd provisional objects found in many Cuban households (shoes fashioned from melted plastic trash, toy cars made from cola cans) and intermingled them with objects of the artists' own. The result was a cabinet of curiosities that celebrated an economy of improvisation, necessity and impoverished invention. Hernández' recent work continues to ponder scarcity and ingenuity. In one untitled drawing from 2005, what appears to be an antique telescope aimed upwards is, on closer inspection, some empty wine bottles lashed to a tripod of spindly wood scraps. Imagination, like love, sometimes just has to make do. (JT)

Shown by Galería Pepe Cobo E24

Selected Exhibitions

2005 'Always a Little Further', Arsenale, Venice Biennale

2005 'Palabras', ARCO, Madrid

2005 Paolo Maria Deanesi Gallery, Trento

2004 'Amateur', De Kabinetten van de Vleeshal, Middelburg

2004 'Democracy' (with Boris Mikhailov), Kunstverein, Arnsberg

2004 'Doku/Fiction', Kunsthalle, Dusseldorf

2004 'Miedo/Fear', Galería Pepe Cobo, Seville

2004 'IN ICTU OCULI', Galería Pepe Cobo, Seville

2004 'Flesh at War with Enigma', Kunsthalle, Basel

2003 Havana Biennial

Everything Is OK
2002
Mirror, acrylic, wood and red carpet
Dimensions variable
Courtesy kurimanzutto

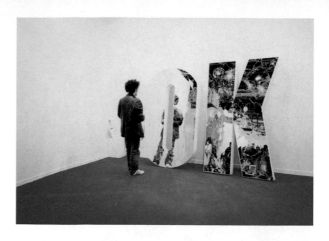

Selected Bibliography

2005 'Jonathan Hernández',
Issa Maria Benítez Dueñas,
tema celeste

2004 *The University by Jonanthan
Hernández*, ed. Ruben Gallo,
University of Wisconsin Press,
Madison

2003 *Installation Art in the New
Millenium*, Nicolas de Oliveira,
Nicola Oxley and Michael
Petry, Thames & Hudson,
London

2003 'Jonathan Hernández',
Bernando Palomo, *El Cultural*

Selected Exhibitions

2005 'Juego Doble: Jonathan
Hernández & Jesús Segura',
Centro Cultural de España
en México, Mexico City

2005 'Ediciones 2002–4',
La Caja Negra, Madrid

2004 'Tráfago', kurimanzutto,
Mexico City

2004 'Video Mundi', Mexican
Fine Arts Museum, Chicago
Cultural Center

2003 'Bon Voyage', CAC
Malaga

2003 'Elephant Juice (Sexo
entre Amigos)', kurimanzutto
@ Restaurant Los Manantiales,
Xochimilco, Mexico City

2003 'Who Laughed?', Center
for Curatorial Studies, Bard
College, Annandale-on-Hudson

2002 'Travelling Without
Moving', Mexico City Airport
Gallery

2001 'The World Is Yours',
Galerie im Parkhaus, Berlin

Jonathan **Hernández**

Born 1972
Lives Mexico City

Tourism is infamously damaging: environmentally, culturally and socially. Jonathan Hernández combines his status as artist and tourist to explore what it means to be voluntarily displaced and a cultural cherry-picker. *No One Over 21* (2000) is an MTV-style video of American teenagers drinking in Tijuana; while in Spain Hernández wrote the word *guiri* – a local derogatory term for a tourist – in breadcrumbs, letting it be instantly and symbolically devoured by pigeons. Hernández' gestures often turn inwards on themselves to reveal as much about self-deception as about social realities. (SO'R)

Shown by kurimanzutto B11

Algunos Aspectos de la Marcha Fúnebre para el Señor Climent (Some Views of the Funeral March for Señor Climent) 2003
Mixed media on canvas
200×200cm
Courtesy Galería Juana de Aizpuru

Selected Bibliography

2005 'Federico Herrero with Pablo León de la Barra', *tema celeste*

2003 'Federico Herrero', Abel H. Pozuelo, *El Cultural, El Mundo*

2003 'Federico Herrero', J. Montoria, *El Cultural, El Mundo*

2003 *New Perspectives in Painting*, Hans-Ulrich Obrist, Phaidon Press, London

2003 *Urgent Painting*, Virginia Pérez-Ratton, Musée d'Art Moderne de la Ville de Paris

Selected Exhibitions

2005 Watari Museum for Contemporary Art, Tokyo

2004 'La alegría de mis sueños', Seville Biennial

2003 'Japan Opera Vertical Thoughts', Gallery Koyanagi Viewing Room, Tokyo

2003 'Paisajes mentales', Galería Juana de Aizpuru, Madrid

2003 'G2003: Un villagio e un borgo accolgono l'arte', Museo Parrocchiale San Sebastiano, Ascona

2002 Sies + Hoeke Galerie, Dusseldorf

2002 'Urgent Painting', Musée d'Art Moderne de la Ville de Paris

2002 'Artistmos', Museum of Fine Arts, Taipei

2001 'Plateau of Humankind', Italian Pavilion, Venice Biennale

Federico **Herrero**

Born 1978
Lives San José

With their cheerfully garish palettes, tangles of biomorphic forms and floating almost-creatures, Federico Herrero's paintings can suggest Paul Klee filtered through the lens of sci-fi films. But the bustling abstractions and images he creates are not limited to the canvas – they spill over into the gallery and the urban areas around it, as if their energy were too great to be contained. As part of his projects Herrero has brought road markings into the museum and re-purposed public signage to serve aesthetic ends. He is intent on erasing boundaries, both formal and social. (SS)

Shown by Galería Juana de Aizpuru C17, Gallery Koyanagi E6

The J-Street Project
2002–5
Video installation; single-
channel colour projection
67 minutes
Courtesy Timothy Taylor
Gallery

Selected Bibliography

2004 *Susan Hiller: Recall – A
Selection of Works 1969–2004*,
ed. James Lingwood, Baltic
Centre for Contemporary Art,
Gateshead

2004 'Speaking Volumes',
Rachel Withers, *Artforum*

2002 *Susan Hiller*, Museet for
Samtidskunst, Rolskilde

1996 *Susan Hiller*, Tate Gallery,
Liverpool

1996 *Thinking about Art:
Conversations with Susan Hiller*,
ed. Barbara Einzig, Manchester
University Press, Manchester

Selected Exhibitions

2005 'Susan Hiller: The J-
Street Project', Timothy Taylor
Gallery, London

2004 'Susan Hiller: Recall –
A Selection of Works
1969–2004', Baltic Centre for
Contemporary Art, Gateshead
and touring

2002 Sydney Biennial

2002 Museet for Samtidskunst,
Rolskilde

2001 'Intelligence', Tate Britain,
London

2001 'Psi Girls', Gagosian
Gallery, New York

2000 'Witness', Artangel
commission at the Chapel,
London

1999 'The Muse in the
Mountain: Artists Reflect',
Museum of Modern Art,
New York

1996 Tate Gallery, Liverpool

1994 'From the Freud Museum',
The Freud Museum, London

Susan **Hiller**

Born 1940
Lives London

Trained as an anthropologist, Susan Hiller has
created an influential body of installation, text,
video and audio works since the 1970s that have
explored the nether world and the fringes and
margins of human belief and experience. Psychic
children, close encounters, psychedelic journeys,
automatic writing and lucid dreaming are all part
of the cultural unconscious Hiller's art attempts
to tap into. Her audio installation *Clinic* (2004)
brings together accounts of near-death experiences
from a range of cultures, expanding her field of
inquiry into the ongoing human need for belief
in the spiritual or paranormal in a rationalist,
technocratic age. (DF)

Shown by Timothy Taylor Gallery F2

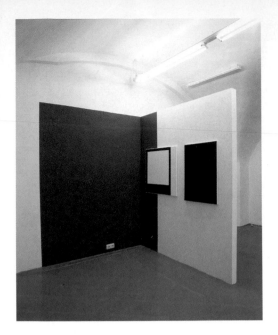

All Over
2005
Installation view,
Neue Galerie Graz Studio
Courtesy Georg Kargl

Selected Bibliography

2005 *Herbert Hinteregger: All Over*, Elisabeth Fiedler, Neue Galerie Graz

2002 *Variable Stücke*, Galerie im Taxispalais, Innsbruck

2001 *Bilanz 2001* (Balance 2001), Tiroler Landesmuseum Ferdinandeum, Innsbruck

2001 'Raving Pictures', Johanna Hofleitner, *Parnass*

1999 *Herbert Hinteregger*, Moritz Küng, Georg Kargl, Vienna

Herbert **Hinteregger**

Born 1970
Lives Vienna

Ink is the crude oil of the information industry, the raw material on which modern service industries depend. It is also a key element in Herbert Hinteregger's painting. He applies patches of ink to the canvas with industrial sponges or by squeezing it out of ballpoint pen cartridges. The resulting compositions are both abstract and concrete, self-reflexive illustrations of what ink is and what you can do with it (besides writing or printing). Yet Hinteregger makes this materialism border on the sublime. As he experiments with ink's watery yet viscous quality, the texture of his works evokes the surface of an unfathomable sea. (JV)

Shown by Georg Kargl G9

Selected Exhibitions

2005 'All Over', Neue Galerie Graz Studio

2005 'The Red Thread', Howard House Gallery, Seattle

2004 'Gegenstände', Kunstraum Innsbruck Project Space

2004 'Get the Picture', Georg Kargl, Vienna

2003 'Ball-Pen-Ink', Remise Bludenz

2002 'Various Pieces', Galerie im Taxispalais, Innsbruck

2001 Georg Kargl, Vienna

2001 'Zusammenhänge im Biotop Kunst', KH Muerz, Mürzzuschlag

2000 Sommer Contemporary Art, Tel Aviv

2000 'Painterly Issues', Contemporary Art Centre, Vilnius

Winterheat
2004
Oil on wood
42×31cm
Courtesy Guido W. Baudach

Selected Bibliography

2005 'Der Ritt übers tosende Zeichenmeer' (The Ride over the Blustering Sea of Signs), Heinz Schütz, *Kunstforum*

2003 'The Eternal Reinvention of Painting', David Galloway, *International Herald Tribune*

2003 'Painting on the Roof', Helga Meister, *Kunstforum*

2001 'Schwermut Forrest' (Melancholy Wood), Esther Buss, *Texte zur Kunst*

2001 'Andreas Hofer', Heidi Fichtner, *Flash Art International*

Selected Exhibitions

2005 'Welt ohne Ende', Städtische Galerie im Lenbachhaus, Munich

2005 'Galassia che vai', Galerie Bleich-Rossi, Graz

2004 'Batman Gallery', Galerie Christine Mayer, Munich

2004 'Heimweh', Haunch of Venison, London

2004 'Kommando Pfannenkuchen', Daniel Hug Gallery, Los Angeles

2003 'Tomorrow People', Guido W. Baudach, Berlin

2003 'actionbutton', Hamburger Bahnhof, Berlin

2003 'Deutschemalerei-zweitausenddrei', Kunstverein, Frankfurt

2003 'Painting on the Roof', Museum Abteiberg, Mönchengladbach

2001 'Down the Hollywood Line', Guido W. Baudach, Berlin

Andreas **Hofer**

Born 1963
Lives Berlin

Andreas Hofer's jumbled installations of watercolours, photographs, papier mâché sculptures and cardboard montages, such as *Batman Gallery* (2004), have been characterized as 'dark wave romanticism'. His imagery combines mysticism with historical reference and Pop culture in a kind of Third-Reich-meets-the-Bayeux-Tapestry comic-book narrative, full of horse-riding warriors, black crows and hooded figures, their robes decorated with Maltese or Latin crosses. That Hofer signs most of his darkly pessimistic works with the tag 'Andy Hope 1930' implies both deliberate retrogression and tongue-in-cheek self-invention. (KB)

Shown by Guido W. Baudach H10, Galerie Michael Neff A15

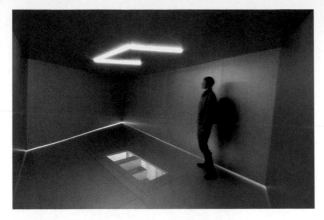

Trapezoid Swinging Room
2005
Alucobond, aluminium, wood, neon
360×500×900cm, pedestal height 140cm
Courtesy Esther Schipper

Selected Bibliography

2003 *Common Wealth*, Jessica Morgan, Tate Publishing, London

2000 *Register*, Germano Celant, Carsten Höller, Fondazione Prada, Milan

2000 >*Tuotanto*</>*Production*<, Daniel Birnbaum and Carsten Höller, Kiasma Museum of Contemporary Art, Helsinki

1999 *Neue Welt* (New World), Museum für Gegenwartskunst, Basel

1996 *Glück/Skop*, Oktagon, Cologne

Carsten **Höller**

Born 1961
Lives Stockholm

Referring to his spiralling slides, which have equipped museums worldwide with a zany alternative to staircases, Carsten Höller has remarked that 'the surprise of the slide is that it is a repeatable surprise'. The quip holds true for his entire *oeuvre*, in which the *doppelgänger* motif is a constant companion. He has lately appeared as 'Karsten', and in his Marseille exhibition last year he presented an identical replica of each of the 12 works on show in a parallel wing of the museum. Put on his *Expedition Equipment for the Exploration of the Self* (1995) – a backpack with a pair of goggles that shows you a reflection of yourself – and be surprised by your own senses. (JöH)

Shown by Air de Paris A4, Galleria Massimo de Carlo E10, Galerie Martin Janda A13, Esther Schipper F5, Galerie Micheline Szwajcer D5

Selected Exhibitions

2005 'La Belgique Visionnaire', Palais des Beaux-Arts, Brussels

2005 Nordic Pavilion, Venice Biennale

2004 Musée d'Art Contemporain, Marseille

2003 'Half Fiction', Institute of Contemporary Art, Boston

2003 'Delays and Revolutions', Italian Pavilion, Venice Biennale

2003 'One Day One Day', Färgfabriken, Stockholm

2002 'Light Corner', Museum Boijmans Van Beuningen, Rotterdam

2002 São Paulo Biennial

2000 'Synchro System', Fondazione Prada, Milan

1999 'Ny Värld', Moderna Museet, Stockholm

Wood
2003
Acrylic ink on photograph
18×31cm
Courtesy doggerfisher

Selected Bibliography

2005 *Freedom of Information*, Greg Hilty and Fiona Bradley, Fruitmarket Gallery, Edinburgh

2005 *Here+Now: Scottish Art 1990–2001*, Katrina Brown, Dundee Contemporary Arts

2001 *Open County*, Musée Cantonal des Beaux-Arts de Lausanne

2000 *A Day Like Any Other*, Francis McKee, Kulturhaus, Stavanger

1997 *Glasgow: Reproduction and Repression*, Ulrich Loock, Kunsthalle, Bern

1996 'Louise Hopkins', *White Music: The Floral as Viral*, Tony Godfrey, Andrew Mummery, London; Tramway, Glasgow

Selected Exhibitions

2005 'Freedom of Information', Fruitmarket Gallery, Edinburgh

2003 doggerfisher, Edinburgh

2003 Andrew Mummery Gallery, London

2001 Angles Gallery, Santa Monica

2001 'Here + Now', Dundee Contemporary Arts

2001 'Open Country', Musée Cantonal des Beaux-Arts de Lausanne

1998 Galleria Raffaella Cortese, Milan

1997 'Pictura Britannica: Art from Britain', Museum of Contemporary Art, Sydney

1997 'Glasgow', Kunsthalle, Bern

1996 Tramway Project Room, Glasgow

Louise **Hopkins**

Born 1965
Lives Glasgow

Louise Hopkins uses paint to make her work, but perhaps it would be inaccurate to describe her as a painter. During the late 1990s Hopkins applied oil paint to obliterate and re-make pre-formulated surfaces – sheet music, maps and furnishing fabric printed with overblown roses. Her practice summoned the monochromatic legacy of Robert Ryman and Agnes Martin, while reinstating such culturally specific forms as song lyrics. More recently she has used black ink to mask the text of newsprint. In works such as *Untitled (the of the)* (2002) the ink obscures all but stuttering strings of prepositions, conjunctions and pronouns. (SL)

Shown by doggerfisher A10

Jonathan **Horowitz**

Born 1966
Lives New York

Jonathan Horowitz' videos and installations take for granted that the borders between Pop culture and the self are more than a little fuzzy. The mass media aren't something 'out there': they are internalized, structuring the way we understand our own lives. Sitcoms create lasting memories; celebrities are imaginary friends and ego surrogates. Horowitz catches the slippages in this televisual fantasy world, highlighting uncanny moments of identification. Through seemingly simple gestures – re-editing and recontextualizing scenes from films, reversing music videos – he offers glimpses at the strangeness of our media landscape. (SS)

Shown by Gavin Brown's enterprise D7, Sadie Coles HQ C10, Yvon Lambert F6, Galerie Barbara Weiss C20

Selected Bibliography

2005 'Profile: Jonathan Horowitz', Dominick Ammirati, *Contemporary*

2003 'Pillow Talk', Chris Hammonds, *tema celeste*

2002 'Go Vegan!', Chivas Clem, *Time Out New York*

2002 'Go Vegan!', Ken Johnson, *The New York Times*

2002 'House of 8 Gables, Back in Black', David Coleman, *The New York Times*

Selected Exhibitions

2005 Galerie Barbara Weiss, Berlin

2003 'Silent Movie', Wadsworth Atheneum Museum of Art, Hartford

2003 Yvon Lambert, Paris

2002 'Pillow Talk', Sadie Coles HQ, London

2001 'Time, Life, People', Kunsthalle, St Gallen

2001 'In Person', Center for Curatorial Studies, Bard College, Annandale-on-Hudson

2000 'The Jonathan Horowitz Show', Greene Naftali, New York

1998 'Bach Two-Part Inventions #9', Kenny Schachter/Rove, New York

Golden Peach
2004
Oil on canvas
36×25cm
Courtesy Private Collection

Selected Bibliography

2005 'Paul Housley', Sue Hubbard, *The Independent*

2003 *Yes! I Am a Long Way from Home*, The Redgate Press, London

2003 'Modern Painters' Broadcast 25/09/03', J.J. Charlesworth, Channel 4 in conjunction with NGCA, Sunderland

2002 *Air Guitar: Art Reconsidering Rock Music*, Emma Mahony, Milton Keynes Gallery

2002 *Paul Housley: Paintings*, Alistair Robinson, Lowry Press, Salford

Selected Exhibitions

2005 'New Ways to Be Alone', Wilkinson Gallery, London

2003 'Dirty Pictures', The Approach, London

2002 'Air Guitar', Milton Keynes Gallery

2002 'The Cat Show', ACME., Los Angeles

2001 'I, Mancunian', The Lowry Gallery, Salford

2001 'Modern Love, hobbypopMUSEUM', VTO Gallery, London

1999 'The Poster Show', Gavin Brown's enterprise, New York

1999 '9/9/99', Anthony Wilkinson Gallery, London

1999 'EAST International', Norwich Art Gallery

1998 'England till it Hurts', Berwick Gymnasium Gallery, Berwick upon Tweed

Paul **Housley**

Born 1964
Lives London

Paul Housley often paints mass-produced objects, but his loosely rendered works also distil the intense contemplation a child focuses on a plastic cowboy, or that an adolescent invests in a prized EP. His small-scale oil paintings are simple, and of ordinary subjects, but they also articulate something important about the 'nation of hobbyists' described by Orwell. The phrase Housley once printed on badges, 'England needs me but I can't get out of bed', encapsulates his memorable mix of parochial claustrophobia and deadpan humour. In Housley's lexicon *Brutus* (2001) is a fitting name for a cat, while a faded yellow floral arrangement possesses the drama of *Tigers on Heat* (2004). (SL)

Shown by Wilkinson Gallery D22

Roadsider (First of the Morning)
2005
Resin
31×8×8cm
Courtesy The Modern Institute /
Toby Webster Ltd

Richard **Hughes**

Born 1974
Lives London

Richard Hughes' assemblages of detritus remodel familiar objects in unfamiliar materials. Often influenced by British youth subcultures, they weave pathos and bathos together with an affecting directness. A dirty old trainer conceals a swirling Op art vortex in its sole; a heap of unwanted clothes, stuffed into plastic bags destined for a charity shop, is transformed into the cover of a legendary rock album; a stunning sunset can be found in old duvets and scraps of Perspex and paper; plaster-cast BMX bike tyres lie discarded at a roadside, intertwined. Hughes' sculptures seek visions of hope and reassurance amid daily, suburban drudgery. (DF)

Shown by The Modern Institute / Toby Webster Ltd B15

Selected Bibliography

2005 'Richard Hughes', Alison M. Gingeras, *Artforum*

2004 'Richard Hughes', Tobi Maier, *a–n Magazine*

2004 'Richard Hughes', David Barrett, *Art Monthly*

Selected Exhibitions

2005 The Modern Institute / Toby Webster Ltd, Glasgow

2005 'The British Art Show', Hayward Gallery, London and touring

2004 'No More Reality', Nils Staerk Contemporary Art, Copenhagen

2004 'Genesis Sculpture – Group Exhibition', Domain Pommery, Reims

2003 'Richard Hughes', roma roma roma, Rome

2003 'The Shelf Life of Milk', The Showroom, London

2003 'Have a Go Heroes', Cell Project Space, London

2003 'East International', Norwich Gallery

1998 'Nothing Original to See Here', Turnpike Gallery, Manchester

The Nightingale
2004
16mm film transferred to DVD
10 minutes
Edition of 3
Courtesy Frith Street Gallery

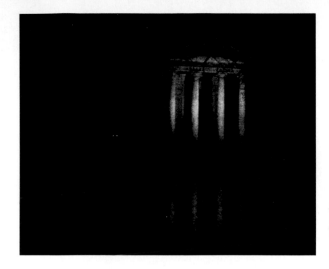

Selected Bibliography

2004 *Stranger than Fiction: From the Arts Council Collection*, Isobel Johnstone, Ann Jones and Sukhdev Sandhu, Hayward Gallery Publishing, London

2004 *Dialogues: Women Artists from Ireland*, Katy Deepwell, IB Tauris, London

2001 'Jaki Irvine', Ian Hunt, *Art Monthly*

2000 *New British Art*, ed. Virginia Button and Charles Esche, Tate Publishing, London

1999 'Jaki Irvine', Daniel Jewesbury, *Art Monthly*

Selected Exhibitions

2005 Frith Street Gallery, London

2005 Henry Moore Institute, Leeds

2004 Irish Museum of Modern Art, Dublin

2004 'Stranger than Fiction', Hayward Gallery, London

2003 'A Century of Artists' Films', Tate Britain, London

2001 'Ivana's Answers', Delfina Project Space, London

2000 'Intelligence: New British Art 2000', Tate Britain, London

Jaki **Irvine**

Born 1966
Lives Dublin

There is a space between meaning and comprehension that mainstream films try to ignore. This, however, is precisely the space that Jaki Irvine is interested in. Her seductive films employ montage, voice-over and music to approximate meaning, which the viewer cannot resist attempting to complete. We try to make sense of abstracted situations – a man meeting his older self, a woman singing a love song to her dog, the luminous dance of fireflies – as we would optimistically speculate on the character of a new lover. In this sense Irvine's slippages between knowledge and anticipation are pure romanticism. (SO'R)

Shown by Frith Street Gallery C1, Kerlin Gallery E14

BB
2000
Silent black and white Super 8
film transferred to 35mm film
Courtesy the artist

Cameron **Jamie**

Born 1969
Lives Paris

Ritualized violence beats at the heart of Cameron Jamie's work. Gnawing disaffection spits from his videos and drawings portraying American suburbia and European folklore. *La Baguette* (1997) involved video documentation of wrestling bouts in Jamie's apartment. The drawings from the 'Goat Project' (2000–03) depict macabre performances in his native California. *BB* (1998–2000), *Spook House* (2003) and *Kranky Klaus* (2003) – a trilogy of films juxtaposing illegal backyard wrestling, Detroit's Halloween traditions and Austria's macho Krampus ritual – were accompanied by the theatrics of rock band The Melvins. As Alex Farquharson wrote, Jamie makes 'little distinction between Old and New World rituals,' seeing them as 'expressions of the same human impulse'. (DF)

Shown by Bernier/Eliades F17, Galerie Nathalie Obadia E23

Selected Bibliography

2004 *KOPBF: Book II*, Douglas Klark Verlag, Dusseldorf

2003 *Drawings: Maps and Composite Actions*, De Vleeshal

2000 *BB*, Herbert Lachmayer, Centrum für Gegenwartskunst, Linz

Selected Exhibitions

2005 Bernier/Eliades, Athens

2004 Kunstverein, Salzburg

2004 'Jo', Neue Galerie am Landesmuseum, Graz

2003 The Wrong Gallery, New York

2003 De Vleeshal, Middleburg

2002 Jablonka Galerie, Cologne

2002 Galerie Chantal Crousel, Paris

2001 'Cameron Jamie: Selected Film and Video Works 1996–2000', Yerba Buena Center for the Arts, San Francisco

2000 Centre National de l'Estampe de l'Art Imprimé, Chatou

2000 'BB', O.K. Centrum für Gegenwartskunst, Linz

Selected Bibliography

2004 *8'26*, Galeries
contemporaines des Musées
de Marseille

2003 *The Gliding Gaze*,
Hans Theys, Middelheim
Museum, Antwerp

2001 *Ann Veronica Janssens:
Lichtspiel* (Ann Veronica
Janssens: Playing with Light),
Mieke Bal, Kunstverein,
Munich

1999 *Une image différente
dans chaque oeil* (A Different
Image in Each Eye), Laurent
Jacob, Liège and Brussels

Selected Exhibitions

2004 Pratt Manhattan Gallery,
New York

2004 'Recent Work/ Obra
Recent', Galería Antoni Tàpies,
Barcelona

2003 'Ann Veronica Janssens:
8'26' ', Galeries contemporaines
des Musées de Marseille

2003 'Travellings',
Openluchtmuseum voor
Beeldhouwkunst Middelheim,
Antwerp

2003 'Licht und Farben',
Kunsthalle, Bern

2003 'Scrub Color II', Schipper
& Krome, Berlin

2002 Ikon Gallery, Birmingham

2002 Galerie Micheline
Szwajcer, Antwerp

2001 'Light Games', Neue
National Galerie, Berlin

2001 'Works for Space',
Kunstverein, Munich

Ann Veronica **Janssens**

Born 1956
Lives Brussels

Since the mid–1980s Ann Veronica Janssens'
installations, sculptures and interventions have
engaged with what she calls 'super-space': the
undefined, fluid area that surrounds a given
space. For *Blue, Red and Yellow* (2001), a small
Modernist-looking pavilion, she used as material
'artificial mist and natural light', which, through
the use of transparent coloured gels, create a
chromologically charged atmosphere that engulfs
those who enter it. *Scrub Colour* (2002), a video
projection of coloured rectangles flashing rapidly
over one other, has a similarly destabilizing effect
on the audience's perceptions, momentarily short-
circuiting thought in favour of hallucinatory
perceptual overload. (KB)

Shown by 1301PE B8, Esther Schipper F5, Galerie
Micheline Szwajcer D5

Selected Bibliography

2004 *Enrique Jezik*, Sala de
Arte Público Siqueiros, Jorge
Reynoso Pohlenz, Mexico City

2003 *Otredad y mismidad:
La escultura de la fuerza ciega*
(Otherness and Sameness: Blind
Strength Sculpture), Galería de
Arte Contemporáneo y Diseño,
Puebla

2003 *IV Bienal do Mercosul:
Arqueologías contemporáneas*
(4th Biennial of Mercosul:
Contemporary Archaeologies),
Edgardo Ganado Kim, Porto
Alegre

2002 *Sécurité*, Yann Chevalier,
Lelia Driben, Enrique Cerón,
Víctor Sosa, Enrique Jezik
and Pierre Raine, Le Confort
Moderne, Poitiers

2002 *Zebra Crossing: Un bestiario
mexicano* (A Mexican Bestiary),
Eduardo Abaroa, Haus der
Kulturen der Welt, Berlin

Enrique **Jezik**

Born 1961
Lives Mexico City

Power tools and heavy machinery are deployed
in Enrique Jezik's installations and video
performances to describe the aggressiveness of
geopolitical confrontations. In *Referendum* (2002)
Jezik addressed the Quebecois separatist struggle,
using a chainsaw to hack the province, physically,
out of a drywall schematic map of Canada. In
other works the artist absents himself, substituting
mechanistic *doppelgängers*, such as front-loaders
equipped with jackhammers, to generate a noisy
dialogue. *Pieza sonora sin título para cuatro máquinas*
(Untitled Sound Piece for Four Machines, 2003)
consisted of four steel cutting machines arranged
in the corners of a room, discharging showers of
sparks into the centre. (SL)

Shown by Galería Enrique Guerrero B10

Selected Exhibitions

2005 'Untitled, (Damage
and Repair)', Galería Enrique
Guerrero, Mexico City

2004 'One and a Half Miles',
Berwick Gymnasium Art
Gallery, Berwick upon Tweed

2004 'Artists and Weapons',
assorted venues, Kalingrado,
Nizhny, Tagil, Izhevsk

2003 Sala de Arte Público
Siqueiros, Mexico City

2003 Mercosul Biennial

2002 'Zebra Crossing', Haus der
Kulturen der Welt, Berlin

2001 'Esgrima' (Fencing), Ex
Teresa Arte Actual, Mexico City

2001 'The Persistence of the
Image', Art Sonje Centre, Seoul

Striped Skirt
2004
Oil on board
306×122cm
Courtesy Victoria Miro Gallery

Chantal **Joffe**

Selected Bibliography

2005 *Chantal Joffe*, Vittoria Coen and Ricardo Conti, Galleria Monica de Cardenas, Milan

2003 *Women: Chantal Joffe*, Sacha Craddock, Victoria Miro Gallery, London

Selected Exhibitions

2005 Victoria Miro Gallery, London

2005 Galleria Monica de Cardenas, Milan

2004 Galleria Il Capricorno, Venice

2004 Bloomberg Space, London

2002 'John Moores 22', Walker Art Gallery, Liverpool

Born 1969
Lives London

Commitment to a mark is a grave moment in painting, but somehow Chantal Joffe makes each application of paint seem like a slip of the brush or a flick of the wrist. Her portraits of anonymous women and babies exist in their own painted world, shedding the associations of the fashion and lifestyle realms from which they originate. A recent series of nine paintings on a billboard scale are even more emphatically corporeal than ever. Arrested narrative and elusive character imbue them with an allure that can only be described as feminine, but it is a femininity that is self-aware, even constructed. (SO'R)

Shown by Victoria Miro Gallery F7

Modern Death / Trap Painting 'I Am Full of Shit and Love and Hate and Plastic and Fascism'
2004
Found wood, acrylic and emulsion
38×35cm
Courtesy Jack Hanley Gallery

Selected Bibliography

2004 *Beautiful Losers*, Carlo McCormick, Aaron Rose et al., DAP, New York

2003 'One Piece at a Time', Michael Wilson, *frieze* 79

2003 'The Dude Is New Age and He's Proud of It', Hilarie M. Sheets, *The New York Times*

2002 *SECA Art Award*, Janet Bishop, San Francisco Museum of Modern Art

2002 'Best of 2002', Matthew Higgs, *Artforum*

Chris **Johanson**

Born 1968
Lives Portland

Chris Johanson is, according to Glen Helfand at www.SFBG.com, 'really into the ethnic culture blender of San Francisco. The air smells like hepatitis, shit, incense, cigarettes, exhaust, the Bay breeze, and food from all the incredible restaurants; it's a good aroma.' His spirited installations, which include murals, paintings and drawings often rendered on found materials, reflect his affection for urban chaos. He is best known for his inventive, often childlike, portraits of people on the street, use of words in images, and cosmic comic-book landscapes. As influenced by skateboarding, social activism, surfing and music as by art, artists and graffiti, Johanson's DIY aesthetic reflects a folksy, fluid approach to image production. (JH)

Shown by Jack Hanley Gallery E11, Georg Kargl G9, The Modern Institute / Toby Webster Ltd B15

Selected Exhibitions

2005 Istanbul Biennial

2005 'Monuments for the USA', CCA Wattis Institute, San Francisco

2004 'The Problem Does Not Compute', The Modern Institute, Glasgow

2004 'Solo Soul', curated by Chris Johanson, Vedanta Gallery, Chicago

2003 'This Is Where You Are', Georg Kargl, Vienna

2003 'SECA Art Award Exhibition', San Francisco Museum of Modern Art

2003 'Dirt Wizards', Brooklyn Fire Proof, New York

2002 'Now Is Now', Deitch Projects, New York

2002 Whitney Biennial, New York

2001 UCLA Hammer Museum, Los Angeles

2000 'Le Nuage Brun', Purple Institute, Paris

Hovleverantören
(Supplier to the Court)
2005
Carved and painted basswood
Height 100cm
Courtesy Galleri Magnus
Karlsson

Richard **Johansson**

Born 1966
Lives Södra Mellby

A painting of a woman wearing a flowerpot for a hat, with a red star emblazoned above her forehead; a painted, life-size sculpture of a man ripping open his shirt to point at a bullet wound next to his heart; and a painted relief of a portrait gallery featuring Fidel Castro, Motörhead's Lemmy, Jesus and a chap with a baseball cap embroidered with the word 'Fuck': these are some of the protagonists of the bewildering world of Richard Johansson. The artist, who lives and works in rural Sweden, has affinities with Folk and Outsider art, but adds a Californian sense of wacky bravado in the vein of Jim Shaw. (JöH)

Shown by Galleri Magnus Karlsson B2

Mise en Scène No. 2 (from 'Fantôme Créole')
2005
Lamda print on glossy paper
120×120cm
Courtesy Victoria Miro Gallery

Selected Bibliography

2005 *Isaac Julien: Fantôme Créole*, Christine van Assche, Centre Georges Pompidou, Paris

2004 *Isaac Julien*, Paulette Gagnon, Musée d'Art Contemporain, Montreal

2001 *Isaac Julien*, Kobena Mercer and Chris Darke, Ellipsis/Film and Video Umbrella, London

2000 *The Film Art of Isaac Julien*, Amada Cruz, Center for Curatorial Studies, Bard College, Annandale-on-Hudson

Isaac **Julien**

Born 1960
Lives London

Isaac Julien's lyrical films have roamed through 1930s' Harlem, 1970s' London, the contemporary Caribbean and the timeless American West, but they return again and again to scenes of dance. Such representations appear emblematic: in the rhythmic motion of bodies in space, desire is activated and troubled. Informed by critical theory and a nuanced awareness of cinematic history, Julien's work highlights those places where the personal and the political rub together. He sets myths and stereotypes of blackness, masculinity and national and sexual identity against each other and against themselves, always following the wayward paths of desire – those moments when the body takes the lead. (SS)

Shown by Yvon Lambert F6, Victoria Miro Gallery F7

Selected Exhibitions

2005 Victoria Miro Gallery, London

2005 Irish Museum of Modern Art, Dublin

2005 'Isaac Julien: Fantôme Créole', Centre Georges Pompidou, Paris

2004 'Isaac Julien: True North', Musée d'Art Contemporain de Montreal

2003 'Isaac Julien: Baltimore', The Aspen Art Museum

2003 The Bohen Foundation, New York

2002 Documenta, Kassel

2001 Turner Prize, Tate Britain, London

2000–02 'The Film Art of Isaac Julien', Center for Curatorial Studies, Bard College, Annandale-on-Hudson

2000 'The Long Road to Mazatlan', Art Pace, San Antonio

Maden Haus
2004
Etching, framed
35×30cm
Courtesy Corvi-Mora

Dorota **Jurczak**

Selected Bibliography

2005 'Jahreszeiten im *Maden Haus*' (Seasons in the *Maden Haus*), Jörn Ebner, *FAZ*

Selected Exhibitions

2005 Corvi-Mora, London

2005 'Hemmungen', Centre Cultural Andratx, Mallorca

2005 'Transterritorial-Mueller', Velada Santa Lucía

2004 'Sammlung Taubenstraße', Kunsthaus, Hamburg

2004 'Kunstlich Kongress', Kunstraum Walcheturm, Zurich

2004 'All Creatures Great and Small', Comme ci Comme ça II, Salon d'Art, Cologne

2003 Nomadenoase, Hamburg

2002 'Ulica Golebi 13', Taubenstraße 13, Hamburg

Born 1978
Lives Hamburg

Dorota Jurczak's etchings and bronzes evoke a Central Europe that seems to exist anywhere between 1790 and 1970. It is a land governed by folklore and superstition, where animal and human worlds exist in close but sexually violent symbiosis; figures metamorphose into birds; extravagantly plumed wildfowl hold emaciated men and women captive; Medusa-like geese torment haunted, wizened old vagrants. Jurczak's elegantly spindly draughtsmanship re-imagines medieval woodcuts as 1970s' children's book illustrations – part Brothers Grimm, part Maurice Sendak – woodland communities where postwar hippie idealism confronts a malevolent ancient paganism. (DF)

Shown by Corvi-Mora E7

To the Man Masturbating in
the Toilet of the Charles De Gaulle
Airport
2002
Video installation
Courtesy Galerie Chantal
Crousel

Selected Bibliography

2005 *Desvelar lo Invisible:
Videocreaciones Contemporáneas*
(Unveiling the Invisible:
Contemporary Video Art),
Victoria Combalia and Juan
Carlos Rego, Consejeria de
Cultura y Deportes, Madrid

2004 *17 & in AUC: The
Transcriptions*, Hassan Khan,
Galerie Chantal Crousel, Paris

2003 *Molditudini–Solitudini*,
Alois Lageder et al., Maschietto
Editore, Florence

2002 *Inter-Play*, Silvia Karman
Cubina and Patrick Charpenel,
Miami Design District, Miami

Selected Exhibitions

2005 'The Hidden Location',
A Space Gallery, Toronto

2005 'Four by Four', Artists
Space, New York

2005 'Desvelar lo
Invisible: Videocreaciones
Contemporáneas', Sala de
Exposiciones Alcala, Madrid

2005 Kunsthalle, Vienna

2004 'Directtransmission',
with Mahmoud Refat, KBB,
Barcelona

2004 'Nearer the Near East',
Schirn Kunsthalle, Frankfurt

2004 Galerie Chantal Crousel,
Paris

2004 'La Ciudad Collage',
Centro de Exposicones
Benalmadena, Malaga

2003 'Contemporary Arab
Representations: Cairo', Witte
de With, Rotterdam

2003 Istanbul Biennial

Hassan **Khan**

Born 1975
Lives Cairo

The entangled urban life of Cairo is the central
preoccupation of many of Hassan Khan's
sophisticated video installations and sound
compositions. The multiple projections and
ambient sound of *Reading the Surface: 100 Faces, 6
Places and 25 Questions* (2001) plot out a complex
diagram of the city's various neighbourhoods and
inhabitants and of the overlapping influences of
Eastern and Western cultures. *Tabla Dubb* (2002),
a fast-paced live mix of urban video images to a
soundtrack combining electronica, tabla drum
music and repeated spoken statements, describes a
city being constantly redefined. (KB)

Shown by Galerie Chantal Crousel D10

Anya **Kielar**

Born 1978
Lives New York

Anya Kielar's sculptures suggest a fetishistic approach to the body, which abandons its fleshy earthbound dimensions to reveal a non-corporeal, perhaps spiritual, 'other'. In *Flutter By* (2005) the body is concealed by a coat and mask of multicoloured paper butterflies, their wings quivering in the air current produced by a standing fan. Kielar has invented a psychic double, whom she names 'Hanya von Roebiebot' in a conflation of old Europe aristocracy and cyborg futurism that is echoed in her works, which suggest both dustily antiquated science and psychedelic clairvoyance. (KB)

Shown by Daniel Reich Gallery B5

Selected Bibliography

2004 Editor's Picks, *New York Arts*

Selected Exhibitions

2005 'Flutter By', Daniel Reich Gallery, New York

2005 'Columbia MFA Thesis Show', Columbia University, New York

2005 'The General's Jamboree', Guild & Greyshkul, New York

2004 'Past Perfect', Kantor Gallery, New York

Bounty
2005
Oil and spray paint on nettle cloth
190×165cm
Courtesy Private Collection, Switzerland

Henning **Kles**

Born 1970
Lives Hamburg

A young boy in shorts and sneakers standing at the bottom of the canvas, his back turned to us, is rolling up the twilit mountain landscape before him as if it were just a painted illusion. Which it is, of course, the whole image being painted in vivid luminescent colours on a large-format canvas, but the boy's action renders his implication in the scene ambivalent, *unheimlich* even. Suffused with ambiguous lighting and dreamlike atmospheres, Henning Kles' paintings are like scenes from contemporary fairy tales, underscored by an existential anxiety about the authenticity of the visual world. (KB)

Shown by Arndt & Partner D21

Selected Bibliography

2005 *Geschichtenerzähler* (Storytellers), Uwe M. Schneede and Christoph Heinrich, Kunsthalle, Hamburg

Selected Exhibitions

2005 'Niemandsland', Arndt & Partner, Zurich

2005 'Geschichtenerzähler', Kunsthalle, Hamburg

2004 Index 04, Kunsthaus, Hamburg

2004 'Kunstlicht Kongress', Kunstraum Walcheturm, Zurich

2003 'Nobody Forever', FAXX Tilburg

Untitled
2004
Acrylic on MDF
122×150cm
Photo: Stephen White
Courtesy Jay Jopling/White
Cube

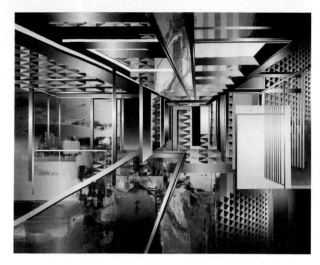

Selected Bibliography

2005 *From Leipzig: Works from the Ovitz Family Collection*, Cleveland Museum of Arts

2004 *Painting as Doubt and the Architecture of Impossibilty*, Mark Gisbourne, Andrew Hunt and Lynda Morris, Norwich Gallery

2004 *Fehlfarben: New Painting from Munich, Dresden, Leipzig and Berlin*, Ulrich Bischoff and Birgit Dalbajawa, Galerie Neue Meister, Staatliche Kunstsammlungen, Dresden

2003 */ x Painting*, Josef Filipp and Hans W. Schmidterner, Museum of Visual Arts, Leipzig

2003 *LIGA: Young Art from Leipzig*, Kunstverein Neustadt am Rubenberge, Leipzig

Selected Exhibitions

2005 Christian Ehrentraut, Berlin

2005 'Loomings', White Cube/ Jay Jopling, London

2005 'Life after Death: New Leipzig Paintings from the Rubell Family Collection', Mass MOCA, North Adams

2005 'From Leipzig', Cleveland Museum of Art

2004 Galerie LIGA, Berlin

2004 'Positions of Contemporary Painting from Leipzig', Marianne Boesky Gallery, New York

2003 Kunstverein Leipzig

2003 'Malerei', Galerie LIGA, Berlin

2002 Galerie Dogenhaus, Leipzig

Martin **Kobe**

Born 1973
Lives Leipzig

Glossy as a fleet of new Mercedes, Martin Kobe's paintings of corporate architecture invite you to slide down their richly coloured, frictionless surfaces. Utterly unpopulated, the spaces Kobe depicts are, in any case, uninterested in people, preferring to reflect on their own cold perfection. Here and there they slip into abstraction, as though their functionality as office space were only an unimportant by-product of their aesthetic purpose. Perhaps it is. In Kobe's paintings style (like power or privilege) seeks always to perpetuate itself – no matter whom it edges out of the picture, no matter what the human cost. (TM)

Shown by White Cube/Jay Jopling F8

Seb **Koberstädt**

Born 1977
Lives Dusseldorf

A dark, ivy-covered, U-shaped MDF tunnel leading nowhere – it seems purpose-built for a hermit devotee of Minimal art and skateboarding (*Untitled*, 2000) – and a ramp-roofed room-within-a-room constructed of found materials, housing a lamp that can only be viewed through a trapdoor opening (*Dying to Live*, 2005) are among Seb Koberstädt's recent sculptures and installations. His works delineate a speculative, context-specific space in which his viewers are asked to negotiate a reconstituted present infiltrated by an art–historical past. (DE)

Shown by Luis Campaña Galerie G16

Selected Bibliography

2005 *Deutschland sucht*, Kunstverein, Cologne

Selected Exhibitions

2005 'Dying to Live', Luis Campaña Galerie, Cologne

2004 'Deutschland sucht', Kunstverein, Cologne

The Voyage of Lady Midnight
Snowdrops through Double
Star Death (The Black Skin
That Is Me and Me)
2005
Mixed media
76×38×38cm
Courtesy Peres Projects
Los Angeles Berlin

Selected Bibliography

2005 'Terence Koh', Laura
Auricchio, *Art Papers*

2004 'The Artist in a Book',
Alexandra Chang, *New York*

2004 *Dedicated to a Proposition*,
Wim Peeters, Extra City Centre
for Contemporary Art, Antwerp

2004 *Koh & 50 Most Beautiful
Boys*, Terence Koh, Peres
Projects, Los Angeles

Selected Exhibitions

2005 'Terence Koh, Gone, Yet
Still', Secession, Vienna

2005 'The Death of Terence
Koh', Peres Projects, Berlin

2004 'Koh & 50 Most Beautiful
Boys', Peres Projects, Los Angeles

2004 'Do Not Doubt the
Dangerousness of My Butterfly
Song', Peres Projects, Los Angeles

2004 'The Whole Family', Peres
Projects, Los Angeles

2004 'Phiiliip: Divided by
Lightning', Deitch Projects,
New York

2004 'The Temple of the Golden
Piss', Extra City Centre for
Contemporary Art, Antwerp

2004 'The Black Album',
Maureen Paley Interim Art,
London

2004 Whitney Biennial,
New York

Terence **Koh**

Born 1977
Lives New York/Los Angeles

Terence Koh works in various media, including
installation, collage painting and Web projects.
His massive installations bring together domestic
sculptural media with unconventional and often
extravagant materials, all covered in a uniform
hue to create articulate and grandly impressive
environments, adorned with suitably abundant
titles. *These Decades That We Never Sleep* (2004) is a
bleached sculptural event in four parts, made of
plaster, wax, pearls, rope, fur and fabric, draped
over drum kits and chandeliers. Koh brandishes
an aesthetic signature of campy horror, a kind of
misplaced decadence or unsettling grandeur laced
with a happily puerile fascination with the tragic,
the outmoded and the obscene. (DJ)

Shown by Peres Projects Los Angeles Berlin E21

Selected Bibliography

2005 *Jan Kopp: Techniques Rappolder*, Carole Boulbès, Annie Claustres and Jacinto Lageira, isthme éditions, Paris

2004 'Jan Kopp: Monstres, vidéo', Elisabeth Lebovici, *Libération*

2001 'Autriche: état des lieux' (Austria: State of Places), Pierre Daum, *Art Press*

2001 'Jan Kopp', Carole Boulbès, *Art Press*

2000 'Jan Kopp: Déplacement et événement' (Jan Kopp: Movement and Event), Yvane Chapuis, *Parachute*

Jan **Kopp**

Born 1970
Lives Paris

In *Perfectly Strange* (1997) Jan Kopp installed photo-booths in Paris and Tokyo that were linked through the Internet – the user of each booth received photos of the stranger in the other location. More recently, in his film *Monsters (Rep.)* (2003) Kopp's exploration of communicative feedback, staged sociability and *mise-en-scène* centred on a dinner party. Amplified by some post-production time-shifting, the actors appear to speak backwards and to gesture too quickly or too slowly. Kopp's practice meddles with the synchronicity of experience as it remixes the phatic devices and linguistic structures that underlie the transmission of cinema, theatre and unrehearsed life. (MA)

Shown by Galerie Maisonneuve H9

Selected Exhibitions

2004 'Monstres et Spectres', Galerie Maisonneuve, Paris

2003 'Remake', CAPC Musée d'Art Contemporain, Bordeaux

2002 'Hortus Ludi', Maress, Art Centre, Maastricht

2001 'Traversées', Musée d'Art Moderne de la Ville de Paris

2001 'Exits', Kunsthalle, Tirol

2001 Lyon Biennial

2000 'Clockwork 2000', PS1 Contemporary Art Center, New York

1999 'Vox Kultur Stiftung', MAK, Cologne

1997 'Perfectly Strange', Centre National de la Photographie, Paris

1994 'Mohnfeld am Potsdamer Platz', Berlin

*Sir-Eat-a-Lot and Pause Boy
Face a Moment of Truth*
2002
Ink and watercolour on paper
150×200cm
Courtesy Giò Marconi

Selected Bibliography

2004 '26. Biennale von
São Paulo: Geschichte der
Ausstellung und Thesen des
Kurators' (26th São Paulo
Biennial: The Story of the
Exhibition and the Curators'
Theses), Hajo Schiff,
Kunstforum

2004 *Jukka Korkeila:
Heavyweight/Jukka Korkeila:
Doubting Thomas*, Angela
Rosenberg, Otava Publishing,
Keuruu

2004 'Painting as a Tool
against Prejudice: Interview
with Jukka Korkeila', Kari
Immonen, *The Finnish Art
Review*

2002 'Paint It Black.
Painting as a Zombie
Medium', Mika Hannula,
Flash Art International

Selected Exhibitions

2004 São Paulo Biennial

2003 'Honey Bear Care
Centre', Uppsala Konstmuseum

2001 'Ars 01', Kiasma Museum
of Contemporary Art, Helsinki

2001 'Make Me Feel: Eight
Statements from the Nordic
Region', Art Athina 2001,
Helexpo Exhibition Centre,
Athens

2000 'Det fluktuerende maleri',
Sorlandets Konstmuseum,
Kristiansand

1999 'Trouble Spot Painting',
MUHKA, Antwerp

1999 'Young Artist of the Year',
Tampere Museum

Jukka **Korkeila**

Born 1968
Lives Helsinki

Jukka Korkeila's paintings reveal a bacchanalian
temperament unchecked by politeness. The images
burst forth their bloated figures, engorged genitals
and paint smeared like filth with cathartic vigour,
yet they are executed with a wink at art history.
Baroque, German Expressionism, comic-book
ribaldry, pornography and rude Pop collide in
huge wall paintings and smaller works on paper,
their imagery evoking a psychological geyser of
signs from the murkier depths of a disturbed psyche
that perhaps lurks within each of us. (SO'R)

Shown by Giò Marconi F10

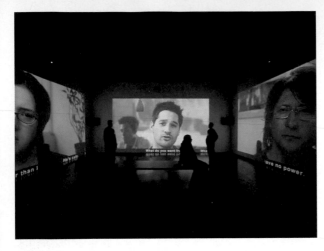

Twelve
2004
Video installation with four projectors
Duration 15 minutes
Courtesy Sprüth Magers Lee

Barbara **Kruger**

Born 1945
Lives New York

Barbara Kruger's bold, graphic text-and-image works – slipped like politically charged Dadaist slogans onto everything from billboards and posters to T-shirts, postcards and the sides of buses – slyly exploit the vocabulary and visual techniques of commercial art and political discourse, laying bare the manipulated disconnect between what you see and what you get. Even an innocuous list can read as both promise and threat: in an untitled work from 2003, superimposed over a photo of a leopard's bared fangs, run the words 'another artist, another exhibition, another gallery, another review, another career, another life', streaming like a weary CNN ticker trying to keep pace with an accelerated, amnesiac art world. (JT)

Shown by Yvon Lambert F6, Sprüth Magers Lee B13

Selected Bibliography

2003 *Barbara Kruger*, Sprüth Magers, London

2002 *Barbara Kruger*, Palazzo delle Papesse–Centro Arte Contemporanea, Siena

1999 *Barbara Kruger*, Museum of Contemporary Art, Los Angeles

1996 *Love for Sale: Words and Pictures of Barbara Kruger*, Abrams, New York

1994 *Remote Control: Power, Cultures and the World of Appearances*, MIT Press, Cambridge

Selected Exhibitions

2005 Gallery of Modern Art, Glasgow

2005 'Twelve', Tramway, Glasgow

2004 Sprüth Magers Lee, London

2004 'The Last Picture Show: Artists Using Photography, 1960–82', UCLA Hammer Museum, Los Angeles

2003 'Double Wall Projects 02', Ludwig Forum, Aachen

2002 Palazzo delle Papesse– Centro Arte Contemporanea, Siena

2002 South London Gallery

2002 'Shopping', Tate Liverpool

2000 Museum of Contemporary Art, Los Angeles

2000 Whitney Museum of American Art, New York

From 'Fragments'
2004
Black and white photograph
Courtesy XL Gallery

Selected Bibliography

1998 'L'Idiotie: Esotérisme Fin de Siècle' (Idiocy: The Esoteric at the End of the Century), Jean-Yves Jouannais, *Artpress*

Selected Exhibitions

2005 'Gobi Test', XL Gallery, Moscow

2005 'StarZ', Museum of Modern Art, Moscow

2003 'Horizons of Reality', MUHKA, Antwerp

2003 'Live Culture', Tate Modern, London

2002 'Museum', XL Gallery, Moscow

2001 'Kuliks', Ikon Gallery, Birmingham

2001 'Deep into Russia', S.M.A.K., Ghent

1999 'Red Corner', XL Gallery, Moscow

1997 'I Bite America, America Bites Me', Deitch Projects, New York

1996 'Interpol', Stockholm

Oleg **Kulik**

Born 1961
Lives Moscow

In a 2003 performance at Tate Modern, Oleg Kulik spun down from the ceiling, spangled in hundreds of tiny mirrors: the artist as shamanistic disco ball. The piece – titled *Armadillo for Your Show* – was both an absurdly grand bit of theatre and a send-up of the expectations of Performance art. Kulik's interventions often work this way; he uses his own body as a field to explore the myths and moralities of the art world. Most famously he has turned himself into a human dog – naked, caged, and unpredictable, exported to galleries around the world. As he has commented: 'A Dogman is a dubious figure, who stays outside culture, outside institutions, posing a question as to what institutions are.' (SS)

Shown by Galerie Krinzinger F15, Galeria Filomena Soares E1, XL Gallery E17

Dots Obsession
2000
Installation view
Courtesy Studio Guenzani

Yayoi **Kusama**

Born 1929
Lives Tokyo

Although she has been described as a Minimalist, a Pop-Surrealist and a Performance artist, Yayoi Kusama prefers to describe her art as self-therapy. For 50 years she has channelled her obsessional neurosis into 'driven images' of polka dots, food and sex. Kusama's 'self-obliterating' urge connects her early monochrome paintings with later hallucinogenic environments such as the mirrored room *Endless Love Show* (1966). In the 1960s Kusama achieved notoriety with her numerous nude happenings. However, the 1998 retrospective 'Love Forever: Yayoi Kusama 1958–1968' emphasized her innovation and influence, while also showcasing arresting new works, such as a boat bristling with phallic tentacles entitled *Violet Obsession* (1994). (SL)

Shown by Studio Guenzani E13

Selected Bibliography

2005 *Yayoi Kusama: Eternity–Modernity*, The National Museum of Modern Art, Tokyo

2004 *Kusamatrix*, Mori Art Museum, Tokyo

2001 *Yayoi Kusama*, Les Presses du Réel, Paris

2000 *Yayoi Kusama*, Phaidon Press, London

1998 *Love Forever:Yayoi Kusama 1958–1968*, Los Angeles County Museum of Art

Selected Exhibitions

2005 Ota Fine Arts, Tokyo

2005 'Yayoi Kusama: Eternity–Modernity', The National Museum of Modern Art, Tokyo

2000 Serpentine Gallery, London

2000 Le Consortium, Dijon

1998 'Love Forever: Yayoi Kusama 1958–1968', Museum of Modern Art, New York

1993 Venice Biennale

1982 Fuji Television Gallery, Tokyo

1965 Internationale Galerij Orez, The Hague

1964 R. Castellani Gallery, New York

1962 Green Gallery, New York

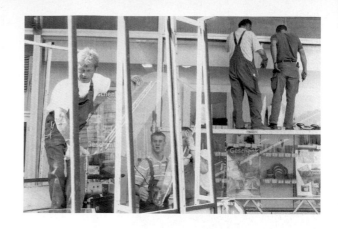

'2. Mai 2002'
(detail)
2002
7 silkscreens
35×53cm each
Courtesy Klosterfelde

Selected Bibliography

2004 *Atomkrieg* (Atomic
War), Antje Majewski, Ingo
Niermann, Kunsthaus,
Dresden

2003 *Gesellschaftsbilder*
(Images of Society),
Madeleine Schuppli,
Kunstmuseum, Thun

2002 'Ulrike Kuschel',
Ralf Christofori, *Kunstforum
International*

2000 'Ulrike Kuschel',
Dominic Eichler, *frieze* 53

1997 *Ortsbegehung 3* (Site
Inspection), Friedrich
Meschede, Neuer Berliner
Kunstverein, Berlin

Selected Exhibitions

2004 'Red Riviera Revisited',
The Red House, Sofia

2004 'Aus aktuellem Anlass',
Johann König, Berlin

2004 'Atomkrieg', Kunsthaus,
Dresden

2003 'Laub', Klosterfelde,
Berlin

2003 'Unbekannte Schwester,
Unbekannter Bruder I',
Kunsthaus, Dresden

2003 'Gesellschafts-
bilder', Kunstmuseum, Thun

2002 'The Berlin Files', De
Chiara Gallery, New York

2001 'Sehnsucht und
Zugehörigkeit', Shedhalle,
Zurich

2000 'Österbotten',
Klosterfelde, Berlin

1999 'Ulrike Kuschel/Maxine
Adcock', Konsthall, Vaasa

Ulrike **Kuschel**

Born 1972
Lives Berlin

Ulrike Kuschel's photography-based practice
explores the legacy of Communism in the former
German Democratic Republic and Eastern Europe.
Whether documenting what remains of the 'Red
Riveria' camping resorts along the Bulgarian
Black Sea coast, or a development in a Berlin park
dedicated to Ernst Thalmann – the Communist
Party of Germany leader executed by the Nazis
– Kuschel's camera witnesses the aftermath of the
ideology of the worker. A 2002 series of men at
work, '2. Mai 2002', pays homage to trade-union
propaganda of the past showing men at work.
In this series, however, the workers are replacing
shopping mall windows that had been shattered
during contemporary Berlin's vandalizing
observance of Labour Day. (MA)

Shown by Klosterfelde A7

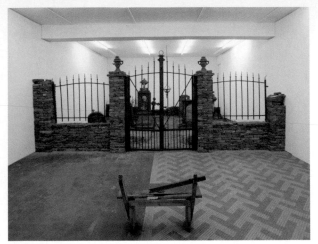

D.O.M.
2004
Mixed media
Dimensions variable
Courtesy Johnen + Schöttle

Robert **Kusmirowski**

Born 1973
Lives Lublin

Robert Kusmirowski's work is steeped in a sense of time passed, in the form of antique furniture, sepia portrait photographs, old newspapers or a decrepit cemetery with dilapidated gravestones. What is not immediately clear, however, is that the objects themselves are as constructed as this atmosphere of Gothic antiquity, being meticulous replicas built from scratch by the artist. The faking process can even implicate the artist himself, as in *Paris–Luxembourg–Leipzig* (2003), for which Kusmirowksi rode a 1920s' bicycle between the cities, documenting his progress with falsified 1920s'-style documents, photographs and press coverage, to create a journey through time as well as space. (KB)

Shown by Foksal Gallery Foundation C14, Johnen + Schöttle D16

Selected Bibliography

2004 'In ewigem Gedenken' (In Eternal Memory), Michal Wolinski, *Fluid–Magazin*

2004 'Einer macht das Licht an' (Someone Turns the Light On), Corinna Daniels, *Die Welt*

2004 'Fünf neue Starten mit geballter Kreativität' (Five New Starts with Concentrated Creativity), Christian Herchenröder, *Handelsblatt*

2004 'Die glorreichen Sieben' (The Glorious Seven), Peter Herbstreuth, *Tagesspiegel*

2004 'Gehn'se mit der Konjunktur' (Let's Go with the Business Cycle), Johannes Wendland, *Zitty*

Selected Exhibitions

2005 Van Abbe Museum, Eindhoven

2005 Kunstverein, Hamburg

2005 Foksal Gallery Foundation, Warsaw

2004 'D.O.M.', Johnen Galerie, Berlin

2004 'Double V', Chronicle Gallery, Bytom

2003 'Double V', CCA Castle Ujazdowski, Warsaw

Untitled
2004
Laserchrome print
Series of 6
129×115cm
Courtesy Gallery Koyanagi

Selected Bibliography

2004 *Luisa Lambri: Locations*, Matthew Drutt, The Menil Collection, Houston

2004 *Luisa Lambri*, Adriano Pedrosa, Coleçao Teixeira de Freitas, Rio de Janeiro

2003 *Living inside the Grid*, Dan Cameron, New Museum of Contemporary Art, New York

2003 *Untitled (Experience of Place)*, Massimiliano Gioni, Verlag Walther König, Cologne

2001 *Luisa Lambri: 34 Questions about Memory and Senses*, Francesco Bonami, Fondazione Sandretto Re Rebaudengo per l'Arte, Turin

Selected Exhibitions

2005 'SANAA', 21st Century Museum of Contemporary Art, Kanazawa

2004 'Vanishing Point', Wexner Center for the Arts, Columbus

2004 'Locations', Menil Collection, Houston

2003 'Dreams and Conflicts: The Dictatorship of the Viewer', Arsenale, Venice Biennale

2003 'Living inside the Grid', New Museum of Contemporary Art, New York

2001 'Chain of Visions', Hara Museum of Contemporary Art, Tokyo

2000 'Contemporary Photography II: Anti-Memory', Yokohama Museum of Art

1999 'dAPERTutto', Arsenale, Venice Biennale

Luisa **Lambri**

Born 1969
Lives Milan

Luisa Lambri photographs the interiors of architectural works by such Modernist giants as Alvar Aalto, Oscar Niemeyer and Le Corbusier. She visits each building a number of times, establishing a relationship with the space and its overlooked details, selecting and framing the nuances of the intimate, emotional narratives of its absent inhabitants. Her lens inveigles its way into the lived space of each building, coaxing out its divergences from the Modernist grid – the organic spill of light or the encroachment of natural forms through a window – reinvesting iconic architecture with human history. (SO'R)

Shown by Marc Foxx C18, Studio Guenzani E13, Gallery Koyanagi E6, Galeria Luisa Strina G7

I'm Drunk with It
2005
Oil on linen
137×182cm
Courtesy Galerie Giti
Nourbakhsch

Sean **Landers**

Born 1962
Lives New York

A few years ago Sean Landers wrote on a painting, 'People think I'm a fucking comedian. Hey, I'm a serious artist for god's sake, look at this painting [...] OK, this painting isn't a good example but I've made lots of serious art before, right?' Funny, narcissistic and obsessed with the idea of genius – other people's and his own – in the early 1990s Landers made diaristic text pieces, paintings, sculptures, videos and sound works dealing with the roller-coaster of anxiety and egotism he was experiencing in his life, his art and the weight of art history. Particularly inspired by Picasso, recently Landers has painted a series of portraits of 20th-century artists such as Ernst and De Chirico. (JH)

Shown by Rebecca Camhi E22, China Art Objects Galleries F13, greengrassi C4, Studio Guenzani E13, Taka Ishii Gallery F4, Galerie Giti Nourbakhsch D4, Andrea Rosen Gallery C3

Selected Bibliography

2005 *Sean Landers: Cartoons*, Regency Arts Press, New York

2004 *Sean Landers*, ed. Beatrix Ruf, JRP Ringier Kunstverlag, Zurich

2004 'Have You Been Thinking of Leaving New York, and, If So, Why?', Sean Landers, *Texte zur Kunst*

2004 'Sean Landers', Sean Landers, *frieze* 83

Selected Exhibitions

2005 Taka Ishii Gallery, Tokyo

2005 Galerie Giti Nourbakhsch, Berlin

2005 'Playtime', Henry Art Gallery, University of Washington, Seattle

2004 Kunsthalle, Zurich

2004 Andrea Rosen Gallery, New York

2003 greengrassi, London

2003 'Influence, Identity and Gratitude (Toward an Understanding of Transgenerational Dialogue as a Gift Economy)', MIT List Visual Arts Center, Boston

2002 Rebecca Camhi Gallery, Athens

2002 'Face/Off: A Portrait of the Artist', Kettle's Yard, Cambridge

2001 'Tele(visions)', Kunsthalle, Vienna

Apparition: The Today Show, NBC, 31 December 2004
2004
Video installation, DVD
Duration 2 minutes, 30 seconds
looped
Dimensions variable
Courtesy Yvon Lambert

Selected Bibliography

2004 'What the World Needs Now...', Jörg Heiser, *frieze* 87

2003 *GNS (Global Navigation System)*, Nicolas Bourriaud, Editions du Cercle d'Art, Paris

2002 *Less Ordinary*, Sungwon Kim, Artsonje Center, Seoul

2001 *Form Follows Fiction*, Jeffrey Deitch, Charta, Milan

1999 *Matthieu Laurette*, Musée d'Art Moderne et Contemporain, Geneva

Selected Exhibitions

2005 'Populism', CAC Vilnius; National Museum of Art, Oslo; Stedelijk Museum Amsterdam; Kunstverein, Frankfurt

2005 'The Today Show', Yvon Lambert, Paris

2003 'Publicness', Institute of Contemporary Arts, London

2003 'GNS (Global Navigation System), Palais de Tokyo, Paris

2002 'Less Ordinary', Artsonje Center, Seoul

2002 'Art and Economy', Deichtorhallen, Hamburg

2001 'Form Follows Fiction', Castello di Rivoli, Turin

2001 'Plateau of Humankind', Italian Pavilion, Venice Biennale

2000 'Au-delà du spectacle', Centre Georges Pompidou, Paris

2000 'Premises', Guggenheim SoHo, New York

Matthieu **Laurette**

Born 1970
Lives Paris

Since 1993, when he first appeared on a French TV game show, Matthieu Laurette has used the media as his means of artistic subversion. For *The Louisiana Repo-Purchase* (2003–4), broadcast by a local TV station, passers-by in New Orleans were asked whether they knew of the possible revocation of the 1803 treaty that legalized the sale of Louisiana by France to the USA – fictional info that, during the Iraq war, toyed with anti-French sentiments. Yet Laurette is never the superior manipulator. He interacts with his subjects at their own level, as if reminding himself of the crucial questions: who's this for, and how does it work? (JöH)

Shown by Yvon Lambert F6

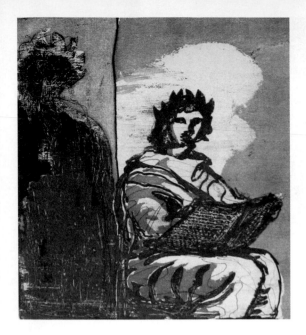

Selected Bibliography

2001 *British and German Contemporary Art*, Alistair Hicks, Deutsche Bank Collection, London

2001 *Contemporary Art in Print*, Patrick Elliot and Jeremy Lewison, Booth-Clibborn Editions, London

2000 *Encounters: New Art from Old*, Richard Morphet, National Gallery, London

1995 *Contemporary British Art in Print*, Patrick Elliot and Jeremy Lewison, Paragon Press, London

1991 *Fifty Etchings*, Stephen Bann, Paragon Press, London

Selected Exhibitions

2005 'Contemporary Voices', Museum of Modern Art, New York

2004 'The Given: Paintings and Watercolors 2000–2004', Marlborough, New York

2004 'Presence', St Paul's Cathedral, London

2003 'Venice Pictures', Galleria Sottoportego, Venice

2003 'The Motif Is Painting Itself', Galerie Fortlaan 17, Ghent

2003 'Representing the World', Frisseras Museum, Athens

2002 Galleri Christian Dam, Copenhagen

2001 'Cloud Metaphor', Pollock Gallery, Dallas

2001 'Paintings, Sculpture, Prints', Marlborough, London

1995 'Four Riders', Fitzwilliam Museum, Cambridge

Christopher **Le Brun**

Born 1951
Lives London

Christopher Le Brun first came to prominence during the 1980s, when his large-scale, semi-abstract canvases were featured in key survey exhibitions such as 'Zeitgeist' (Berlin, 1982) and 'New Art' (Tate, 1983). Works from this period, such as *Dream, Think, Speak* (1981–2), employed a metaphorical and allusive style still apparent in his practice today. Since the early 1990s Le Brun has also been well known for his etchings, lithographs and woodcuts. The printing process, which allows a transparent trace of an earlier print to be incorporated into the next in a series, mirrors the dense accumulation of meanings in his work as a whole. (SL)

Shown by Paragon Press A1

Jack Too Jack's 'Shades of Destructors'
2004
Projection
Courtesy Gavin Brown's
enterprise

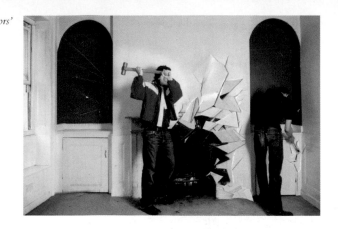

Selected Bibliography

2004 7 *Windmill Street W1*, Migros Museum and JRP/ Ringier, Zurich

2004 'Horror Vacui', Catherine Wood, *Parkett*

2002 'Fiorucci Made Me Hardcore', Frances Summers, *Sleazenation*

2002 'Openings: Mark Leckey', Matthew Higgs, *Artforum*

2001 'Revolutions per Minute', Nathanial Mellors, *frieze 62*

Selected Exhibitions

2004 'Septic Tank', Gavin Brown's enterprise, New York

2004 'Parade', Cabinet, London

2004 'Faces in the Crowd', Whitechapel Art Gallery, London

2004 Manifesta, San Sebastian

2003 Migros Museum, Zurich

2003 'Fast Forward. Media Art Sammlung Goetz', ZKM Centre for Art and Media, Karlsruhe

2003 'The Fourth Sex: The Extreme People of Adolescence', Pitti Imagine, Florence

2002 'Remix', Tate Liverpool

2001 'Century City', Tate Modern, London

2000 'Protest & Survive', Whitechapel Art Gallery, London

Mark **Leckey**

Born 1964
Lives London

Mark Leckey's work is what might transpire if the J.K. Huysmans character Des Esseintes were to trawl through London's late night grime rather than the endless permutations of his own desires. Leckey's carefully tuned videos, sculptures and performances identify a thread that elegantly twists its way around Victorian dandyism, Minimalist sculpture and UK dance music. Together with Ed Liq and Bonnie Camplin, Leckey's performances with the band donAteller meld sample culture with the measured, decadent arrogance of Weimar cabaret. For the performance *Big Box Statue Action* (2003) at Tate Britain he pitted Jacob Epstein's monumental sculpture *Jacob and the Angel* (1940–41) against a sound system of the same dimensions – two sculptures in street corner conversation. (DF)

Shown by Gavin Brown's enterprise D7, Galerie Daniel Buchholz D14, Cabinet E12

Zoe **Leonard**

Born 1961
Lives New York

Probably the most memorable moment of Documenta 9 came when Zoe Leonard hung her own photographs of vaginas alongside the museum's 18th-century paintings of burghers' wives and mythic nymphs in Kassel's Neue Galerie. Typical of Leonard's 1990s' uppity bad-girl style, the installation held up a mirror to the art world and its biases, while chipping away at the visual conventions surrounding gender and taste. Her more recent installations – images of flayed animals shot in the Yukon, a taxonomical display of loved-to-death and discarded dolls – defy the constraints of her *agent provocateur* reputation, while continuing to ask who gets to decide what is beautiful and why. (JT)

Shown by Galerie Gisela Capitain D12, Galería Pepe Cobo E24, Yvon Lambert F6

Selected Bibliography

2002 *Visions from America: Photographs from the Whitney Museum of American Art, 1940–2001*, Whitney Museum of American Art, New York

2001 *Double Life: Identity and Transformation in Contemporary Art*, Sabine Breitwieser, Generali Foundation, Vienna

1998 *Zoe Leonard*, Centre National de la Photographie, Paris

1997 *Zoe Leonard*, Anna Blume, Secession, Vienna

1996 *The Fae Richards Photo Archive*, Zoe Leonard and Cheryl Dunye, Artspace Books, San Francisco

Selected Exhibitions

2003 Wexner Center for Contemporary Art, Columbus

2003 'Mouth Open, Teeth Showing', Museum of Contemporary Art, Siegen

2000 Paula Cooper Gallery, New York

1998 Philadelphia Museum of Art

1997 Secession, Vienna

1993 The Renaissance Society at The University of Chicago

1992 Documenta, Kassel

1990 'Zoe Leonard', Galerie Gisela Capitain, Cologne

2005
Charcoal on paper and
cardboard sculpture
Installation view, Musée d'Art
Contemporain de Rochechouart
Courtesy Art : Concept and
Musée d'Art Contemporain de
Rochechouart

Selected Bibliography

2004 'Andrew Lewis', Bruce Haines, *frieze* 81

2001 '50 Projects in 50 Weeks', Michael Wilson, *Art Monthly*

2001 'Ark Royale with Cheese', *The Guardian*

2001 'Andrew Lewis', Martin Herbert, *Time Out London*

Selected Exhibitions

2005 'Points de Vue', Musée d'Art Contemporain de Rochechouart

2004 'Couronne Imperiale', Art : Concept, Paris

2004 'Photo Opportunities', The New Art Gallery, Walsall

2004 'Systems', The Space, inVIA (Institute of International Visual Arts), London

2002 'White Van Men GB', Galerie Serieuse Zaken II, Amsterdam

2001 'Ark Royale with Cheese', Laurent Delaye Gallery, London

2000 'The Spatial Awareness', Fig-1, London

Andrew **Lewis**

Born 1968
Lives Argenton sur Creuse

Andrew Lewis' 'Points de Vue' (2003) is a series of 45 charcoal drawings of people visiting picture postcard locations such as the Houses of Parliament or the Acropolis. Although in some images his naively drawn characters happily pose for photographs or admire the view, in many something has gone wrong. Couples argue, or lone figures lie exhausted on the ground. Often a barrier, such as a high wall or ornate fence, keeps the visitors at a distance from the attraction. The interaction of architecture and people, a constant theme in Lewis' drawings and sculptures, has developed into a means of describing an atomized society. (SL)

Shown by Art : Concept E2

Anna (Let Me In, Let Me Out)
2005
Oil on canvas
214×275cm
Courtesy Sutton Lane

Selected Bibliography

2005 'The Aesthetics of
Horror and Disgust', Justin
Lieberman, *NYArts*

2005 'Justin Lieberman',
Eliza Williams, *ArtReview*

2005 'Justin Lieberman',
Diana Baldon, *Exit*

2000 'Doubletake', Matthew
Murphy and Joshua Meyer,
artsMEDIA

Justin **Lieberman**

Born 1977
Lives New York

Justin Lieberman's practice exploits the form of the gag or one-liner. His work is characterized by a satirical candour and an aesthetic of cultivated amateurishness. These traits are manifest in his denial of medium-specificity and his complication of technical virtuosity. *Art in the Age of Mechanical Reproduction* (2005) collages gallery cards and private view invitations in an irreverent institution critique. In others, a Punkish veneer references the West Coast junk art legacy – a mock-allegiance testified to in his work's cultured banality and his scepticism towards the idea that the encounter with art will elevate and educate the viewer. (DJ)

Shown by Sutton Lane H3

Selected Exhibitions

2005 'Time and Money',
Sutton Lane, London

2005 'Sutton Lane in Paris',
Galerie Ghislaine Hussenot, Paris

2005 'Reflection Part II',
Sutton Lane, London

2004 'Folk Art is the Work of
Satisfied Slaves', LFL Gallery,
New York

2004 MFA Thesis Show,
Yale University, New Haven

2003 'Today's Man', John
Connelly Presents, New York

2002 'The Dishwasher's Song',
Oni Gallery, Boston

2001 'dis/en/courage',
LFL Gallery, New York

2000 'Futuremaybe', Oni
Gallery, Boston

The Heart
2004
Polyester
60×100×160cm
Courtesy galerie bob van orsouw

Selected Bibliography

2003 *Sportopia*, Jennifer Allen
and Joep van Lieshout, Le
Rectangle, Centre d'Art de la
Ville de Lyon

2002 *Atelier van Lieshout*, J. Allen
Franchise, Openluchtmuseum
Middelheim, Antwerp

2001 *Schwarzes und graues
Wasser* (Black and Grey
Water), Jennifer Allen, BAWAG
Foundation, Vienna

1998 *The Good, the Bad + the
Ugly*, BelBin Associates, Peter J.
Hoefnagels, Bart O. Lootsma,
and Menno J. Noordervliet,
Atelier van Lieshout, NAi
Publishers, Rotterdam

1997 *A Manual*, Piet de Jonge
et al., Museum Boijmans Van
Beuningen, Atelier van Lieshout,
NAi Publishers, Rotterdam

Selected Exhibitions

2005 'Der Disziplinator',
Museum für Angewandte Kunst,
Vienna

2003 Venice Biennale

2003 'Sportopia', Le Rectangle,
Centre d'Art de la Ville de Lyon

2002 Camden Arts Centre,
London

2002 galerie bob van orsouw,
Zurich

2002 'Muscles', Stedelijk
Museum, Schiedam

2001 PS1 Contemporary Art
Center, New York

2001 'Schwarzes und Graues
Wasser', BAWAG Foundation,
Vienna

1999 Museum of Contemporary
Art, Miami

Atelier **van Lieshout**

Born 1963
Live Rotterdam

Atelier van Lieshout (AVL) is a controversial
artistic, design and architecture collective, directed
by its founder, Joep van Lieshout. Since 1995 it has
produced a wide array of experimental sculpture,
interiors and shelters, all characterized by a DIY
ethos, a pragmatic approach and a desire for self-
sufficiency mixed with more than just a touch
of provocation and anarchy – its projects, for
example, include a mobile weapons factory. After
tackling most aspects of domestic interiors, from
compost toilets to a bed for multiple partners, in
2001 AVL established their own free state: AVL-
ville. (DE)

Shown by Tanya Bonakdar Gallery E5, Galerie
Krinzinger F15, Giò Marconi F10, galerie bob van
orsouw D19, Galerie Fons Welters E19

Untitled
2005
Gouache and coloured pencil
on paper
72×53cm
Courtesy Alison Jacques Gallery

Selected Bibliography

2005 *Vitamin D*, Phaidon Press, London

2005 *Works on Paper*, Kirsty Bell, Max Hetzler Galerie, Berlin

2003 *Drawing Now: Eight Propositions*, Laura Hoptman, Museum of Modern Art, New York

2003 *Gesellschaftsbilder* (Images of Society), Peter Gross, Felicity Lunn and Madeleine Schuppli, Kunstmuseum, Thun

2001 *Tailsliding*, Stephen Hepworth and Colin Ledwith, The British Council, London

Graham **Little**

Born 1972
Lives London

Surfaces, for Graham Little, are places with depth. By transcribing style magazine shoots in meticulous colour pencil drawings he underlines the fact that fashion, as a cultural product, thrives most vigorously in the perfect world of the page. (He has commented that 'when you try to bring it into your life by wearing the clothing, it completely flops.') Little's cuboid, MDF constructions are concerned with veneer – mixing and matching polka dots and Paul Smith stripes with *trompe-l'oeil* stonewalling and water droplets. The perfect public sculptures for a shopping mall, they refract consumer desire (and our niggling concerns about 'the real') from every frictionless facet. (TM)

Shown by Alison Jacques Gallery D17

Selected Exhibitions

2005 'Works on Paper', Max Hetzler Galerie, Berlin

2005 Alison Jacques Gallery, London

2005 'Girls on Film', Zwirner & Wirth, New York

2004 'Collage', Bloomberg Space, London

2002 'Gesellschaftsbilder, Kunstmuseum, Thun

2002 Works on Paper Inc., Los Angeles

2002 Camden Arts Centre, London

2002 'Drawing Now: Eight Propositions', Museum of Modern Art, New York

2002 'Now Is the Time', Dorsky Gallery, New York

2001 'Tailsliding', Bergen Contemporary Art Centre

Poem of the River
2005
Steel, found objects, plastic
and paint
229×84×79cm
Courtesy Tanya Bonakdar
Gallery

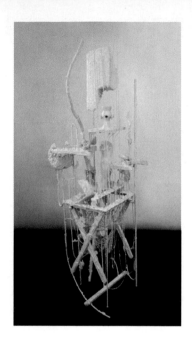

Selected Bibliography

2005 *Charles Long: More Like
a Dream than a Scheme*, Vesela
Sretenovic, David Winton Bell
Gallery, Brown University,
Providence

1997 *Performance Anxiety*, ed.
Amanda Cruz, Museum of
Contemporary Art, Chicago

1996 *Defining the Nineties:
Consensus Making in New York,
Miami, and Los Angeles*, ed.
Bonnie Clearwater, Museum of
Contemporary Art, Miami

Selected Exhibitions

2005 'More Like a Dream than
a Scheme', David Winton Bell
Gallery, Brown University,
Providence

2005 'The Shape of Colour:
Excursions in Colour Field Art',
Art Gallery of Ontario

2004 'Atmosphere', Museum of
Contemporary Art, Chicago

2003 'Happiness', Mori Art
Museum, Tokyo

2001 'Lateral Thinking-
Art of the 1990s', Museum of
Contemporary Art, San Diego

2001 'Arte Contemporáneo
Internacional', Museo de Arte
Moderno, Mexico City

2000 'Media City Seoul
2000', Contemporary Art and
Technology Biennial, Seoul

1999 'Charles Long, Ernesto
Neto, Siobhán Hapaska',
Magasin 3 Konsthall, Stockholm

1998 St Louis Art Museum

1997 Whitney Biennial,
New York

Charles **Long**

Born 1958
Lives Los Angeles

Best known for marrying grotesque biomorphic
form with retro-futuristic Modernist design, in such
works as *The Amorphous Body Study Center*, made
in 1995 in collaboration with the band Stereolab,
Charles Long's recent work has taken a less Space-
Age and more folksy turn. Inspired by his seven-
year-old son's drawings, assemblages such as *The
Direction of My Home* (2003) and *A Slave Chemist*
(2004) have an improvised quality, almost redolent
of the intuitive processes of amateur science. Still
juxtaposing the solidity of plastics and metals with
the softer textures of plaster and papier mâché, his
sculptures exude a sense of gawky playfulness that
attractively offsets more serious formal concerns.
(DF)

Shown by Tanya Bonakdar Gallery E5

Selected Bibliography

2005 'Not-So-Still-Life',
Michael Duncan, *Art in America*

2004 *New Sculpture*, Lisette
Pelsers and Adriaan van
Ravestein, Rijksmuseum
Twenthe, Enschede

1998 *Andrew Lord's Human Touch*,
Jerry Saltz, Johnson Community
College of Art, Overland Park

1995 *Andrew Lord: New Sculpture*,
Maureen Finn and Richard
Shone, Camden Arts Centre,
London

1992 *Poems / Andrew Lord:
Sculptures*, James Schuyler,
Gallery Bruno Bischofberger,
Zurich

Selected Exhibitions

2005 Donald Young Gallery,
Chicago

2004 Paul Kasmin Gallery,
New York

2004 'A Secret History of Clay',
Tate Liverpool

2003 'New Sculpture',
Rijksmuseum Twenthe,
Enschede

2003 'Site and Insight:
An Assemblage of Artists',
PS1 Contemporary Art Center,
New York

2002 'Blur', Stedelijk Museum,
Amsterdam

1998 Johnson County
Community College Gallery of
Art, Overland Park

1996 'New Sculpture',
Camden Arts Centre, London

1995 Whitney Biennial,
New York

1993 Carnegie Museum of Art,
Pittsburgh

Andrew **Lord**

Born 1950
Lives New York

As critical writing on his work often points out,
Andrew Lord is not a ceramicist but a sculptor who
works in ceramics. As that distinction suggests,
he has little interest in the usual concerns of
craft – that is, in creating functional objects. He
instead uses traditional domestic objects as subject
matter and starting-point. Like still life come to
life, Lord's work explores the way familiar forms
occupy, extend and distort space. These complex,
beautifully shaped pots, jars and pitchers speak of
what made them – both the histories their designs
evoke, and the physical history of the artist's hands
on clay. (SS)

Shown by Donald Young Gallery G8

The Ice Caves
2005
Wood, paint
180×180×1cm
Courtesy Sutton Lane

Selected Bibliography

2005 'Camilla Løw',
Michael Archer, *Artforum*

2005 'Camilla Løw',
Diana Baldon, *MAP*

2005 *Contemporary Nordic
Sculpture*, Wanås Foundation,
Knislinge

2004 'Future of Ecstasy:
Carol Bove / Camilla Løw',
Vincent Honoré, *O2*

2004 *Britannia Works*, The
British Council, Athens

Selected Exhibitions

2005 'Contemporary Nordic
Sculpture 1980–2005', The
Wanas Foundation, Knislinge

2005 'Sutton Lane in Paris',
Galerie Ghislaine Hussenot, Paris

2004 Sutton Lane, London

2004 'Britannia Works', The
British Council, Athens

2003 'Echo Show', Tramway,
Glasgow

2003 'Women Men Children',
Transmission Gallery, Glasgow

2003 'East International',
Norwich School of Art and
Design

2002 'The Shadows',
Transmission Gallery, Glasgow

2002 'Greyscale/CMYK',
Tramway, Glasgow

Camilla Løw

Born 1976
Lives Glasgow

Harmonizing the utilitarian abstraction of the
Russian Constructivists with the clean lines and
rational ergonomics of Scandinavian design,
Camilla Løw's sculptures nevertheless have
strongly anthropomorphic qualities. These
brightly coloured objects lean, hang, stand or are
suspended, inhabiting rooms with a loucheness
at odds with their severe Formalist heritage. The
wood and cord sculpture *Viva* (2004), for instance,
dangles and flops to the floor like a marionette
awaiting its puppeteer, while 7 (2004) – comprising
yellow, black and green sheets of Perspex skewered
on a long metal rod – leans precariously against
the wall, as if daring the viewer to enter its highly
sensitized airspace. (DF)

Shown by Sutton Lane H3

Year of the Rooster
2005
Metal structure, mattress,
fluorescent light
213×134×138cm
Courtesy Sadie Coles HQ

Selected Bibliography

2005 *Sarah Lucas: Catalogue Raisonné*, Hatje Cantz Verlag, Ostfildern-Ruit; Tate Publishing, London

2005 *God Is Dad*, Gladstone Gallery, New York

2002 *Sarah Lucas*, Matthew Collings, Tate Publishing, London

2000 *Sarah Lucas: Self Portraits and More Sex*, Victoria Combalia and Angus Cook, Tecla Sala, Barcelona

1996 *Sarah Lucas*, ed. Karel Schampers, Museum Boijmans Van Beuningen, Rotterdam

Sarah **Lucas**

Born 1962
Lives London

Sarah Lucas' self-portraits or scrap-crafted sculptures trade in stereotypes, lewd associations, tawdriness and the cultural clichés of the British working class, with its emphasis on smoking-drinking-pub life, toilet humour and tabloid journalism. One of the brashest of the 'Young British Artists' to emerge in the early 1990s, Lucas has adopted a more meditative and tentative approach in her recent work, though an irreverent humour still underlies it. An upended bed frame adorned with nylon tights and a cement-filled bucket (*Man Versus Human Nature*, 2005) is an elegant, ambiguous sculpture that suggests the metaphysical double bind of body and desire or the meagreness of human relations. (KB)

Shown by Sadie Coles HQ C10, Gladstone Gallery C6

Selected Exhibitions

2005 'God Is Dad', Gladstone Gallery, New York

2005 Kunsthalle, Zurich; Kunstverein, Hamburg; Tate Liverpool

2004 'In-A-Gadda-Da-Vidda', Tate Britain, London

2002 Tate Modern, London

2000 'Sarah Lucas: Beyond the Pleasure Principle', The Freud Museum, London

2000 'Sarah Lucas: Self Portraits and More Sex', Tecla Sala, Barcelona

1997 'The Law', St Johns Lofts, London

1997 Museum Boijmans Van Beuningen, Rotterdam

1997 'Car Park', Ludwig Museum, Cologne

1996 Portikus, Frankfurt

Fänger
(Catcher)
2005
Mixed media on canvas
220×190cm
Courtesy Jablonka Lühn

Selected Bibliography

2005 *Passionate Freud*, Nina Koidl and Ludwig Seyfarth, Salon Verlag, Cologne

2005 'Blumen zum Abschied' (Flowers at the Parting), Uta M. Reindl, *Kunstforum*

2005 'Natur ohne Niedlichkeit im NAK' (Nature without Cuteness at NAK), *Aachener Zeitung*

2005 'Everyday Is Valentine's Day', Kirstin Stremmel, *Stadtrevue*

2005 'Sebastian Ludwig und Christoph Schellberg im NAK', Helga Meister, *Kunstforum*

Selected Exhibitions

2005 Patrick Painter, Inc., Santa Monica

2005 'Ablenkung', Neuer Aachener Kunstverein, Aachen

2005 'Passionate Freud: Romantic Atmospheres and States of Matter', Art Frankfurt

2004 'Every Day is Valentine's Day', Jablonka Lühn, Cologne

2003 Jablonka Lühn, Cologne

2003 'Kunststudenten stellen aus', Kunst-und Ausstellungshalle der Bundesrepublik Deutschland, Bonn

2002 'Merry-Go-Round', Ausstellungsraum c/o Peter Gorschlüter, Karlsruhe

Sebastian **Ludwig**

Born 1977
Lives Dusseldorf

In his recent mixed-media works Sebastian Ludwig presents scenes loaded with symbolic meaning. *Zschawn* (2003) could be an abandoned merry-go-round but seems here somehow forlorn; *Rudel* (2004) shows wolves in a fantasy landscape; and *Meute* (2004) depicts a pack of dogs that have discovered a white sphere in a forest clearing. Rather than placing his images in any specific time or place, and by drawing on visual sources from both the Middle Ages and the Romantics, Ludwig's paintings reveal a world tinged with melancholy, in which things find themselves overgrown and in a state of decay. (DE)

Shown by Jablonka Lühn C16, Patrick Painter, Inc. C2

Post White Pain
2003
Acrylic on canvas
250×186cm
Courtesy Private Collection and
Emily Tsingou Gallery

Selected Bibliography

2004 *Werte Schaffen* (Creating Values), hobbypopMUSEUM, Verlag Walther König, Cologne

2003 *Deutschemalerei-zweitausenddrei* (German Painting 2003), Nicolaus Schaffhausen, Lukas & Sternberg, New York

2002 *hobbypopMUSEUM*, Verlag Walther König, Cologne

1999 'Spiel des Lebens' (The Game of Life), *Post Düsseldorf*

1998 'Keep on Riding', *Forum Kunst*

Dietmar **Lutz**

Born 1968
Lives Dusseldorf/London

Dietmar Lutz is a figurative painter and co-founder, with Sophie von Hellermann, of the hobbypopMUSEUM project. His large paintings are executed in a breezy manner, with thinned acrylic paint in bright colours that soaks into the raw canvas. A studiedly casual air characterizes his subjects, as in the series 'The Journey' (2003), which depicts street views and people on a daily London commute. Although whacked onto the canvas in a laconic and smartly dumbed-down way, his pictures sometimes suggest slow, sunlit days or, as in *Death in Königswinter* (2002), showing a topless man kneeling before a landscape, capture a sense of intelligent bemusement. (DE)

Shown by Emily Tsingou Gallery E3

Selected Exhibitions

2004 'Controfigura', Alberto Peola Gallery, Turin

2004 'Glut', Kunsthalle, Dusseldorf

2004 'Stockwell Observatory', Karyn Lovegrove Gallery, Los Angeles

2003 'The Journey', Emily Tsingou Gallery, London

2003 'Deutschemalerei-zweitausenddrei', Kunstverein, Frankfurt

2003 Tache-Levy Gallery, Brussels

2003 'Dirty Pictures', The Approach, London

2002 'Present Future', Artissima, Turin

2002 'Geometry of the Heart', Emily Tsingou Gallery, London

1999 'Site', Neuer Aachener Kunstverein, Aachen

Cadaver Exquisito II
(Exquisite Corpse II)
2005
Newspaper cut-outs on paper
56×75cm
Courtesy Peter Kilchmann

Selected Bibliography

2005 *La Ascención: Jorge Macchi/ Edgardo Rudnitzky*, Adriana Rosenberg, Argentine Pavilion, Venice Biennale

2005 *Musac Colección Vol. I*, Belén Sola, Museo de Arte Contemporáneo de Castilla y León

2003 *Cream 3*, Phaidon Press, London

2003 'Jorge Macchi', Jorge Lopez Anaya, *Revista Lápiz*

2002 *Fuegos de artificio*, Marcelo Pacheco, Galería Ruth Benzacar, Buenos Aires

Selected Exhibitions

2005 'Doppelgänger', Casa Encendida, Madrid

2005 Peter Kilchmann, Zurich

2005 Artpace, San Antonio

2005 'La Ascensión', Argentine Pavilion, Venice Biennale

2005 'Doppelgänger', Galería Ruth Benzacar, Buenos Aires

2005 'The Experience of Art', Italian Pavilion, Venice Biennale

2004 São Paulo Biennial

2004 'Réplica, with Cristian Roman', MUCA Roma, Mexico

2004 'Treble', Sculpture Center, New York

2003 Istanbul Biennial

Jorge **Macchi**

Born 1963
Lives Buenos Aires

Making use of drawing, photography and found materials such as newspapers and atlases, Jorge Macchi takes familiar sign systems and makes them seem strange again. In a Paris street map the heavily bridged River Seine is relabelled as a series of 32 oblong pools, while in *The Speaker's Corner* (2002) quotation marks cut from newspaper headlines are pinned inside a glass box like a collection of butterflies. Despite such semiotic re-routings, Macchi's work still seems bound to the (hopeless) project of finding sense in a senseless world, something to combat the realization that, as the artist has said, 'reality is woven from three threads: knowledge, terror and oblivion'. (TM)

Shown by Peter Kilchmann C22, Galeria Luisa Strina G7

Selected Bibliography

2005 'Goshka Macuga',
Jessica Lack, *Guardian Guide*

2004 'Goshka Macuga',
Sacha Craddock, *Contemporary*

2004 'I Am a Curator',
Paul O'Neill, *Art Monthly*

2003 'Goshka Macuga',
Martin Herbert, *Time Out
London*

2003 'Goshka Macuga',
Pablo Bronstein, *Untitled*

Goshka **Macuga**

Born 1967
Lives London

If Goshka Macuga's art is about taxonomic systems, it is also about curiosity and what happens when we put together things that aren't supposed to fit. Creating cod-museological installations of books, art (her own and others'), souvenirs, scientific implements and unnameable historical gee-gaws, she is perhaps as much a curator as an artist, albeit one who's happily swapped academic 'good practice' for unabashed poeticism. If data, in Macuga's work, are things not so much to be understood and used as to be felt, so much the better. Museums, after all, are where we house memories, and memories rarely come accompanied by a catalogue number or curt explanatory note. (TM)

Shown by Kate MacGarry H8

Selected Exhibitions

2005 Kate MacGarry, London

2005 'The British Art Show',
Hayward Gallery, London and
touring

2004 'Autumn Catalog Leather
Fringes', Kunsthalle, Basel

2004 'Perfectly Placed', South
London Gallery

2003 'Kabinett der Abstraction',
Bloomberg Space, London

2003 'Picture Room', Gasworks,
London

2003 'The Straight or Crooked
Way', Royal College of Art,
London

2002 'The Friendship of the
Peoples', Project, Dublin

2002 'T.O.F.U', Bart Wells
Institute, London

Selected Bibliography

2002 'DeAnna Maganias',
Catherine Cafopoulos, *Artforum*

2002 'DeAnna Maganias,
Tina Sotiriadis, *Art in America*

2001 'DeAnna Maganias',
Marina Fokidis, *Flash Art
International*

Selected Exhibitions

2005 'Expanded Painting',
Prague Biennial

2004 'Twist: Recent Video Art
from Greece', Video Zone: 2nd
International Video Biennial,
Tel Aviv

DeAnna **Maganias**

Born 1967
Lives Athens

Unnerving shifts in scale and references to domestic
life in DeAnna Maganias' installations suggest
a continuing preoccupation with the uncanny.
One piece, for example, is a miniature moving
chair crafted from fabric, clay and an electric
air pump. Another, *Elusive Object of My Fears*
(2001), is a smaller than life-size elevator made
of cardboard and paper. Recent works have also
evoked collective anxieties: for example, a replica
of one floor of an office building, with flickering
imitation flames, in *July 2000* (2000) or an eerily
deserted model of an airport waiting room in *Then
It Will Be . . .* (1999–2001). (KJ)

Shown by Rebecca Camhi E22

2004 'The Mediterraneans',
Museum of Contemporary Art,
Rome

2004 'European Space–
Sculpture Quadrennial', Riga

2004 'Arco Greece 2004:
Contemporary Perspectives in the
Visual Arts', Sala de Consejería
de Cultura y Deportes, Madrid

2003 'Outlook', Athens School
of Fine Arts

2003 Istanbul Biennial

2001 'Vaguely Familiar Places',
Rebecca Camhi Gallery, Athens

2000 'Kiss from Greece', Galerie
Wohnmaschine, Berlin

1999 'Metro: New Trends in
Contemporary Greek Art',
DESTE Foundation, Athens

True Story
2005
Laser-cut aluminium and
steel wire
Dimensions variable
Courtesy Andrew Kreps Gallery

Jan **Mancuska**

Born 1972
Lives Prague

For his installation *Read It* (2004) Jan Mancuska
divided Andrew Kreps Gallery, New York, in two
with a chipboard wall, into which was incised
a text describing various pieces of furniture in
objective, timbre-less language. Through the
holes made by the text, visitors could glimpse
the furniture it described. While the piece (like a
number of the artist's recent works) owed much
to classic Conceptualism, it was complicated by a
fly-in-the-ointment physicality. If Joseph Kosuth
famously made 'art after philosophy', Mancuska
(with his clever, funny piling of tautology on
tautology) makes whatever comes after that.
(TM)

Shown by Andrew Kreps Gallery B14

Selected Bibliography

2005 'Jan Mancuska', Lisa
Pasquariello, *Artforum*

2005 'Jan Mancuska True
Story', Max Henry, *Time Out
New York*

2004 'Jan Mancuska', Sarah
Schmerler, *Art in America*

2004 'Jan Mancuska Read It',
Roberta Smith, *The New York
Times*

2004 'Jan Mancuska', Rachel
Stevens, *Flash Art International*

Selected Exhibitions

2005 'Sutton Lane in Paris',
Galerie Ghislaine Hussenot, Paris

2005 'True Story', Andrew
Kreps Gallery, New York

2005 Czech and Slovak
Pavilion, Venice Biennale

2005 'Jan Mancuska and Jonas
Dahlberg', Kunstverein, Bonn

2004 'Read It', Andrew Kreps
Gallery, New York

2004 'The Ten
Commandments', Deutsches
Hygiene Museum, Dresden

2004 'Time and Again',
Stedelijk Museum, Amsterdam

2004 'Like Beads on an Abacus
Designed to Calculate Infinity',
Rockwell Gallery, London

2003 'Jan Mancuska, Boris
Ondreicka', Centre For
Contemporary Art and NoD
Experimental Space, Prague

2003 Prague Biennial

Untitled (rose)
2004
Pencil on photograph, fireguard,
found mount, picture frame,
bronze rose
65×45×20cm
Courtesy Private Collection,
New Jersey

Selected Bibliography

2003 'Inside Outside', Charles
Darwent, *The Independent on
Sunday*

2003 'Andrew Mania', Jessica
Lack, *Guardian Guide*

2002 'Art à la Mode', Matthew
Collings, *Modern Painters*

2002 'Andrew Mania', Martin
Herbert, *Time Out London*

2002 'Andrew Mania', Sally
O'Reilly, *Art Monthly*

Selected Exhibitions

2005 'Andrzej Mania',
Chisenhale Gallery, London

2005 Vilma Gold, London

2005 'Tears for Fears', Jack
Hanley Gallery, San Francisco

2005 John Connelly Presents,
New York

2005 'Gods & Monsters', Peres
Projects, Los Angeles

2004 'Collage Show (Max Ernst
to the Present Day)', Bloomberg
Space, London

2004 'Inside Outside', Milton
Keynes Gallery

2002 'He Was Kind and Went
By the Name of Almas', Vilma
Gold, London

2001 Bluecoat Gallery,
Liverpool

2000 'Bloomberg New
Contemporaries', Milton Keynes
Gallery

Andrew **Mania**

Born 1974
Lives Bristol

There are few artists who can claim that their
mother encountered a yeti in a Russian forest, or
that their father once rescued Benito Mussolini
from an Alpine prison. Such stories, history and
personal memory are deeply ingrained within
Andrew Mania's concentrated clusters of framed
curios and spindly drawings. His wall installations
evoke a non-specific nostalgia for a generic notion
of cultural heritage, yet in their odd collision of
imagery also generate their own set of myths and
lore. (DF)

Shown by John Connelly Presents A12, Diana
Stigter H14, Vilma Gold D20

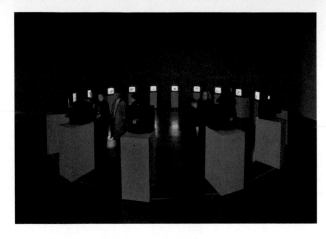

Selected Bibliography

2005 *Christian Marclay*, Kim Gordon, Jennifer Survey, Matthew Higgs, Blaise Cendrars and Christian Marclay, Phaidon Press, London

2004 'Christian Marclay', Philip Sherburne, Ingrid Schaffner and Philippe Vergne, *Parkett*

2004 *Christian Marclay*, Russell Ferguson et al., UCLA Hammer Museum; Steidl, Los Angeles

2003 'Mix-master', Carol Diehl, *Art in America*

2002 'Démonter le cinéma' (Deconstructing Cinema), Yann Bervais, *Artpress*

Christian **Marclay**

Born 1955
Lives New York

The sound of music is not always a pretty thing. Christian Marclay demonstrated this in *Guitar Drag* (2000), a video documenting what happens to an amplified Stratocaster when you haul it behind a pick-up truck down the dirt roads of eastern Texas. The guitar howls and wails like an ecstatic Jimi Hendrix solo – a neat trick until you realize this is where James Byrd was dragged to his death by a truckload of white racists in 1998. The exercise in Concrete music becomes a political act as succinct as they come. Marclay's multi-channel video installation *Shake, Rattle and Roll* (2004) is as anti-music as Fluxus was anti-art; which is to say, not very. (JT)

Shown by Gallery Koyanagi E6, Yvon Lambert F6

Selected Exhibitions

2005 Barbican Art Gallery, London

2004 'The Sounds of Christmas', Tate Modern, London

2003 'Telephones', Sprengel Museum, Hanover

2003 UCLA Hammer Museum, Los Angeles

2002 'The Sounds of Christmas', Museum of Contemporary Art, Miami

2002 'Sampling/Christian Marclay', San Francisco Museum of Modern Art

2001 'Telephones', Museum of Contemporary Art, Chicago

1998 'Freie Sicht aufs Mittelmeer', Kunsthaus, Zurich

1998 'Crossings', Kunsthalle, Vienna

1997 'Pictures at an Exhibition', Whitney Museum of American Art at Phillip Morris, New York

Grandeur et décadence d'un petit commerce de cinéma
(The Rise and Fall of a Small Business in Cinema)
2004
Film still
16mm film transfer
Two-channel DVD projection
Courtesy Galerie Krobath Wimmer

Selected Bibliography

2004 *Dorit Margreiter: 10104 Angelo View Drive*, Matthias Michalka, Museum of Modern Art, Vienna; Verlag Walther König, Cologne

2002 *Dorit Margreiter: Short Hills*, Eva Maria Stadler, Grazer Kunstverein; Revolver, Frankfurt

2001 *Dorit Margreiter: Everyday Life*, Silvia Eiblmayr, Galerie im Taxispalais, Innsbruck; Triton Verlag, Vienna

Selected Exhibitions

2005 'A Certain Tendency', Thomas Dane, London

2005 'Occupying Space: Sammlung der Generali Foundation', Haus der Kunst, Munich; Witte de With, Rotterdam; Museum of Contemporary Art, Zagreb

2005 'Icestorm', Kunstverein, Munich

2004 '10104 Angelo View Drive', Museum of Modern Art, Vienna

2004 Liverpool Biennial

2004 'Shake', Villa Arson, Nice

2003 'Déplacements', Musée d'Art Moderne de la Ville de Paris

2002 'Event Horizon', Galerie Krobath Wimmer, Vienna

2001 'Everyday Life', Galerie im Taxispalais, Innsbruck

1999 'Short Hills', Kunstverein, Graz

Dorit **Margreiter**

Born 1967
Lives Vienna/Los Angeles

For her 16mm piece *10104 Angelo View Drive* (2004) Dorit Margreiter revisited a late Modernist mansion in Beverly Hills designed by John Lautner. With a cool, detached eye the camera scans the space and its spectacular view of L.A. But these static shots are juxtaposed with super-short sequences staged by the Queer performance group Toxic Titties, involving camp doctor games, dildos and world domination conspiracies. The pristine pad becomes a flamboyantly filthy den. Margreiter's interest in the connection between Modernist urban sites, cinema and TV goes beyond the merely amusing, and instead seeks to show how people construct their social identities through cultural products and fictional scenarios. (JöH)

Shown by Galerie Krobath Wimmer H7

Parachute
2005
Oil on canvas
91×72cm
Courtesy Gallery Koyanagi

Kae **Masuda**

Born 1978
Lives Kyoto

Kae Masuda's neo-Pop paintings have a deliberately decorative quality, deploying vivid sky blues, pinks and sap greens in patterns such as stripes and checks. These abstract two-dimensional forms are undercut by the inclusion of representational aspects such as figures skiing or playing badminton. The works' playful nature reflects the emergence of both *kawaii* (cute) and *otaku* (geek) subcultures in postwar Japan. Musada's negotiation of different fictive layers could be seen in a recent painting in which tiny cars raced across a chequered skirt. In others, such as *Circuit* (2002), her use of fixed patterns implies that fashion and leisure operate as distractions within a brilliantly coloured system. (SL)

Shown by Gallery Koyanagi E6

Selected Bibliography

2004 'Kae Masuda', Minoru Otagaki, *Kyoto Shimbun*

2004 'Kae Masuda', Tsukasa Ikegami, *Bijtsu Techo, Bijutsu Shuppan-sha*

Selected Exhibitions

2004 'Fluid Drive', Dohjidai Gallery of Art, Kyoto

2004 Mori Yu Gallery, Kyoto

2004 'Yellow Garden 2', Mori Yu Gallery, Kyoto

2002 Mori Yu Gallery, Kyoto

2002 'Vector 12', CASO, Osaka

2002 'Snow White', Dohjidai Gallery of Art, Kyoto

Night Flower #18
2004
C-print
50×60cm
Courtesy Counter Gallery

Selected Bibliography

2005 *Gareth McConnell*, Tom Morton, British Council/ Finnish Photo Festival, Helsinki

2004 *Gareth McConnell*, Charlotte Cotton, Photoworks/ Steidl, Brighton

2004 *Back 2 Back*, Byam Shaw School of Art, London

2002 *Wherever You Go*, Lighthouse, Poole

Selected Exhibitions

2005 'To Be Continued ...', Hippolyte Gallery, Helsinki

2005 'Les Rencontres d'Arles: Disovery Award', Magasin des Ateliers, Arles

2005 Counter Gallery, London

2004 'Gareth McConnell: Three Projects, 1998–2003', Belfast Exposed Gallery of Contemporary Photography

2003 'Details of Sectarian Murals and Portraits and Interiors from the Albert Bar', Art and Photographs, London

Gareth **McConnell**

Born 1962
Lives London

Gareth McConnell's recent series of photographs 'Night Flowers' (2004) focuses on the flora of municipal spaces – the often overlooked blooms that flourish outside libraries, banks, office buildings and churchyards. Shot at night, using only the sodium luminescence of street lamps (a self-imposed restriction as tough and as profitable as any tenet of Dogme 95), McConnell's flowers become as magical as those that inhabit the neo-medieval fantasy worlds of Burne-Jones. If these works provoke epiphanies, however, they are of a very contemporary sort – the realization that, against all the odds, the public sphere is still somewhere where beauty (and hope) takes root. (TM)

Shown by Counter Gallery E20

Heiligenschein
(Halo)
2005
MDF and steel
Diameter 213cm
Courtesy maccarone inc.

Corey **McCorkle**

Born 1969
Lives New York

The artist Mungo Thompson once wrote that Corey McCorkle's work 'romanticizes the ambition for transcendence, and provides atmosphere for it'. Indeed, McCorkle's installations and objects may allude to New-Age spiritual desires, but they do so with an attention to modern design that reminds us at once how stylish Utopia is supposed to be, and how Utopian Art Nouveau furniture once was. Existing in the space between the pure emptiness of the meditating mind and the bourgeois luxury that often surrounds it, McCorkle insists on art's, and consequently his own, place in this feedback loop of simple function and higher aspiration. (PE)

Shown by Stephen Friedman Gallery D11, maccarone inc. B3

Selected Exhibitions

2005 'Jesus Christ Says She Is the Sun', Kunsthalle, Bern

2005 'Monster Trucks', Marres, Maastricht

2005 'Greater New York', PS1 Contemporary Arts Center, New York

2005 'Make It Now', The Sculpture Center, New York

2005 'Idyll As to Answer That Picture', Middelheim Museum, Antwerp

2004 Kunstverein, Bonn

2003 'Jugendstil', objectif, Antwerp

2003 'Findhorn Pastoral', maccarone inc., New York

2002 Stephen Friedman Gallery, London

Traffic (Our Second Date)
2004
Mixed media sculpture with
cameras, electronics, sound and
live video output
110×127×94cm
Courtesy Postmasters Gallery

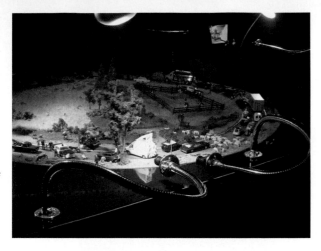

Selected Bibliography

2005 'The Producers', Stephanie
Cash, *Art in America*

2004 *Cut: Film as Found Object
in Contemporary Video*, Stefano
Basilico, Milwaukee Art
Museum

2004 *Our Grotesque*, Rob Storr,
SITE Santa Fe

2004 'Jennifer and Kevin
McCoy', Ken Johnson, *The New
York Times*

2004 *Jennifer and Kevin McCoy:
Transposing Time and Space*, David
Fraenkel, Sala Rekalde, Bilbao

Selected Exhibitions

2005 'How We Met', Galería
1000 Eventi, Milan

2005 'Night Sites', Kunstverein,
Hanover

2004 'Learning to Watch', Sala
Rekalde, Bilbao

2004 'Soft Rains', Postmasters
Gallery, New York

2004 'Cut: Film as Found
Object in Contemporary Video',
Museum of Contemporary Art,
Miami

2004 'Zones of Confluence',
Villette Numérique, Paris

2004 'Our Grotesque', SITE
Santa Fe

2003 'Soft Rains', FACT,
Liverpool

2002 'we like to watch',
Postmasters Gallery, New York

2002 'Love and Terror', Butler
Art Institute, Youngstown

Jennifer and Kevin **McCoy**

Born 1968/1967
Live New York

Over the last ten years the husband–and–wife team
of Jennifer and Kevin McCoy has created works in
a variety of media that turn popular culture in on
itself, exposing the narrative conventions beneath
much television and film. Their omnivorous
deconstruction of genres ranging from slasher flicks
to 'Loony Toons' is as sly as it is cool. In videos,
sculptures, live events and Internet-based projects
the McCoys prey on our unconscious emotional
symbiosis with Pop culture, and reframe the
circular ways in which our desires and fictional
structures construct each other. (PE)

Shown by Postmasters Gallery H12

Orion
2002
Polyester resin, fibreglass and wood
56×100×8cm
Courtesy Galerie Almine Rech

Selected Bibliography

2004 *John McCracken*, S.M.A.K, Ghent

2000 *Rencontres 4: John McCracken* (Encounters 4), Almine Rech/Images Modernes, Paris

1999 *John McCracken*, A Arte Studio Invernizzi, Milan

1995 *John McCracken*, Institut für Museologie, Vienna

1995 *John McCracken*, Thomas Kellein, Kunsthalle, Basel

John **McCracken**

Born 1934
Lives Santa Fe

'My works can be thought of as windows, doorways, visitors [...] or perhaps esoteric, futuristic objects.' John McCracken rose to prominence in the 1960s as part of a generation of artists associated with the first wave of Minimalist sculpture, taking part in the pivotal 1966 exhibition 'Primary Structures' at the Jewish Museum in New York. Best known for his 'planks' – highly polished, resin-coated beams of wood connecting traditional floor-based sculpture with the realm of painting – McCracken has long asserted the transcendental potential latent within his sensuously coloured objects: ' "figures" that exist in the space of our present world in order to speak of that possible world-that-could-be.' (DF)

Shown by Hauser & Wirth Zürich London C9, Lisson Gallery D8, Galerie Almine Rech G1, David Zwirner C11

Selected Exhibitions

2004 S.M.A.K., Ghent

2004 'Singular Forms (Sometimes Repeated): Art from 1951 to the Present', Guggenheim Museum, New York

2004 'Beyond Geometry', Los Angeles County Museum of Art

2000 'Elysian Fields', Centre Georges Pompidou, Paris

1999 'Postmark: An Abstract Effect', SITE Santa Fe

1998 A Arte Studio Invernizzi, Milan

1997 'Continuity and Contradiction', Miami Art Museum

1997 'Chimériques Polymères', Musée d'Art Moderne et Contemporain, Nice

1995 Kunsthalle, Basel

1995 Newport Harbor Art Museum

Graph
2004
Acrylic gouache on canvas
65×100cm
Courtesy Kate MacGarry

Selected Bibliography

2005 *Makeover: Paintings by Seven Pacific Rim Artists*, Charlotte Huddleston, Govett Brewster Art Gallery, New Plymouth, New Zealand

2005 'Peter McDonald', Jessica Lack, *Guardian Guide*

2003 *East International*, Lynda Morris, Norwich Gallery

2003 'East International, Norwich Gallery', Sotiris Kyriacou, *Contemporary*

2003 'Good Bad Taste', Martin Coomer, *Time Out London*

Selected Exhibitions

2005 Kate MacGarry, London

2005 'Makeover', Govett Brewster Gallery, New Plymouth

2005 Gallery Side 2, Tokyo

2004 'Painting', Kate MacGarry, London

2003 'East International', Norwich Gallery

2003 Keith Talent Gallery, London

Peter **McDonald**

Born 1973
Lives London

The characters that populate Peter McDonald's paintings are human enough to do human-enough things – they go to the hairdresser, sit in class and even hug giant blue eggs. Yet their translucent, blob-headed, coloured-coded appearance lends the world they inhabit the quality of a comic-book allegory, conceived as if a teaching aid to illustrate something rather less benign. Judging from the schoolroom scenes depicted in *Teaching* (2004) and *No Answer* (2004), however, the characters seek to explain McDonald's cartoonish chromatic conceit not to us but to themselves. (MA)

Shown by Kate MacGarry H8

Untitled
2005
C-print
13×13cm
Courtesy Nicole Klagsbrun
Gallery

Selected Bibliography

2005 'First Take: Adam
McEwen', David Rimanelli,
Artforum

2004 'Adam McEwen', Roberta
Smith, *The New York Times*

2004 'Adam McEwen', Martha
Schwendener, *Artforum*

2004 'What's So Funny About
Contemporary Art?', Linda
Yablonsky, *ARTnews*

2003 'Best of 2003', Chrissie
Iles, *Artforum*

Selected Exhibitions

2005 'Greater New York',
PS1 Contemporary Art Center,
New York

2004 'History Is a Perpetual
Virgin Endlessly and Repeatedly
Deflowered by Successive
Generations of Fucking Liars',
Nicole Klagsbrun Gallery,
New York

2004 'Let the Bullshit Run a
Marathon', Nicole Klagsbrun
Gallery, New York

2004 'Happy Days Are Here
Again', David Zwirner Gallery
C11, New York

2004 'The Ten
Commandments', Deutsches
Hygiene Museum, Dresden

2003 The Wrong Gallery,
New York

2003 Alessandro Bonomo
Gallery, Rome

2003 'Melvins', Anton Kern
Gallery, New York

2003 'A Matter of Facts', Nicole
Klagsbrun Gallery, New York

2002 'Yes We're Excerpts',
Andrew Kreps Gallery,
New York

Adam **McEwen**

Born 1965
Lives New York

Adam McEwen's tricksterish text-based pieces
seem to point towards an alternative universe
– one much like our own, but not quite the same.
For starters, Malcolm McLaren is deceased: a
convincingly simulated full-page newspaper
obituary memorializes the impresario of
simulation. And in deadpan paintings the sorts of
signs found on the doors of old-fashioned shops
are made to speak in new voices: 'Sorry, We're
Dead', they proclaim, or 'Sorry, We're Sorry'. In
addition to his art-making, McEwen also writes
and curates, and played drums for Martin Creed's
former band Owada. If a common thread unites
these activities, it's a love of words and the off-
kilter rhythms of pop life. (SS)

Shown by Nicole Klagsbrun Gallery G17

Warsepp de Sau
2003
Oil on canvas
60×50cm
Courtesy Stuart Shave | Modern Art

Selected Bibliography

2004 *Képi Blanc Nackt* (The Foreign Legion Naked), Schirn Kunsthalle, Frankfurt

2004 *Albert Oehlen, Jonathan Meese: Spezialbilder* (Albert Oehlen, Jonathan Meese: Special Pictures), Verlag Walther König, Cologne

2002 *Young Americans,* Contemporary Fine Arts, Berlin

2002 *Revolution*, Kestner Gesellschaft, Hanover

Selected Exhibitions

2004 Dommuseum, Salzburg

2004 Schirn Kunsthalle, Frankfurt

2003 Modern Art, London

2003 'Deutschemalerei-zweitausendrei', Kunstverein, Frankfurt

2003 'Grotesk!', Schirn Kunsthalle, Frankfurt

2002 'Young Americans', Contemporary Fine Arts, Berlin

2001 Leo Koenig Inc., New York

2001 'Musterkarte', Galería Heinrich Ehrhardt, Madrid

2000 'Soldat Meese (Staatsanimalismus), Maldoror-Turm', Städtisches Museum Abteiberg, Mönchengladbach

1999 Contemporary Fine Arts, Berlin

Jonathan **Meese**

Born 1971
Lives Berlin/Hamburg

The clandestine codes and rules so beloved of cults are the starting-point for thinking about the work of Jonathan Meese. In these secret organizations, however, Meese finds not strength and glory so much as the forces of regression and the seductive allure of a collective death wish. The atmosphere of his installations could be compared to the otherwordly air of terminal stagnation in Kurtz' camp in *Apocalypse Now*. In his performances Meese feeds his followers mannequins of dead soldiers with canned meat, while he rants about the Holy Grail like a slapstick version of Charles Manson. The true joy of the cult, if you follow Meese, lies in the satisfaction of the priest who, drowsy with fever, rises from his sweaty deathbed to find his church is dying too. (JV)

Shown by Leo Koenig Inc. E25, Galerie Krinzinger F15, Stuart Shave | Modern Art D13

High Life
2003
Wood, enamel paint, plaster, canvas
239×122×11cm
Courtesy Andrew Kreps Gallery

Selected Bibliography

2005 'Greater New York 2005', David Rimanelli, *Artforum*

2004 'Adaptive Behavior', Marcel Krenz, *Flash Art International*

2002 'Mommie Queerest', Jerry Saltz, *The Village Voice*

2002 'Robert Melee: You, Me and Her', Holland Cotter, *The New York Times*

2000 'Robert Melee', Roberta Smith, *The New York Times*

Robert **Melee**

Born 1966
Lives New Jersey

They say there's nothing more American than mom and apple pie. It is hard to say where that leaves Robert Melee and his own mother, whom the artist infamously put on display, dressed as a camp drag queen, at a 2002 opening at Andrew Kreps. Melee's recent multimedia installations and 'home entertainment units' traverse similarly theatrical and often discomfiting terrain, offering eye-popping exegeses of the domestic compulsions and impulses sublimated within suburban décor, or the kind of quasi-autobiographical taboo-breaking once thought reserved for Paul McCarthy and John Waters. (JT)

Shown by Andrew Kreps Gallery B14

Selected Exhibitions

2005 Sutton Lane Gallery, London

2005 'Make It Now: New Sculpture in New York', Sculpture Center, New York

2005 'Greater New York', PS1 Contemporary Art Center, New York

2005 Summer Group Show, Sutton Lane Gallery, London

2004 'Current 31: Robert Melee', Milwaukee Art Museum

2004 'Adaptive Behavior', New Museum of Contemporary Art, New York

2003 Art Statements, Art Basel

2003 'Greetings from New York: A Painting Show', Galerie Thaddaeus Ropac, Salzburg

2000 'Units', Jay Jopling/White Cube, London

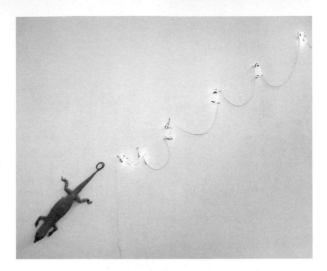

Alligator with Fibonacci Numbers to 377
1971–9
Dimensions variable
Courtesy Gladstone Gallery

Selected Bibliography

2003 *Mario Merz, Obras Históricas: Instalaciones* (Historical Works: Installations), Danilo Eccher, Hopefulmonster, Turin

2000 *Il Gatto Che Attraversa il Giardino è il Mio Dottore* (The Cat That Walks Through the Garden Is My Doctor), Alain Cueff, Daniel Soutif and Guy Tosatto, Hopefulmonster, Turin

1989 *Mario Merz*, Germano Celant, Electa, Milan

1985 *Mario Merz*, Harald Szeemann, Kunsthaus, Zurich

Selected Exhibitions

2003 Fondation Mario Merz, Turin

2003 'Mario Merz, Obras Históricas: Instalaciones', Fundación Proa, Buenos Aires

2000 'Il Fiume Appare, 1986', Galleria Civica d'Arte Moderna e Contemporanea, Turin

2000 'Il Gatto Che Attraversa il Giardino è il Mio Dottore', Carré d'art/Musée d'Art Contemporain, Nîmes

1999 Fundaçao de Serralves, Porto

1996 'Der Iglu, Idee und Installation', Wilhelm Lehmbruck Museum, Duisburg

1990 'Terra Elevata o la Storia del Disegno', Castello di Rivoli, Turin

1989 Guggenheim Museum, New York

1989 Museum of Contemporary Art, Los Angeles

Mario **Merz**

Born 1925
Died 2003

Members of the Arte Povera movement critiqued the culture and politics of the 1960s by radically undermining orthodox hierarchies of technique, material and the permanent object. Mario Merz employed neon lighting, bottles, umbrellas, metal and wax, among other materials drawn from everyday life, to create ephemeral habitats, which were often later adapted into another temporary piece. Merz' most enduring motifs include the igloo – he created improvised structures constructed from and covered with innumerable man-made and organic materials – and the spiral, derived from the Fibonacci number sequence and a symbol of the mystical order of creation and growth. (SO'R)

Shown by Gladstone Gallery C6, Galerie Pietro Spartà G13, Sperone Westwater B19

Selected Bibliography

2004 *Aernout Mik Dipersions*, Jennifer Fisher, Jim Drobnick, Stefanie Rosenthal and Ralph Rugoff, DuMont, Cologne

2004 *AC: Aernout Mik. Dispersion Room/Reversal Room*, Antje von Graevenitz and Gerhard Kolberg, Museum Ludwig, Cologne

2003 *Aernout Mik*, Dan Cameron, Marta Gili and Jorge Wagensberg, Fundació la Caixa, Barcelona

2002 *Aernout Mik: Elastic*, Daniel Birnbaum, Koninklijke Nederlandse Akademie van Wetenschappen, Amsterdam

2002 *Aernout Mik: Reversal Room*, Philip Monk, The Power Plant, Toronto

Aernout **Mik**

Born 1962
Lives Amsterdam

Aernout Mik's silent video loops depict people caught in catastrophes and enacting elaborate rituals. At least, that seems to be what's going on: often it's hard to tell precisely what is occurring in these end- and beginning-less quasi-narratives. The protagonists (if that word is appropriate for such obscurely motivated characters) mindlessly rush or aimlessly wander about their constructed environments, impelled through narrow mazes, escaping toppling buildings and other fabricated disasters. Mik's Absurdist studies of group dynamics occupy a weird place between sociology and vaudeville, and end up feeling like news footage produced by Samuel Beckett. (SS)

Shown by carlier | gebauer F12, Galleria Massimo de Carlo E10, Projectile Gallery E15

Selected Exhibitions

2005 'Refraction', New Museum of Contemporary Art, New York; Museum of Contemporary Art, Chicago

2005 'inSite 2005', San Diego/ Tijuana

2005 'Vacuum Room', Centre pour l'Image Contemporaine, Geneva; Argos, Brussels

2004 Camden Arts Centre, London

2004 'Dispersion Room', Ludwig Museum, Cologne; Haus der Kunst, Munich

2004 São Paulo Biennial

2003 'In Two Minds', Stedelijk Museum, Amsterdam

Look at Me / I Look at Water
2004
Colour photographs
Installation view (detail)
Courtesy XL Gallery

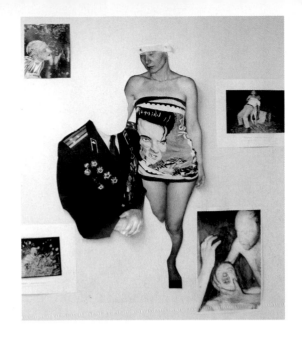

Selected Bibliography

2004 *Soziale Kreaturen: Wie Körper Kunst wird* (Social Creatures: How Bodies Become Art), ed. Patricia Drück and Inka Schube, Sprengel Museum, Hanover

2004 'Boris Mikhailov', Larissa Harris, *Artforum*

2003 *Boris Mikhailov: A Retrospective*, Fotomuseum Winterthur/Scalo

2003 'Best of 2003', Kate Bush, *Artforum*

2000 *Hasselblad Award 2000*, Hasselblad Center for Photography, Gothenburg

Selected Exhibitions

2005 'Look at Me / I Look at Water', Centre de la Photographie, Geneva

2004 'In the Street', Galerie Barbara Weiss, Berlin

2004 Institute of Contemporary Art, Boston

2002 'TV Mania', Galerie Barbara Weiss, Berlin

2001 The Saatchi Gallery, London

2000 Hasselblad Center for Photography, Gothenburg

2000 The Photographers' Gallery, London

1998 Stedelijk Museum, Amsterdam

1998 'Les Misérables (About the World)', Sprengel Museum, Hanover

1995 Portikus, Frankfurt

Boris **Mikhailov**

Born 1938
Lives Berlin/Kharkov

For almost 40 years Boris Mikhailov has been producing photographs of his hometown, the bleak Ukraine city of Kharkov. Often harrowing, sometimes touching or humorous, his images chronicle daily life before and after the collapse of communist rule. Yet Mikhailov is neither a simple documentarian nor a diarist. Working in thematic series, employing a range of strategies and styles, his concerns are essentially Conceptual. Steeped in moral and aesthetic ambiguity, the photographs acknowledge and trouble the artist's own position as an observer and a subject of history. (SS)

Shown by Niels Borch Jensen Gallery H2, Galerie Barbara Weiss C20, XL Gallery E17

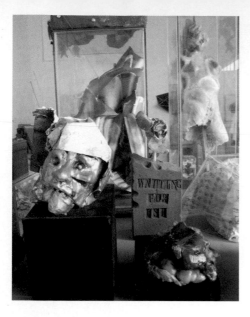

Untitled
2005
Mixed media
Dimensions variable
Courtesy Anton Kern Gallery

Selected Bibliography

2002 'Matthew Monahan', Roberta Smith, *The New York Times*

2002 'Matthew Monahan and Georg Herold', Elizabeth Schambelan, *Art in America*

2002 'New York Cut Up, Massimiliano Gioni, *Flash Art International*

Selected Exhibitions

2005 Anton Kern Gallery, New York

Matthew **Monahan**

Born 1972
Lives Los Angeles

Matthew Monahan's first solo show in New York placed his totemic figure drawings alongside a group of masks from central Africa. His more recent sculptures, most of them portrait heads supported by inventive sorts of assemblage pedestals, feel imbued with the stoic grandeur of such masks. In these works Monahan conjures a cocktail of classical, medieval and Surrealist undertones, which combine to create a powerful, original and often disturbing presence. For Monahan, as for Alberto Giacometti, sculpture is an exercise in drawing, and vice versa: a group of his torqued paper portraits suggests an artist working slowly and deliberately through self-doubt towards a hardened and truthful likeness. (PE)

Shown by Anton Kern Gallery D6, Galerie Fons Welters E19

2002 'Lara Schnitger and Matthew Monahan: Civilized Special Zone', Chinese European Art Centre, Xiamen

2002 'Matthew Monahan and Georg Herold', Anton Kern Gallery, New York

2001 Group exhibition, The Modern Institute, Glasgow

2000 'Matthew Monahan: Gozaimas', Stedelijk Museum Bureau Amsterdam

2000 'Exorcism Aesthetic Terrorism', Museum Boijmans Van Beuningen, Rotterdam

1999 'Matthew Monahan: Like Stink on a Monkey', Archipel, Apeldoorn

1999 'Art Lovers', Liverpool Biennial

1997 Anton Kern Gallery, New York

1997 'Matthew Monahan: Zeno's Quiver', Stedelijk Museum, Amsterdam

Beautiful Legs Come at
Great Expense
2004
C-print
80×60cm
Courtesy Luhring Augustine

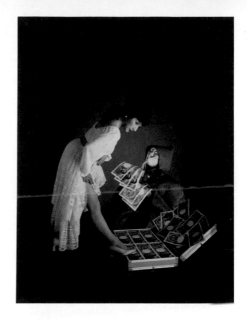

Selected Bibliography

2004 *Photography as Contemporary Art*, Charlotte Cotton, Thames & Hudson, London

2004 *La Certeza Vulnerable: Cuerpo y Fotografía en el Siglo XXI* (The Vulnerable Certainty: Bodies and Photography in the 21st Century), David Pérez, Rústica, Alicante

2004 *History of Japanese Art*, Penelope Manson, Prentice Hall, New York

2004 'What Are You Looking At', Gilda Williams, *Tate Etc.*

Selected Exhibitions

2004 'Los Nuevos Caprichos', Luhring Augustine, New York

2003 'Barco Negro on the Table', MEM, Osaka

2003 'The Artist's Treasures', Shugoarts, Tokyo

2002 'A Story of M's Self Portraits', Kawasaki City Museum

Yasumasa **Morimura**

Born 1951
Lives Osaka

From the *Mona Lisa* and Manet's *Olympia* to screen icons such as Jodie Foster in *Taxi Driver* Yasumasa Morimura has uncannily imitated an array of well-known figures from art history and cinema in his garish, staggeringly convincing photographs. Many of the subjects he impersonates have been female, suggesting his project as an updated version of kabuki. His work invokes gender politics and hybrid identity, but more notably uses performativity to reanimate art-historical questions. Recently Morimura has revisited paintings by Goya, including *The Duchess of Alba*, *Saturn Devouring his Children* and the witches and hanged men in the corrosively satirical series of etchings 'Los Caprichos'. (KJ)

Shown by Galería Juana de Aizpuru C17, Studio Guenzani E13, Luhring Augustine B12, Galerie Thaddaeus Ropac F14

Ball and Socket Woman
2005
Oil on canvas
235×160cm
Courtesy The Modern Institute /
Toby Webster Ltd

Victoria **Morton**

Born 1971
Lives Glasgow

Martin Herbert, writing in *frieze*, described a painting by Victoria Morton as 'a flaming miasma of tangerine, hot pink, crimson and brilliant white that roars diagonally across a mud-dark background, throwing sparks against it – a bunch of carnations igniting on a dying bonfire'. Her vivid, restless paintings reflect a faith not only in the ongoing reinvention of painting but also in the possibilities inherent in abstraction. Morton, who is also a musician, has made it clear that she's interested in applying the ideas of musical composition to painting; she has also written and performed music to accompany her installations of paintings. (JH)

Shown by Gavin Brown's enterprise D7, Sadie Coles HQ C10, The Modern Institute / Toby Webster Ltd B15

Selected Bibliography

2005 *Bonner Kunstverein*, Revolver Verlag, Frankfurt

2003 'The Vortex: Victoria Morton', Martin Herbert, *frieze* 76

2003 *Painting Not Painting*, Will Bradley, Tate St Ives

2002 'Victoria Morton', Moira Jeffrey, *The Herald Magazine*

2001 'Victoria Morton', Polly Staple, *Make*

Selected Exhibitions

2005 Tramway, Glasgow

2005 The Modern Institute / Toby Webster Ltd, Glasgow

2004 'Curiosity Action Crowd', Sadie Coles HQ, London; Kunstverein, Bonn

2003 'Careless Freedom', roma roma roma, Rome

2003 'Blue Dog Tooth', Il Capricorno, Venice

2002 'Plus and Minus', The Fruitmarket Gallery, Edinburgh

2002 'Night Geometry', Gavin Brown's enterprise, New York

2001 Sadie Coles HQ, London

1999 The Modern Institute, Glasgow

Org. (5 poils)
(Org. (5 Hairs))
2004
Felt pen on paper
38×29cm
Courtesy Galerie Chantal
Crousel

Selected Bibliography

2005 *Le tunnel*, Al Dante, Paris

2005 *Entretiens* (Interviews),
Régis Durand, Jeu de Paume,
Paris

2005 *Le Grand Tour: Syrie, Liban,
Palestine*, Jean-Luc Moulène,
Alexis Tadié, Patrick Tosani,
Ange Leccia, Elias Sanbar and
Akram Zaatari, Isthme Editions,
Musée Nicéphore Nièpce, Paris

2004 *Oeuvres*, Alexandre and
Daniel Costanzo, Galerie
Chantal Crousel, Paris

2002 *Jean-Luc Moulène*,
Geneviève Clancy, Catherine
David, Vincent Labaume and
Jean-Pierre Rehm, Hazan, Paris

Selected Exhibitions

2005 Musée du Louvre, Paris

2005 Jeu de Paume, Paris

2005 '(My Private) Heroes',
MARTa museum, Herford

2004 Galerie Chantal Crousel,
Paris

2004 CCA Kitakyushu

2004 'Do You Believe in
Reality?', Taipei Biennial

2003 'Documents d'objets',
Contemporary Art Centre,
Geneva

2003 'Dreams and Conflicts,
The Viewer's Dictatorship',
Arsenale, Venice Biennale

2002 São Paulo Biennial

2002 'Les Heures Immobiles',
Place Bab El Sarail, Saïda

Jean-Luc **Moulène**

Born 1955
Lives Paris

Over the past two decades Jean-Luc Moulène
has developed a practice that is largely based on
photography but also embraces sculpture and
drawing. His recent photographs shoot what could
be Pop motifs (newspapers, packets of Gauloises,
cartoonishly purple aubergines) through a lens
that is chilly, removed and unenamoured of
mass culture. These are not so much images of
something as photo systems competing with other,
more implicated-in-the-spectacle photo systems.
Sophie Berrebi, writing in *frieze*, has said Moulène's
sculptures appear 'more as "relative densities" in
space, as Don DeLillo once described an odd group
of people in a room, than as specific objects'. (TM)

Shown by carlier | gebauer F12, Galerie Chantal
Crousel D10

New York Radio Station Star
2004
Acrylic on paper
95×146cm
Courtesy The Approach and
Blum & Poe

Dave **Muller**

Born 1964
Lives Los Angeles

Dave Muller's art is one of exchange, operating
at a crossroads between producing and curating.
Whether it's his 'Three-Day Weekend' events
– where artists are invited to exhibit for a few days,
hang out, share a beer and listen to music – or a
project trading favourite records for drawings by
the artist, Muller's activities explore how cultural
artefacts accrue social value. Highly detailed,
large-scale watercolours of his record collection
(Muller is an avid music fan) and posters for other
artists' exhibitions site his work within a network
of social reciprocity – perhaps the space where art
really exists. (DF)

Shown by The Approach G3, Blum & Poe G6,
Gladstone Gallery C6

Selected Bibliography

2005 'Dave Muller', Julian
Myers, *frieze* 88

2004 *Playlist*, Nicolas
Bourriaud, Palais de Tokyo,
Paris

2004 'Subject Matters', Scott
Rothkopf, *Artforum*

2002 *Dave Muller: Connections*,
Amanda Cruz and Dave Muller,
Center for Curatorial Studies,
Bard College, Annandale-on-
Hudson

Selected Exhibitions

2005 The Approach, London

2004 'Art Now: Evan
Holloway & Dave Muller',
San Francisco Museum of
Modern Art

2005 Lyon Biennial

2004 Whitney Biennial,
New York

2004 'I Like Your Music',
Blum & Poe, Los Angeles

2004 'Playlist', Palais de
Tokyo, Paris

2004 'A Molecular History of
Everything', Australian Centre
for Contemporary Art, Victoria

2003 'Dave Muller', Murray
Guy, New York

2002 'Dave Muller:
Connections', Center for
Curatorial Studies, Bard College,
Annandale-on-Hudson

2001 'Current 85, Dave Muller:
Spatial', St Louis Art Museum

Form in a Bag
2004
Graphite on paper
36×30cm
Courtesy greengrassi

Selected Bibliography

2005 *Now and Then: Art Now at Tate Britain*, Katharine Stout, Tate Publishing, London

2005 'Living Dust, Norwich Art Gallery', Tom Morton, *frieze* 88

2004 *Recognition*, Michael Archer, ed. Catson Roberts, Arnolfini, Bristol

2003 'Transformer: David Musgrave', Martin Herbert, *frieze* 71

2003 'Fire and Ice', Richard Cork, *New Statesman*

Selected Exhibitions

2005 Marc Foxx, Los Angeles

2005 'Waste Material', curated by David Musgrave, The Drawing Room, London

2004 greengrassi, London

2004 'Living Dust, curated by David Musgrave', Norwich Art Gallery

2003 'Recognition, Anna Barriball and David Musgrave', Arnolfini, Bristol

2003 'Art Now', Tate Britain, London

2002 Transmission Gallery, Glasgow

2001 'Casino 2001', S.M.A.K., Ghent

2001 greengrassi, London

2000 'The British Art Show', Hayward Gallery, London and touring

David **Musgrave**

Born 1973
Lives London

What does it take for an image to be an image? David Musgrave's work rides the liminal threshold of depiction, gently seeking the point at which something – a mark or object – becomes a representation of something else. Games are played with materiality – *Approximate Figure* (2003), for instance, initially looks like scattered, crumpled paper, yet on closer inspection reveals itself to be finely wrought aluminium sheets arranged in a vague semblance of the human form. From the pure physicality of their putty, acrylic or graphite make-up to the point at which they register as schematic figures Musgrave's delicate works are a constant dance across multiple levels of visual legibility. (DF)

Shown by greengrassi C4

2005
Installation view,
Annely Juda Fine Art
Courtesy Annely Juda Fine Art

Selected Bibliography

2005 *David Nash: Pyramids Rise, Spheres Turn, and Cubes Stand Still,* Ian Barker, Annely Juda Fine Art, London

2004 *David Nash: Making and Placing – Abstract Sculpture 1978–2004,* Richard Cork, Tate Publishing, London

1996 *David Nash: Forms into Time,* Marina Warner, Academy Editions, London

1996 *The Sculpture of David Nash,* Julian Andrews, Lund Humphries, London

1994 *David Nash: Voyages and Vessels,* Graham W. J. Beal, Jocelyn Art Museum, Omaha

Selected Exhibitions

2005 'Pyramids Rise, Spheres Turn and Cubes Stand Still', Annely Juda Fine Art, London

2004 'David Nash: Making and Placing – Abstract Sculpture 1978–2004', Tate St Ives

2003 New Art Centre Sculpture Park and Gallery, Roche Court, Salisbury

2001 'Black and Light', Annely Juda Fine Art, London

1996 'Forms into Time 1971–1996', Museum van Hedendaagse Kunst, Antwerp

1994 'Otoineppu: Spirit of Three Seasons', Asahikawa Museum of Art, Hokkaido and touring

1991 'Wood Quarry', Mappin Art Gallery, Sheffield

1990 'David Nash: Sculpture 1971–90', Serpentine Gallery, London

1984 Tochigi Prefectural Museum of Fine Arts, Tochigi-ken

David **Nash**

Born 1945
Lives Blaenau Ffestiniog

David Nash lives and works in an old chapel in north Wales. He makes large, tactile sculptures from wood and fallen or uprooted trees, and uses fire, air and water to transform their surfaces. The artist is a long-time supporter of the environmental movement and has continually explored the relationship between people and nature. To him the tree trunk represents a 'metaphor for wisdom and experience'. Other central elements of Nash's work are the cube, the sphere and the pyramid, which he employs as the starting-point for many of his sculptures and drawings. (JH)

Shown by Annely Juda Fine Art F1

Hreash House
2004
Colour 16mm negative film
transferred to DVCAM
Duration 20mins
Courtesy Counter Gallery

Selected Bibliography

2005 *Over In*, Adam Szymczyk, Kunsthalle, Basel

2005 'Rosalind Nashashibi', Jennifer Higgie, *frieze* 88

2004 'Street Patterns', *Sodium and Asphalt*, Ann Gallagher, British Council

2004 'Rosalind Nashashibi: Temple Bar Gallery, Dublin', Caoimhin Mac Giolla Leith, *Artforum*

2004 'Soft and Strict Strands', Maria Lind, *00TAL*

Selected Exhibitions

2005 'The British Art Show', Hayward Gallery, London and touring

2005 Counter Gallery, London

2005 'Acid Rain', Galerie Michel Rein/Glassbox Galerie, Paris

2004 'Over In', Kunsthalle, Basel

2004 'Art Now', Tate Britain, London

2004 'Sodium and Asphalt: Contemporary British Art in Mexico', MACO, Monterrey

2004 'Songs For Home and Economy', CCA, Glasgow

2003 'Beck's Futures', Institute of Contemporary Arts, London

2003 'Humaniora, Visions for the Future V', Fruitmarket Gallery, Edinburgh

2003 'Zenomap', Scottish Pavilion, Venice Biennale

Rosalind **Nashashibi**

Born 1973
Lives Glasgow

Rosalind Nashashibi's films and videos explore the patterns and rhythms of the everyday, the non-event or the seemingly inconsequential, in Palestine, Scotland or the USA. Except in the titles she gives her works, her intentions are never made explicit and, despite their duration, none of her films has a real beginning or end. Importantly, Nashashibi never translates or subtitles. In an age of overdetermined art experiences, pretentious explanations and dramatic news footage her work appeals to those aspects of our intelligence that are fuelled by empathy and recognition of common ground, despite geographical, cultural or linguistic differences. (JH)

Shown by Counter Gallery E20, doggerfisher A10

The Disappearance of Gustav
2005
Oil on canvas
148×117cm
Courtesy Maestro Collection,
Los Angeles, and Klemens Gasser
& Tanja Grunert, Inc.

Elizabeth **Neel**

Born 1975
Lives New York

Elizabeth Neel has developed a signature style
of painterly abstraction, which she uses to create
visually aggressive, just recognizable disaster
scenes. In works such as *Strung Up* (2005) and
Flushed Out (2005) paint appears to gush from
the canvas. Neel works with gesture and colour,
revisiting Expressionistic tactics and breathing
new life into familiar visual tropes. Her portraits of
mangled carcasses, broken trees and abandoned
junk reference such painters as Rembrandt, Chaim
Soutine and Francis Bacon. Neel also creates video
works in collaboration with her brother Andrew.
These include studies of car crashes and bull-
riding, furthering her exploration of the haunting
presence of trauma, violence and death. (DJ)

Shown by Klemens Gasser & Tanja Grunert,
Inc. C21

Selected Bibliography

2005 'A Branch of a Truly
American Tradition', David
Cohen, *The New York Sun*

Selected Exhibitions

2005 Klemens Gasser & Tanja
Grunert, Inc., New York

2005 Central Utah Art Center,
Ephraim

2005 'Flower Power',
Klemens Gasser & Tanja
Grunert, Inc., New York

2005 'Catch & Carry',
Volume Gallery, New York

Massaidorf
(Masai Village)
2005
Oil on canvas
210×150cm
Courtesy Hauser & Wirth Zürich
London

Selected Bibliography

2005 *Gespräche über die Arbeit* (Conversations about Work), Scalo, Zurich/London

2004 *Leben mit Kunst* (Living with Art), Hatje Cantz Verlag, Ostfildern-Ruit

1995 *Caro Niederer: Öffentliche und Private Bilder* (Caro Niederer: Public and Private Images) Oktagon Verlag, Stuttgart

Selected Exhibitions

2005 Haus Lange, Krefeld

2005 'Conversations about Work', Hauser & Wirth, Zurich

2004 'Living with Art', Ikon Gallery, Birmingham

2004 'Living with Art', Kunstmuseum, St Gallen

2003 'Memoria e Valore', Le Case d'Arte, Milan

2001 'Interieurs: Leben mit Kunst', Galerie Brigitte Weiss, Zurich

Caro **Niederer**

Born 1963
Lives Zurich

Although Caro Niederer is essentially a painter, her interest lies just as much in the process of translation through which a source image becomes a painting, or in the journey a work makes from studio to private collection. A recent series of loosely sketched monochromatic paintings is based on family photographs – children playing on the beach, or a snowy mountain landscape – while an ancillary series entitled 'Interior Photographs' documents the images' incorporation in the domestic settings of friends or collectors. Niederer is fascinated by these shifts through various degrees of the personal, from private snapshot to intimate act of painting, to owned object. (KB)

Shown by Hauser & Wirth Zürich London C9

Jockum Nordström

Born 1963
Lives Stockholm

Uncanny, ambiguous and graphically inventive, Jockum Nordström's pencil drawings and mixed-media collages have been compared to single-frame storyboards combining multiple scenes. In the nocturnal landscape of *The Architects* (2001), for example, a woman perched on an architectural model plays a violin while a couple has sex in the foreground. Nordström's influences include Folk art, Surrealism, Lukas Cranach and James Ensor, but he generates his own iconography: ships, carriages, owls, archaically garbed figures and musical instruments appear with deadpan frequency. He has created album covers, children's books and animated films, but he says, 'When I make my artwork, I never think about the observers. I'm working inwards.' (KJ)

Shown by Galleri Magnus Karlsson B2, David Zwirner C11

Selected Bibliography

2005 *A Stick in the Wood*, Texts by Annika Gunnarsson et al., Steidl, Göttingen

2005 'Jockum Nordström', Melissa Gronlund, *frieze* 89

2003 *International Paper*, UCLA Hammer Museum, Los Angeles

2003 *Jockum Nordström: Between the Table and the Legs*, Dorothy Spears and Marten Castenfors, Galleri Magnus Karlsson, Stockholm

2002 *Drawing Now: Eight Propositions*, ed. Laura Hoptman, Museum of Modern Art, New York

Selected Exhibitions

2005 'Jockum Nordström: A Stick in the Wood', Moderna Museet, Stockholm

2004 'Pin-Up: Contemporary Collage and Drawing', Tate Modern, London

2004 Galleri Magnus Karlsson, Stockholm

2003 David Zwirner, New York

2003 'Poetic Justice', Istanbul Biennial

2003 'International Paper', UCLA Hammer Museum, Los Angeles

2002 'Drawing Now: Eight Propositions', Museum of Modern Art, New York

1999 'Beckers Artist Prize', Wetterling Gallery, Stockholm

Triangulation: Remaking Tarzan
2003
3 video projections, 3 DVD
players and 3 rear-projection
screens
Each side 200×266cm
Courtesy the artist

Selected Bibliography

2004 'Crying Wolf', John
Welchmann, *Flash Art
International*

2003 *8th International Istanbul
Biennial*, Sakir Eczacibasi,
Istanbul Foundation for Culture
and Arts, Istanbul

2003 'Mexico's New Wave',
Malcolm Beith, *Newsweek*

2002 *Mexico City: An Exhibition
about the Exchange Rates of Bodies
and Values*, Klaus Biesenbach,
PS1 Contemporary Art Center,
New York; Kunst-Werke, Berlin

2002 *California Biennial*,
Irene Hofmann, Culture
Ministry, Los Angeles

Selected Exhibitions

2004 'HCI', Galería Enrique
Guerrero, Mexico City

2004 'Adaptative Behavior',
New Museum for Contemporary
Art, New York

2003 Istanbul Biennal

2003 ICP International Triennal
of Contemporary Photography,
New York

2003 'Mexico City: An
Exhibition about the Exchange
Rates of Bodies and Values', PS1
Contemporary Art Center, New
York; Kunst-Werke, Berlin

2002 'Pictures of You', Americas
Society, New York

2002 'ALIBIS', Centre Culturel
du Mexique, Paris

2002 Witte de With, Rotterdam

2001 'Policies of Differences:
End of the Century
Iberoamerican Art', Generalitat
Valenciana, Valencia

Yoshua **Okon**

Born 1970
Lives Los Angeles/Mexico City

The inequity, crime and rampant corruption
marking Mexico provide the working leitmotiv
for Yoshua Okon, whose videos and performances
– like a series of wry pseudo-sociological
experiments executed for the camera – document
a blend of staged and unscripted situations. For
Oríllese a la Orilla (1999–2000), Okon convinced
bribe-hungry cops to perform silly and humiliating
tasks (dancing, telling off-colour jokes) for paltry
200-peso payoffs. In *Coyoteria* (2003), Okon
spoofed Joseph Beuys' cohabitation with a coyote
by spending a day confined with a hired human
'coyote' (Mexican slang for the unsavoury
middlemen who smuggle migrants across the US-
Mexican border). (JT)

Shown by Galería Enrique Guerrero B10, galleria
francesca kaufmann C19, Projectile Gallery E15

Passage
500 Japanese steel workers were
given chocolates and asked to mould
sculptures from silver foil wrappings
after eating the chocolates
2004
Silver foil sculptures, wooden
table, paint
350×600×90cm
Courtesy Galerie Martin Janda

Selected Bibliography

2005 *Roman Ondák*, Kölnischer
Kunstverein/Walther König
Verlag, Cologne

2005 'Taking a Line for a
Walk', Jan Verwoert, *frieze* 90

2005 'First Take', Jessica
Morgan, *Artforum*

2004 'Roman Ondák', Catrin
Lorch, *frieze* 85

2003 *Cream3*, Phaidon Press,
London

Roman **Ondák**

Born 1966
Lives Bratislava

Roman Ondák produces conceptual interventions
in everyday life. For *Good Feelings in Good Times*
(2003) he had a queue form outside the gallery
for half an hour every afternoon of his exhibition,
highlighting a ritual that epitomizes both normal
life and the breakdown of that normality – for
example, when people stand in line for items in
short supply. In *Occupied Balcony* (2002) Ondák
hung a Persian rug over the main balcony of Graz
Town Hall, blurring the boundaries between
images of the bourgeois interior and projections
of the cultural other. Through such moments of
instability Ondák questions the structures and
patterns by which politics inscribes itself into
everyday life. (JV)

Shown by Galerie Martin Janda A13

Selected Exhibitions

2005 Tate Modern, London

2005 Galerie Martin Janda,
Vienna

2005 'Universal Experience',
Museum of Contemporary Art,
Chicago

2004 'Passage', CCA,
Kitakyushu

2004 'Spirit and Opportunity',
Kunstverein, Cologne

2004 'Time and Again',
Stedelijk Museum, Amsterdam

2003 'Utopia Station', Arsenale,
Venice Biennale

2002 'I Promise It's Political',
Ludwig Museum, Cologne

2001 'Ausgeträumt ...',
Secession, Vienna

2000 Manifesta, Ljubljana

Coda
2003
C-print
79×63cm framed
Courtesy Gladstone Gallery

Selected Bibliography

2004 *Whitney Biennial 2004*, Chrissie Iles, Shamim M. Momin and Debra Singer, Whitney Museum of American Art, New York

2002 *Catherine Opie: Skyways + Icehouses*, Douglas Fogle, Walker Art Center, Minneapolis

2000 *Catherine Opie*, Kate Bush, Joshua Decter, Russell Ferguson, The Photographers' Gallery, London

1997 *American Art 1975–1995 from the Whitney Museum: Multiple Identity*, Castello di Rivoli/ Charta, Milan

Selected Exhibitions

2004 'Surfers', Regen Projects, Los Angeles; Gorney, Bravin & Lee, New York; Stephen Friedman Gallery, London

2004 'Children', Studio Guenzani, Milan

2002 'Catherine Opie: Icehouses', Regen Projects, Los Angeles; Studio Guenzani, Milan

2002 'Opie: Skyways and Icehouses', Walker Art Center, Minneapolis

2001 'Wall Street, London', Stephen Friedman Gallery, London

Catherine **Opie**

Born 1961
Lives Los Angeles

Working within the traditions established by photographers such as Eugène Atget, Edward Weston and Robert Frank, and interested in the divisions and collisions of personal and collective identities, Catherine Opie's approach to taking photographs could be described as 'cultural portraiture'. Her series of queer portraits and American landscapes include large colourful images of homes in Los Angeles, delicate silver gelatin prints of freeways, ice-fishing houses and architectural elements in and around the Twin Towers in New York, road trips through the American hinterland and pictures of surfers taken in the faintly misty early morning. (JH)

Shown by Stephen Friedman Gallery D11, Gladstone Gallery C6, Studio Guenzani E13

Rivière blanche
(White River)
2004
Murano glass, aluminium
350×100×30cm
Courtesy Galerie Emmanuel
Perrotin

Selected Bibliography

2005 *Le petit théâtre de peau d'âne*
(Donkey Skin), Pierre Loti/
Jean-Michel Othoniel, L'Oeil,
Paris

2004 'Contrepoint',
Connaissance des arts

2003 'La beauté piégée'
(Entrapped Beauty), Natacha
Wolinski, *Beaux-Arts*

2003 *Crystal Palace*, Fondation
Cartier, Paris

1999 'The Interpretation of
Desires', Edmund White, *Parkett*

Jean-Michel **Othoniel**

Born 1964
Lives Paris

Not many can claim to have Catherine Deneuve
as a contributor to their exhibition catalogues.
Inspired by the dandyesque *fin-de-siècle* writer Pierre
Loti, Michel Othoniel restaged the fable 'Donkey
Skin' in exuberant fashion, using embroidered
fabric and colourful handmade glass (*Le petit théâtre
de peau d'âne*, 2004). (Deneuve, who played the
princess in Jacques Demy's 1970 film version of the
story, praised Othoniel's flamboyant four-poster
bed.) While his glass designs make King Ludwig
of Bavaria and Enzo Gucci look like restrained
puritans, Othoniel says he's heavily influenced by
the private gardens of Outsider artists: 'My desire
to hang necklaces from the branches of trees comes
from these naive representations of Eden.' (JöH)

Shown by Galerie Emmanuel Perrotin D3

Selected Exhibitions

2005 'Le Petit théâtre de peau
d'âne', Théâtre du Chatelet,
Paris

2005 Galerie Emmanuel
Perrotin, Paris

2004 'House of Glass', Museum
of Contemporary Art, Miami

2004 'Contrepoint', Musée du
Louvre, Paris

2003 'Crystal Palace',
Fondation Cartier, Paris

2003 'Fragile', Musée des
Beaux-Arts de Reims

2002 'Lágrimas', Museo del
Vidrio, Monterrey

2001 'Collier', Museum Dhondt-
Dhaenens, Deurle

2001 'Heart of Glass', Queens
Museum of Art, New York

2000 'Le Kiosque des
Noctambules', Métro station
Palais Royal: Musée du Louvre,
Paris

Misnomer
2005
Stainless steel
376×488×353cm
Courtesy James Cohan Gallery

Selected Bibliography

2004 *Roxy Paine/Bluff*,
Anne Wehr, Public Art Fund,
New York

2002 *Roxy Paine: Second Nature*,
Joseph D. Ketner, Lynn M.
Herbert and Gregory Volk,
Contemporary Arts Museum,
Houston

2002 'Nature vs. Machines?
There's No Need to Choose',
Steven Henry Madoff, *The New
York Times*

2002 'A Steel Tree in Central
Park? Well, Times Have
Changed', Carol Vogel,
The New York Times

2001 *Roxy Paine*, ed. Elyse
Goldberg and Julia Sprinkel,
James Cohan Gallery, New
York

Selected Exhibitions

2005 'Sculpture', James Cohan
Gallery, New York

2002–3 'Roxy Paine: Second
Nature', SITE Santa Fe;
Rose Art Museum, Brandeis
University, Waltham

2002 James Cohan Gallery,
New York

2002 'Scumaks', Bernard Toale
Gallery, Boston

2001 Museum of Contemporary
Art, North Miami

2001 Christopher Grimes
Gallery, Los Angeles

2001 Galerie Thomas Schulte,
Berlin

1999 Roger Bjorkholmen
Gallery, Stockholm

1998 Musée d'Art Américain
Giverny

1998 Galerie Renate Schroder,
Cologne

Roxy **Paine**

Born 1966
Lives New York

Roxy Paine's work emphasizes the divide between artistic fiction and natural reality, playing with ideas of trickery and simulation. His art-making machine *Scumak* (2001) questions the philosophical implications of art's position between industrial technology and natural creation. Paine is renowned for his giant, public tree sculptures, rendered in reflective stainless steel. Each tree's title is a variation on the theme of deception, including *Placebo* (2004) and *Bluff* (2002). The man-made resilience of the sculptures contrasts poignantly with the replicated breaks and decay included in their structure. (DJ)

Shown by James Cohan Gallery B9

Road Agent
2005
Oil on canvas
244.8×162.6cm
Courtesy Timothy Taylor
Gallery

Selected Bibliography

1999 *Richard Patterson: New Paintings*, James Cohan Gallery, New York

1998 *Head First: Portraits from the Arts Council Collection*, Richard Shone, Art Council Collection, London

1997 *Paintings by Richard Patterson*, Stuart Morgan, Anthony d'Offay Gallery, London

1997 *Sensation:Young British Artists from the Saatchi Collection*, Norman Rosenthal, Royal Academy of Arts, London

Selected Exhibitions

2005 Timothy Taylor Gallery, London

2002 James Cohan Gallery, New York

2001 'Casino 2001', S.M.A.K., Ghent

1998 'Heads First: Portraits from the Arts Council Collection', The City Gallery, Leicester and touring

1997 Anthony d'Offay Gallery, London

1997 'False Impressions', The British School at Rome

1997 'Sensation: Young British Artists from the Saatchi Collection', Royal Academy of Arts, London and touring

1997 'About Vision', Museum of Modern Art, Oxford and touring

1996 'ACE! Arts Council Collection of New Purchases', Hatton Gallery, Newcastle and touring

1988 'Freeze', Surrey Docks, London

Richard **Patterson**

Born 1963
Lives Dallas

Richard Patterson walks a line between painterly abstraction and photographic representation. A photographic image or plastic figurine, often daubed with sumptuous pigment, is photographed and then rendered on canvas with the silkiest quality of paint. The source imagery stems from Pop and contemporary culture – a photograph of Daisy from *The Dukes of Hazzard* or a plastic toy soldier or Minotaur – but is embedded in a myopic depth of field that confounds its original immediacy. (SO'R)

Shown by James Cohan Gallery B9, Timothy Taylor Gallery F2

How to Recover from Hyper Mode
2004
Mixed media
Dimensions variable
Courtesy Herald St

Selected Bibliography

2005 'Nick Relph & Oliver Payne', Agnieszka Kurant, *Flash Art International*

2005 *Raw Cane Sugar*, Cuauhtemoc Medina, Carnegie International, Pittsburgh

2004 *Oliver Payne & Nick Relph:Taschen*, Hans-Ulrich Obrist, Kerber Verlag, Oslo

2003 'West End Boys', Dan Fox and Polly Staple, *frieze* 75

2002 '1000 Words', Michael Wilson, *Artforum*

Selected Exhibitions

2005 Gavin Brown's enterprise, New York

2005 Carnegie International, Carnegie Institute, Pittsburgh

2005 Serpentine Gallery, London

2005 China Art Objects, Los Angeles

2004 'How to Recover from Hyper Mode', Millers Terrace, London

2004 Kunsthalle, Zurich

2004 'Sodio y Asfalto', Museo Tamayo Arte Contemporáneo, Monterrey

2003 'Utopia Station', Arsenale, Venice Biennale

2003 'Days Like These', Tate Britain, London

Oliver **Payne** & Nick Relph

Born 1977/1979
Live New York

Payne and Relph's installations and lyrical films are mordant updates of the 'state-of-the-nation' treatise. Reminiscent of the work of Derek Jarman, Peter Greenaway and Patrick Keillor, their 2000–01 trilogy *Driftwood, House and Garage* and *Jungle* examined city, suburb and countryside. Incisive narrative observation accompanies beautiful and banal imagery, painting a complex portrait of contemporary Britain. *Gentlemen* (2003) focuses on the corporate appropriation of youth subcultures. As Relph said in *frieze*, 'Smashing a Starbucks window has become a lifestyle choice now, so you might as well go full circle: buy a fucking latte, sit down and have a think.' (DF)

Shown by Gavin Brown's enterprise D7, Herald St A8

Back of Evan (Variation #1)
2005
Silicone, hair, pigment,
aluminium
119×109×38cm
Courtesy Sperone Westwater

Selected Bibliography

2003 *Absolutely Unreal*, Nancy Tousley and David Clark, Glenbow Museum, Calgary

2002 'Més enllà de l'hiperrealisme' (Beyond Hyper-realism), Xavier Barral i Altet, *AVUI*

2002 *L. Faux and No One: In Particular*, Xandra Eden, The Power Plant Contemporary Art Gallery, Toronto

2001 'Human, All Too Human', Gary Michael Dault, *The Globe and Mail*

Evan **Penny**

Born 1953
Lives Toronto

Evan Penny's hyper-real sculptures and photographs reflect shifting attitudes towards realism in the digital age. In the 1970s Penny began crafting startlingly detailed and uncanny figurative sculptures, which he would sculpt in clay and then cast in polyester resin or silicone. His recent series remain engaged with realism and echo the diminishing indexical nature of photography. These include 'No One – in Particular' (2001–04), composite portraits of fictitious people, and 'Anamorphs' (1996–7), figures that verge on disappearing because of anamorphic distortion. In the series 'L. Faux' (2000–01) pores, hairs and wrinkles combine with photographic 'mistakes' such as blurring and double exposures. (KJ)

Shown by Sperone Westwater B19

Selected Exhibitions

2005 'Figure It Out', Hudson Valley Center for Contemporary Art, Peekskill

2005 Sperone Westwater, New York

2004 'Absolutely Unreal', Glenbow Museum, Calgary; Museum London, Ontario; Mendel Art Gallery, Saskatoon

2003 Selections from 'L. Faux', Kitchener Waterloo Art Gallery, Ontario

2002 'L. Faux and No One: In Particular', The Power Plant Contemporary Art Gallery, Toronto; Galería Segovia Isaacs, Barcelona

1997 Festival Internacional de Arte Ciudad de Medellín

1995 'Figuring the Body: Three Projects', Trepanier/Baer Gallery, Calgary

1991 'Recent Work', 49th Parallel, New York

Maison Témoin/La Maison d'Elvis
(Model House/House of Elvis)
2004
Colour photograph mounted
using dyasec process on
aluminium
Edition of 7+1AP
120×180cm
Courtesy Galerie Maisonneuve

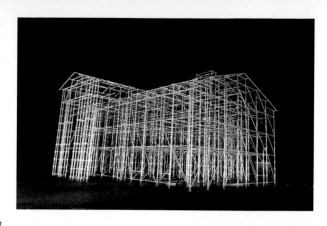

Selected Bibliography

2003 'Alexandre Perigot:
Biennale de Venise', Jacinto
Laqeria, *Parachute*

2003 *Interlude 12/Alexandre
Perigot*, Venice Biennale, Venice

2002 'Les Créateurs qui perçent
le mystère des blondes' (The
Creatures that Pierce the
Mystery of Blondes) Dominique
Frétard, *Le Monde*

2000 *Au-delà du spectacle* (Let's
Entertain), Philippe Vergne,
Walker Art Center, Minneapolis

1999 'Ambiance!', Bernard
Blistène, *Art Press*

Selected Exhibitions

2005 'Maison Témoin/La
Maison d'Elvis', Grande Halle de
la Villette, Paris

2004 'Café des Sports', Galerie
Maisonneuve, Paris

2003 'Dreams and Conflicts:
The Dictatorship of the Viewer',
Arsenale, Venice Biennale

2002 'Radio Popeye', Musée
d'Art Moderne et Contemporain,
Geneva

2001 Lyon Biennial

2001 'Maison Témoin/La
Maison de Dalida', Centre
Georges Pompidou, Paris

2000 'Let's Entertain', Walker
Arts Center, Minneapolis

2000 'Séances de chutes', Neues
Kunstmuseum, Lucerne

1998 'Freestyle', Fondation
Cartier, Paris

1995 'On Tour', Musée d'Art
Contemporain, Marseille

Alexandre **Perigot**

Born 1959
Lives Paris

For his 2002 project *Blondassess* Alexandre Perigot
created a series of haystacks in open fields that
resembled the heads of famous blondes. Formed
from genetically modified hay, his effigies of
Claudia Schiffer, Pamela Anderson and Sharon
Stone spoke not only of the standardization
of ideals of physical perfection but also of the
abandoned notion of the 'artist as peasant'.
Perigot's other projects have included seminars on
suicide and *Café des Sports* (2004), a public sculpture
that replicates the visual experience of drunkenness
in the viewer. While his work confronts the horrors
of the spectacle and our self-harming attempts to
block it out, it does so with a wry grin. (TM)

Shown by Galerie Maisonneuve H9

Selected Bibliography

2005 'The Stage of
Accumulation and
Reproduction', Will Bradley,
Afterall

2002 *Die Dritte Dimension* (The
Third Dimension), H. Fricke,
P. Herbstreuth, A. Nollert and I.
Podeschwa, Portikus, Frankfurt

2002 'Pre-Fabs Sprout: Manfred
Pernice', Jan Verwoert, *frieze* 69

2002 'Manfred Pernice:
Restepfanne', Kirsty Bell,
Camera Austria

1999 'Manfred Pernice', Yilmaz
Dziewior, *Artforum*

Manfred **Pernice**

Born 1963
Lives Berlin

Manfred Pernice translates architecture into
sculpture. He takes standard elements of postwar
Functionalist buildings – the dull cubes and
cylinders of prefab Modernism – and turns them
into sculptures on an architectural scale, made
from chipboard, planks, tiles or concrete. He then
attaches found photos, poems and text fragments
to the surfaces of these pieces, adding a dimension
of social and personal reference. In doing so
Pernice's works reflect the concrete specifics of
the built environment around us while poetically
allegorizing the emotional dynamics of the world
we inhabit. (JV)

Shown by Anton Kern Gallery D6, Mai 36
Galerie D19, Galerie Neu F11, Produzentengalerie
Hamburg E18

Selected Exhibitions

2005 'Die Häßliche Luise',
Galerie Neu, Berlin

2004 Anton Kern Gallery,
New York

2003 Pinakothek, Munich

2003 'Plateau of Humankind',
Italian Pavilion, Venice Biennale

2002 'Restpfanne', Galerie Neu,
Berlin

2002 Documenta, Kassel

2000 Witte de With, Rotterdam

2000 'la-Dosenfeld '00',
Portikus, Frankfurt

2000 'Werkraum 2',
Nationalgalerie im Hamburger
Bahnhof, Berlin

1998 'Platz', Galerie Neu, Berlin

Untitled
2005
Gouache, colour pencil,
antiseptic, eoline on paper
65×50cm
Courtesy Art : Concept

Selected Bibliography

2005 'Secrets and Lies: Philippe
Perrot', Tom Morton, *frieze* 91

2005 'Les secrets de la famille
Perrot' (The Secrets of the
Perrot Family), Didier Ottinger,
Art Press

2004 'Philippe Perrot', Verdier
Evence, *Artpress*

2004 'The New Romantics',
Grace Glueck, *The New York
Times*

1999 'Primitive Passion',
Richard Leydier, *Art Press*

Selected Exhibitions

2005 'The Third Peak', Art :
Concept, Paris

2004 'She's Come Undone',
Artemis Greenberg van Doren
Gallery, New York

2004 'The New Romantics',
Greene Naftali, New York

2003 'The Virgin Show', The
Wrong Gallery, New York

2003 'Today's Man', John
Connelly Presents, New York;
Hiromi Yoshii, Tokyo

2002 'Guide to Trust N°2',
Yerba Buena Center for the Arts,
San Francisco

2002 'Peinture (figure) Peinture',
Cattle Depot Artists Village,
Hong Kong

1999 'Primitive Passion', Palais
des Papes, Avignon

Philippe **Perrot**

Born 1967
Lives Paris

In Philippe Perrot's paintings families act out
fraught, psycho-sexually charged domestic dramas
against acid–yellow grounds (their colour recalls
the powdery compound scattered about the bases
of lamp posts to repel pee-happy dogs). Peppered
with a semi-private iconography that includes
cartoon-faced mushrooms, matches, crucifixes,
gobbets of 16th-century Italian painting and
various phallic comestibles that seem to be being
not so much eaten as enthusiastically fellated,
these images appear born of a Freudian fever
dream. However, with their patent absurdity and
protective, Byzantine icon-like backgrounds,
Perrot's paintings do not so much wallow in
private darkness as ward it off with a laugh – and
perhaps a prayer. (TM)

Shown by Art : Concept E2, John Connelly
Presents A12, Marc Foxx C18

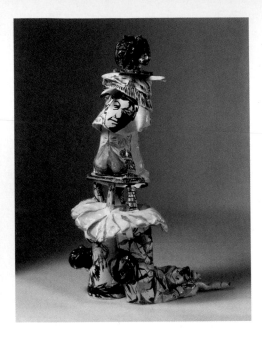

Selected Bibliography

2003 *International Paper*, James Elaine, UCLA Hammer Museum, Los Angeles

2003 'Alessandro Pessoli: Caligola', Roberta Smith, *The New York Times*

2003 'Unplugged', Ali Subotnick, *Work: Art in Progress*

2000 'Drawings: Signs of Change', Alessandro Pessoli, *tema celeste*

2000 'Alessandro Pessoli', Holland Cotter, *The New York Times*

Selected Exhibitions

2005 Chisenhale Gallery, London

2004 Marc Foxx, Los Angeles

2004 'Alessandro Pessoli: Caligola: Film and Drawings', Pollock Gallery, Dallas

2004 'Alessandro Pessoli: The Void Winners', Xavier Hufkens, Brussels

2003 'Alessandro Pessoli: Il gaucho biondo', Studio Guenzani, Milan

2003 'Seriously Animated', Philadelphia Museum of Art

2003 'International Paper', UCLA Hammer Museum, Los Angeles

2002 'Alessandro Pessoli: Sandrinus', Anton Kern Gallery, New York

2002 'Alessandro Pessoli: Caligola', greengrassi, London

1997 'Alessandro Pessoli: One Day to Live', The Drawing Center, New York

Alessandro **Pessoli**

Born 1963
Lives Milan

In Alessandro Pessoli's paintings, drawings and hand-drawn video animations, dark atmospheres and ominous events contrast with colour bursts and imaginative leaps. The artist creates a world driven by dreamlike logic, full of indeterminate intensity and mixed messages. People, animals, aeroplanes, skulls, UFOs, songs and landscapes jostle for attention. *Caligola* (1999–2002), for example, is a ten-minute film in which a cast of animals and people journey through magical landscapes, confronting death, love, suffering and hope in equal measure. (JH)

Shown by Marc Foxx C18, greengrassi C4, Studio Guenzani E13, Anton Kern Gallery D6

Weird Zebra
2005
Plywood and paint
51×131×90cm
Courtesy John Connelly Presents

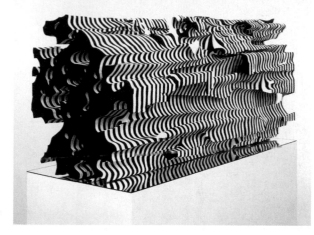

Selected Bibliography

2005 'Ara Peterson', Holland Cotter, *The New York Times*

2005 'Psychedelic Solutions', Paul Laster, *artkrush*

2005 'Jim Drain & Ara Peterson', Abraham Orden, *artUS*

2005 'Arts & Entertainment: Visual Arts: Color Does Wild Dance at the Moore Space', Anne Tschida, *The Miami Herald*

2004 'Gorefest 2004', Robert Nickas, *Vice Magazine*

Selected Exhibitions

2005 'The Wedge', Ratio 3, San Francisco

2005 'Selected Videos 97–05', John Connelly Presents, New York

2005 'Tedious Limbs', Deitch Projects, New York

2004 'Wiggin Village', with Jim Drain, The Moore Space, Miami

2004 'The Transparent Eyeball', Liverpool Biennial

2004 'Bizarre Love Triangle', with Jim Drain and Eamon Brown, Mattress Factory, Pittsburgh

2004 'Curious Crystals of Unusual Purity', PS1 Contemporary Art Center, New York

2003 'It Happened Tomorrow', with Jim Drain and Eamon Brown, Lyon Biennial

2003 'Regarding Amy', Greene Naftali, New York

2003 'Third Annual Roggabogga', as Forcefield, Whitney Museum of American Art, New York

Ara **Peterson**

Born 1973
Lives Providence

Simulation gives way to the real in Ara Peterson's works, which blur the hard-edged and the organic, the crude and the transcendent, the computer-generated and the hand-crafted. *Weird Zebra* (2005) evokes crumpled, disintegrating Op art; Peterson bases such sculptures on synthesized wave formations taken from his video animations. A former member of the Rhode Island–bred Forcefield collective, he has paired with fellow Forcefield provocateur Jim Drain to produce works such as *Untitled (Kaleidoscope)* (2003), a large-scale mirrored video projection that evoked 1960s' era psychedelia and perceptual experimentation. (KJ)

Shown by John Connelly Presents A12

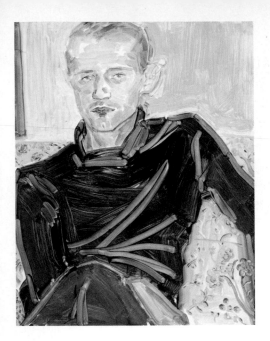

Michael Clark
2005
Monotype on handmade paper
97×76cm
Courtesy Two Palms

Selected Bibliography

2005 'Elizabeth Peyton', Craig Garrett, *Flash Art International*

2004 'Peyton's Place', Dodie Kazanjian, *Vogue*

2003 'Elizabeth Peyton', Tom Morton, *frieze* 75

2002 'Elizabeth Peyton', Edward Leffingwell, *Art in America*

2002 'Elizabeth Peyton', Giorgio Verzotti, *Artforum*

Elizabeth **Peyton**

Born 1965
Lives New York

The subjects of Elizabeth Peyton's portraits positively drip with star quality: her gorgeous friends, Britpop icons, David Hockney, Oscar Wilde, Napoleon – every one is graced with a hypnotizing presence. These mannered, idealized depictions seem to grow naturally out of the artist's predilection for a certain kind of forlorn masculine beauty. She's keen on romantically floppy hair, beseeching eyes and poetically pouting crimson lips. Done in a jewel-toned palette with loose, confident brushwork, her paintings charm and startle with their open declarations of fannish love. Working out of and through her own fascination, Peyton's project is to re-imagine portraiture for a post-Warhol age. (SS)

Shown by Gavin Brown's enterprise D7, Sadie Coles HQ C10, Two Palms H11

Selected Exhibitions

2005 Sadie Coles HQ, London

2004 Gavin Brown's enterprise, New York

2003 Neugerriemschneider, Berlin

2002 Royal Academy of Arts, London

2001 Deichtorhallen, Hamburg

2000 Westfälischer Kunstverein, Munster

2000 Aspen Art Museum

1999 Castello di Rivoli, Turin

1998 Kunstmuseum, Wolfsburg; Museum für Gegenwartskunst, Basel

Desiderata
2004
Single-channel DVD
Courtesy Projectile Gallery

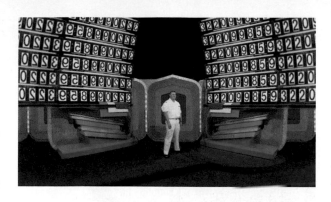

Selected Bibliography

2004 *Paul Pfeiffer*, K21 Kunstsammlung Nordrhein-Westfalen, Hatje Cantz Verlag, Ostfildern-Ruit

2004 'Paul Pfeiffer: The Morning after the Deluge', Gabriel Coxhead, *Contemporary*

2003 *Paul Pfeiffer*, Museum of Contemporary Art, Chicago; MIT List Visual Arts, Cambridge; DAP, New York

2003 'Paul Pfeiffer', Jennifer Gonzalez, *BOMB*

2002 'Paul Pfeiffer', Holland Cotter, *The New York Times*

Selected Exhibitions

2005 'Faces in the Crowd: Picturing Modern Life from Manet to Today', Castello di Rivoli, Turin

2004–5 'Pirate Jenny', The Project/Gagosian Gallery, New York; carlier | gebauer, Berlin

2004 Thomas Dane, London

2004 K21 Kunstsammlung, Dusseldorf

2003 'The Morning after the Deluge', carlier | gebauer, Berlin

2003 Cairo Biennial

2002 'Tempo', Museum of Modern Art, New York

2001 'Orpheus Descending', Project with the Public Art Fund, New York

2001 'Loop', Kunsthalle der Hypo-kultursiftung, Munich

2001 UCLA Hammer Museum, Los Angeles

2000 Whitney Biennial, New York

1998 'Pure Products Go Crazy', The Project, New York

Paul **Pfeiffer**

Born 1966
Lives New York

Digital images are metaphor as much as material for Paul Pfeiffer. Rigorous but multivalent, including allusions to art-historical touchstones, sporting events, cinema and biblical themes, his works in various media explore the subjective states that are obscured or made possible by contemporary image production. In *Fragment of a Crucifixion (After Francis Bacon)* (1999), a looped shot of basketball player Larry Johnson, the star appears to howl in anguish rather than victory. Other resonant subjects have included a dancing Michael Jackson, with his head removed and his torso amorphous, in *Live Evil (Bucharest)* (2004), and real-time footage of wasps building a nest, in *Empire* (2004). (KJ)

Shown by carlier | gebauer F12, Thomas Dane D23, Giò Marconi F10, Projectile Gallery E15

Miss Parkett
2004
5-colour lithograph on Somerset
white paper
66×51cm
Courtesy Parkett Editions

Richard **Phillips**

Born 1962
Lives New York

Richard Phillips' high-keyed realist paintings
are indebted to photography, in particular the
images in fashion and pornographic magazines
from the late 1960s to the early '80s. He is also
very influenced by the paintings of Jack Goldstein.
Phillips groups together seemingly disparate
subjects: for example, Deepak Chopra with Demi
Moore, and German foreign minister Joschka
Fisher alongside a copy of a painting of a squirrel,
a nude and a woman's head covered in semen.
According to Christian Rattemeyer, Phillips
believes in the 'continuing relevance of the grand
gestures of painting, its potential for dissent or
resistance beyond the cynical refusal of skill'. (JH)

Shown by Johnen + Schöttle D16, Parkett
Editions H6, White Cube/Jay Jopling F8

Selected Bibliography

2004 'Richard Phillips',
Diedrich Diederichsen,
Jutta Koether and Christian
Rattemeyer, *Parkett*

2000 *Richard Phillips: Kunsthalle
Zürich*, Bernhard Bürgi and
Ronald Jones, Schirmer/Mosel,
Munich

Selected Exhibitions

2005 'Law, Sex & Christian
Society', Friedrich Petzel
Gallery, New York

2004 'Paintings and Drawings',
Le Consortium, Dijon

2003 'Neue Bilder', Galerie
Max Hetzler, New York

2002 'Birds of Britain', White
Cube, London

2001 'America', Friedrich Petzel
Gallery, New York

2000 Kunsthalle, Zurich

1999 Johnen + Schöttle,
Cologne and Munich

1998 Stephen Friedman Gallery,
London

1997 Shoshana Wayne Gallery,
Santa Monica

1997 'Richard Phillips: New
Paintings', Turner & Runyon
Gallery, Dallas

Self Portrait # 1
2003
Pigment Print
137×112cm
Courtesy Alison Jacques Gallery

Selected Bibliography

2004 *Every Single One of Them*, Twin Palms Publishers, New Mexico

2004 *Whitney Biennial*, Chrissie Iles, Shamim M. Momin and Debra Singer, Whitney Museum of American Art, New York

2003 *Short Stories on Photography*, The Henry Art Gallery, New York

2003 *Self-Portraits*, Cheim & Read, New York

2002 *Jack Pierson: Regrets*, Bonnie Clearwater, Museum of Contemporary Art, Miami

Selected Exhibitions

2004 Alison Jacques Gallery, London

2004 'Self-Portraits', Regen Projects, Los Angeles

2004 Whitney Biennial, New York

2003 Cheim & Read, New York

2003 Galerie Aurel Scheibler, Cologne

2003 'Why Jack Pierson', University of the Arts, Rosenwald-Wolf

2002 'Regrets', Museum of Contemporary Art, Miami

2002 'Electric Dreams', Barbican Art Gallery, London

2002 'Visions of America', Whitney Museum of American Art, New York

2000 'Quotidiana: The Continuity of the Everyday in 20th Century Art', Castello di Rivoli, Turin

Jack **Pierson**

Born 1960
Lives New York

Plangently beautiful, Jack Pierson's photographs, word sculptures, paintings, drawings, installations and collages are as intimate as works by Joseph Cornell. Suffused with over-ripe colour and laced with loss, longing and hints of pleasure, his photographs depict subjects ranging from flowers, naked young men and ageing Hollywood stars to lush landscapes. Pierson's word sculptures, spelling out things like 'betrayal', 'blue' and 'Paradise Lights', recall Ed Ruscha's cool Pop utterances but are more weathered, elegiac and tinged with emotion; they sometimes complement Beat-inflected installations. Recent abstract collages comprising cut-up photographs are both radiant and sensual. (KJ)

Shown by Taka Ishii Gallery F4, Alison Jacques Gallery D17, Galerie Thaddaeus Ropac F14, Galerie Aurel Scheibler G15

Portraits (Manhattan) Volume I
2005
Single-channel film installation
in three parts: *Axis, Sports* and
Hic et Ubique
Dimensions variable
Courtesy Max Wigram Gallery

Selected Bibliography

2004 'John Pilson', Karen
Rosenberg, *frieze* 80

2003 'John Pilson', Neil
McClister, *Artforum*

2003 *Cream 3*, Phaidon Press,
London

2003 'The Digital Vernacular',
John Pilson, *Cabinet*

John **Pilson**

Born 1968
Lives New York

Like anyone who has done a nine-to-five job,
John Pilson gets the creeps in bland offices after
hours. But in Pilson's videos and photographs the
personalities of buildings and the suspected dream-
life of even the most banal work environment
are given voice. In *A la claire fontaine* (2001), in
an otherwise vacant office block, a young girl
is discovered doodling in her own condensed
breath on a window pane. In *St Denis* (2003), a
somnambulant tour of a grand 19th-century New
York hotel turned shabby 21st-century office, the
light fittings and carpeting seem saturated with the
unresolved discontents of past occupants, including
Abraham Lincoln, Lee Harvey Oswald and Marcel
Duchamp. (JT)

Shown by Nicole Klagsbrun Gallery G17, Max
Wigram Gallery G11

Selected Exhibitions

2005 Nicole Klagsburn Gallery,
New York

2004 'John Pilson: Dark
Empire', MW Projects, London

2004 'Simulation City', Centre
pour l'Image Contemporaine,
Geneva

2003 'Altered Spaces: Video
Art and the Physical World',
Cheekwood Museum of Art,
Nashville

2003 'The Moderns', Castello di
Rivoli, Turin

2002 'John Pilson: Clean Lines',
Art Basel

2002 'Moving Pictures',
Guggenheim Museum,
New York

2001 'The Americans', Barbican
Art Gallery, London

2001 'Plateau of Humankind',
Italian Pavilion, Venice Biennale

2000 'John Pilson: Above the
Grid', PS1 Contemporary Art
Center, New York

Beast
2005
Plaster, acrylic and enamel paint
105×27×7cmcm
Courtesy Sorcha Dallas

Selected Bibliography

2004 'Mixed Paint', Matt Price, *Flash Art International*

2004 'J.P Munro, Alex Pollard, Tony Swain', Laurence Figgis, *Untitled*

2003 'Leaving Glasvegas', Neil Mulholland, *Sculpture Matters*

2003 'Scotland Rocks', Michael Bracewell, *Tate Magazine*

Selected Exhibitions

2005 'Selective Memory', Scottish Pavilion, Venice Biennale

2005 'Campbell's Soup', Glasgow School of Art

2005 Krinzinger Gallery, Vienna

2004 'Mourning', Sies & Hoke Gallery, Dusseldorf

2004 'See-Through Mask', Sorcha Dallas (off-site project), Glasgow

2004 Art Statements, Art Basel

2004 Kerlin Gallery, Dublin

2004 'Not in New York', Stux Gallery, New York

2004 'J.P Munro, Alex Pollard, Tony Swain', Transmission Gallery, Glasgow

2003 'Aperto Scotland', Prague Biennial

Alex **Pollard**

Born 1977
Lives Glasgow

Antique articulated rulers (and their plaster cast proxies) dominate Alex Pollard's recent sculptures and collages. In the artist's hands these devices are transformed, variously, into brontosauruses, a Duchampian, staircase-descending *Bureaucrat* (2005) and thought bubbles in the Orwellian *Thought Crime* (2005). While they may be seen as manifestations of the Enlightenment's malevolent, measure-to-manage quality (William Blake's antiseptic vision of Newton comes to mind), they also function as affirmative figures of formal value. For Pollard they are perhaps the perfect symbol – after all, a ruler may gauge, *pace* Blake, both the universe and a grain of sand. (TM)

Shown by Sorcha Dallas A14

Minnesota Road Atlas Series
2005
Ink on printed paper
44×60cm
Courtesy Kerlin Gallery

Selected Bibliography

2002 *The Paradise*, Douglas Hyde Gallery, Dublin

1999 *The End and the Beginning*, Irish Museum of Modern Art, Dublin

1997 *At One Remove*, Henry Moore Institute, Leeds

1997 *Irish Geographies*, Djanogly Art Gallery, Nottingham

Selected Exhibitions

2004 'Aligned', Frith Street Gallery, London

2002–3 'The Paradise', Douglas Hyde Gallery, Dublin

2002 Sydney Biennial

1999–2000 'The End and the Beginning', Irish Museum of Modern Art, Dublin

1999 'Land', Angel Row Gallery, Nottingham

1997 'Art Now', Tate Gallery, London

1997 'Magnetic', Sean Kelly Gallery, New York

1997 'Selections', Drawing Center, New York

1997 'Re-Dressing Kathleen', McMullen Museum of Modern Art, Boston

1997 'Irish Geographies', Djanogly Art Gallery, Nottingham

Kathy **Prendergast**

Born 1958
Lives London

There is a distinct similarity between the arteries of the body and the road network of a city. Kathy Prendergast draws our attention to this in her 'City Drawings', which she has been working on since 1992. Drawings of all the world's capital cities are wrought in fine pencil marks, like vulnerable, filigree veins. In a more recent, digitally produced series Prendergast has removed all the places names from a map of the United States, except those that reflect emotional states, such as Happy Landing, Lover's Leap or Moodyville, in a meticulous investigation of how place and individual demeanour are irrevocably intertwined. (SO'R)

Shown by Kerlin Gallery E14

The Uncle's House
2003
Oil on canvas
115×145cm
Courtesy Rebecca Camhi

Selected Bibliography

2004 'People, Works and Ideas', Rania Georgiadou, *Vogue Hellas*

2004 *Vitamin P: New Perspectives in Painting*, Phaidon Press, London

2001 'Mantalina Psoma', George Karouzakis, *Harper's Bazaar*

2001 'Mantalina Psoma', *The Breeder*

Selected Exhibitions

2005 Kapinos Galerie, Berlin

2004 Lorcan O'Neil Gallery, Rome

2003 TinT Gallery, Thessaloniki

2002 'All Fashioned', Centre of Contemporary Art, Larissa

2001 Rebecca Camhi, Athens

2001 'Summer Camp-Camp Summer', Hydra

1999 '250 Years Goethe', Goethe Museum, Dusseldorf

1999 'Mind the Gap', Haus der Kulturen der Welt, Berlin

1999 Alter Doerendorfer Gueterbahnhof, Dusseldorf

1993 Zielke Gallery, Berlin

Mantalina **Psoma**

Born 1967
Lives Athens

Painted with dry, controlled brushstrokes that here and there glint with unexpected lustre or dissipate into a powdery miasma, Psoma's figures (with their spotless complexions, their hard-to-pin-down nationalities) are the high-end everymen of a tomorrow that, while not dystopian, seems already dulled with pre-scripted dreams. Suffused with the chilly light of a hospital or an upmarket cosmetics counter, these works seem to promise hope and misfortune, real beauty and heartbreaking artifice, in the same softly uttered breath. Looking at them is, like childhood, an experience in which we're frequently astonished, not least by ourselves. (TM)

Shown by Rebecca Camhi E22

Untitled
2005
C-print mounted on Diasec
160×205cm
Courtesy Galería Pepe Cobo

Selected Bibliography

2005 *Gonzalo Puch*, Galería Pepe Cobo, Madrid

2003 *Gonzalo Puch: Incidentes*, Centro Andaluz de Arte Contemporáneo, Sevilla

2002 *Gonzalo Puch*, Fundación Antonio Perez, Cuenca

1997 *Gonzalo Puch*, Imago '97, Universidad de Salamanca

Selected Exhibitions

2005 Galería Pepe Cobo, Madrid

2005 'Gonzalo Puch: Incidentes', Julie Saul Gallery, New York

2005 'Empirismos', LiboaPhoto, Lisbon

2004 'Incidentes', Centro Andaluz de Arte Contemporáneo, Seville

2004 'Colección Telefónica de Fotografia Contemporánea', Museo de Arte Contemporáneo de Vigo

2004 'Fotografia de los años 80 y 90 en la Colección del Museo Nacional Centro de Arte Reina Sofia', Fundación Juan March, Palma de Mallorca

2004 'In Ictu Oculi', Galería Pepe Cobo, Seville

2004 'Uncharted Territory: Subjective Mapping by Artists and Cartographers', Julie Saul Gallery, New York

2003 Galería Pepe Cobo, Seville

2002 'El Aula Ideal', Fundación Antonio Perez, Cuenca

Gonzalo **Puch**

Born 1950
Lives Madrid

Gonzalo Puch's recent photographs take micro-level Sisyphean tasks and make them speak about macro-level absurdities. In one piece Puch puffs into an inflatable globe that has become misshapen through the artist's efforts – a critique perhaps of overweening art world ambition or of various human endeavours that have bent and buckled our planet. In another image a man plasters a wall with cut-out paper numbers, scissoring out meaningless digits like a cosmic auditor who knows the quantity of everything and the quality of nothing. Asking tough questions about labour, value and distortions of scale, this work attempts to apply the brakes to a world speeding out of control. (TM)

Shown by Galería Pepe Cobo E24

Mixed Exhibits
2003
Film still, 4 minute loop, 16mm
film transferred onto DVD
Dimensions variable
Courtesy Galerie Krobath
Wimmer

Selected Bibliography

2004 *Wachstum und Entwicklung*,
Galerie im Taxispalais
Innsbruck, Revolver Verlag,
Frankfurt

2003 *Florian Pumhösl*,
Kunstverein, Cologne; Revolver
Verlag, Frankfurt

2000 *Humanist and Ecological
Republic and Lac Mantasoa*,
Secession, Vienna

1997 *Champs d'Expérience:
BAWAG Foundation, Vienna*,
BAWAG Foundation Editions,
Vienna

Selected Exhibitions

2005 Galerie Krobath Wimmer,
Vienna

2005 Galerie Daniel Buchholz,
Cologne

2005 'No Manifesto', GAMEC,
Bergamo

2005 'Occupying Space:
Sammlung Generali
Foundation', Haus der Kunst,
Munich; Witte de With,
Rotterdam; Museum of
Contemporary Art, Zagreb

2005 'Model Modernism',
Artists' Space, New York

2004 Centre d'Edition
Contemporaine, Geneva

2004 'Wachstum und
Entwicklung', Galerie im
Taxispalais, Innsbruck

2003 Kunstverein, Cologne

2003 Art Statements, Art Basel

2000 'Humanist and Ecological
Republic and Lac Mantasoa',
Secession, Vienna

Florian **Pumhösl**

Born 1971
Lives Vienna

Modernism – its unfulfilled promises and
ambiguous manifestations – is the subject of
Florian Pumhösl's investigations. In his installation
Humanist and Ecological Republic (2000) he displayed
modular architectural elements taken from the
grammar of global Modernism so as to reveal the
uncanny affinities between the Unesco-type spirit
of postwar internationalism and the colonization
of the globe through the architectural logic of
instrumental reason. In recent works Pumhösl
has focused on photogrammetry, questioning
modern visual technology's claim to objective
representation. For him the myth of objectivity
becomes opaque as the image turns into a mute
trace of the bare facticity of its subject. (JV)

Shown by Galerie Daniel Buchholz D14, Galerie
Krobath Wimmer H7

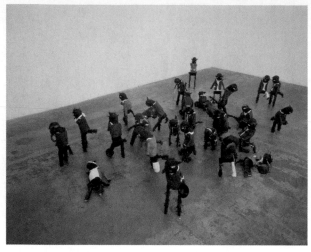

Selected Bibliography

2004 'Jonathan Pylypchuk',
Craig Burnett, *Art Monthly*

2003 'Jonathan Pylypchuk',
Ken Johnson, *The New York Times*

2001 'Jonathan Pylypchuk',
Meghan Dailey, *Artforum*

2001 'Jonathan Pylypchuk',
Roberta Smith, *The New York
Times*

Selected Exhibitions

2005 Galerie Ghislaine
Hussenot, Paris

2004 'You Won't Live Past 30',
China Art Objects Galleries,
Los Angeles

2004 'Erections Pointing at
Stars and Angels', aspreyjacques,
London

2004 'You Are the Only One
Left', Galleri Christina Wilson,
Copenhagen

2004 'I Will Live with My
Hands Like This', Galleria
Massimo de Carlo, Milan

2003 'And Now Occasionally
and Reluctantly I Lift My Head
from Where It Usually Hangs in
Shame', Friedrich Petzel Gallery,
New York

2003 'Royal Art Lodge: Ask
the Dust', The Drawing Center,
New York

2003 Project Room, Tomio
Koyama Gallery, Tokyo

2003 'Just Plug Everyone Now',
Borgmann Nathusius, Cologne

1999 'One Day Art Sale',
China Art Objects Galleries,
Los Angeles

Jonathan **Pylypchuk**

Born 1972
Lives Los Angeles

In Jonathan Pylypchuk's sculptures, paintings and
collages creatures resembling thrift-store Muppets
play out dramas of mutual dependency that would
put Kermit and Miss Piggy to shame. When not
caught up in the business of fumbling or fighting,
they offer each other succour, although it's often
repelled with blows or verbal abuse. This is cruel
stuff, made crueller by the fact that Pylypchuk's
critters – with their make-do-and-mend
physiologies – so clearly can't afford not to help
each other out. Drawing human parallels with
such animal behaviour is easy. What's harder (and
what Pylypchuk achieves) is making these parallels
hopelessly, apocalyptically funny. (TM)

Shown by Galleria Massimo de Carlo E10, China
Art Objects Galleries F13, Alison Jacques Gallery
D17, Tomio Koyama Gallery B6, Galleri Christina
Wilson B4

W 6/2005
2005
Watercolour on paper
30×42cm
Courtesy Galerie Barbara Wien

Selected Bibliography

2005 'Malerei/36 Positionen' (Painting/36 Positions), Bureau des Arts Plastiques, Berlin, *Kunstbulletin*

2004 *Uwaga Berlin!/Achtung Berlin!* (Attention Berlin!), Knut Ebeling, Baltic Gallery for Contemporary Art, Slupsk

2003 'Das Spektakel als Monument' (The Spectacle as Monument), Harald Fricke, *Die Tageszeitung*

Selected Exhibitions

2005 Galerie Barbara Wien, Berlin

2005 Jack Hanley Gallery, San Francisco

2005 'Wittgenstein in New York', Kupferstich-Kabinett, Berlin

2005 'Obra sobre Papel', Michael Soskine Inc., New York/Madrid

2004 'Uwaga Berlin!/Achtung Berlin!', Baltic Gallery for Contemporary Art, Slupsk

2004 'Architektur im Bild', M 3, Berlin

2004 'Papierarbeiten von Männern / Works on Paper by Men', Oliver Croy, Berlin

2004 'Editions', WBD, Berlin

2003 WBD, Berlin

2003 Future 7 Collection, Berlin

2002 'WeltModel', Galleri Thomassen, Gothenburg

2001 'Freie Wahlen/ Free Elections', Kunsthalle, Baden-Baden

Thomas **Ravens**

Born 1964
Lives Berlin

In Thomas Ravens' watercolours *Blade Runner*-type visions of future metropolises converge with contemporary shopping mall culture and stadium rock concerts. Like an army of ants in a forest clearing, human masses gather in fictional urban landscapes as if waiting for something to happen – a sports match, or Judgement Day. However, the small scale of the watercolours and Ravens' attention to minute detail prevent the work from merely duplicating a fascination with gargantuan architecture and the roar of the masses. Ravens invites us to share an abstract, elevated vantage point, as if from the perspective of aliens removed from our tumultuous struggle between atomized individual and global audiences, and centralized and decentralized structures. (JöH)

Shown by Galerie Barbara Wien C20

#534
2004–5
Oil and alkyd on polyester
71×142cm
Courtesy galerie bob van orsouw

Selected Bibliography

2005–6 *Leave Yourself Behind:
Paintings and Special Projects
1967–2005*, Kevin Mullins,
Ulrich Museum of Art, Wichita
State University, Wichita

2004 *Still Mapping the Moon:
Perspectives on Contemporary
Painting*, Georg Imdahl,
Kunstmuseum, Bonn

2003 *Cream 3*, Phaidon Press,
London

2002 *Another World: Twelve
Bedroom Stories*, Kunstmuseum,
Lucerne

2001 *David Reed: You Look Good
in Blue*, Konrad Bitterli and
Stephan Berg, Kunstmuseum,
St Gallen; Kunstverein, Hanover

David **Reed**

Born 1946
Lives New York

'I want to make paintings that are paintings and images of paintings simultaneously', David Reed has said. His sleek abstractions accomplish this through a vocabulary of sinuous Baroque curves, seemingly translucent surfaces and glowing acid colours ('techno-mannerist', in Arthur Danto's phrase). The gesture – the physical trace of the artist's hand – is both invoked and effaced, as uncannily perfect brushstrokes twist across the picture plane in impossible contortions. Reed has brought the mythology of abstract painting into contact with the aesthetic of spectacle: this is an art that owes as much to the billboard and the cinema screen as it does to its Modernist forebears. (SS)

Shown by galerie bob van orsouw D19

Selected Exhibitions

2005–6 'Leave Yourself Behind',
Roswell Museum and Art Center,
New Mexico; Ulrich Museum
of Art, Wichita State University,
Wichita

2005 'New Paintings', galerie
bob van orsouw, Zurich

2004 Max Protetch Gallery,
New York

2002 'You Look Good in
Blue', Kunstverein, Hanover;
Kunstverein, St Gallen

2000 galerie bob van orsouw,
Zurich

1999 'David Reed: Painting/
Vampire Study Center', Moore
College of Design, Philadelphia

1998 'David Reed: Motion
Pictures', PS1 Contemporary Art
Center, New York

1998 'Paintings, Motion
Pictures', Rose Art Museum,
Waltham

I, Bonelessly Whistling
2004
Plastics, clothes, diverse
electronics
86×70×56cm
Courtesy Galerie Krinzinger

Selected Bibliography

2004 *Reserve der Form* (Reserve
of the Form), Revolver Verlag,
Frankfurt

2004 *Bewegliche Teile*
(Connecting Parts), Katia
Schurl, Kunsthaus, Graz;
Museum Tinguely, Basel;
Verlag Walther König, Cologne

2003 *Werner Reiterer*, Brigitte
Huck et al, Kunsthaus, Basel

1998–9 *Homöopathetisch*
(Homeopathetic), Kornelia
Berswordt-Wallrabe, Gerhard
Graulich, Staatliches Museum,
Schwerin

1996 *Abstrakt/Real*, Rainer
Fuchs and Lorand Hegyi,
Museum Moderner Kunst,
Triton Verlag, Vienna

Selected Exhibitions

2005 'A Lucky Strike – Kunst
findet Stadt', Gesellschaft für
Aktuelle Kunst, Bremen

2005 Galerie Loevenbruck, Paris

2004–5 'Bewegliche Teile',
Kunsthaus, Graz; Tinguely
Museum, Basel

2004 'My Brain Is Your Hole',
Galerie Krinzinger, Vienna

2004 'Reserve der Form',
Künstlerhaus, Vienna

2003 'Die kennen sich! Kennen
Sie die?', Kunsthaus, Basel

2003 'Herbarium der Blicke',
Bundeskunsthalle, Bonn

2001 'A One Man and Two
Hours Show', Kunstverein,
Hanover

2000 'Lebt und arbeitet in
Wien', Kunsthalle, Vienna

1998 'Homöopathetisch',
Staatliches Museum, Schwerin

Werner **Reiterer**

Born 1964
Lives Vienna

Werner Reiterer's installations, whether within the
gallery or embedded in the urban environment
beyond, are mischievous, usually to the point of
absurdity. A stuffed cat on the ceiling is attached
to a canister of helium via a tube stuck up its
rectum; a flag runs up and down its pole in synch
with a lift inside a building; a street lamp swivels
to greet anyone approaching; stickers printed with
'laughing gas' are placed in New York ventilation
shafts – Reiterer's interventions invite and revel in
the credulity of the viewer. (SO'R)

Shown by Galerie Krinzinger F15

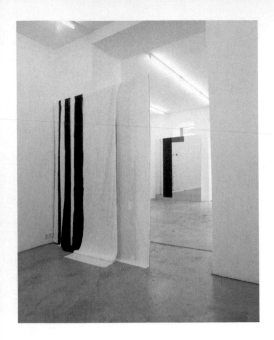

London Report
2005
Installation view, Gabriele
Senn Galerie
Courtesy Gabriele Senn Galerie

Selected Bibliography

2004 *Frieze Art Fair 2004*, Michael S. Riedel, Dennis Loesch, Revolver Verlag, Frankfurt

2004 *Johnson Robert*, Michael S. Riedel, Revolver Verlag, Frankfurt

2004 *Scheissen und Brunzen* (Shitting and Pissing), Michael S. Riedel, Revolver Verlag, Frankfurt

2003 *Oskar-von-Miller Strasse 16*, Michael S. Riedel, Dennis Loesch, Silverbridge, Paris

2003 *Detroit City Map*, Michael S. Riedel, x-15, Frankfurt

Michael S. **Riedel**

Born 1974
Lives Frankfurt

With the zeal of a hacker Michael S. Riedel explores the aftermath of Appropriation art, mimicking its tendency towards infinite regress. Recently he used the cover of Andy Warhol's novel *a* – transcriptions of chat at the Factory – for an artist's book of conversation at a space in Frankfurt. In 2001, during a show in Vienna of Christopher Wool's paintings of black letters on white, Riedel recorded comments by exhibition visitors and staff and transcribed them in black on the white walls of a gallery nearby. (JöH)

Shown by Gabriele Senn Galerie H4

Selected Exhibitions

2005 'Momentane Monumente', Aedes West, Berlin

2005 'London Report', Gabriele Senn Galerie, Vienna

2005 'Moscow Biennial', Revolution Square 2/3, Moscow

2004 'False Portikus', Project, Frieze Art Fair, London

2004 'Wiener Linien: Kunst und Stadtbeobachtung seit 1960', Wien Museum, Vienna

2003 'Au fur et à mesure...', Gabriele Senn Galerie, Vienna

2003 'Kontext, Form, Troja', Secession, Vienna

2002 'Gilbert & George', Oskar-von-Miller Strasse 16, Frankfurt

2001 'Christopher Wool', Gabriele Senn Galerie, Vienna

*The Sailor Who Fell From Grace
with the Sea*
(detail)
2004
Enamel on sintra
325×275cm
Courtesy Andrea Rosen Gallery

Selected Bibliography

2003 *Matthew Ritchie: Proposition
Player*, Herbert Heon et al.,
Contemporary Arts Museum,
Houston

2002 *Games of Chance and Skill*,
Jenelle Porter and Matthew
Ritchie, MIT Press, Cambridge

2000 *The Fast Set*, Bonnie
Clearwater and Matthew
Ritchie, Museum of
Contemporary Art, Miami

Selected Exhibitions

2005 'Remote Viewing',
Whitney Museum of American
Art, New York

2004 São Paulo Biennial

2004 'The Encounters in the 21st
Century: Polyphony: Emerging
Resonances', 21st Century
Museum of Contemporary Art,
Kanazawa

2003–5 'Matthew Ritchie:
Proposition Player',
Contemporary Arts Museum,
Houston

2003 'Painting Pictures',
Kunstmuseum, Wolfsburg

2002 'Drawing Now: Eight
Propositions', Museum of
Modern Art, New York

2002 Sydney Biennial

2002 'After Lives', Andrea
Rosen Gallery, New York

2000 'Concentrations 38:
Matthew Ritchie', Dallas
Museum of Art

2000 'The Fast Set', Museum of
Contemporary Art, Miami

Matthew **Ritchie**

Born 1964
Lives New York

Everything is something else in Matthew Ritchie's
cosmology – the half-borrowed, half-invented
grand narrative that serves as the skeleton key
for his work. Angels from the Apocrypha are
lobes of the brain, but are also chemical elements
and debauched characters in some hard-boiled
novel. This protean network of associations gets
translated into vertiginous paintings and drawings,
kaleidoscopic mosaics and light-boxes, their forms
a mix of Abstract Expressionism, topographical
maps and sci-fi comics. Ritchie seems motivated
by an old-fashioned belief in the power of
painting, a desire to fill it with all it can hold. (SS)

Shown by Andrea Rosen Gallery C3

Kirstine **Roepstorff**

Born 1972
Lives Berlin/Copenhagen

'What I like about the collage', Kirstine Roepstorff has explained, 'is that it refers directly to our negotiated "common" reality and yet it mirrors different versions of it; brought together in one image, this could look like a misunderstanding.' Drawing on the strident legacy of Hannah Höch, Roepstorff makes photomontages – as well as banners and installations – that exploit and orchestrate this potential for tangled motives. Taking on subjects such as the international diamond market, the economics of debt trading or the collusion of terror and therapy, her work deploys magazine pages, photocopies, sequins, ribbon and glitter in a heady exorcism of luxury and degradation. (MA)

Shown by Peres Projects Los Angeles Berlin E21, Galleri Christina Wilson B4

Selected Bibliography

2005 *New York City: The World's Capital of Therapy*, Pernille Albrethsen, Nordic Institute for Contemporary Art, Helsinki

2004 *Who Decides Who Decides*, Solvej Helweg Olesen, Revolver Verlag, Frankfurt

2004 *Queen of Diamonds*, Cecilie Høgsbro, Galleri Christina Wilson, Copenhagen

2001 'nu Introduces Kirstine Roepstorff', Pernille Albrethsen, *nu: The Nordic ArtReview*

Selected Exhibitions

2005 'Populism', Nordic Institute for Contemporary Art, Helsinki; Contemporary Art Centre, Vilnius; Stedelijk Museum, Amsterdam; Kunstverein, Frankfurt

2005 'Critical Societies', Badischer Kunstverein, Karlsruhe

2004 'Queen of Diamonds', Galleri Christina Wilson, Copenhagen

2004 'I Feel Mysterious Today', Palm Beach Institute of Contemporary Art, Miami

2004 'Momentum', Nordic Festival of Contemporary Art, Moss

2004 '1½', Peres Projects, Los Angeles

2003 'Kirstine Roepstorff & Niels Erik Gjerdevik', Konsthallen, Bohusläns

2003 'Out to Grass', Galerie Koch & Kesslau, Berlin

Falling... Spilling... Sprawling...
(detail)
2005
MDF, wood, paint
200×300×50cm
Courtesy Marc Foxx

Selected Bibliography

2005 'Matthew Ronay', Adam
E. Mendelsohn, *ArtReview*

2005 'Matthew Ronay: It's
an Uprising!', Rachel Comer-
Greene, *Time Out New York*

2004 'Matthew Ronay', Aspara
DiQuinzio, *Whitney Biennial
2004,* Whitney Museum of
American Art, New York

2002 'Matthew Ronay, Zoey
Mondt, *frieze 66*

2002 'Matthew Ronay's
Miniature Stage Sets', David
Pagel, *The Los Angeles Times*

Selected Exhibitions

2005 'Shine the Light',
Marc Foxx, Los Angeles

2005 'It's an Uprising!',
Andrea Rosen Gallery,
New York

2005 'Make it Now: New
Sculpture in New York',
Sculpture Center, New York

2004 Whitney Biennial,
New York

2003 'Evan Holloway, Matthew
Ronay, Hiroshi Sugito', Marc
Foxx, Los Angeles

2003 'New Slang: Emerging
Voices in Sculpture', Luhring
Augustine, New York

2002 'Artists Imagine
Architecture', Institute of
Contemporary Art, Boston

2002 'Gallery 2: Catarina Leitao
& Matthew Ronay', Andrea
Rosen Gallery, New York

2001 Marc Foxx, Los Angeles

Matthew **Ronay**

Born 1976
Lives New York

Matthew Ronay's bright, intricate sculptures are
made from materials as diverse as wood, metal,
paper and string, cans, socks and spaghetti. They
often posit 'what-if' scenarios about the future
of society. Like strange toys with mysterious
functions, the sculptures are by turns melancholy
and enthusiastic, and often allude to open-ended
narratives enclosed within a twilight world of
riotous, extended childhood. The artist is also a
wordsmith: his titles include *Ice Cream Perfectly on
Three Blades of Grass* (2001) and *Five Headed Cock in
Drag* (2005). (JH)

Shown by Marc Foxx C18, Andrea Rosen
Gallery C3

Trilogy of Failure (Part 2):
The Stunned Man
2004
Filmed on Super 16mm,
transferred to DVD 16:9
2-screen installation;
33 minute loop
Courtesy Max Wigram Gallery

Selected Bibliography

2004 *Asylum*, Julian Rosefeldt,
Baltic Centre for Contemporary
Art, Gateshead

2004 'Julian Rosefeldt', Sally
O'Reilly, *frieze* 87

2000–01 *Global Soap: An Atlas*,
Julian Rosefeldt, Deutsche Bank
Kunststipendium, Berlin

1998 *News*, ed. Reinhard
Spieler, Kunstsammlung
Nordrhein-Westfalen, Dusseldorf

Julian **Rosefeldt**

Born 1965
Lives Berlin

Julian Rosefeldt's multi-screen video projections
are theatrically choreographed studies of social
or psychological ambiguities. The first two
instalments of *Trilogy of Failure* (2004), for instance,
confuse us with optical, audio or logical trickery
as a man and his *doppelgänger* systematically
wreck and repair a flat, and a Foley artist
unwittingly provides sound effects for his double,
who rearranges furniture into a huge stack. The
pointlessness of neurotic tasks isolated from the
real workings of the world takes on allegorical
significance, as Rosefeldt applies his experience
in experimental theatre to render them at once
dramatic and voyeuristic. (SO'R)

Shown by Arndt & Partner D21, Max Wigram
Gallery G11

Selected Exhibitions

2005 Arndt & Partner, Zurich

2005 'Manipulations: On
Economies of Deceit', Prague
Biennial

2005 'Biennial of Urgency',
Palais de Toyko, Paris

2005 Art Basel

2004 MW Projects, London

2004 'Julian Rosefeldt: Asylum',
Baltic Centre for Contemporary
Art, Gateshead

2002 'Hommage à Max
Beckmann', Centre Georges
Pompidou, Paris

2001 'Julian Rosefeldt: Global
Soap', Künstlerhaus Bethanien,
Berlin

2001 'Televisions', Kunsthalle,
Vienna

1999 'Deep Storage', PS1
Contemporary Art Center,
New York

Large Swimmers
2004
Oil on linen
213×274cm
Courtesy Projectile Gallery

Selected Bibliography

2004 'Peter Rostovsky', Max Henry, *Time Out New York*

2004 'Peter Rostovsky', Ken Johnson, *The New York Times*

2004 *Vitamin P: New Perspectives in Painting*, Phaidon Press, London

2001 'Peter Rostovsky', Gregory Williams, *Artforum*

1999 'Daniel J. Martinez and Peter Rostovsky', Holland Cotter, *The New York Times*

Selected Exhibitions

2004 Art Pace, San Antonio

2004 'Lewis & Clark Territory: Contemporary Artists Revisit Place, Race, and Memory', Tacoma Art Museum

2004 'Deluge', The Project, New York

2003 Prague Biennial

2003 'MetroSpective', Public Art Fund, New York

2002 'Thriller', Galleria Maze, Turin

2001 'Casino 2001', S.M.A.K., Ghent

2001 James Harris Gallery, Seattle

2000 Rauma Biennial, Balticum

1999 'Outer Boroughs', White Columns, New York

Peter **Rostovsky**

Born 1970
Lives New York

Try telling Peter Rostovsky that the Sublime died in the 19th century. Among other things, the artist makes meticulous miniature dioramas depicting human figures enthralled by the grandeur of nature. Consciously referring to a continuum of transcendentalism that links Caspar David Friedrich, *Close Encounters of the Third Kind* and the latest SUV ad, Rostrovsky's figurines are tiny Ralph Waldo Emersons or Henry Thoreaus enjoying equally miniaturized epiphanies. While he sometimes models his figures on TV characters, in works such as *Epiphany Model 4:The Meteor Shower* (2004) Rostovsky's protagonists seem to be ordinary Gore-Tex-clad eco-tourists, glorying in perfect, if culturally constructed, moments of recreational incomprehension. (JT)

Shown by Projectile Gallery E15

Arrangement
2004
Oil on canvas
190×280cm
Courtesy Galleri Nicolai Wallner

Christoph **Ruckhäberle**

Born 1972
Lives Leipzig

Christoph Ruckhäberle's paintings have an oddly early 20th-century feel. Classically posed figures, faintly evoking Pablo Picasso's *Les Demoiselles d'Avignon*, hang out in sparsely furnished cafés, dressing rooms and gentlemen's clubs. Unable to look each other in the eye (perhaps they know they are anomalies and do not wish to encounter their own mirror-images), they instead turn inwards, into their own thoughts. Looking at Ruckhäberle's chromatic, mathematically beautiful canvases, one might imagine the people he paints endlessly ponder the problems of Modernity, unaware that the world, unwilling or unable to solve those problems, has moved on. (TM)

Shown by Sutton Lane H3, Galleri Nicolai Wallner A3

Selected Bibliography

2005 'Christoph Ruckhäberle', Andrew Marsh, *Flash Art International*

Selected Exhibitions

2005 Galleri Nicolai Wallner, Copenhagen

2004 Sutton Lane Gallery, London

2004 Zach Feuer, New York

2004 Galleri Nicolai Wallner, Copenhagen

2003 Galerie Liga, Berlin

Countdowns
2004
Two-channel DVD projection
Courtesy Salon 94 and
Greenberg Van Doren Gallery

Selected Bibliography

2005 'Lesser New York', Jerry
Saltz, *The Village Voice*

2004 'I, Assassin', Michael
Wilson, *frieze 83*

2003 'The Art and Artists of
the Year: Auspicious Debuts',
Roberta Smith, *The New York
Times*

2002 'Come to Life', John
Kelsey, *Time Out New York*

Selected Exhibitions

2005 'Let's Go', Greenberg Van
Doren, New York

2005 'Marking Time', Getty
Research Institute, Los Angeles

2005 'Greater New York',
PS1 Contemporary Art Center,
New York

2005 'Irreducible:
Contemporary Short Form
Video 1995–2005', CCA Wattis
Institute, San Francisco

2004 'Lets Go', The Moore
Space, Miami

2004 Whitney Biennial,
New York

2003 'Untitled', Center For
Curatorial Studies, Bard College,
Annandale-on-Hudson

2003 'Clandestines', Arsenale,
Venice Biennale

2003 'Strange Days', Museum of
Contemporary Art, Chicago

2002 'Come to Life', Salon 94,
New York

Aïda **Ruilova**

Born 1974
Lives New York

Aïda Ruilova's video works actualize the moment
when a strip light blinks into life. Her flickering
montages and dissonant sound-tracks provide
compelling flashes but no overall picture. Her
protagonists follow on from Tarkovsky's *Stalker*
– wandering through dripping tunnels, decayed
housing and eerie woods, muttering repetitive
phrases that may also be threats. In *Countdowns*
(2004) Ruilova's thinly sliced shots capture a man
running up a sand dune inscribed with the number
5, a woman grasping a burning candle in the shape
of a 2. Like the pram that tumbles down the steps
in Eisenstein's *Battleship Potemkin*, the countdown is
infused with a sense of morbid wonder. (SL)

Shown by Salon 94 B18, Vilma Gold D20

Tom **Sachs**

Born 1966
Lives New York

One suspects that armed with enough glue guns, raw plywood and foamcore, electrical circuitry and mechanical junk, Tom Sachs could handily re-create the world and all the iconic objects cluttering it. Such was the impression given by *Nutsy's* (2002), a sprawling scale model of Corbusier's Radiant City where the pristine Villa Savoye and a drive-thru McDonald's were not only neighbours but were shown to be close architectural cousins. Sachs' *bricoleur* obsessions have a socio-political bent, and his recent objects – a sinister state-of-the-art refrigerator crafted from found materials, a handgun display case constructed out of wooden NYPD barricades – transform the cast-off flotsam of unchecked consumerism into frenetic critiques. (JT)

Shown by Galerie Thaddaeus Ropac F14, Sperone Westwater B19

Selected Bibliography

1996 'Tom Sachs', Mark Van de Walle, *Artforum*

2001 'Tom Sachs', Peter Halley, *Index*

2004 'The Questionable Tom Sachs', *Sculptural Sphere*, Tom Healy, Sammlung Goetz, Munich

2004 'Tom Sachs: 15 April 2003', *Inside the Studio: Two Decades of Talks with Artists in New York*, ed. Judith Olch Richards, DAP, New York

2003 *Tom Sachs: Nutsy's*, Guggenheim Foundation, New York

Selected Exhibitions

2004 'Connecticut', Sperone Westwater, New York

2004 'Sculptural Sphere', Sammlung Goetz, Munich

2004 São Paulo Biennial

2002–3 'Nutsy's', Deutsche Guggenheim, Berlin; The Bohen Foundation, New York

2001 'White', Galerie Thaddaeus Ropac, Paris

2000 'American Bricolage', Sperone Westwater, New York

1999 'SONY Outsider', SITE Santa Fe

1997 Galleria Gian Enzo Sperone, Rome

Untitled
(detail)
2004
Pencil on paper
79×109cm
Courtesy Taka Ishii Gallery

Hiroe **Saeki**

Born 1978
Lives Kyoto/Osaka

Hiroe Saeki makes exquisite pencil drawings. As if marinated in the decorative animal and plant imagery of the scrolls and folding screens of artists from the Japanese Edo period such as Ito Jakuchu and Kano Sansetsu, Saeki's works on paper speak of the ephemeral elegance of the natural world. Her renderings of fragile fungi, filigree foliage, mossy tendrils and blossoms attended by translucent butterflies or bees possess a trained, luxurious and fragile artificiality denoted by *geijutsu*, the term more often used, before the importation into the Japanese language of the word 'art', to describe the practice of creating beautiful things. (MA)

Shown by Taka Ishii Gallery F4

Selected Exhibitions

2005 Taka Ishii Gallery, Tokyo

2004 'invisible birds', Taka Ishii Gallery, Tokyo

Reaktor
(Reactor)
2005
Concrete, microphones, mixer,
amplifier and speaker
Dimensions variable
Courtesy Jack Hanley Gallery

Selected Bibliography

2005 *Light Sculpture*, Simone
Menegoi, Vincenza; Colpo di
Fulmine, Verona

2004 *Manifesta 5: European
Biennial of Contemporary Art,
San Sebastian, Spain, 2004*, ed.
Massimiliano Gioni and Marta
Kuzma, Actar Pro, Barcelona

2004 *New Contemporaries,*
Barbican Art Gallery, London;
Liverpool Biennial

2004 *Great Expectations: Fuori
Uso 2004* (Great Expectations:
Out of Order 2004), ed.
Charlotte Laubard, Chiara
Parisi, Alessandro Rabottini,
Marcello Smarrelli, Ferrotel,
Pescara

Michael **Sailstorfer**

Born 1979
Lives London/Munich

Against the backdrop of a society that propagates
a consumer lifestyle, Michael Sailstorfer celebrates
the joy of making stuff for himself, reassembling
bits and pieces discarded by an economy dead-
set on overproduction. Projects have included
converting the debris of a family home into a sofa
(*Hertrichstraße 119*, 2001), taking an old police
car and welding it into a drum kit (*Schlagzeug*,
Percussion, 2003) or, for Manifesta 5, recycling
wood and ventilation units from a defunct fish
warehouse and turning them into a barracks
(*Breadboard Construction Marilyn*, 2004). Sailstorfer
offers practical alternative solutions for those who
would rather create than buy. (JV)

Shown by Art : Concept E2, Jack Hanley Gallery
E11, Zero A11

Selected Exhibitions

2005 Jack Hanley Gallery,
Los Angeles

2005 'Ruckkehr ins All',
Kunsthalle, Hamburg

2005 Yokohama Triennial

2005 'We Disagree', Andrew
Kreps Gallery, New York

2005 'Zeit ist keine Autobahn',
Zero, Milan

2004 'Bewegliche Teile',
Kunsthaus, Graz; Museum
Tinguely, Basel

2004 'New Contemporaries',
Barbican Art Gallery, London;
Liverpool Biennial

2004 Manifesta, San Sebastian

2004 Sydney Biennial

2003 'Welttour', Galerie Markus
Richter, Berlin

3029 Names
2004
Projection on wooden box,
computer, software, data
projector
Dimensions variable
Courtesy Bernier/Eliades

Selected Bibliography

2005 'Charles Sandison',
Ossian Ward, *ArtReview*

2004 *Ein Leuchten* (It's Obvious),
Museum der Moderne Kunst,
Salzburg

2004 'Charles Sandison',
Guitemie Maldonado, *Artforum*

2003 *Talking Pieces:Text und
Bild in der neuen Kunst* (Talking
Pieces: Text and Image in the
New Art), Gerhard Finckh,
Heggen Druck, Leverkusen

2002 *Between Heaven &
Earth*, La Criée, Centre d'Art
Contemporain, Rennes

Selected Exhibitions

2005 Bernier/Eliades, Athens

2004 Loop04, Barcelona

2004 Galeria Anhava, Helsinki

2004 Galerie Ulrich Fiedler,
Cologne

2004 Room X, Kiasma Museum
of Contemporary Art, Helsinki

2004 Lisson Gallery, London

2004 Ardnt & Partner, Berlin

2004 'Algorithmic Revolution',
ZKM Centre for Art and Media,
Karlsruhe

2004 Foire Internationale d'Art
Contemporain (FIAC), Paris

2004, Villette Numérique, Paris

Charles **Sandison**

Born 1969
Lives Tampere

The combination of technology and language
could make for dry, dehumanized work, but
Charles Sandison's installations reflect the
undercurrents of society itself. Projecting onto
a wall, floor or ceiling, a computer programme
attaches behaviours to words, generating an
agitated graphic animation. For instance, the word
'child' duplicates itself when the words 'male' and
'female' meet; elsewhere 'good' and 'evil' strive to
overwhelm one another and dominate the field.
The ploys demonstrate the relationship between
language and action, as well as between individual
intention and accumulative patterns of behaviour.
(SO'R)

Shown by Arndt & Partner D21, Bernier/Eliades
F17, Yvon Lambert F6, Lisson Gallery D8

Cave Painting, Meramec Caverns II
2005
Acrylic on canvas
134×168cm
Courtesy CRG Gallery

Selected Bibliography

2005 'Lisa Sanditz', Randy Kennedy, *The New York Times*

2004 *New American Paintings 2004*, Open Studios Press, Boston

2003 'Lisa Sanditz', Gregory Montreuil, *Flash Art International*

2003 'Season Tickets', Roberta Smith, *The New York Times*

2003 'Turning a Wall into Art at the Queens Museum', Carl McGowan, *Newsday*

Lisa **Sanditz**

Born 1973
Lives New York

Like crazy quilts of *ad hoc* American culture, Lisa Sanditz' paintings evoke the peculiar mix of nature and artifice of the United States. Her work has included such themes as images of outdoor recreation, following Brueghel's 'Seasons' and 'Months' series, while recent subjects include a group of abstractly decorated caravans in upstate New York and a cave in Missouri that has been bizarrely denatured, with linoleum and bright lighting, for the comfort of tourists. She says, 'I look for certain oddities – sometimes tragic, sometimes comic – that are so emblematic of […] this corporate and makeshift land that they are really far from odd.' (KJ)

Shown by CRG Gallery C23

Selected Exhibitions

2005 'Organized Living', CRG Gallery, New York

2005 'Landscape Confection', Wexner Center for the Arts, Columbus

2004 Rodolphe Jansen Gallery, Brussels

2004 'Looking at Painting', Galerie Tanit, Munich

2004 'Reordering Reality: Collecting Contemporary Art', Columbus Museum of Art

2004 'Happy', OH + T Gallery, Boston

2004 'Singing My Song', ACME., Los Angeles

2003 'Season Tickets', CRG Gallery, New York

2003 'Thinking in Line: A Survey of Contemporary Drawing', University Gallery, University of Florida, Gainesville

Stare
2005
Oil on canvas
305×250cm
Courtesy Gagosian Gallery

Selected Bibliography

2005 *Jenny Saville*, Danilo Eccher, Museo d'Arte Contemporanea, Rome

2004 *Disparities and Deformations: Our Grotesque*, Robert Storr, SITE Santa Fe

2002 *Jenny Saville: Migrants*, Linda Nochlin, Gagosian Gallery, New York

2002 *Closed Contact: Jenny Saville & Glen Luchford*, Katherine Dunn, Gagosian Gallery, Beverly Hills

1999 *Jenny Saville: Territories*, Martin Gayford, Gagosian Gallery, New York

Selected Exhibitions

2005 Museo d'Arte Contemporanea, Rome

2004 'Summer Exhibition', Royal Academy of Arts, London

2004 'Our Grotesque', SITE Santa Fe

2003 'Jenny Saville: Migrants', Gagosian Gallery, New York

2003 'Painting', Museo Correr, Venice Biennale

2002 'Closed Contact: Jenny Saville & Glen Luchford', Gagosian Gallery, Beverly Hills

2002 'The Physical World: An Exhibition of Painting and Sculpture', Gagosian Gallery, New York

2001 'Narcissus', National Portrait Gallery of Scotland, Edinburgh

2000–01 'Painting the Century: 101 Masterpieces, 1900–2000', National Portrait Gallery, London

1999 'Jenny Saville: Territories', Gagosian Gallery, New York

Jenny **Saville**

Born 1970
Lives Sicily

The immediate impression when looking at Jenny Saville's paintings is of excess: large canvases portray mountainous women at indulgently close quarters. Vividly rendered in a palette of meaty reds and grisly blues, the overblown painterliness holds a repellent allure, like the corporeal curiosity to which we all succumb. Their all-overness reflects the diffusion of erogenous zones around the female body, drawing a distinct line of provenance through the politics of art history, replacing the patriarchal gaze with the embodiment of universal anxieties about mortality and sexuality. (SO'R)

Shown by Gagosian Gallery D9

Cans Roll under Seats on Buses
2005
Photos and text
Dimensions variable
Courtesy Galleria Sonia Rosso

Mathew **Sawyer**

Born 1977
Lives London

Mathew Sawyer's surreptitious interventions in other people's lives have a cultivated tenderness. For *It'll All Come Out in the Wash* (1999) lovelorn lyrics by such melancholy songsmiths as Neil Young and Lou Reed were written on scraps of paper and slipped into the pockets of unsuspecting passers-by. In *Someone to Share My Life With* (2002), an equally shy initiative, Sawyer stole a pair of shoes from a neighbour and secretly painted a swallow on the sole of each one. The neighbour's reaction, if any, is left to us to imagine. (KB)

Shown by Galleria Sonia Rosso A6

Selected Bibliography

2005 *Terrain Vague:Ambivalent Sites of Reflection in Current Documentary*, Susanne Neubauer, Documentary Creations, Lucerne

2003 'Matthew Higgs on Mathew Sawyer', Matthew Higgs, *Artforum*

Selected Exhibitions

2005 'The Return of Death and Hot Pop Corn', Galleria Sonia Rosso, Turin

2005 'Documentary Creations', Kunstmuseum, Lucerne

2004 'Your Heart Is No Match for My Love', Soap Factory, Minneapolis

2004 'The Concert in the Egg', The Ship Gallery, London

2003 'The Distance Between Me and You', Lisson Gallery, London

2003 'Passing Water', Art Metropole, Toronto

2003 'Someone to Share My Life With', The Approach, London

2002 'To Whom it May Concern', CCAC, Logan Galleries, London

2002 'Sound and Vision', Royal Festival Hall, London

Bomb
2004
Spray paint on canvas
244×183cm
Courtesy Patrick Painter, Inc.

Selected Bibliography

2004 'Newer, Bigger, Better', Ann Magnuson, *Loft Magazine*

2004 'Concrete Canvas', Scott Timberg, *Los Angeles Times*

2004 'Hidden Art and Politics', James Verini, *Los Angeles Times*

1998 *Kenny Scharf*, Barry Blinderman, Gregory Bowen, Bill McBride, Ann Magnuson and Robert Farris Thompson, University Galleries, Normal

1997 *Kenny Scharf: Pop-Surrealist*, Kenny Scharf, Salvador Dalí Museum, St Petersburg

1996 *El Mundo de Kenny Scharf* (The World of Kenny Scharf) Museo de Arte Contemporáneo de Monterrey

Selected Exhibitions

2005 Paul Kasmin Gallery, New York

2005 'Outer Limits', Patrick Painter, Inc., Santa Monica

2004 Kevin Bruk Gallery, Miami

2004 'California Grown', Pasadena Museum of Contemporary Art

2004 'SchaBlobz', Kenny Schachter ConTEMPorary, New York

2004 'East Village USA', New Museum of Contemporary Art, New York

2003 'Night Light', Patrick Painter, Inc., Santa Monica

2002 'Muted', Chac Mool Gallery, Los Angeles

2001 'Made in the USA 1970–2001', Museum Ludwig Galerie, Oberhausen

Kenny **Scharf**

Born 1958
Lives Los Angeles

Back in the early 1980s Kenny Scharf's work landed on the art world like a happy alien invader, bearing a message of playful, cartoonish excess. His busy, Popsicle-hued paintings brought the products of TV-saturated childhood fantasies back to life, relocating them to moody landscapes that recalled the haunted spaces of Yves Tanguy. In the years since his arrival on the scene Scharf has continued to mine the pleasures and idiosyncrasies of commodified fun. A self-proclaimed 'Pop Surrealist', he demonstrates that the shared dreams of consumer culture are just as psychologically resonant as those we conjure in private. (SS)

Shown by Paul Kasmin Gallery G12, Patrick Painter, Inc. C2

1st Part Conditional
2004
35mm, 3 minutes, DVD
Courtesy Giò Marconi

Markus **Schinwald**

Born 1973
Lives Vienna

Markus Schinwald draws eclectically on fashion, design and architecture to create works that often evoke a sense of displacement or an awkward stance that forces reflection. After studying fashion design Schinwald first became known for works such as *Jubelhemd* (Celebration Shirt, 1997), which forces its wearer to hold up his hands. Since then, while the idea of the body as a malleable interface remains central, he has increasingly been involved in exploring how identity, context, emotion and awareness are constantly subjected to sophisticated cultivation. (DE)

Shown by Galerie Karin Guenther Nina Borgmann B7, Georg Kargl G9, Giò Marconi F10

Selected Bibliography

2005 'Markus Schinwald', Daniele Perra, *tema celeste*

2004 'Markus Schinwald', Brigitte Huck, *Artforum*

2004 'Markus Schinwald', Dominic Eichler, *frieze* 81

2004 'Markus Schinwald', Susanne Jäger, *Flash Art International*

2003 *LoveHateAusst*, Angela Stief, Blickle Stiftung, Kraichtal

Selected Exhibitions

2004 'Tablau Twain', Kunstverein, Frankfurt

2004 'Dictio Pii', Sprengel Museum, Hanover

2003 'Ceaseless Blur', TAV Gallery, Taipei

2000 'Oxygen, Flipping through Kiesler', MAK Center for Art and Architecture, Los Angeles

1999 'Gap', Museum Fridericianum, Kassel

Land Deiner Väter
(Land of Your Fathers)
2005
Oil on canvas
220×150cm
Courtesy carlier | gebauer

Selected Bibliography

2004 *Erik Schmidt: Urban Posing*,
Renate Goldmann, Adriano
Sack and Dirk Skreber, Snoeck
Verlagsgesellschaft, Cologne

Selected Exhibitions

2005 'Der schönste Jäger von
Deutschland', carlier | gebauer,
Berlin

2005 'Bridge Freezes before
Road', Gladstone Gallery,
New York

2005 'Come-in', Museu Paco
das Artes, São Paulo

2004 'Uptown Suit and Tie',
Artists Space, New York

2003 'Actionbutton',
Hamburger Bahnhof, Berlin

2001 'Breathless', Lombard
Freid Fine Arts, New York

1999 'Work is Personal', Galerie
EIGEN + ART, Berlin

Erik **Schmidt**

Born 1968

Lives Berlin

In a scene from one of Erik Schmidt's recent videos
(*Suitwatchers Anonymous*, 2003) a businessman,
played by the artist, whips his office chair with
his belt until all its fluffy white stuffing comes
out. The sexually suggestive action in the piece
provides a release from the middle-class urban
ennui that Schmidt's work evokes and ironically
challenges. His treatment of subjects such as car
parking, his own hair, fashion advertising and droll
commercial streetscapes suggests that normality is
only skin deep. (DE)

Shown by carlier | gebauer F12

Bretter
2005
Oil on canvas
200×300cm
Courtesy Galerie EIGEN + ART
Leipzig/Berlin

Selected Bibliography

2005 'Der fordernde Gott' (The Demanding God), Gerd Held, *FAZ*

2004 'Die Stadt der Leinwandhelden' (The City of Movie Heroes), Gerhard Mack and Georg Hohenberg, *art*

2004 'Die Wellenreiter' (The Surfer), Kathrin Wittneven, *Der Tagesspiegel*

2004 'New Power, New Pictures', Johannes Schmidt, *Flash Art International*

2004 'A League of Their Own', Carina Villinger, *Art and Auction*

David **Schnell**

Born 1971
Lives Leipzig

A founding member of Liga, the group of young painters from Leipzig formed in 2000, David Schnell is a central figure in the currently celebrated 'New Leipzig School' of painting. Taking landscape as a starting-point, his paintings' exaggeratedly steep central perspectives already lead them astray from their pastoral origins. Added to this, the rigid geometry, such as that defining the tree trunks in *Stangen in Mai (Gestaenge 4)* (2004), which seem to pierce the earth like falling spears, suggests a landscape violated by the organizing principles of computer graphics. Realism fragments and gives way to the distractions of another, more virtually aligned, reality. (KB)

Shown by Galerie EIGEN + ART Leipzig/ Berlin B17

Selected Exhibitions

2005 Galerie EIGEN + ART, Berlin

2005 'Artists from Leipzig', Arario Collection, Chungnam

2005 'Life after Death: New Paintings from the Rubell Family Collection', MASS MoCA, North Adams

2005 'From Leipzig', Cleveland Museum of Art

2005 'David, Matthes und ich', Kunstverein, Nuremberg; Kunstverein, Bielefeld

2004 'Eitel. Schnell. Weischer.', Galerie EIGEN + ART, Berlin

2004 'Direkte Malerei', Kunsthalle, Mannheim

2003 'Sieben mal Malerei', Neuer Leipziger Kunstverein im Museum der Bildenden Künste

2002 'Wandertag', Galerie Liga, Berlin

Birthday
2004
Oil on canvas
112×91cm
Courtesy Diana Stigter

Selected Bibliography

2005 Critics' Picks, Brian Sholis, www.artforum.com

2005 'Maaike Schoorel', Douglas Heingartner, *Flash Art International*

2005 'Rising to Painting's Challenge', Michael Glover, *The Independent*

2005 'Must I Paint You a Picture?', *Time Out London*

2005 'It's Art', A.A. Gill, *The Sunday Times Magazine*

Selected Exhibitions

2005 'Alex Bircken, Mari Eastman, Maaike Schoorel', Maureen Paley, London

2005 'New Accents in Contemporary Dutch and Flemish Art', Museum Kunstpalast, Dusseldorf

2005 'Expanded Painting', Prague Biennial

2005 'The Triumph of Painting', The Saatchi Gallery, London

2004 Rheinschau, Cologne

2004 'Twilight', Diana Stigter, Amsterdam

2004 'Must I Paint You a Picture?', Haunch of Venison, London

2003 'someplace unreachable', Ibid Projects, London

2002 'Darling Buds', Diana Stigter, Amsterdam

Maaike **Schoorel**

Born 1973
Lives London/Amsterdam

Every image is in some way involved with the process of remembering. Maaike Schoorel's paintings, often based on old family photographs, make this visible while harnessing the visceral advantages that paint has over negatives or pixels. Creamy grounds, muted tones, blurs, stains and sketchy details take her compositions to the edge of abstraction – leaving them to hover somewhere between emerging into full view and just fading away. The light and airy nature of Schoorel's paintings suggests that the past is to be found not by peering into dark recesses, but rather by staring into the glare of an imagined sun. (DE)

Shown by Maureen Paley C12, Diana Stigter H14

East
2005
Framed C-print on aluminium
125×165cm
Courtesy Kerlin Gallery

Selected Bibliography

2003 'Paul Seawright', Cristin Leach, *The Irish Times*

2003 'Imagining Wales', Hugh Adams, *Contemporary Art in Context*

2003 'War and Print', Aidan Dunne, *Irish Times*

2003 'Paul Seawright', Gordon Taylor, *Contemporary*

2001 *Artists from Wales at the 50th International Art Exhibition, Venice*, Wales Arts International, Cardiff

Paul **Seawright**

Born 1965
Lives Caerleon

Paul Seawright's earliest photographs depicted the politically charged spaces of his Belfast childhood, in scenes filled with a mysterious residue of past violence. He has since moved on to portraying what he terms 'generic malevolent landscapes': menacing, edgy spaces on the margins of cities. Shot in stark, washed-out colours, these unpopulated no man's lands show what happens when the comforts of urban security start to break down. A recent commission from the Imperial War Museum took Seawright to Afghanistan, where he produced a series of spare, haunting images of bombed-out battlegrounds. Whether the minefields are literal or metaphorical, his work evokes the constant threat of life during wartime. (SS)

Shown by Kerlin Gallery E14

Selected Exhibitions

2005 'Field Notes', FotoMuseum Provincie, Antwerp

2004 'Hidden', Sies + Hoke Galerie, Dusseldorf

2003 'Always a Little Further', Arsenale, Venice Biennale

2003 'Gestures', Festival of Contemporary Images, Paris

2003 'Disaster Area', The Glasshouse, Amsterdam

2002 'The Unblinking Eye', Irish Museum of Modern Art, Dublin

2002 'The Gap Show', Museum am Ostwall, Dortmund

2002 'Gewalt-Bilder', Museum Bellerive, Zurich

2001 'The Map', Douglas Hyde Gallery, Dublin

2001 'LA International Biennial', Angles Gallery, Los Angeles

Jurassic Pork II
2005
Installation view,
Palais de Tokyo
© Florian Kleinefenn

Selected Bibliography

2005 *Jurassic Pork II*, Onestar
Press, Paris

2003 *Café Noir*, Musée d'Art
Moderne et Contemporain,
Geneva

2002 *Les Somnambules* (The
Sleepwalkers), Olivier Zahm,
Editions du Regard, Paris

2001 *Alain Séchas*, Musée d'Art
Moderne et Contemporain de
Strasbourg

1998 *Alain Séchas*, Patrick
Javault, Edition Hazan

Selected Exhibitions

2005 'Jurassic Pork II', Palais de
Tokyo, Paris

2003 Galerie Pietro Spartà,
Chagny

2002 'Les Somnambules',
Chapelle Saint Louis de la
Salpêtrière, Paris

2002 'Trivial Pursuit', Musée
d'Art Moderne et Contemporain,
Geneva

2001 'Jurassic Pork', Le
Consortium, Dijon

2001 Musée d'Art Moderne et
Contemporain, Strasbourg

1999 'Exposition Solo 12', Kunst
Museum, Bonn

1998 'Culturgest', Caixa Geral
de Depositos, Lisbon

1997 Fondation Cartier, Paris

1996 São Paulo Biennial

Alain **Séchas**

Born 1955
Lives Paris

Alain Séchas has been exhibiting internationally
since the mid–1980s, but it wasn't until the 1996
São Paulo Biennial that his now emblematic
white cats started to appear, in the form of
towering acrylic sculptures, posters and drawings.
Undoubtedly a play on the artist's surname,
his cats (*ses chats*) – like Philip Guston's 'hoods'
or Robert Crumb's Fritz the Cat before them
– have participated in an often violent world of
delinquency and disappointment, addiction and
adolescence that is at odds with their seemingly
childlike comic–book characterization. (MA)

Shown by Galerie Pietro Spartà G13

Tino **Sehgal**

Born 1976
Lives Berlin

Tino Sehgal's pieces are actions carried out, often by museum or gallery staff, during the course of an exhibition: a singing guard at the Venice Biennale in 2003, for example; two kids performing what seems like a series of instructional pieces in an empty booth at the Frieze Art Fair that same year; or someone crawling along the floor like a wounded robot at London's Institute of Contemporary Art in 2005. Sehgal's starting-point is the question of whether it is possible to circumvent the usual reliance on physical materials, but the resulting work is less about pious dematerialization than about conceptual closure. (JöH)

Shown by Galleria Massimo de Carlo E10, Johnen + Schöttle D16, Jan Mot B16

Selected Bibliography

2005 'No Picture Please', Claire Bishop, *Artforum*

2005 'An Interview', Tim Griffin, *Artforum*

2004 'This Is Jörg Heiser on Tino Sehgal', Jörg Heiser, *frieze* 82

2003 'This Is Tino Sehgal', Jens Hoffmann, *Parkett*

Selected Exhibitions

2005 German Pavilion, Venice Biennale

2005 Institute of Contemporary Arts, London

2005 Fundaçao Serralves, Porto

2005 Moscow Biennial

2004 Art Statements, Art Basel

2004 'This Objective of That Object', Gallery Johnen+Schöttle, Cologne

2004 Van Abbe Museum, Eindhoven

2004 'Formalismus', Kunstverein, Hamburg

Fresh Purse
2005
Pocketbook frame, fabric,
thread, chain, flowers, plastic
stem holders, water and mixed
media
100×150×125cm (dimensions
variable with flowers)
Courtesy Galerie Aurel Scheibler

Selected Bibliography

2005 'Kreationen voller Magie'
(Creations Full of Magic),
Johanna Di Blasi,
Kölner Stadtanzeiger

2002 'New Sculpture
Transforms Common Objects',
R. B. Strauss, *Avon Grove Sun*

2001 'The Sculptor Weaves
Beauty in Delaware', Edward
Sosanski, *The Philadelphia Inquirer*

2001 'Craft Forms Exhibition in
Wayne', Pauline Bogaert, *The
Philadelphia Inquirer*

1997 'Sprawling Works: 13
Sculptors', William Zimmer,
The New York Times

Selected Exhibitions

2005 'Fresh', Galerie Aurel
Scheibler, Cologne

2004 'New Works', Priska C.
Juschka Fine Art, New York

2004 'Maravee', Villa Otteli-
Savorgnan, Ariis di Rivignano

2003 'Sculpture', Priska C.
Juschka Fine Art, New York

2003 'Explaining Magic',
Rotunda Gallery, New York

2001 'Rachel Selekman', E.A.
Draper Showcase Gallery,
Delaware Center for the
Contemporary Arts, Wilmington

2000 'Craft Forms', Wayne Art
Center

1992 A.I.R. Gallery II,
New York

Rachel **Selekman**

Born 1963
Lives New York

Rachel Selekman's 'Floral Purses' are a bizarre
conflation of ladies' embroidered evening bags
with slightly alarming-looking phallic spouts,
often sprouting a bouquet of flowers or a watery
stream of silken threads. The luscious fabrics of the
bags are seductively sensuous and speak not only
of the luxury of women's accessories but also of
a surrogate female sexuality. The artist, who has
used handbags as a sculptural form for over ten
years, describes them as 'stand-ins for the body or
parts of the body'. (KB)

Shown by Galerie Aurel Scheibler G15

Selected Bibliography

2004 *Rapport de Forces*, Bruno
Serralongue, Onestar Press, Paris

2004 *Spillovers*, Bruno
Serralongue, Cneai/Air de Paris,
Chatou

2003 *Bruno Serralongue*, Nicolas
Bourriaud, Actes Sud/Altadis,
Paris

2003 *The Last Picture Show:
Artists Using Photography*, Kate
Bush, Walker Art Center,
Minneapolis

2002 *Bruno Serralongue*, Pascal
Beausse, Eric Troncy and Alexis
Vaillant, Presses du Réel, Dijon

Selected Exhibitions

2005 'Spillovers', Centre de la
Photographie, Geneva

2005 'Covering the Real',
Kunstmuseum, Basel

2005 'Universal Experience:
Art, Life and the Tourist's Eye',
Museum of Contemporary Art,
Chicago

2005 'The Invisible Insurrection
of a Million Minds', Sala
Rekalde, Bilbao

2004 Air de Paris

2004 'Primavera Fotográfica',
MACBA, Barcelona

2004 'Paysages invisibles',
Musée d'Art Contemporain
de Rochechouart

2004 'Eblouissement', Jeu de
Paume, Paris

2003 'Multiple Exposure',
Galerie im Taxispalais, Innsbruck

2003 'Strangers', ICP Triennial,
New York

Bruno **Serralongue**

Born 1968
Lives Paris

The events in Cuba in 1997 surrounding the 30th
anniversary of the death of Che Guevara, the
restoration of Hong Kong to China the same
year and the Free Tibet concert in Washington
DC in 1998 were all witnessed by the camera of
Bruno Serralongue. Always operating without
press accreditation – though sometimes in the
service of newspapers – the artist self-consciously
adopts a peripheral, non-official, minor-stream
anti-reportage. 'I offer another kind of news', he
has written. 'I perform a sort of reappropriation of
information, because there is no reason it should
stay in the hands of professionals.' (MA)

Shown by Air de Paris A4

Perlhuhn
2003
C-print on aluminium
119×150cm
Courtesy Salon 94

Selected Bibliography

2004 'El Topo', Maurizio Cattelan, Massimiliano Gioni and Ali Subotnick, *Domus*

2004 'Shirana Shahbazi', Roberta Smith, *The New York Times*

2005 'Chronicles of the Everyday: Photographs, Paintings, Collectives and Cultural Identity', Kristin M. Jones, *frieze* 90

2005 *Shirana Shahbazi: Accept the Expected*, Centre d'Art Contemporain, Geneva

2005 *Graceland*, Swiss Embassy in Tehran

Selected Exhibitions

2005 Centre d'Art Contemporain, Geneva

2005 'Universal Experience: Art, Life, and the Tourist's Eye', Museum of Contemporary Art, Chicago

2005 Prague Biennial

2004 'Flowers, Fruits and Portraits', Salon 94, New York

2004 The Wrong Gallery, New York

2004 Trans Area, New York, New York

2004 'Non Toccare la Donna Bianca', Fondazione Sandretto Re Rebaudengo, Turin

2004 'Delays and Revolutions', Italian Pavilion, Venice Biennale

2003 The Museum of Contemporary Photography, Chicago

2003 'Girls' Night Out', Orange County Museum of Art, Newport Beach

Shirana **Shahbazi**

Born 1974
Lives Zurich

Born in Iran and raised in Germany, Shirana Shahbazi approaches her own cultural crossings, and those of her subjects, with a light hand. Her images attempt to capture the everyday, yet in doing so they reveal 'the everyday' as subjective and situational. Shahbazi's work moves easily between celebrations in Tehran and street scenes in Zurich, between the objective tradition of German photography and the heroic style of the Iranian poster artists whose work she reproduces. Can the viewer can feel 'at home' with these shifts? That is where her images gain their charge. (SS)

Shown by galerie bob van orsouw D19, Salon 94 B18, The Wrong Gallery H1

Untitled, from 'Twelve Short Walks'
2005
Etching
41×50cm
Courtesy Paragon Press

George **Shaw**

Born 1966
Lives Ilfracombe

George Shaw depicts the suburbs of his youth, using enamel model aircraft paints to draw out their every damp, bland detail. He presents us with in–between places: underpasses, paths home and the backs of bad pubs. These are spots in which to build dens and bury secrets, to smoke stolen cigarettes and kiss the third-prettiest girl in school. There is nostalgia in Shaw's paintings, but also a muted spirituality and sense of half-absorbed dread. Suffused with the odd, cloudless–day light of memory, these immaculate images – which Shaw has described as 'headstones' – seem to square up to the artist's own flight from suburbia, a place whose flower beds and shrubberies conceal the bodies of his abandoned adolescent heroes. (TM)

Shown by Paragon Press A1, Wilkinson Gallery D22

Selected Bibliography

2004 'The Late George Shaw: The Art Show', Channel 4, London

2003 *This Was Life (Collected Writings 1996–2003)*, George Shaw, Ikon Gallery, Birmingham

2003 *What I Did This Summer*, George Shaw and Michael Bracewell, Ikon Gallery, Birmingham

2001 *Scenes from the Passion*, George Shaw, Anthony Wilkinson Gallery, London

Selected Exhibitions

2005 'Ash Wednesday', Wilkinson Gallery, London; Gorney Bravin Lee, New York

2004 'Art of the Garden', Tate Britain, London

2003–4 'What I Did This Summer', Dundee Contemporary Arts; Ikon Gallery, Birmingham

2003 'Days Like These', Tate Triennial, Tate Britain, London

2002 'Face Off', Kettles Yard, Cambridge

2001 'The New Life', Wilkinson Gallery, London

Drummer
2005
Ball point on paper
22×15cm
Courtesy Galleria Franco Noero

Selected Bibliography

2004 *Steven Shearer*,
Contemporary Art Gallery,
Vancouver

2003 'Steven Shearer', Bruce
Hainley, *Artforum*

2003 *Baja to Vancouver.:The
West Coast and Contemporary Art*,
Matthew Higgs, CCA Wattis
Institute, San Francisco

2002 'Openings: Steven
Shearer', Matthew Higgs,
Artforum

2002 *Rock My World*, Ralph
Rugoff, CCA Wattis Institute,
San Francisco

Selected Exhibitions

2005 The Power Plant
Contemporary Art Gallery,
Toronto

2005 Galerie Eva
Presenhuber, Zurich

2005 BAWAG Foundation,
Vienna

2004 Contemporary Art
Gallery, Vancouver

2004 'Pin-Up: Contemporary
Collage and Drawing', Tate
Modern, London

2003 Galleria Franco Noero,
Turin

2003 Blum & Poe, Santa
Monica

2003 'Go Johnny Go',
Kunsthalle, Vienna

2003 Gallery Side 2, Tokyo

1999 American Fine Arts
Co., New York

Steven **Shearer**

Born 1968
Lives Vancouver

By cataloguing adolescent obsessions such as
Death Metal and Glam Rock, Steven Shearer
mines a rich vein of cultural anthropology and
personal autobiography. His work has included
shots of former teen idols – Leif Garrett, Shaun
Cassidy – and amateur photos, taken from
websites, of electric guitars and their owners.
But he strikes conceptual gold when he makes
a connection between these preoccupations and
Modernist Utopian aesthetics – viewing 1970s'
fanzines, for example, as degraded versions of
avant-garde collage. In other pieces he uses
archaic materials such as silverpoint drawing to
signal that serious fandom merits serious art. (KJ)

Shown by Galleria Franco Noero E8, Galerie Eva
Presenhuber C7

Untitled (A Short Question and Answer Session)
2004
Ink and marker on paper
38×29cm
Courtesy Galleri Nicolai Wallner

David **Shrigley**

Born 1968
Lives Glasgow

They say one should never explain a joke. In one of David Shrigley's cartoons an artist states: 'I don't actually do the paintings myself, I get a bunch of handicapped kids to do them for me.' Another, sporting a goatee, says, 'I went around town and asked dossers if I could buy their underpants from them. I got six pairs for £5 each and used them for my show in France.' A third claims: 'I go around bars at the weekends and deliberately get into fights and get my head kicked in while a friend of mine videos it.' (DF)

Shown by Stephen Friedman Gallery D11, Anton Kern Gallery D6, Yvon Lambert F6, Galerie Francesca Pia C20, Galleri Nicolai Wallner A3

Selected Bibliography

2004 *Blocked Path*, David Shrigley, Galleri Nicolai Wallner, Copenhagen

2004 *Rules*, David Shrigley, Redstone Press, London

2003 *Yellow Bird with Worms*, David Shrigley, Kunsthaus, Zurich

1995 'Jesus Doesn't Want Me for a Sunbeam: David Shrigley', Michael Bracewell, *frieze* 25

Selected Exhibitions

2005 'New Works', Anton Kern Gallery, New York

2005 'I Am So Exhausted', Galleri Nicolai Wallner, Copenhagen

2004 'New Works', Yvon Lambert, Paris

2003 'Antidepressants', Galleri Nicolai Wallner, Copenhagen

2003 Kunsthaus, Zurich

2002 UCLA Hammer Museum, Los Angeles

Falle für Präriehunde
(Trap for Prairie Dogs)
2000
Wood and metal
115×119×189cm
Courtesy Jablonka Galerie

Selected Bibliography

2001 *Andreas Slominski*, Daniel Kothenschulte, Jablonka Galerie, Cologne

1999 *Andreas Slominski*, Nancy Spector, Collier Schorr, Jens Hoffmann and Hans-Ulrich Obrist, Deutsche Guggenheim, Berlin

1999 'Andreas Slominski', Nancy Spector, Patrick Frey, Julian Heynen, Bettina Funcke and Jens Hoffmann, *Parkett*

1998 *Andreas Slominski*, Bernhard Bürgi and Max Wechsler, Kunsthalle, Zurich

1995 *Andreas Slominski*, Jean Christophe Ammann, Kunstverein, Bremerhaven; Kunstmuseen, Krefeld

Selected Exhibitions

2003 Fondazione Prada, Milan

2000 Jablonka Galerie, Cologne

1999 Deutsche Guggenheim, Berlin

1998 Kunsthalle, Zurich

1997 Kunsthalle, Hamburg

1997 White Cube, London

1997 Bonnefanten Museum, Maastricht

1995 Museum Haus Esters, Krefeld

1991 Jablonka Galerie, Cologne

1988 Kabinett für Aktuelle Kunst, Bremerhaven

Andreas **Slominski**

Born 1959
Lives Werder/Hamburg

The wilful absurdity of Andreas Slominski's work has earned him a reputation as a trickster. His eccentric traps may be improvised from an old ketchup bottle or beautifully wrought in wood, while other objects embody farcically convoluted processes with under-inflated results. For a recent show Slominski pressed the nose-cone of a glider into some expanded foam, exhibiting the depression as abstract imagery, traced the letter 'U' from the side of a huge ship and built a temporary artificial ski slope into the gallery, compressing the ski wax into a candle, which stood as testimony on a plinth. (SO'R)

Shown by Sadie Coles HQ C10, Jablonka Galerie C16, Galerie Neu F11, Produzentengalerie Hamburg E18

Gate 2 Street (Kadena Air Base), Okinawa City, Japan 2004
2004
Infra-red video stills
Courtesy Galerie Neu

Sean **Snyder**

Born 1972
Lives Berlin/Frankfurt

In a recent *tour de force* of solo exhibitions Sean Snyder laid out a dense network of interrelations – often among Cold War visual codes and Modernist architecture that have been distributed globally, despite perceived political divisions. He excavates stories such as that of the Balkan town of Skopje, which, under UN supervision, was rebuilt after a 1963 earthquake – using plans originally drawn up for Tokyo Bay. *Analepsis* (2003–4) is a silent montage of oblique, generic spaces and of ways to film them. Snyder is not 'just' an urban sociologist: focusing less on the 'hard' facts than on the 'soft' gaps between them, he extrapolates a place's aesthetic as much as social significance. (JöH)

Shown by Galerie Chantal Crousel D10, Galerie Neu F11

Selected Bibliography

2004 'Embedded Pyongyang', Krystian Woznicki, *Springerin*

2003 *Cream 3*, Phaidon Press, London

2003 'Shanghai Links, Shanghai Rechts' (Shanghai Left, Shanghai Right), Stefanie Tasch, *Texte zur Kunst*

2002 'Jump Cut Cities', Jan Verwoert, *Afterall*

2002 'The Slobozian Question', Charles Esche, *Afterall*

Selected Exhibitions

2005 Portikus, Frankfurt

2005 Secession, Vienna

2004 Kunsthalle, St Gallen

2004 De Appel, Amsterdam

2004 'Utopia Station', Haus der Kunst, Munich

2003 'Territories', Kunst-Werke, Berlin

2003 'Para/Sites', Kunstverein, Karlsruhe

2003 'Living inside the Grid', New Museum of Contemporary Art, New York

2002 Galerie Neu, Berlin

1998 Berlin Biennial

Tonight
2002
Video
7 minutes, 54 seconds loop
Edition of 3+2AP
Courtesy Galeria Fortes Vilaça

Selected Bibliography

2005 *Follies*, The Bronx
Museum of the Arts, New
York; MARCO, Monterrey

1999 *Vanishing Point*, Galeria
Camargo Vilaça, São Paulo

1996 *Histórias* (Histories),
Galeria Camargo Vilaça,
São Paulo

Valeska **Soares**

Selected Exhibitions

2005 'Narcissus', Galeria Fortes
Vilaça, São Paulo

2005 'Always a Little Further',
Arsenale, Venice Biennale

2004 'Non Toccare la Donna
Bianca', Fondazione Sandretto
Rebaudengo, Turin

2004 Liverpool Biennial

2003–4 'Follies', The Bronx
Museum of the Arts, New York

2003 'Puro Teatro', Museo
Rufino Tamayo, Mexico City

2003 'Detour', Galeria Fortes
Vilaça, São Paulo

2001 'Virgin Territory',
National Museum of Women
in the Arts, Washington, D.C.

2001 'Ultrabaroque', San
Francisco Museum of
Modern Art

Born 1957
Lives New York

Valeska Soares collects objects such as tiles,
pastries and perfume, which she then displaces,
rearranges and reconfigures into groups of
sculptures, installations, photographs and videos.
She combines Minimalism (polished metals and
repetition) with a baroque and documentary
sensibility – one piece, for example, includes
a looped video of footage from the 1940s of a
Modernist night-club in Brazil, while another re-
creates the flowerpots and saucers from a garden
the artist once had. Soares has described her work
as 'a visit to my private universe [...] there's no
way to separate where your thoughts come from.'
(JH)

Shown by Galeria Fortes Vilaça C15

Brothers in Arms (Not a Political Film)
2004
Video still
Courtesy Sommer
Contemporary Art

Doron **Solomons**

Born 1969
Lives Tel Aviv

Doron Solomons' videos question the inevitability of ambivalence in political arguments. The 2004 work *Brothers in Arms (Not a Political Film)*, for example, does not offer the ideal of political balance in its commentary on the Israel–Palestine conflict. Rather, it explores the equivocal and the politically contradictory, using images of symmetry and connection, such as the image of conjoined twins. Avoiding and critiquing the false stability of visual propaganda, Solomons' videos investigate the logics of political debate both locally and globally, and reflect on specific crises while also bearing a more general relevance. (DJ)

Shown by Sommer Contemporary Art A2

Selected Bibliography

2004 'Doron Solomons', Janet Kreynak, *Artforum*

2003 'Doron Solomons: "Father"', Natalie Kosoy, *Studio*

2002 'The Virtual Shahid', Uzi Tzur, *Haaretz*

Selected Exhibitions

2005 'The New Hebrews', Martin Gropius Bau Museum, Berlin

2005 'Getting Emotional', Institute of Contemporary Art, Boston

2004 'Art in the Age of Terrorism', Millais Gallery, Southampton

2004 'Terrorvision', Exit Art, New York

2002 'Dreams and Conflicts: The Dictatorship of the Viewer', Arsenale, Venice Biennale

Shell
2004
Acrylic on wood
80×180cm
Courtesy Sommer
Contemporary Art

Selected Bibliography

2004 *Channel Zero*, Katerina Gregos, Amsterdam

2000 *Art Now*, ed. Uta Grosenick and Burkhard Riemschneider, Taschen, Cologne

Selected Exhibitions

2005 'The New Hebrews', Martin Gropius Bau Museum, Berlin

2005 'Trial of Power', Kunstraum Kreuzberg/ Bethanien, Berlin

2004 'Untitled', Palazzo delle Papesse, Siena

2002 'Port', Tel Aviv Museum of Art

2001 'Plateau of Humankind', Italian Pavilion, Venice Biennale

2000 Fondazione Sandretto Re Rebaudengo per l'Arte, Turin

Eliezer **Sonnenschein**

Born 1967
Lives Berlin

Hijacking the aesthetics of gaming graphics, corporate logos and slick advertising, Eliezer Sonnenschein creates visually arresting installations and digital prints. Increasingly – for example, in *Port* (2001) – his critique of capitalism and aggressive marketing has turned on the art world itself. Tracking the figure of the artist as a protagonist in a morality tale involving 'The Underground', 'Art School' and 'Art History', Sonnenschein addresses invisible hierarchies, business potential and brand appeal in a humorously cynical take on his chosen career. (MA)

Shown by Galerie Nathalie Obadia E23, Sommer Contemporary Art A2

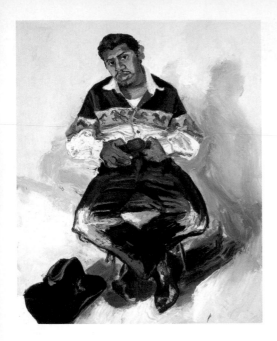

Fernando Pinón
2003
Oil on canvas
152×122cm
Courtesy ACME.

Selected Bibliography

2005 'Face Time', Robert L. Pincus, *San Diego Union-Tribune*

2005 'John Sonsini', Ken Johnson, *The New York Times*

2002 'It's All About the Gaze', Eve Wood, www.artnet.com

2000 'The Collaborators John Sonsini and His Model, Gabriel, Make a Fine Art Pair', Myrium Bradley, *Art Connoisseur*

1999 'L.A. Portraiture: Post Cool', Michael Duncan, *Art in America*

Selected Exhibitions

2005 'New Paintings', Anthony Grant, Inc., New York

2005 'Cerca Series: John Sonsini', Museum of Contemporary Art, San Diego

2004 'About Painting', Tang Museum, Skidmore College, Saratoga Springs

2003 'Portraits', ACME., Los Angeles

2002 'L.A. Post Cool', The San José Museum of Art

2002 'Nude + Narrative', P.P.O.W., New York

2002 'Representing L.A.', Frye Art Museum, Seattle

2001 'Made in California: Art, Image, and Identity 1900–2000', Los Angeles County Museum of Art

1999 'Portraits from L.A.', Robert V. Fullerton Museum, California State University, San Bernardino

1996 'Paintings', Rosamund Felson Gallery, Santa Monica

John **Sonsini**

Born 1950
Lives Los Angeles

In recent years John Sonsini has pursued an ambitious project, producing hundreds of portraits of day labourers in the Los Angeles area – mostly from Mexico, El Salvador and Guatemala. After the painting is completed, the sitters sign the back with their name and that of their native country. Sonsini says: 'For an undocumented immigrant (which virtually all these men are) the notion of one's image and one's name intersects with the activity of the painter's notion of remaking likenesses and presences in a remarkable way.' Other paintings have focused on Sonsini's long-time muse Gabriel, an important collaborator in the day-labourer project. (KJ)

Shown by ACME. D15

Untitled
2004
Mixed media
Dimensions variable
Courtesy Foksal Gallery
Foundation

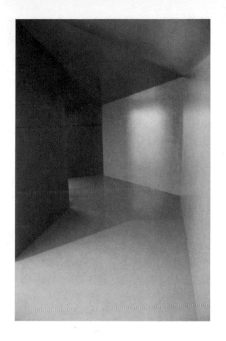

Selected Bibliography

2005 'Monika Sosnowska',
Tom Morton, *frieze* 89

2003 *Hidden in a Daylight*,
Foksal Gallery Foundation,
Warsaw

2003 *Architectures of Gender:
Contemporary Women's Art in
Poland*, Sculpture Center, New
York; National Museum,
Warsaw

2003 *Bewitched, Bothered and
Bewildered: Spatial Emotion in
Contemporary Art and Architecture*,
Migros Museum, Zurich; Łaznia
Centre for Contemporary Art,
Gdansk

Monika **Sosnowska**

Selected Exhibitions

2005 Gallery Gisela Capitain,
Cologne

2004 Serpentine Gallery,
London

2004 Kunstlerhaus Bethanien,
Berlin

2004 De Appel Gallery,
Amsterdam

2004 The Modern Institute,
Glasgow

2004 Stella Lohaus Gallery,
Antwerp

2004 'Barraque D'Dull
Odde', Galleria Continua, San
Giminiano

2004 'Cordially Invited', Basis
Voor Actuele Kunst, Utrecht

2003 'Labyrinth', kurimanzutto,
Mexico City

2003 'Splendor Geometrik',
Gallery Gisela Capitain,
Cologne

Born 1972
Lives Warsaw

Inspired by *Alice in Wonderland*, Monika Sosnowska's
Little Alice (2001) constructs a succession of rooms
in ever-diminishing proportions. The confusions
and instabilities of scale that tormented Alice are
echoed elsewhere in Sosnowska's work, with its
calculated disorientation of the viewer's spatial
perceptions. Labyrinthine constructions, long
winding tunnels that gradually become lower
and narrower, or a six-metre-long corridor with
12 doorways opening onto it are disguised with
apparently functional or familiar details such as
wainscoting painted a universal institutional green.
Are these devices sent to enrapture us, trap us or
liberate us from our spatial complacency? (KB)

Shown by Galerie Gisela Capitain D12, Foksal
Gallery Foundation C14, kurimanzutto B11, The
Modern Institute / Toby Webster Ltd B15

Selected Bibliography

2004 'Glenn Sorensen', Rebecca Geldard, *Time Out London*

2004 'Glenn Sorensen', Francesco Galdieri, *tema celeste*

2003 'Glenn Sorensen', Karen Rosenberg, *frieze* 74

2002 'Glenn Sorensen', Roy Exley, *Flash Art International*

2001 'Extended Painting', Luca Beatrice, *Flash Art*

Glenn **Sorensen**

Born 1968
Lives Åhus

Glenn Sorensen's introspective paintings feel as if they were painted in twilight: their soft, often violet and lavender palette is quiet and faintly blurred, like dreamy studies in concentrated reverie. His subject matter is his environment: flowers, fabric patterns, a child, a cigarette, a woman. His paint handling emanates the puzzled awkwardness that occurs when you're trying to understand what it is you are looking at; the result is the kind of image that might occur to you when your mind is wandering and is suddenly struck by the strange beauty of something you had previously overlooked. (JH)

Shown by Corvi-Mora E7, Raucci/Santamaria Gallery A5, Galleri Nicolai Wallner A3

Selected Exhibitions

2005 Annet Gelink Gallery, Amsterdam

2004 Galleri Nicolai Wallner, Copenhagen

2004 Galleria Raucci/ Santamaria, Naples

2004 Corvi-Mora, London

2003 The Nordic Watercolour Museum, Skärhamn

2003 Annet Gelink Gallery, Amsterdam

2003 'De Bortbjudna', Rooseum Center for Contemporary Art, Malmö

2002 Klemens Gasser & Tanja Grunert, Inc., New York

2002 'The Galleries Show', Royal Academy of Arts, London

2001 Corvi-Mora, London

Rapunzel
2005
Video installation
Dimensions variable
Courtesy Lehmann Maupin

Selected Bibliography

2005 *Art History*, Marilyn Stokstad, Prentice Hall, Upper Saddle River

2005 *Visual Music*, Kerry Brougher, Thames & Hudson, London

2004 'Making the Trees Dance', Michelle Falkenstein, *ARTnews*

2003 'Mending the Breach', Eleanor Heartney, *Art in America*

2003 'Jennifer Steinkamp', Christopher Miles, *Artforum*

Selected Exhibitions

2005 'Extreme Abstraction', Albright-Knox Gallery, Buffalo

2005 'Beau Monde', SITE Santa Fe

2005 'Visual Music', Hirshhorn Museum and Sculpture Garden, Smithsonian Institution, Washington, D.C.

2005 'The Shape of Colour', Art Gallery of Ontario

2005 greengrassi, London

2004 'Dervish', Lehmann Maupin, New York

2004 Gwangju Biennial

2004 Museo de Arte Contemporáneo de Castilla y León, Madrid

2003 Istanbul Biennial

2000 Fremont Street Experience, Las Vegas

Jennifer **Steinkamp**

Born 1958
Lives Los Angeles

Trees twist and writhe, flower petals flutter like coyly batting eyelids, hanging vines and clutches of fauna shudder and quake like ecstatic visions in an enchanted garden. Jennifer Steinkamp's complex computer-generated animations, bristling with light and eye-dazzling specificity, visualize the speeded–up time-frames and imagined emotive inner lives of natural organisms we normally think of as static and nobly immobile, acted on but never acting for themselves. Her 2004 installation *Dervish* showed four individual trees dominating fours walls, each gyrating wildly with a devotional energy transmitted through every fibre of its being, from its gracefully rotating trunk to the merest leaf. (JT)

Shown by ACME. D15, greengrassi C4, Lehmann Maupin F18

Untitled
2004
Oil and enamel on canvas
240×198×5cm
Courtesy Galleria Massimo
de Carlo

Selected Bibliography

2004 *Art from 1951 to the Present*, Guggenheim Foundation, New York

2004 *Love/Hate: da Magritte a Cattelan* (Love/Hate from Magritte to Cattelan), Villa Manin, Passariano

2004 *Home Depot*, Museum für Moderne Kunst, Frankfurt

2001 *Progetto Ansitz Lowengang* (Ansitz Lowengang's Project), Giorgio Verzotti, Fotolito Longo, Bolzano

2000 *Painting Zero Degree*, Independent Curators International, New York

Selected Exhibitions

2004 'Home Depot', Museum für Moderne Kunst, Frankfurt

2004 'Love/Hate: da Magritte a Cattelan', Villa Manin, Passariano

2004 'Moving Outlines', Contemporary Arts Museum, Baltimore

2004 'Art from 1951 to the Present', Guggenheim Museum, New York

2003 'Commodification of Buddhism', The Bronx Museum of the Arts, New York

2003 'Dreams and Conflicts: The Dictatorship of the Viewer', Arsenale, Venice Biennale

2002 'Franz West, Rudolf Stingel', Museum der Moderner Kunst, Salzburg

2000 'Painting Zero Degree', Cranbrook Museum of Art, Bloomfield Hills

Rudolf **Stingel**

Born 1956
Lives New York

The history of modern painting is a mess, but one that deserves to be dealt with. This is precisely what Rudolf Stingel does, continually embracing and mocking, assailing and expanding the potential of the self-referential canvas today. Works may consist of graffiti scratched into silver foil covering industrial insulation panels (*Untitled*, 2001–2) or diptychs of polystyrene boards into which patterns are stamped by foot (*Untitled*, 2000). His is a materialist aesthetic that, with both Punkish disdain and artistic devotion, celebrates the cheapness and grace of the monochrome. (JV)

Shown by Sadie Coles HQ C10, Galleria Massimo de Carlo E10, Georg Kargl G9

Imagined Studio
2004–5
Embroidered photograph on
canvas
83×113cm
Courtesy Galerie Fons Welters

Selected Bibliography

2004 'Berend Strik: Niet
Zonder Emotie' (Not Without
Emotion), Pietje Tegenbosch,
Museumtijdschrift

2004 'De Ruis Voorbij' (Beyond
the Noise), Xandra de Jongh,
Kunstbeeld

2004 'Een Vrouw Borduren:
De Zachte Harde Wereld van
Berend Strik' (Embroidering
a Woman: The Sweet Tough
World of Berend Strik), Edzard
Mik, *Vrij Nederland*

2004 'Mutations', *Body Electric*,
Sven Lütticken, Fries Museum,
Amsterdam

2003 'Aperto Amsterdam',
Andreas Schlaegel, *Flash Art*

Selected Exhibitions

2005 Jack Tilton Gallery,
New York

2005 'TexStyle', Blindarte
Contemporanea, Naples

2004 'Body Electric', Fries
Museum, Leeuwarden

2004 'Freestyle', Galerie Fons
Welters, Amsterdam

2001 'Reproductive Rights Are
Human Rights', Galerie Annette
De Keyser, Antwerp

1999 International Studio
Program, New York

1998 Richard Heller Gallery,
Los Angeles

1998 Galerie Lars Bohman,
Stockholm

1994 'Sadness, Sluices,
Mermaids, Delay', Stedelijk
Museum, Amsterdam

Berend **Strik**

Born 1960
Lives Amsterdam

The content of Berend Strik's photographic
collages often toys with the threshold of decency,
in contrast to the delicate and homely beauty of
his added stitching or glued fabrics. Works such as
Body Electric (2003) are handmade interventions
into what Strik depicts as the crudeness of the
photographic imagination. Enlarged magazine
clippings, found photographs and drawings are
altered and enhanced by the poetic qualities of
his chosen form. Pornographic imagery and a
fascination with kitsch recur throughout his work;
the apparently obscene is decorated and partially
obscured, in curious and unsettling symmetry with
his similar defacing of less aggressive imagery. (DJ)

Shown by Galerie Fons Welters E19

Selected Bibliography

2005 *Museum Photographs*, Hans Belting et al., Schirmer/Mosel, Munich

2004–5 *Forme per il David* (Forms for David), ed. Bruno Cora, Giunti Editore, Florence

2004 *Pergamon Museum*, Wolf-Dieter Heilmeyer, Schirmer/Mosel, Munich

2002 *Thomas Struth 1977–2002*, C. Wylie et al., Yale University Press, New Haven

2002 *New Pictures from Paradise*, Ingo Hartmann et al., Schirmer/Mosel, Munich

Selected Exhibitions

2005 'Audience, Read This Like Seeing It for the First Time', Marian Goodman Gallery, New York

2005 'Imágenes del Perú', Museo de Arte de Lima

2004 'Pergamon Museum', Museum für Fotografie im Hamburger Bahnhof, Berlin

2004 CAPC Musée d'Art Contemporain, Bordeaux

2002–3 Dallas Museum of Art; Museum of Contemporary Art, Los Angeles; Metropolitan Museum of Art, New York; Museum of Contemporary Art, Chicago

2002 'Pergamon Museum', Marian Goodman Gallery, New York

2001 'Thomas Struth: My Portrait', The National Museum of Modern Art, Tokyo

1999 Centre National de la Photographie, Paris

Thomas **Struth**

Born 1954
Lives Dusseldorf

Thomas Struth's monumentally scaled photographs range across genre and geography: he has depicted empty urban streets and crowded museum galleries, and gone from spare domestic portraits to lush jungle landscapes. Yet a singular focus persists in his project – as Peter Schjeldahl has noted, Struth's subject is 'the world according to photography'. His pictures juxtapose two sorts of time: the instantaneous shutter click of the camera and the slow accretion of detail that happens in the viewer's eye and mind. The power of these images depends on an almost spiritual faith in the not so simple act of looking. (SS)

Shown by Marian Goodman Gallery F9

North Wall
2005
Polyester, stainless steel armature
and cable
505×825×125cm
Courtesy Lehmann Maupin

Selected Bibliography

2004 'Do-Ho Suh', Paul
Laster, *tema celeste*

2003 'Do-Ho Suh', Ken
Johnson, *The New York Times*

2002 'The Art of Do-Ho
Suh: Home in the World',
Frances Richard, *Artforum*

2002 'The Singular Pluralities
of Do-Ho Suh', Joan Kee,
Art Asia Pacific

2001 'Do-Ho Suh', Jenny Liu,
frieze 56

Selected Exhibitions

2005 'Reflection', Hermes,
Tokyo

2004 Lehmann Maupin,
New York

2003 Lehmann Maupin,
New York

2003 'The Perfect Home',
Kemper Art Museum,
Kansas City

2003 Art Sonje Centre, Seoul

2003 'Poetic Justice', Istanbul
Biennial

2002 Seattle Art Museum

2002 Serpentine Gallery,
London

2001 Korean Pavilion,
Venice Biennale

2000 'Greater New York',
PS1 Contemporary Art Center,
New York

Do-Ho **Suh**

Born 1962
Lives Seoul/New York

A stainless steel parachutist tethered to thousands
of embroidered signatures by scarlet threads; a
ghostly apartment sewn from filmy smoke-blue
nylon; hordes of plastic figurines supporting a glass
floor – these are just a few of Do-Ho Suh's layered,
obliquely metaphorical installations. A feeling
of East–West displacement prevails: some works
draw from Eastern traditions, such as the Japanese
belief that red stitching protects soldiers, or the use
in Korea of translucent screens to divide domestic
spaces, while in others Modernist devices such as
the grid provide touchstones. (KJ)

Shown by Lehmann Maupin F18

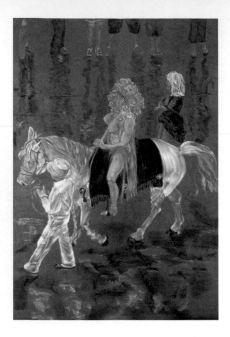

man godiva
2005
Oil and graphite on linen
279×191cm
Courtesy Olbricht Collection,
Germany, and Klemens Gasser &
Tanja Grunert, Inc.

Selected Bibliography

2005 'Like a Quarter Mile
Race: Alex Katz and Ena
Swansea', *Parkett*

2005 *The Triumph of Painting*,
Alison Gingeras and Barry
Schwabsky, The Saatchi
Gallery, London

2004 *Central Station*, Hans-
Ulrich Obrist, Laurence Dreyfus
and Sophie Delpeux, La Maison
Rouge, Paris

2004 'Ena Swansea', Melissa
Kuntz, *Art in America*

2004 'The Feeling of Now',
Adrian Danatt, *The Art
Newspaper*

Ena **Swansea**

Born 1965
Lives New York

The first paintings that Ena Swansea exhibited, in
the late 1990s, were studies of dappled light and
shadow, hovering on the brink of abstraction.
Since then she has switched to a figurative mode,
producing roughly lyrical portraits and group
scenes that exude a sleepy sensuality. Many of the
newer works are painted over a rich black graphite
ground, creating the sense that her subjects are
emerging from the murky interior of the canvas.
The stories these pictures tell seem less hidden
than private – potentially available but just out of
reach. The unknown remains Swansea's concern,
whether the shadows in her work are formal or
dramatic. (SS)

Shown by Klemens Gasser & Tanja Grunert,
Inc. C21

Selected Exhibitions

2005 'Wet Paintings', Ascan
Crone/Andreas Osarek, Berlin

2005 'Greater New York',
PS1 Contemporary Art Center,
New York

2005 'The Triumph of Painting',
The Saatchi Gallery, London

2005 'Story-Tellers',
Kunsthalle, Hamburg

2005 'Slices of Life: Blueprints
of the Self in Painting', Austrian
Cultural Forum, New York

2004 'situation', Klemens Gasser
& Tanja Grunert, Inc., New York

2004 'x rays', Mario Diacono at
Ars Libri, Boston

2004 'Central Station', La
Maison Rouge, Paris

2004 'Portraits', Esso Gallery,
New York

2003 'After Matisse Picasso',
PS1 Contemporary Art Center,
New York

Banded King Snake Counterpoise
2004
Mixed media on canvas
2 parts, 116×94cm each
Courtesy Jablonka Galerie

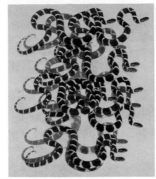 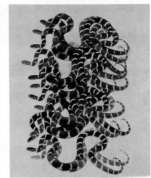

Selected Bibliography

2002 *Philip Taaffe: Ten Paintings*, Roger Lipsey, Jablonka Galerie, Cologne

2001 *Philip Taaffe*, Vittoria Coen and Francesco Pellizzi, Galleria Civica, Edizione Mazzotta, Trento

2000 *Philip Taaffe*, Enrique Juncosa, Robert Rosenblum and Robert Creeley, IVAM Institute Valencia d'Arte Moderne

1998 *Composite Nature*, Stan Brakhage and Philip Taaffe, Peter Blum Editions, New York

1996 *Philip Taaffe*, Brooks Adams, Secession, Vienna

Selected Exhibitions

2004 Jablonka Galerie, Cologne

2001 Galerie Civica d'Arte Contemporanea, Trento

2000 IVAM Centre del Carme, Valencia

1999 Gagosian Gallery, New York

1998 Thomas Amman Fine Art, Zurich

1997 Peter Blum, New York

1996–7 Secession, Vienna

1993 Center for Fine Arts, Miami, Florida

1988 Galerie Lucio Amelio, Naples

1984 Pat Hearn Gallery, New York

Philip **Taaffe**

Born 1955
Lives New York

While Philip Taaffe's work from the 1980s incorporated elements sourced from earlier painters such as Barnett Newman and Bridget Riley, more recent years have seen an exponential multiplication of his decorative sources. His rainbow-hued schemes now combine elements drawn from aquatic and zoological life with a profusion of ornamental motifs ranging from the baroque to the ethnological. Taaffe uses silkscreens, stencils, woodblocks, linocut and collage to create mesmerizing, kaleidoscopic images such as *Bal Astérie* (1999), a painting of multiple starfish adrift in the sea, and *Water Drawing* (2004), in which marbled layers of colour swirl like a psychedelic light show. (SL)

Shown by Rebecca Camhi E22, Jablonka Galerie C16, Gagosian Gallery D9, Galerie Thaddaeus Ropac F14

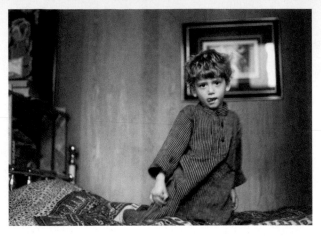

Selected Bibliography

2005 *Fiona Tan: Countenance*, Mark Godfrey, Modern Art Oxford

2005 'Who Are You?', Adrian Searle, *The Guardian*

2005 'Is That Portrait Staring at Me?', Philip Gefter, *The New York Times*

2004 *Fiona Tan: Correction*, Francesco Bonami, Museum of Contemporary Art, Chicago

2002 *Fiona Tan*, De Pont Foundation for Contemporary Art, Tilburg

Fiona **Tan**

Born 1966
Lives Amsterdam

Time and recollection are Fiona Tan's central concerns. She has stated that 'my confusion about my own identity triggered a considerable number of my art works. Because of my mixed background and migrations, I have been asking questions about where cultural and individual identity is located.' More interested in inquiry and proposition than in conclusion, Tan employs projections, soundscapes, performance and photography to create complex, atmospheric environments. Her subjects have ranged from tracing the history of her family, colonialism and autobiography to American prisons, the fallibility of memory and identity politics. (JH)

Shown by Frith Street Gallery C1

Selected Exhibitions

2005 'Saint Sebastian', Musée d'Art Contemporain, Montreal

2005 'Countenance', Modern Art Oxford

2004 'Correction', Museum of Contemporary Art, Chicago

2004 'Time Zones', Tate Modern, London

2002 'Fiona Tan: Akte 1', De Pont Foundation for Contemporary Art, Tilburg

2002 Documenta, Kassel

2001 'Plateau of Humankind', Italian Pavilion, Venice Biennale

Alquitrans
2002–4
Oil, wood, ink, pigments
on canvas
46×61cm
Courtesy Raucci/Santamaria
Gallery

Selected Bibliography

2002 *Millions of Dead Tamagotchi*, David Robbins, Bluecoat Gallery, Liverpool

2002 *Lazy Clever Doubt*, Caoimhìn Mac Giolla Léith, Douglas Hyde Gallery, Dublin

1999 *Pádraig Timoney: Membranes of [Things Past]*, Liam Gillick, The Orchard Gallery

1998 'Pádraig Timoney', Michael Archer, *Artforum*

1994 *Pádraig Timoney*, Declan Sheehan, Raucci/Santamaria Gallery, Naples

Selected Exhibitions

2005 Raucci/Santamaria Gallery, Naples

2004 The Modern Institute, Glasgow

2003 'The Grapevine in the Limelight', 38 Langham Street, London

2003 Art Statements, Art Basel

2002 'Millions of Dead Tamagotchi', Bluecoat Gallery, Liverpool

2002 'Lazy Clever Doubt', Douglas Hyde Gallery, Dublin

2002 Greene Naftali, New York

2000 'The British Art Show', Hayward Gallery, London and touring

1999 'Fantasy Heckler', Liverpool Biennial

1997 'No Tim Page Diary', Galerie Analix, Geneva

Pádraig **Timoney**

Born 1968
Lives Naples

Pádraig Timoney often goes to flamboyant lengths for his art. He once flew from the UK to Los Angeles especially to buy a blank videotape (resulting in the sculpture *The Hunter Became ... the Hunted*, 1997), and he visited Jerusalem to find cobwebs. A native of Northern Ireland, Timoney has been making strategic objects and obstinate paintings since the late 1980s – works whose intractability and murky motivation have garnered frequent comparisons to the political climate of that province. *Bad Reputations Start Fires* (1995), for example, comprises an acid-filled fire extinguisher, while *Plastic Lumps* (2003) is a canvas that sports paint like brightly coloured tumescent turds. (MA)

Shown by The Modern Institute / Toby Webster Ltd B15, Raucci/Santamaria Gallery A5

A Morning Burn's Kiss
2004
Watercolour on paper
112×100cm
Courtesy Galerie Anne de
Villepoix

Selected Bibliography

2004 *The Sick Opera*, Jérôme
Sans and Peter Doroshenko,
Palais de Tokyo, Paris

2004 *Settlements*, John Peffer,
Musée d'Art Moderne de Saint-
Etienne

2001 'Eutropia', Philippe
Hardy, *Revue italo-française*

2000 *A quoi rêvent les années
90* (What Do the '90s Dream
of?), Jean-Charles Masséra and
Barthélémy Toguo, Espace
Mira Phalaina, Montreui

1998 *Parasites*, Jean-Charles
Masséra, Centre d'Art Plastiques
de Saint-Fons

Barthélémy **Toguo**

Born 1967
Lives Paris

Whether wearing a Parisian dustman's overalls in a first-class train carriage or taking a seat on a plane in a gigantic wooden hat, Barthélémy Toguo's work displays a talent for absurdity. His drawings, paintings and multimedia environments often actualize abstract political themes, such as sweatshop labour, suggested in the fantastical sculpture *China Town Exile* (2001). Toguo puts the viewer in an uneasy position: washing the stars and stripes for a New York performance in 2001 or surrounding the *Innocent Sinners* (2005) installation of his knowingly 'primitive' drawings and paintings with a carpet of flattened cardboard that had originally been used to ship plantains and bananas. (SL)

Shown by Galerie Anne de Villepoix D1

Selected Exhibitions

2005 'Domicile privé/public',
Musée d'Art Moderne, Saint-
Etienne

2004 'Africa Remix', Museum
Kunst Palast, Dusseldorf;
Hayward Gallery, London;
Centre Georges Pompidou, Paris

2004 'The Sick Opera', Palais de
Tokyo, Paris

2003 'Pure and Clean', Institute
of Visuals Arts, Milwaukee

2003 'Outlook', Athens

2003 'Ökonomien der Zeit',
Migros Museum, Zurich

2002 'Mamie Water', Galerie
Anne de Villepoix, Paris

2000 'Pénicilline', Centre
Culturel Français, Turin

1999 'Baptism', Kunstmuseum
Dusseldorf in der Tonhalle,
Dusseldorf

1999 'Migrateurs', ARC, Musée
d'Art Moderne de la Ville de
Paris

NATO (NSC 3805 – Includes:
Trucks and Trailers. Precision Heavy
Haul Inc. AZ, USA)
2005
Watercolour on Arches paper
21×30cm
Courtesy Annely Juda Fine Art

NATO Supply Classification (NSC) 3805 - Earth moving and excavating
equipment (includes Scrapers; Ditchers; Loaders; Graders; Special
Construction Type Earth and Rock Hauling Trucks and Trailers)

'Miscellaneous' - Precision Heavy Haul, Inc.
Heavy Specialized Transport Services
433 South 83rd Avenue, Tolleson, AZ 85353 USA

Selected Bibliography

2005 *Modern Art: A Critical
Introduction*, Pam Meecham
and Julie Sheldon, Routledge,
London

2004 'Operation Swanlake',
Jean Wainwright, *Art Monthly*

2002 'Self-Created Worlds',
Michael Duncan, *Art in America*

2002 *_Reload_Rethinking Women
+ Cyberculture*, MIT Press,
Cambridge

1999 *No Other Symptoms: Time
Travelling with Rosalind Brodsky*,
Black Dog, London

Selected Exhibitions

2005 'The Blur of the
Otherworldly', Center for Art
and Visual Culture, Baltimore
and touring

2004 'Operation Swanlake',
Annely Juda Fine Art, London;
Künstlerhaus Bethanien, Berlin

2004 'PLANET B: The B-
Movie in Contemporary Art',
Vorarlberger Kunstverein-
Magazin 4; Künstlerhaus,
Bregenz; Palais Thurn & Taxis

2003 'Don't Call it
Performance', Museo Nacional
Centro de Arte Reina Sofia,
Madrid and touring

2002 Sydney Biennial

1999 Media Art Biennial, WRO
Centre for Media Art, Wrocław
and touring

1996 Institute of Contemporary
Arts, London

1990 'Decoy', Serpentine
Gallery, London

Suzanne **Treister**

Born 1958
Lives London/Berlin

Although Suzanne Treister's ongoing *alter-ego*
project *Time Travelling with Rosalind Brodsky* could
be read as fanciful escapism, it is also a determined
protest against the strictures of time and space.
Since her travels through space and time began
in 1980, the fictional Brodsky has attempted to
rescue her grandparents from the Holocaust,
consulted with Freud, Jung and Kristeva, and
visited swinging London. Brodsky's quasi-
scientific findings are presented in exhibitions such
as 'Operation Swanlake' (2004), which use video,
computer prints, photographs and drawings to
posit links between disparate objects and entities –
in this case, Soviet navy ships, Tchaikovsky and a
black hole in the constellation of Cygnus. (SL)

Shown by Annely Juda Fine Art F1

Selected Bibliography

2004 *Gavin Turk*, Royal Jelly Factory, London

2003 *Gavin Turk in the House: A Reader*, Deborah Curtis, Open House, Sherborne

2002 *Copper Jubilee: Gavin Turk*, The New Art Gallery, Walsall

1993–4 *Gavin Turk: Collected Works 1988–1993*, Jay Jopling, London

Selected Exhibitions

2005 'Melange', Galerie Krinzinger, Vienna

2005 'White Elephant', Sean Kelly, New York

2004 'The Golden Thread', White Cube, London

2004 'Mike Kelley: The Uncanny', Tate Liverpool; Museum Moderner Kunst, Stiftung Ludwig, Vienna

2002 Tate Britain Sculpture Court Display, London

1999 'The Importance of Being Ernesto', Galerie Krinzinger, Vienna

1998 'UK Maximum Diversity', Galerie Krinzinger, Benger Fabrik Bregenz

1997 'Sensation: Young British Artists from the Saatchi Collection', Royal Academy of Arts, London

1997 'Material Culture', Hayward Gallery, London

1995 'Young British Artists III', Saatchi Collection, London

Gavin **Turk**

Born 1967
Lives London

Gavin Turk strains the notions of authorship and authenticity through a sensibility that is informed by both the sobriety of Jacques-Louis David and the snotty anger of Punk. Casting himself in the roles of political and cultural revolutionaries such as Che Guevara, Sid Vicious and Joseph Beuys, in wax sculptures and Andy Warhol-influenced prints, Turk creates a genealogy that posits himself as their natural heir, and in the process asks us what we really want from the figure of the artist. Like his bronze casts of bin bags and dirty polystyrene teacups, these are works that hover uncomfortably between the degradation of the high and the apotheosis of the low. (TM)

Shown by Galerie Krinzinger F15, Galerie Almine Rech G1, White Cube/Jay Jopling F8

Olympic
2005
Neon light, steel
5 circles; diameter 300cm each
Courtesy Studio Guenzani and
Haunch of Venison

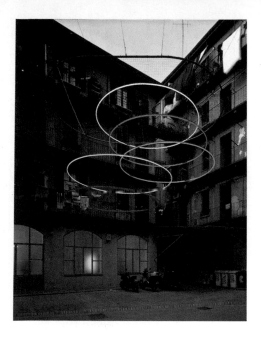

Selected Bibliography

2004 *My Private #2*, Barbara
Casavecchia and Anna Daneri,
Via Pasteur, Milan

2003 'Estetica Situazionale
(la dimensione sociale nel
lavoro di Patrick Tuttofuoco)'
(Situational Aesthetics (The
Social Dimension in the Work
of Patrick Tuttofuoco)), Jens
Hoffman, *Flash Art*

2003 *Name: Just Add Artist, Patrick
Tuttofuoco*, Emanuela Audisio,
Luca Cerizza, Massimiliano
Gioni, Jeffrey Inaba and Peter
Zellner, Schneider TM, Silvana
Editoriale, Milan

2002 'Patrick Tuttofuoco',
Alessandra Pioselli, *Artforum*

2002 'Patrick Tuttofuoco',
Massimiliano Gioni, *tema celeste*

Selected Exhibitions

2004 Manifesta, San Sebastian

2004 'Encounters in the 21st
Century', 21st Century Museum
of Contemporary Art, Kanazawa

2003 'La Zona', Giardini,
Venice Biennale

2003 'Spectacular', Museum
Kunstpalast, Dusseldorf

2002 Studio Guenzani, Milan

2002 'Exit', Fondazione
Sandretto Re Rebaudengo,
Turin

2001 'Turn On', Ikon Gallery,
Birmingham

2000 'L'Art dans le monde',
Musée de Beaux-Arts, Paris

Patrick **Tuttofuoco**

Born 1974
Lives Milan

In Patrick Tuttofuoco's work the world seems to
have responded to a cry of 'Bigger, Faster, More
More More'. While his architectural assemblages
are steeped in the social and political dynamics of
Modernist Utopias, they also capture the pulsing,
cartoon energy that characterizes, for example,
Postmodern South-East Asian boom towns. If these
structures are as twitchily unstable as they are
ambitious, it is because movement – the legacy of
the Futurists – is related to his project. The motor
of desire, it is also what drives new relationships,
ideas and forms. (TM)

Shown by Studio Guenzani E13, Haunch of
Venison F16

Piotr **Uklanski**

Born 1968
Lives Paris/New York

Piotr Uklanski's disparate practice has ranged from his acclaimed *Dance Floor* (1996), a piece that joined the dots between *Saturday Night Fever* and Donald Judd, to his controversial photo series 'The Nazis' (1998), a compilation of over 100 portraits of film actors portraying Nazis. The connection between these works is an examination of how both wonder and numbness are instilled in the spectator. This interest was apparent in one of his most striking works, *Untitled (The Full Burn)* (1998), for which Uklanski paid a stuntman to perform a 30-second full body burn in front of the stunned audience at the Manifesta 2 opening. (SL)

Shown by Gavin Brown's enterprise D7, Galleria Massimo de Carlo E10, Galerie Emmanuel Perrotin D3

Selected Bibliography

2004 *Earth, Wind and Fire*, Piotr Uklanski, Kunsthalle, Basel

2004 *Zimna Wojna*, Piotr Uklanski, Galleria Massimo de Carlo, Milan

1999 *The Nazis*, Piotr Uklanski, Editions Patrick Frey, Zurich

Selected Exhibitions

2005 'Polonia', Galerie Emmanuel Perrotin, Paris

2005 'Façade', Arbeiterkammer, Vienna

2004 'Earth, Wind and Fire', Kunsthalle, Basel

2004 'Zimna Wojna', Galleria Massimo de Carlo, Milan

2002 'Mirroring Evil: Nazi Imagery/Recent Art', The Jewish Museum, New York

2000 'Au-delà du spectacle', Centre Georges Pompidou, Paris

2000 'Project 72', Museum of Modern Art, New York

Selected Bibliography

2004 *Paloma Varga Weisz*,
Jean-Christophe Ammann,
Guido de Wird and Anna-
Catharina Gebbers, Museum
Kurhaus Kleve; Revolver
Verlag, Frankfurt

2004 *Raumfürraum*,
Kunstverein/Kunsthalle,
Dusseldorf

2003 *actionbutton*,
Hamburger Bahnhof, Berlin

1999 *Paloma Varga Weisz*,
Valeria Lieberman, Sammlung
Ackermans, Dusseldorf

Selected Exhibitions

2004 Museum Kurhaus Kleve

2003 'Stubaifrau', Galerie
Konrad Fischer, Dusseldorf

2002 'Big Trip', Galerie Konrad
Fischer, Dusseldorf

2002 Kunstraum Galerie der
Stadt Schwaz, Tirol

2002 Castello di Rivoli, Turin

2001 Kabinett für Aktuelle
Kunst, Bremerhaven

2001 Kunstverein, Bremerhaven

2000 'Paloma Cabaret', Adeline
Morlon Art Direction, Dusseldorf

2000 'Demut', Galerie Vera
Munro, Hamburg

1999 Sammlung Ackermans,
Xanten

Paloma **Varga Weisz**

Born 1966
Lives Dusseldorf

Paloma Varga Weisz' carved wooden sculptures
feature hybrid, not quite human, beings of the
artist's own invention. They are named according
to their distinguishing features: Bumpman,
Dogman, Boxman. Like stock characters from old
fairy tales, they exist only in terms of their function
in a narrative. But the stories they belong to are
lost; they seemed moored, waiting to be noticed.
Tapping into the murky, half-remembered
landscape of childhood mythology, Varga Weisz'
work creates a coherent, if enigmatic, world. (SS)

Shown by Sadie Coles HQ C10, Gladstone
Gallery C6

Don't Go Outside, They're Waiting For You
2004
Installation view, Blum & Poe
Courtesy Blum & Poe

Chris **Vasell**

Born 1974
Lives Chicago/Los Angeles

Chris Vasell works in a very aquatic, trippy, stain-happy mode of painting, with the flamboyant chromatic filigree of 1960s' psychedelia toned down for a more sombre age. Skeins of translucent, drenching pigment drift across his pictures like heavy-hued cloudbursts opening up on a clammy summer day (*Bereshit*, 2004), or boil with the caustic effervescence of acid poured over the bonnet of a brand new car. But Vasell isn't just making pretty, refined messes: tucked into the coagulating, dried-up eddies of paint are frequent figurative references – a lip, a flared nostril, a floating pair of staring eyes – that suggest a disconsolate unease with what painting can summon out of the ether. (JT)

Shown by Blum & Poe G6

Selected Bibliography

2005 'Eek! Are They Watching Us?', David Pagel, *The Los Angeles Times*

2004 'What Are You Looking At?: New Art through the Eyes of Ten Curators and Directors', Peter Nesbett, *Art on Paper*

2001 'On the Underbelly of the Zeitgeist', Christopher Knight, *The Los Angeles Times*

Selected Exhibitions

2005 Galerie Emmanuel Perrotin, Paris

2005 'Don't Go Outside, They're Waiting for You', Blum & Poe, Los Angeles

2005 Aspen Art Museum

2004 'Stalemate', Museum of Contemporary Art, Chicago

2004 'On Paper', Nicole Klagsbrun Gallery, New York

2003 'I See a Darkness', Blum & Poe, Santa Monica

2003 'Inaugural Group Show', Blum & Poe, Los Angeles

2003 'Some Things We Like…', aspreyjaques, London

The Raft
2004
Video installation
Projection size: 223×396cm
Courtesy James Cohan Gallery

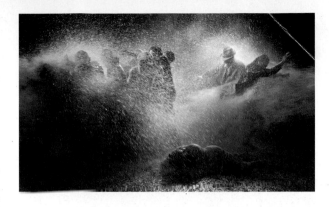

Selected Bibliography

2003 *Bill Viola: The Passions*,
John Walsh, The J. Paul Getty
Museum, Los Angeles

2002 *Bill Viola: Going Forth by
Day*, Guggenheim Foundation,
New York

1997 *Bill Viola*, David A. Ross,
Whitney Museum of American
Art, New York

1993 *Bill Viola: Vedere con la mente
e con il cuore* (Bill Viola: To See
with the Mind and with the
Heart), ed. Valentina Valentini,
Gangemi Editore, Rome

1988 *Bill Viola*, Marilyn A.
Zeitlin, Contemporary Arts
Museum, Houston

Selected Exhibitions

2005 'Visions', Kunstmuseum,
Århus, Denmark

2004 'Temporality and
Transcendence', Guggenheim
Bilbao

2004 'Hall of Whispers', De Pont
Foundation for Contemporary
Art, Tilburg

2003 'The Passions', The J. Paul
Getty Museum, Los Angeles

2002 'Going Forth by
Day', Guggenheim Museum,
New York

1997 Whitney Museum of
American Art, New York

1996 'The Messenger', Durham
Cathedral

1995 'Buried Secrets', U.S.
Pavilion, Venice Biennale

1992 'Unseen Images',
Städtische Kunsthalle, Dusseldorf

1979 'Projects: Bill Viola',
Museum of Modern Art,
New York

Bill **Viola**

Born 1951
Lives Long Beach

For all its technical sophistication Bill Viola's work deals in age-old issues. Throughout his career the pioneering video artist has probed the mysteries of human feeling: the ways the body registers emotion and how that emotion is imparted to the viewer. Filled with dreamlike scenes of anguish and frailty, his recent video pieces and installations have drawn on Renaissance painting and invoke an unspecified but powerfully felt spirituality. Earlier this year Viola produced a large-scale video accompaniment to Peter Sellars' production of Richard Wagner's *Tristan and Isolde*, with slow-motion images of fire and water, of immersions and magical transformations, paralleling the action on the stage. (SS)

Shown by James Cohan Gallery B9, Haunch of Venison F16

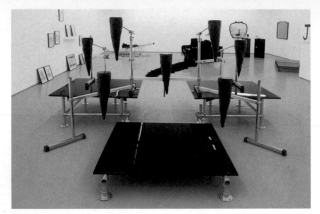

Hate Them
2004
Polystyrene, polyurethane, tinted epoxy, wood, steel, drum stands and hardware
153×366×244cm
Courtesy Maureen Paley

Selected Bibliography

2005 'The Black Album', Jonathan Jones, *The Guardian*

2004 'My Pop: Banks Violette', Jan Tumlir, *Artforum*

2004 'Ritual', Hedi Slimane, *Dazed & Confused*

2004 'Many Happy Returns: This is Today', Jack Bankowsky, *Artforum*

2004 'I Do This, I Do That: The Personality Artist and Heavy Metal Dandyism', Jesse Pearson, *Parkett*

Banks **Violette**

Born 1973
Lives New York

A sort of Pop nihilist, Banks Violette seems fixated on the nasty edge of rock-and-roll. Confessing envy for the power that music can exert over the minds of young listeners, Violette makes drawings and sculptures on subjects culled from the dark history of Heavy Metal–motivated killings and rock star suicides. His attraction to narratives involving youth and violence can make him seem like a macho analogue to Marlene McCarty – like her, Violette never shows us blood or gore, making our fascination with his subjects even more morbid. (PE)

Shown by Maureen Paley C12

Selected Exhibitions

2005 Whitney Museum of American Art, New York

2005 Gladstone Gallery, New York

2004 'The Black Album', Maureen Paley, London

2004 Whitney Biennial, New York

2004 'Penteholocaust/The Sixty-Sided Stone of the Androgyne', Peres Projects, Los Angeles

2004 'Scream', Anton Kern Gallery, New York

2003 'Kult 48 Klubhouse', Deitch Projects, New York

Non-Naissance
2004
Watercolour and gouache on
newspaper
155×110cm
Courtesy Meyer Riegger

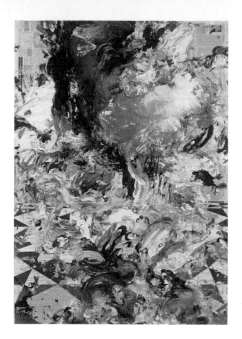

Selected Bibliography

2004 'Gabriel Vormstein',
Michael Wilson, *Artforum*

2004 Critics' Picks, Brian
Sholis, www.artforum.com

2003 *Deutschemalerei-
zweitausenddrei* (German Painting
2003), Nicolaus Schaffhausen,
Lukas & Sternberg, New York

2003 *actionbutton*, Veit Loers,
Staatliche Museen, Berlin

2003 *Quetzalcoatl Comes Through*,
Revolver Verlag, Frankfurt

Selected Exhibitions

2005 'William Blake and Sons',
Lewis Glucksman Gallery, Cork

2005 'Desenhos: A–Z', Colecção
Madeira Corporate Services,
Porta 33, Funchal, Madeira

2004 'La morte non trapasso',
Meyer Riegger, Karlsruhe

2004 'seems to be', Casey
Kaplan, New York

2004 'Deutschland sucht ...',
Kunstverein, Cologne

2003 'actionbutton', Hamburger
Bahnhof, Berlin

2003 'Deutschemalerei-
zweitausenddrei', Kunstverein,
Frankfurt

2001 'Der Wegelagerer', Meyer
Riegger, Karlsruhe

2001 'Circles: Berlin–Montana
Sacra', ZKM Centre for Art and
Media, Karlsruhe

2000 'Moon White Future',
hobbypopMUSEUM, Dusseldorf

Gabriel **Vormstein**

Born 1974
Lives Berlin

Although continuously threatened with extinction
by the Internet, the newspaper has remained one of
the few constants of the information age. Gabriel
Vormstein chooses double-page newspaper spreads
as the supports for his acrylic and watercolour
works, to suggest both the tradition that the
newspaper (or the painting) represents and the
transience of the daily news and the painted
image. Expressionistic slathers of acrylic, delicately
rendered Schiele figures or diagrammatic
formalism hint at the inevitable transition of style
from urgency to nostalgia. Meanwhile cryptic
arrangements of branches, bound with painted
fabric and tape, propose a Romantic application
of nature at odds with a technological present.
(KB)

Shown by Meyer Riegger C5

Aquafresh plus Crest with Scope (Mya)
2004
CD-ROM; scanned image and scanned toothpaste, digital print with gold leaf on archival watercolor paper
64×38cm
Courtesy Galerie Catherine Bastide

Selected Bibliography

2005 'Please Recycle: The Art of Kelley Walker', Tim Griffin, *Artforum*

2004 'Notes on Renewed Appropriationisms', Bruce Hainley, *Artforum*

2004 'Eunice Kim and Joe Bradley', Roberta Smith, *The New York Times*

2003 *After the Observatory*, Robert Nickas, Paula Cooper Gallery, New York

2003 'Cumulus from America', Lauri Firstenberg, *Parkett*

Selected Exhibitions

2005 'Greater New York', PS1 Contemporary Art Center, New York

2005 'Pictures Are the Problem', Pelham Art Center, New York

2005 'Guyton\Walker: The Failever of Judgement Part III', Greene Naftali, New York

2004 'Last One On Is a Soft Jimmy', Paula Cooper Gallery, New York

2004 'Curious Crystals of Unusual Purity', PS1 Contemporary Art Center, New York

2004 'Wade Guyton and Kelley Walker', Midway Contemporary Art, St Paul, Minnesota

2003 Paula Cooper Gallery, New York

2001 'Exposition W', Musée des Beaux-Arts, Dole

Kelley **Walker**

Born 1969
Lives New York

One of Kelley Walker's best-known works, *Schema: Aquafest plus Crest with Tartar Control* (2003), borrows an image of a 1960s race riot from Warhol's *Red Race Riot* (1963) and anoints it with expressionistic smears of toothpaste. History may not be sacrosanct to Walker, but neither is his own work – he produces limited edition CDs of his images, which buyers can re-work at will. His recent sculptural works, including mirrored Rorschach blots and giant tactile versions of the 'recyclable' symbol, continue to assert the role of the subject amid the endless circularity of signs. (SL)

Shown by Galerie Catherine Bastide E16

Vogelfänger
(Birdcatcher)
2005
Pencil and chalk on paper
120×81cm
Courtesy Iris Kadel

Selected Bibliography

2003 *Karoline Walther*, Academy of Fine Arts, Karlsruhe

2003 *Kunstpreis Junger Westen* (Young Western Art Prize), Ferdinand Ulrich and Hans-Jürgen Schwalm, Kunsthalle, Recklinghausen

Selected Exhibitions

2005 'Drift', Paraplufabriek, Nijmegen

2005 'Röhrender Hirsch am Bergsee', Palazzo, Liestal

2004 'Äste der Imagination', Künstlerhaus, Stuttgart

2004 'Silbersee', Playstation/ Galerie Fons Welters, Amsterdam

2003 'Riesenslalom', Iris Kadel, Karlsruhe

2003 'Anderswelten', Kunstraum, Munich

2003 'Meisterschüler,', Staatliche Kunsthalle, Baden-Baden

Karoline **Walther**

Born 1976
Lives Karlsruhe

Karoline Walther's large-scale chalk and pencil drawings evoke urban sites and the natural environment like hazy yet vivid memories. Take *Silbersee* (Silver Lake, 2004), for example: an empty swimming-pool with its half-gloomy, half-glistening mosaic tiles hovers in an otherwise empty picture plane, overshadowed only by the pendulous 'curtain' of a weeping willow. It's as if the two elements of the image created a sense both of home and of displacement. In other works fragile pencil delineations of trees and houses are juxtaposed with saturated fields of crayon – like ghosts of earlier experiences invading the Modernist dream of the *tabula rasa*. (JöH)

Shown by Iris Kadel A9

Fort Trommel: Symbole mit neuer DNA
(Fort Trommel: Symbols with New DNA)
2005
Mixed media
Installation size 10×12m
Courtesy Galerie Gebr. Lehmann

Selected Bibliography

2005 *Urbane Realitäten: Focus Istanbul* (Urban Realities: Focus Istanbul), Christoph Tannert, Künstlerhaus Bethanien, Berlin

2003 *Pompa Introitus*, VVV Leuven

2002 *Viva November*, Schloßmuseum Wolfsburg

2002 *Circles: Individuelle Sozialisation und Netzwerkarbeit* (Circles: Individual Socialization and Networking), Revolver Verlag, Frankfurt

2000 *Richtfest* (Topping-Out Ceremony), HDK, Berlin

Suse **Weber**

Born 1970
Lives Berlin

Suse Weber's sculptural installations often employ symmetry and loaded political symbols such as the red star, the crescent moon or paraphernalia from the East German youth movement the FDJ, combined in ways designed to shift their readability. In the installation *Fort Trommel (Symbole mit neuer DNA)* (Fort Trommel (Symbols with New DNA), 2005) wooden pallets form partition walls and suggest a fortification. As in this ensemble, Weber's work addresses sexism and racism, remixing provocative signs connected with ideological and cultural belief systems. The undercurrent of her pieces suggests an ever-present potential for conflict. (DE)

Shown by Galerie Gebr. Lehmann G10

Selected Exhibitions

2005 'Urban Realities: Focus Istanbul', Martin-Gropius-Bau, Berlin

2005 'Fort Trommel (Symbole mit neuer DNA)', Galerie Gebr. Lehmann, Dresden

2004 'Dönerdoll', Galerie Meerrettich, Berlin

2003 'Scene Weimar', ACC Galerie, Weimar

2003 'Destination', Autocenter, Berlin

2003 'Blackblood Envy', Maschenmode Berlin, Guido W. Baudach, Berlin

2001 'Viva November', Städtische Galerie, Wolfsburg

2001 'Circle 5', ZKM Centre for Art and Media, Karlsruhe

1999 'Choreography of a Riot', Galerie Yoko Ito, Tokyo

Dadd's Hole
2004–5
Oil on canvas
41×27cm
Courtesy Private Collection and
Emily Tsingou Gallery

Selected Bibliography

2005 'Mathew Weir',
Charles Danby, *i-D*

2005 'Mathew Weir',
Pablo Lafuente, *Flash Art
International*

2005 'Mathew Weir',
Tom Morton, *frieze* 91

2005 'Mathew Weir',
Charles Danby, *ArtReview*

2004 *Bloomberg New
Contemporaries,* S. Craddock and
J.J. Charlesworth, Bloomberg,
London

Selected Exhibitions

2005 'A Violet from Mother's
Grave', Emily Tsingou Gallery,
London

2005 'Co-operative Society',
Northern Gallery for
Contemporary Art, Sunderland

2004 'Mathew Weir', Roberts
and Tilton, Los Angeles

2003 'Breaking God's Heart',
38 Langham Street, London

2003 'Bloomberg New
Contemporaries', Cornerhouse
Gallery, Manchester

Mathew **Weir**

Born 1977
Lives London

Mathew Weir's meticulous, intensely chromatic
paintings of 19th-century ceramic caricatures of
black males are as beautiful as they are politically
chafing. Rendered in absolutely flat brushstrokes
(Weir's paint looks, to lift from Frank Stella, 'as
good as it does in the can'), works such as *Shithouse*
(2004–5) – in which a figurine of a black boy
takes a last, proud peek back through a privy
door before he departs – do not so much mount a
critique of their motifs as subject them to aesthetic
rehabilitation through an indiscriminating
painterly all-over-ness. While this is a dangerous
game, what emerges, in the end, is the weakness of
outmoded racist discourse. (TM)

Shown by Emily Tsingou Gallery E3

Without Mirror
2005
Oil on canvas
50×40cm
Courtesy Peter Kilchmann

Selected Bibliography

2005 *That Would Have Been Wonderful*, Gianni Jetzer, Editions Patrick Frey, Zurich

2005 'Grace among the Fragments of Reality', Eva Karcher, *Sleek*

2005 'Andro Wekua', Gianni Jetzer, *Flash Art*

2005 'Eine Kindheit am Schwarzen Meer' (A Childhood at the Black Sea), Kathleen Bühler, *Neue Zürcher Zeitung*

2004 *The Place to Be*, Hilde Teerlinck, CRAC Alsace, Altkirch

Andro **Wekua**

Born 1977
Lives Zurich

The collages, drawings, installations and sculptures of Andro Wekua often look emotionally scarred. *Just Kidding* (2004), for instance, consists of two horrific life-size ceramic girls wearing wigs, their mouths thin-lipped and their eyes blinded by blue eye shadow, who sit facing their own reflection in a black Perspex panel. The seductive if troubled or even deadly narcissistic gap between the figures and their image can be seen as a metaphor for the artist's work in general, which is characterized by motifs and images drawn from his own childhood in Georgia, whose legacy of racial tension expresses itself in the present in terms of rupture and brutal dissonance. (DE)

Shown by Peter Kilchmann C22

Selected Exhibitions

2005 'Insert: Andro Wekua', Kunstverein, Bonn

2005 Peter Kilchmann, Zurich

2005 'Lively Memories', Plattform, Berlin

2005 'Expanded Painting', Karlin Hall, Prague

2005 'Come Back/Le Retour', Centre Rhénan d'Art Contemporain, Altkirch

2005 'ID Troubles: US Visit', Nurture Art, New York

2004 'That Would Have Been Wonderful', Neue Kunst Halle, St Gallen

2004 'Emotion Eins', Kunstverein, Frankfurt

2004 'Strategies of Desire', Kunsthaus Baselland, Muttenz

2004 'Shake: ID Troubles', Halle für Kunst, Lüneburg

#031
2004
Chromogenic print
Edition of 5
90×82cm, framed
Courtesy Donald Young Gallery

Selected Bibliography

2002 *James Welling Abstract*,
Rosalyn Deutsche, Art Gallery
of York University, Toronto

2000 *James Welling: Photographs
1974–1999*, ed. Sarah J.
Rogers, Wexner Center for the
Arts, Columbus

1999 *James Welling. New
Abstractions*, Alain Cueff,
Sprengel Museum, Hanover

1992 *James Welling, Photographs*,
Davis Deitcher, Asmund
Thorkildsen, Künsternes Hus,
Oslo

1990 *James Welling Photographs
1977–1990*, Ulrich Loock,
Walter Michaels and Catherine
Queloz, Kunsthalle, Bern

Selected Exhibitions

2003 'The Last Picture Show:
Artists Using Photography,
1960–82', Walker Art Center,
Minneapolis and touring

2002 'James Welling: Abstract',
Donald Young Gallery, Chicago
and touring

2002 'Visions from America',
Whitney Museum of American
Art, New York

2001 'As Painting: Division and
Displacement', Wexner Center
for the Visual Arts, Columbus

2000 'James Welling 1974–1999',
Wexner Center for the Arts,
Columbus and touring

1999 'New Abstractions',
Sprengel Museum, Hanover

1998 'Forum: James Welling',
Carnegie Museum of Art,
Pittsburgh

1992 Documenta, Kassel

James **Welling**

Born 1951
Lives New York/Los Angeles

Photographic media retain a degree of mystery
in James Welling's work – albeit mystery of a
particular kind, stemming from the nature of
looking and technological mediation rather than
from the nature of what is depicted. Working
since the late 1970s in black and white or glowing
colour, Welling has created abstract photograms
and photographs of subjects such as railway
lines, architecture, aluminium foil, hanging
curtains or a painter's palette. Preoccupied with
the manipulation of light, they are rigorously
Conceptual yet sensuous. In the series 'Tricolor
Photographs' (1998), for example, black and white
negatives shot through red, blue or green filters
are digitally superimposed, producing unsettling
images of gardens or marshes. (KJ)

Shown by Maureen Paley C12, Donald Young
Gallery G8, David Zwirner C11

Ohne Titel (Beton)
(Untitled (Concrete))
2005
Magazine collage
42×30cm
Courtesy Produzentengalerie
Hamburg

Selected Bibliography

2004 *Chemie* (Chemistry), Tom Holert and Vanessa Joan Müller, Secession, Vienna

2004 *The Future Has a Silver Lining*, Heike Munder et al., Migros Museum, Zurich

2003 'French Junkies', Wolf Jahn, *Artforum*

2003 'Nicole Wermers', Jan Verwoert, *frieze* 72

2000 'Nicole Wermers', Anna-Catharina Gebbers, *Kunstmagazin*

Selected Exhibitions

2005 'Alles. In einer Nacht.', Tanya Bonakdar Gallery, New York

2004 'Chemie', Secession, Vienna

2004 'The Future Has a Silver Lining', Migros Museum, Zurich

2004 'Pin Ups, Contemporary Drawing and Collage', Tate Modern, London

2004 '2 oder 3 Dinge, die ich von ihr weiss', Produzentengalerie, Hamburg

2003 'Reisefreiheit: Neue Kunst in Hamburg', Kunsthaus, Hamburg

2002 'French Junkies', Produzentengalerie, Hamburg

2001 'Szenarien oder der Hang zum Theater', Kunstverein, Bonn; Stadthaus, Ulm

2001 Museum Ludwig, Cologne

2001 'Szenenwechsel XX', Museum für Moderne Kunst, Frankfurt

Nicole **Wermers**

Born 1971
Lives Hamburg/London

Nicole Wermers employs all the materials currently favoured by a certain school of trashy sculpture – plywood, Formica, Perspex, bits of venetian blinds – but her works refuse the conceptual neutrality of their counterparts. A group of half-size columns appear to be ruminations on Minimalism but turn out to be prototypes for free-standing ashtrays (*French Junkies 1–11*, 2002). Small cubic constructions, viewed from above, reveal themselves as doll's-house interiors, as in *Vacant Shop III* (2000), a model of an abandoned shop littered with tiny wrecked shelves and drawers. Materiality is here employed on a miniature scale in quirky meditations on form and function. (KB)

Shown by Herald St A8, Produzentengalerie Hamburg E18

Vase (Popular Ceramics)
2004
Polystyrene, resin, tempera
92×97×61cm
Courtesy Wilkinson Gallery

Selected Bibliography

2005 'Olav Westphalen: Greetings from America', Max Henry, *The Paris Review*

2003 'The First Long Island City Blimp Derby', Ken Johnson, *The New York Times*

2002 'Openings: Olav Westphalen', Saul Anton, *Artforum*

2002 'Tell Tale Signs', Michael Wilson, *frieze* 70

1995 'Olav Westphalen', Franz Ackermann, *Texte zur Kunst*

Selected Exhibitions

2005 'Avenger of Widows and Orphans', Galerie Klosterfelde, Berlin

2004 Whitney Biennial, New York

2004 maccarone inc., New York

2004 'Kotzrohr and Popular Ceramics', Wilkinson Gallery, London

2003 'The First Long Island City Blimp Derby', Sculpture Center, New York

2002 'London–Berlin', Institute of Contemporary Arts, London

2001 'Televison', Kunsthalle, Vienna

2000 'E.S.U.S.', Project of the Public Art Fund at the Whitney Museum at Philip Morris; Konstcentrum Gavle, Bergens Konstforening

2000 'Greater New York', PS1 Contemporary Art Center, New York

2000 'Arrested Ambition', Apex Art, New York

Olav **Westphalen**

Born 1963
Lives New York

For the New York-based German artist Olav Westphalen humour is more of a medium than an effect. Ribbing ponderous targets that have included Andreas Gursky, site-specific public art, American transcendentalism and boardroom thieves, Westphalen often begins with a flat-footedly dumb bit of satire and then craftily recycles the resulting tepid laugh back into the work. His visual jokes don't ask us to think differently – in fact, Westphalen seems to assume we wouldn't anyway. Once we figure that out, the game changes entirely. If you are trying to chuckle and slowly tiring yourself out, you're probably in the presence of one of the artist's better pieces. (PE)

Shown by maccarone inc. B3, Galerie Michael Neff A15, Wilkinson Gallery D22

Sunset Clause
2004
Photocopied paper, pins, vinyl stickers, glass (sand-blasted, acid-brightened, brilliant-cut and silver-leafed) in walnut frame
119×155cm
Courtesy The Approach

Martin **Westwood**

Born 1969
Lives London

Martin Westwood fuses the trappings of the corporate world with the intricate passions of the handmade. His multi-layered collages, often held together with map pins, depict generic business scenes of sales assistants and customers sealing transactions or employees meeting targets. Westwood finesses these episodes by deploying shredded documents or cut-out and stencilled invoices, for example, which he often decorates with masked and spray-painted patterns. With *fatfinger (HAITCH. KAY. EKS)* (2003) Westwood's office-bound craft ecology makes a bid for the built environment, deploying chewing-gum-dashed blue carpet tiles, logo-festooned papier-mâché balloons and talismans made from stationery. (MA)

Shown by The Approach G3

Selected Bibliography

2005 'Martin Westwood', J.J. Charlesworth, *Other Criteria*

2003 'Inflation at Work', Cristin Leach, *The Sunday Times*

2003 *fatfinger (HAITCH.KAY. EKS)*, Project Arts Centre Dublin

2003 'Best of 2003', Martin Herbert, *Artforum*

1999 'Martin Westwood', Martin Coomer, *Time Out London*

Selected Exhibitions

2005 'Art Now', Tate Britain, London

2004 'Angelus Novus', Collective Gallery, Edinburgh

2004 'Reflections', Artuatuca Kunsterfgoed Festival, Tongeren

2004 'Wider than the Sky', 117 Commercial Street, London

2003 'Hard Pressed Flowers', The Approach, London

2003 'fatfinger (HAITCH. KAY. EKS)', Project Arts Centre, Dublin

2003 'East of Eden', 14 Wharf Road, London

2002 'The Galleries Show', Royal Academy of Arts, London

2001 'A Seed is a Stone', The Approach, London

Hot Stage
2005
Perspex and solvent
122×122×3cm
Courtesy 1301PE

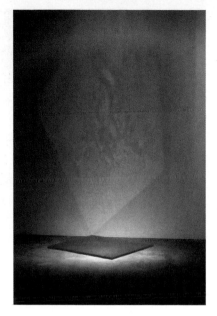

Selected Bibliography

2004 'Pae White', Jan Tumlir, *Artforum*

2004 'The Many Colors of Pae White', Arty Nelson, *LA Weekly*

2004 'Filaments Hold the Firmament', David Pagel, *Los Angeles Times*

2002 'Of Costumes, Clouds, and Culture', Robin Laurence, *The Georgia Straight*

2002 'Luxe, calme et volupté', Jennifer Higgie, *frieze* 66

Selected Exhibitions

2005 'Another Cherry Blossom', greengrassi, London

2005 'Cotton Mouth', neugerriemschneider, Berlin

2005 'Untitled', 1301PE, Los Angeles

2004 'Amps and Ohms', Centre d'Art Contemporain, Delme

2004 'Ohms and Amps', La Salle de Bains, Lyon

2004 UCLA Hammer Museum, Los Angeles

2003 'Fire 'n' Ice', 1301PE, Los Angeles

Pae **White**

Born 1963
Lives Los Angeles

Influenced as much by the weather as by design, and as much by the infinite shapes of the moon as by art history, Pae White both exhibits in galleries and designs advertisements, shopping bags, catalogues, books and invitations. She considers her design work an integral component of her art practice, but whereas her shows often embrace the ephemeral (cobwebs, birds, water and mobiles), her 'commercial' work teasingly spins variations on themes of communication and ownership. Interdependence is central. Imagine, she seems to be saying, what art would be like without design, or design without art – or with people who kept their imaginations to themselves. The world would be a very different place, and not a better one. (JH)

Shown by 1301PE B8, China Art Objects Galleries F13, greengrassi C4, galleria francesca kaufmann C19

Comtesse de Castiglione
2005
Collage and graphite on paper
46×56cm
Courtesy Sadie Coles HQ

Selected Bibliography

2003 *Fast Forward: Media Art, Sammlung Goetz*, Stephan Urbaschek, Kunstverlag Ingvild Goetz, Sammlung Goetz, Munich

2002 *Rapture: Art's Seduction by Fashion since the 1970s*, Chris Townsend, Thames & Hudson, London

2002 *Art Now*, ed. Uta Grosenick and Burkhard Riemschneider, Taschen, Cologne

2001 *The Americans*, Mark Sladen, Barbican Art Gallery, London

1998 *T.J. Wilcox*, Institute of Contemporary Arts, London

T.J. Wilcox

Born 1965
Lives New York

Whether meditating on personalities from the *ancien régime* or drawing on Hollywood costume dramas, travelogues and cartoons, T. J. Wilcox's film installations usually contain what Charles LaBelle described in *frieze* as a 'quizzical combination of romantic nostalgia and bemused wonderment at historical minutiae'. Working from Super 8 transferred to video and then back to film, Wilcox employs the lush and elusive caress of celluloid to convey a deeply personal take on stories rich with the melancholy of fantastical desire. Implicating the audience in his dramas, he contaminates us with a mothballed majesty that is both depressive and oddly moving. (PE)

Shown by Galerie Daniel Buchholz D14, China Art Objects Galleries F13, Sadie Coles HQ C10, Galerie Meyer Kainer G2

Selected Exhibitions

2005 'Garlands', Kunstverein, Munich

2004 Whitney Biennial, New York

2003 'Garlands', Sadie Coles HQ, London

2003 'Fast Forward: Media Art Sammlung Goetz', ZKM Centre for Art and Media, Karlsruhe

2001 Galerie Daniel Buchholz, Cologne

2001 'The Americans', Barbican Art Gallery, London

2000 Kunsthaus, Glarus

2000 'Greater New York', PS1 Contemporary Art Center, New York

1997 Venice Biennale

Kodak Three Point Reflection Guide,
©1968 Eastman Kodak Company,
(Corn) Douglas M. Parker Studio,
Glendale, California, April 17,
2003
2003
Dye transfer print
Edition of 10
41×51cm
Courtesy Galerie Gisela Capitain

Selected Bibliography

2005 *Christopher Williams,*
Contemporary Art Gallery,
Vancouver

2004 *Ringier Annual Report
2003*, Ringier AG, Corporate
Communications, Zurich

2000 *Christopher Williams:
Couleur Européene / Couleur
Soviétique / Couleur Chinoise,*
Haus Lange Haus Esters,
Kunstmuseen, Krefeld

1997 *Christopher Williams.
For Example: Die Welt ist
Schön,* Museum Boijmans
Van Beuningen, Rotterdam;
Kunsthalle, Basel; Kunstverein
Hamburg

Selected Exhibitions

2005 'For Example: Dix-
Huit Leçons Sur La Société
Industrielle', Contemporary Art
Gallery, Vancouver

2005 'It Takes Some Time
to Open an Oyster', Centro
Cultural Andraxt, Mallorca

2005 'Christopher Williams &
De Rijke/De Rooij', Secession,
Vienna

2005 'Bildwechsel/01,
Sammlung F.C. Gundlach',
Deichtorhallen, Hamburg

2004 Galerie Gisela Capitain,
Cologne

2004 'Im Rausch der Dinge',
Fotomuseum Winterthur

1997 'For Example: Die Welt ist
schön', Museum Boijmans Van
Beuningen, Rotterdam

Christopher **Williams**

Born 1956
Lives Los Angeles

Christopher Williams uses language and
photography to address the issues of structure,
representation and illusion that painting and
sculpture often rely on or exploit. Since the 1980s
he has been part of the move by photographers
to free Conceptual art from the rigid neutrality of
academic formalism, preferring an emphasis on
content. His photographs often employ outdated
methods, such as dye transfer and platinum
printing techniques, but do not evoke a sense of
nostalgia. Rather, by delegating the actual work
of photography to others, Williams creates a level
of critical distance between the initial idea and the
eventual product. (DJ)

Shown by Galerie Gisela Capitain D12, David
Zwirner C11

Untitled
2005
Acrylic on wood
60×40cm
Courtesy Leo Koenig Inc.

Kelli **Williams**

Born 1972
Lives New York

Kelli Williams uses a warm, fleshy palette to
create multiple-figure compositions that feed
on religious and sexual excess. She says of these
complicated fever dreams, 'I usually base them
on paranoid, Manichaean rants about earthly
torment'. A naked, cloven-hoofed woman coyly
spreads her legs for examination by a satyr; nude
and sometimes fetishistically deformed women
cavort in front of the Stars and Stripes (with
inverted pentagrams – symbols of the devil – in the
blue field instead of regular stars); bloody hearts
fill a red sky above a greyish landscape littered
with upside-down crucifixes and sexually explicit
vignettes. Williams' two primary influences –
kitsch and pornography – combine in a toxic brew.
(KJ)

Shown by Leo Koenig Inc. E25

Selected Exhibitions
2005 'Leaving Cockaigne',
Leo Koenig Inc., New York

Springtime for the RNC
2005
Oil on acrylic on canvas
244×264cm
Courtesy 303 Gallery

Selected Bibliography

2004 *Sue Williams*, Kukje Gallery, Seoul

2003 *Sue Williams: Art for the Institution and the Home*, Dan Cameron and Jaun Carlos Román, Secession, Vienna; IVAM, Valencia

2003 *Sue Williams: A Fine Line*, Barry Schwabsky, Palm Beach Institute of Contemporary Art

2001 *Art and Feminism*, ed. Helena Reckitt, text by Peggy Phelan, Phaidon Press, London

1997 *Birth of the Cool*, Kunsthaus, Zurich

Selected Exhibitions

2005 303 Gallery, New York

2005 'Extreme Abstraction', Albright-Knox Art Gallery, Buffalo

2004 Addison Gallery of American Art, Andover

2003 Carpenter Center, Harvard University, Cambridge

2002–3 Secession, Vienna

2002 Palm Beach Institute of Contemporary Art

2000 'Open Ends', Museum of Modern Art, New York

1999 'The American Century: Art & Culture 1900–2000', Whitney Museum of American Art, New York

1997 Centre d'Art Contemporain, Geneva

1997 Whitney Biennial, New York

Sue **Williams**

Born 1954
Lives New York

Corrosive humour has long been a feature of Sue Williams' work. She first attracted attention for paintings rife with raw, satirical, often misunderstood images of sexually violated women. Over the past decade her work has grown increasingly abstract, drawing on Abstract Expressionist and Colour Field painting. She still offers sexual and scatological imagery, but the squirting phalluses and ruffled orifices reach new levels of calligraphic lightness and lyricism. The squiggles in *Impatient Symmetry* (2002), for example, suggest a Rorschach blot without ominous undertones; her ink-on-acetate drawings, recalling animation cells and evoking ungraspable narratives, unleash pure, anarchic energy. (KJ)

Shown by 303 Gallery C13, Bernier/Eliades F17, Galerie Eva Presenhuber C7, Stuart Shave | Modern Art D13

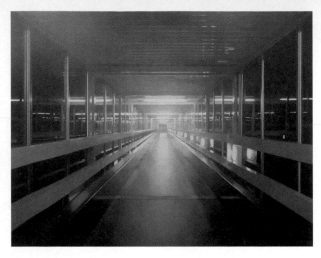

Night Walkway 3
2005
Oil on canvas
191×243cm
Courtesy 1301PE

Paul **Winstanley**

Born 1954
Lives London

Supremely reticent but moody and haunting, the images in Paul Winstanley's paintings, often deliberately out of focus, manage to evoke tracking and panning shots in suspense films. Winstanley works in multiple stages – he shoots videos, makes stills from them and then bases his paintings on photographs of the stills. As Mark Durden has written in *frieze*, his work 'can be said to exploit the impurities of photo-mechanical vision'. Some works depict landscapes seen through windows in Modernist buildings; others show desolate interiors of restaurants, TV lounges, walkways or corporate lobbies and interview rooms – alienating realms of fluorescent light, reflections and glossy surfaces. (KJ)

Shown by 1301PE B8, Kerlin Gallery E14, Galerie Nathalie Obadia E23

Selected Bibliography

2004 'Space Inveilers', Sue Hubbard, *The Independent*

2004 Critics' Picks, Jens Asthoff, www.artforum.com

2004 'Blow Up', *Flash Art International*

2003 'Paul Winstanley', William Feaver, *ARTnews*

2003 'Paul Winstanley', Anne Fielding, *Time Out London*

Selected Exhibitions

2005 'Untitled', 1301PE, Los Angeles

2005 'Homeland', Kerlin Gallery, Dublin

2005 'Flashback', Kunstverein, Freiburg

2004 'Untitled', The New Art Centre, Roche Court, Salisbury

2004 'Untitled', Vera Munro, Hamburg

2004 'John Moores 23 Exhibition of Contemporary Painting', Walker Art Gallery, Liverpool

2004 'Munch Revisted', Museum am Ostwall, Dortmund

2004 'Blow Up', St Paul's Gallery, Birmingham

2003 'Untitled', Maureen Paley Interim Art, London

2003 'Oeuvres Recentes', Galerie Nathalie Obadia, Paris

Weltausstellung
(World Fair)
2004
Polysterol, lacquer, MDF, LED
630×270cm
Courtesy Johann König

Selected Bibliography

2005 'A Detour into the Cul-de-sac of Ever-never-land', April Lamm, *ArtReview*

2004 Critics' Picks, Eva Scharrer, www.artforum.com

2004 'Johannes Wohnseifer: Father and Son', Noah Chaslin, *Time Out New York*

2003 *Self-Destroying History*, Raimar Stange, Fine Arts Unternehmen Books, Zug/Berlin

Selected Exhibitions

2005 'Cityscape into Art', Hara Museum of Contemporary Art, Tokyo

2005 'The Triumph of Painting', The Saatchi Gallery, London

2005 'La nouvelle peinture allemande', Carré d'art, Musée d'Art Contemporain, Nîmes

2005 'Zur Vorstellung des Terrors: Die RAF-Ausstellung', Kunst-Werke, Berlin

2005 'Cool Hunters', ZKM Centre for Art and Media, Karlsruhe

2004 'Kapelle', Johann König, Berlin

2004 'Connected Presence' (with Jeppe Hein), Union Gallery, London

2003 'Into the light', Ludwig Forum, Aachen

2003 Sprengel Museum, Hanover

2003 'TWODO', Neuer Aachener Kunstverein, Aachen

Johannes **Wohnseifer**

Born 1967
Lives Cologne

Art can be like the daily papers. Only better. Sigmar Polke and Martin Kippenberger knew it, and Johannes Wohnseifer knows it too. In his paintings and installations he gives poignant commentaries on current political issues, often mixing fact and fiction, precise references and arcane allusions, irony and analysis – with a bit of conspiracy theory thrown in for good measure. After all, it is from thrillers that we learn how the world really works: Mies van der Rohe invented the McDonald's franchise restaurant, the Stealth bomber is what we love best about the States, while the Baader–Meinhof group are the only significant pop stars Germany ever produced. Arguably. (JV)

Shown by Galerie Gisela Capitain D12, Johann König D2, Yvon Lambert F6

Amelie **von Wulffen**

Born 1966
Lives Berlin

Amelie von Wulffen's collages illustrate the point in memory where clearly recalled fact ends and the elaborations of imagination begin. Cut-out photographs – of ornate furniture, modernistic interiors or romantic landscapes, an Egon Schiele drawing or portraits of her childhood heroes (the unlikely pair John Travolta and Alexander Solzhenitsyn) – are fixed points from which washy compositions in murky shades of acrylic spin out. Interior and exterior merge unfettered by considerations of perspective or narrative coherence. With an easy fluidity von Wulffen combines antique and modern, low and high culture, general and personal history, and those old adversaries painting and photography. (KB)

Shown by Greene Naftali G5

Selected Bibliography

2005 *Amelie von Wulffen*, Jonas Storves, Centre Georges Pompidou, Paris

2004 'Amelie von Wulffen', Johanna Burton, *Artforum*

2003 *Dreams and Conflicts: The Dictatorship of the Viewer*, ed. Francesco Bonami, Venice Biennale

2003 'Bruch Stucke' (Fragments), Philipp Kaiser, *Parkett*

2003 *Wo die Dämmerung Grun Ist* (Where the Dawn Is Green), Dirk von Lowtzow and Rita Kersting, Galerie Ascan Crone, Andreas Osarek, Berlin

Selected Exhibitions

2005 Centre Georges Pompidou, Paris

2005 Kunstverein, Basel

2005 Kunstverein, Dusseldorf

2004 'Paare. Mobel. Landschaften.', Greene Naftali, New York

2004 Manifesta, San Sebastian

2004 Berlin Biennial

2003 'Dreams and Conflicts: The Dictatorship of the Viewer', Arsenale, Venice Biennale

2003 'ars viva 02/03 – Landschaft', Kunstverein in Hamburg

2002 'Wo die Dämmerung Grun Ist', Galerie Ascan Crone, Berlin

2001 'Museum der Römischen Kultur', Kunstverein, Braunschweig

Once a Noun, Now a Verb ...
2005
Chandelier, flat-screen monitor,
Morse code unit, computer
Dimensions variable
Courtesy Jay Jopling/White
Cube

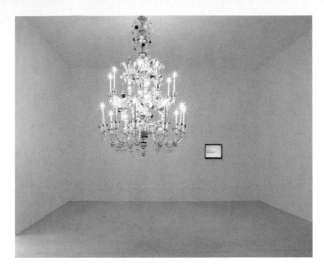

Selected Bibliography

2004 *Cerith Wyn Evans*, Andreas
Spiegl, Jan Verwoert, Julianne
Rebentisch and Manfred
Hermes, Lukas & Sternberg,
New York

2004 *Thoughts Unsaid, Now
Forgotten...*, Bill Arning, MIT
List Visual Arts Center, Boston

2004 *Cerith Wyn Evans*, Jennifer
Higgie, Camden Arts Centre,
London

2003 *Look at that picture ... How
does it appear to you now? Does it
seem to be persisting?*, Annushka
Shani, Jay Jopling/White Cube,
London

2000 *Art Now*, Rachel
Meredith, Tate Publishing,
London

Selected Exhibitions

2005 '299792458m/s', BAWAG
Foundation, Vienna

2004 Kunstverein, Frankfurt

2004 'Utopia Station', Haus der
Kunst, Munich

2003 'Look at that picture ...
How does it appear to you now?
Does it seem to be persisting?',
White Cube, London

2003 'Utopia Station', Arsenale,
Venice Biennale

2002 Documenta, Kassel

2001 Kunsthaus, Glarus

2001 Yokohama Triennale

2000 'Art Now', Tate Britain,
London

2000 'The Greenhouse Effect',
Serpentine Gallery, London

Cerith **Wyn Evans**

Born 1958
Lives London

'I'm interested in the wilful abuse of the viewer,
in ways of not just making life much easier. I
believe that approach has benefits in ethical terms.'
In Cerith Wyn Evans' work the transmission of
meaning is deviant. Informed by key philosophical
and literary works, and by his background in
experimental filmmaking, visual and verbal
languages are encrypted and transformed. A text,
for instance, is translated into Morse code, which
is then broadcast by a flashing, ornate chandelier
or bounced across the shimmering surface of
a glitter ball. Relay circuits of reference are
created; interstices between image and word open
possibilities for freely associative meaning. (DF)

Shown by Yvon Lambert F6, Galerie Neu F11,
White Cube/Jay Jopling F8

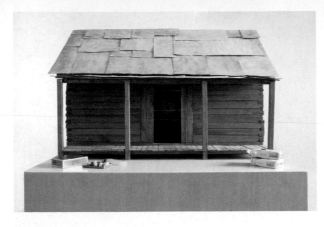

Smoking at Home n°1
2004
Wood, metal, DVD player,
smoke detector, laser, paint,
electronics
73×58×51cm
Courtesy Raucci/Santamaria
Gallery

Selected Bibliography

2005 *Greater New York*,
PS1 Contemporary Art
Center, New York

2005 'James Yamada', Marco
Altavilla, *Flash Art*

2004 'James Yamada: Not
Just Another Armchair Animal
Activist', Christopher Bollen,
V Man

2003 'James Yamada', Cay
Sophie Rabinowitz, *Boiler*

2001 *Crossing the Lines*, Queens
Museum of Art, New York

Selected Exhibitions

2005 'We Are What We Eat',
Raucci/Santamaria Gallery,
Naples

2005 'Greater New York',
PS1 Contemporary Art
Center, New York

2005 'Between You and Me',
Art House, Austin

2005 'We Disagree', Andrew
Kreps Gallery, New York

2004 Art Statements, Art Basel

2004 Mills College of Art
Museum, Oakland

2003 'The East West Rivalry
Continues', Southern Florida
College, Lakeland

2001 'Crossing the Lines',
Queens Museum of Art,
New York

2000 'Some New Minds', PS1
Contemporary Art Center, New
York

1998 'Scapes and Aggregates
(Landscape In-Formation)',
Allen Museum of Art, Oberlin

James **Yamada**

Born 1968
Lives New York

James Yamada's photographic practice builds
elaborate, contingent visual texts. In a recent series
animals were lured to a *faux* naive sculptural 'bait'
and then photographed. Yamada uses a simlar
bait–and–switch tactic to create collisions between
viewer, object and landscape. In images such as
Nice Wire (2003) the humming-bird trap is a neat
emblem for the entrapment of the viewer, caught
by the work he is contemplating. Slowly passing
time, and even boredom, are shown to be integral
to the experience of the art work. (DJ)

Shown by Raucci/Santamaria Gallery A5

HERO: this is WE
2005
DVD
Courtesy Galerie Martin Janda

Selected Bibliography

2004 *Art Works: Autobiography*,
Jun Yang and Barbara Steiner,
Thames & Hudson, London

2003 'Man of the World: Jun
Yanq', Bert Rebhandl, *frieze* 73

2003 'Look Like Them/Talk
Like Them', Sabine B. Vogel,
Kunstbulletin

2001 *Encounter*, Tokyo Opera
City Cultural Foundation,
Tokyo

Selected Exhibitions

2005 'The Experience of Art',
Italian Pavilion, Venice Biennale

2004 Büro Friedrich, Berlin

2004 'Ficciones Documentals',
Fundació la Caixa, Barcelona

2004 'SHAKE: ID Troubles',
Villa Arson, Nice

2003 Galerie Martin Janda,
Vienna

2002 Musée d'Art
Contemporain, Marseille

2002 Manifesta, Frankfurt

2001 'Coming Home: Daily
Structures of Life – Version D00',
Galerie für Zeitgenössische
Kunst, Leipzig

1999 Le Printemps de Cahors

1999 Galerie Martin Janda,
Vienna

Jun **Yang**

Born 1975
Lives Vienna

Within daily life cultural differences are reflected in
bizarre imaginings and telling misapprehensions.
Born in China and raised in Austria, Jun Yang
has involuntarily become an expert in these
everyday slippages. Many of his works are based
on revealing anecdotes, which he recounts with
the detached humour of a novelist. In the video
Jun Yang & Soldier Woods (2002) he reflects on the
frequent misspellings of his name, which routinely
result in gender confusion. The video *Coming Home
– Daily Structures of Life* (2000) is a compilation of
footage from Hollywood films showing Chinese
restaurants. In the commentary Yang describes
how recent immigrants, irrespective of their former
jobs, inevitably end up opening restaurants as this
is the role allocated for them in Western culture.
(JV)

Shown by Galerie Martin Janda A13

yo-ho, yo-ho, yo-ho …
2004
Ink on paper
228×183cm
Courtesy the artist

Selected Bibliography

2005 *The Elegance of Silence: Contemporary Art from East Asia*, Mitsuyo Ogawa, Mori Art Museum, Tokyo

2003 *The 22nd Seoknam Art Prize*, Soo-mi Kang, Seoul

1999 *Beyond the Landscape*, Hunee Jung, Art Sonje Centre, Seoul

1999 *Relay*, Shinwon Hwang, Seoul

Selected Exhibitions

2005 'The Elegance of Silence', Mori Art Museum, Tokyo

2005 'Looking Both Ways: Three Artists from Korea', Center for Curatorial Studies, Bard College, Annandale-on-Hudson

2004 'Officina Asia', Galleria d'Arte Moderna, Bologna

2003 'echowords', Gallery Doll, Seoul

2002 Gwangju Biennial

2001 'Get Scattered', Art Center of the Korean Culture & Art Center, Seoul

2000 'Young Korean Artists Exhibition 2000: Towards the New Millennium', National Museum of Contemporary Art, Kwachon

1999 'Beyond Landscape', Art Sonje Centre, Seoul

Yoo Seung-Ho

Born 1973
Lives Seoul

At first glance Yoo Seung-Ho's work resembles traditional Korean landscape painting – all swift, confident brushstrokes and delicate washes of ink. Look closer, though, and his mountains, ravines and rivers are all formed from words. These lexical topographies are often onomatopoeic, employing Korean ideograms that imitate the sound of rainfall, or of water trickling down a slope. For all these works' visual appeal, they are also deeply conceptual, exploring how the word for a thing, and the thing itself, are not independent entities but are, rather, symbiotic – bound together by our (culturally specific) modes of perception. (TM)

Shown by pkm Gallery G4

Seppelchen
2003
Budgerigars, wood, lacquer
Dimensions variable
Courtesy Galerie Michael Neff

Selected Bibliography

2000 *Phillip Zaiser*, Kunsthaus, Essen

Selected Exhibitions

2004 'Labor der Freiheit', Künstlerhaus Mousonturm, Frankfurt

2004 'Noch warm und schon Sand drauf', Galerie Hilger, Vienna

2003 'Growing up Absurd', Jette Rudolph Gallery @ POST-LA, Los Angeles

2002 'VISIO', Hamburger Bahnhof, Berlin

2002 'Plain Air', Galerie Michael Neff, Frankfurt

2001 'atrium vagari', Künstlerhaus, Essen

2001 'Frankfurter Kreuz', Schirn Kunsthalle, Frankfurt

2001 'Plague', Galerie Espace Ernst Hilger, Paris

2001 'Death Race 2000', Thread Waxing Space, New York

2000 'Dribbdedach (Zakynthos)', ZKM Centre for Art and Media, Karlsruhe

Phillip **Zaiser**

Born 1969
Lives Frankfurt

A trashed hotel bedroom (*Bitte Zimmer Aufräumen*, Please Tidy Up the Room, 1999), a rustic take-out (*Call-a-Pizza*, 2000), a miserable venue for an Indie rock band (*Roadhouse*, 1997) and a sleazy lounge decorated with mirrors and glittering beer bottle caps threaded on string (*Gogo*, 1997) are among the theatre–set-like room installations by Phillip Zaiser. Both fake and familiar, his works evoke characters and plots taken from the kind of urban narratives that one sees on TV – or encounters on a stroll in a lively part of any city. (DE)

Shown by Galerie Michael Neff A15

Urban Landscape
2003
Stainless steel installation
730×730cm
Courtesy CourtYard Gallery

Selected Bibliography

2005 *Universal Experience: Art, Life and the Tourist's Eye*, Francesco Bonami et al., Museum of Contemporary Art, Chicago; DAP, New York

2004 *The Elegance of Silence: Contemporary Art from East Asia*, ed. Kim Sunhee, Mori Art Museum, Tokyo

2002 *Art Tomorrow*, Edward Lucie-Smith, Editions Pierre Terrail, Paris

1999 *Transience: Chinese Experimental Art at the End of the Twentieth Century*, Wu Hung, University of Chicago Press

Selected Exhibitions

2005 'Universal Experience', Museum of Contemporary Art, Chicago

2005 'The Elegance of Silence: Contemporary Art from East Asia', Mori Art Museum, Tokyo

2004 'Playing with QI Energy', House of Shiseido, Tokyo

2004 'Chinese Imagination', Jardin des Tuileries, Paris

2003 'CHINaRT', Museo Arte Contemporanea di Roma and touring

2003 'Urban Landscape', Guangdong Museum of Art, Guanzhou; Central Academy of Fine Arts, Beijing

2003 Guangzhou Triennial

2000 'Open 2000: International Sculpture Installation Exhibition', Venice

1997 'Cities on the Move', PS1 Contemporary Art Center, New York

Zhan Wang

Born 1962
Lives Beijing

Conceptual sculptor Zhan Wang is perhaps best known for his stainless steel sculptures, modelled on the kind of ornamental boulders the Chinese call *jiashanshi* (fake mountain rocks) and which Westerners call 'scholars' rocks'. These hollow, glittering sculptures are posed as an alternative to the traditional rocks often placed outside Beijing skyscrapers in a nod to regional architecture. In 2000 Zhan fashioned his largest work, a copy of the largest meteorite ever recovered, which he still hopes to dispatch into space. In a related work, *Beyond 12 Nautical Miles Floating Rock Drifts on the Open Sea* (2000), he launched a fake *jiashanshi* into the international waters off China. (SL)

Shown by CourtYard Gallery H13

Untitled (Flower)
2004
Oil on canvas
100×85cm
Courtesy Foksal Gallery
Foundation

Jakub Julian **Ziółkowski**

Born 1980
Lives Krakow

Combining the bizarrely funny with the hauntingly apocalyptic, Jakub Julian Ziółkowski's paintings convey both the intimacy of personal dreams and the intensity of ecstatic visions. *Deszcz* (Rain, 2003) shows a small figure riding stormy ocean waves in a tiny boat, protecting himself against the rain with an umbrella though the sun shines brightly; in *Wojna* (War, 2004) the sky appears striped in red and trees sway in unison as if they belonged to a choir. In the world Ziółkowski unfolds, everything is illuminated in the multi-coloured light of an unconstrained imagination. (JV)

Selected Exhibitions

2005 'Stuffed Knee Limp Colour', Foksal Gallery Foundation, Warsaw

2004 Gallery Pod Schodami, Academy of Fine Arts in Krakow

2004 Gallery 1, Lublin

Shown by Foksal Gallery Foundation C14

Geist ohne Körper
(Mind without Body)
2004
Bronze
Edition of 3+1AP
Diameter 44cm
Courtesy Guido W. Baudach

Thomas **Zipp**

Born 1966
Lives Berlin

Thomas Zipp's recent exhibitions have included ensembles of sculpture, paintings and drawings full of symbols heavy in patina, mystical allusions and post–ideological refuse. Critic Angela Rosenberg described his work *Nobody Loves an Albatross* (2000) as resembling a 'narrative of a bizarre hermit looking for the aesthetic quality in everything, not by nailing meaning down but by opening up symbols'. A 2004 show, 'Futurism Now! SAMOA Leads', consisted of dark oil paintings, an office desk and a map of the world – a setting worthy of a Goth hell-bent on global domination. *Neroin* (2003) included sculptures that look part cement mixer and part barbecue, devouring wood next to an image of a nuclear test. (DE)

Shown by Guido W. Baudach H10, Alison Jacques Gallery D17, Galerie Michael Neff A15, Patrick Painter, Inc. C2

Selected Bibliography

2004 'Drogen, Gewalt, Sex, Religion' (Drugs, Violence, Sex, Religion), Christoph Schütte, *FAZ*

2004 'Die Augenzeugen des Unsichtbaren' (The Eyewitnesses of the Invisible), Florian Illies, *Monopol*

2003 'Painting on the Roof', Helga Meister, *Kunstforum International*

2000 'Thomas Zipp', Angela Rosenberg, *Flash Art International*

Selected Exhibitions

2005 'The Return of the Subreals', Kunstverein, Oldenburg

2005 'The New Tycho', Galería Heinrich Ehrhardt, Madrid

2005 'man muss das adjektiv abschaffen', Baronian_Francey, Brussels

2004 'Futurism Now! SAMOA Leads', Daniel Hug Gallery, Los Angeles

2004 'The New Breed', Galerie Michael Neff, Frankfurt

2004 'Heimweh', Haunch of Venison, London

2003 'Neroin', Guido W. Baudach, Berlin

2003 'actionbutton', Hamburger Bahnhof, Berlin

2003 'Painting on the Roof', Museum Abteiberg, Moenchengladbach

2001 'Exorcise the Demons of Perhaps', Guido W. Baudach, Berlin

*Prototype for Billboard at A–Z West:
'These Things I Know For Sure',
#14*
2005
Flash and polyurethane varnish
on birch panel
104×180cm
Courtesy Andrea Rosen Gallery

These things I know for sure:

#14. We are most happy when we are moving
forwards towards something that is not yet attained.
This feeling also extends to physical motion in space...
we are happier in a car because we are moving
forward towards an identifiable and attainable goal.

Selected Bibliography

2005 *Critical Spaces*, Morsiani,
Smith et al., Contemporary Arts
Museum, Houston

2003 *Andrea Zittel*, Raimund
Schumacher and Mimi Zeiger,
Sammlung Goetz, Munich

2002 'Diary #01: Andrea
Zittel', *tema celeste*

2000 *Personal Programs; Andrea
Zittel*, ed. Zdenek Felix, Hatje
Cantz Verlag, Ostfildern-Ruit

Selected Exhibitions

2005 'Critical Spaces',
Contemporary Arts Museum,
Houston; New Museum of
Contemporary Art, New York;
and touring

2004 Whitney Biennial,
New York

2001 'A–Z Cellular
Compartment Units', Ikon
Gallery, Birmingham

1999 'Point of Interest',
Project with the Public Art Fund,
New York

1999 Deichtorhallen, Munster

1997 Documenta, Kassel

1997 'Skulptur Projekte in
Munster', Landesmuseum
Munster, Hamburg

1996 'Andrea Zittel:
Living Units', Museum für
Gegenwartskunst, Basel

1995 San Francisco Museum of
Modern Art

1993 Venice Biennale

Andrea Zittel

Born 1966
Lives Joshua Tree/Los Angeles

All the little everyday decisions we make about
our surroundings – and those that are made for
us – are, for Andrea Zittel, occasions worthy of
scrutiny and opportunities to imagine alternatives.
Working as both designer and test subject, she has
turned her own life into an ongoing experiment in
domestic science. Each aspect of her environment
– clothing, furniture, food – has been examined,
customized and (perhaps) improved. Zittel's many
projects have taken her from an artificial island off
the coast of Denmark to a self-sufficient settlement
in the California desert. Wryly Utopian, her
designs for living offer novel solutions to constant
needs. (SS)

Shown by Sadie Coles HQ C10, Andrea Rosen
Gallery C3

Selected Bibliography

2003 *Heimo Zobernig*, Museum Moderner Kunst, Stiftung Ludwig, Vienna; Verlag Walther König, Cologne

1999 *Der Katalog*, Hans Petschar, Ernst Strouhal and Heimo Zobernig, Springer Verlag, Vienna

1995 *Farbenlehre* (Theory of Colours), Ferdinand Schmatz and Heimo Zobernig, Springer Verlag, Vienna

1992 *Lexikon der Kunst 1992* (Encyclopaedia of Art 1992), Ferdinand Schmatz and Heimo Zobernig, Editions Patricia Schwarz, Stuttgart

Heimo **Zobernig**

Born 1958
Lives Vienna

Heimo Zobernig's varied practice mines American 1960s' Minimalism. Austere and severe, his paintings and sculpture seek to orient the viewer in the space of the art encounter, and reproduce personal situations and intimate references in a spatial, diagrammatic form. In character with his reworking of Minimalism, Zobernig toys with the apparent reciprocity of the perceptual encounter, a relation made tangible in the interactions with the sobering dimensions of his objects. (DJ)

Shown by Galerie Meyer Kainer G2, Andrea Rosen Gallery C3

Selected Exhibitions

2004 'On Reason and Emotion', Sydney Biennial

2003 Museum of Modern Art, Vienna

2001 'Plateau of Humankind', Arsenale, Venice Biennale

1999 'Der Katalog', MAK, Vienna

1998 Kunstverein, Bonn

1997 Documenta, Kassel

1996 The Renaissance Society at the University of Chicago

1994 Kunsthalle, Bern

1992 Documenta, Kassel

1986 'De Sculptura', Messepalast, Vienna

Interior
2005
Acrylic on canvas and wood
Panel 1: 156×156cm
Panel 2: 152×152cm
Courtesy Galerie Aurel Scheibler

Selected Bibliography

2004 'A Star of the Underground in Separate Constellations', Roberta Smith, *The New York Times*

2004 'Joe Zucker', Carly Berwick, *ARTnews*

2003 *Joe Zucker: Ravenna*, Klaus Kertess, GBE (Modern), New York

2001 *Joe Zucker: Joe's Lakes*, Terry Myers, Galerie Aurel Scheibler, Cologne

1991 *Joe Zucker: Peg Men*, Klaus Kertess, Galerie Aurel Scheibler, Cologne

Selected Exhibitions

2005 'Interior/Exterior', Galerie Aurel Scheibler, Cologne

2004 'Unhinged', Paul Kasmin Gallery, New York

2004 Nolan/Eckman Gallery, New York

2003 GBE Modern, New York

1995 Whitney Biennial, New York

1991 Galerie Aurel Scheibler, Cologne

1982 Albright-Knox Gallery, Buffalo

1979 Galerie Bischofberger, Zurich

1978–9 'New Image Painting', Whitney Museum of American Art, New York

1974 Bykert Gallery, New York

Joe **Zucker**

Born 1941
Lives East Hampton

Since the 1960s Joe Zucker has been making uncompromisingly idiosyncratic Conceptual paintings that bridge Pop, Minimalism and post-Minimalism. Unconventional materials have been central to his work, as has narrative. In recent years Zucker has built paintings by pouring acrylic paint into cardboard boxes and then letting it dry at various angles. The diptychs in his 'Unhinged' series (2004), made of wooden dowels and paint on canvas, also involve poured paint, but stratified areas of colour depict abstracted houses, volcanoes and sailing boats. These images appear in the bottom half, below a monochrome field; the palette ranges from bright hues to shades evoking storm clouds or night skies. (KJ)

Shown by Paul Kasmin Gallery G12, Galerie Aurel Scheibler G15

The Parallel
2005
Acrylic, transfers on canvas
183×305cm
Courtesy Jablonka Lühn

Selected Bibliography

2005 'World of Interiors: Kevin Zucker Likes to Tweak Perspective in His Meticulous Architectural Renderings', Meredith Mendelsohn, *ARTnews*

2005 *Greater New York*, PS1 Contemporary Art Center, New York

2004 'The Illusion of Youth', Marc Spiegler, *Art and Auction*

2003 'Kevin Zucker', Craig Houser, *Flash Art International*

2002 'A Triumph for the New Museum', Daniel Kunitz, *The New York Sun*

Kevin **Zucker**

Born 1976
Lives New York

Ever since Renaissance painting mapped things onto a grid, space has been virtual – meaning that contemporary computer graphics stand within a long tradition. Exploring this history, and inverting it, Kevin Zucker configures spaces on computer and transfers them back onto the canvas. Some of these are interiors drawn from art history. In *Untitled* (2004), for example, a ship from a Canaletto drawing travels towards digital infinity on a sea of bare wire frames, while in another (also *Untitled*, 2004) Victorian Londoners perambulate in a soft grey void. By seeking to control space in the grid, it seems the modern mind has lost itself in an empty world of its own making. (JV)

Shown by Jablonka Lühn C16

Selected Exhibitions

2005 'Greater New York', PS1 Contemporary Art Center, New York

2005 'Neo-con', Gavin Brown's enterprise at Passerby, New York

2004 'Open House', Brooklyn Museum of Art, New York

2004 Jablonka Lühn, Cologne

2004 'Symbolic Space', Hudson Valley Center for Contemporary Art, Peekskill

2004 'Somewhere Apart', Paolo Curti/ Annamaria Gambuzzi & Co., Milan

2003 Mary Boone Gallery, New York

2003 Jablonka Lühn, Cologne

2002 'Out of Site', New Museum of Contemporary Art, New York

2002 Mary Boone Gallery, New York

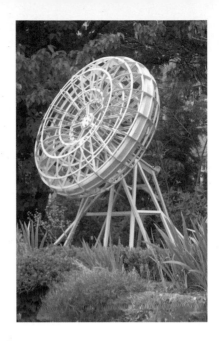

Rotating Space
2004
Wood, steel
215×165×315cm
Courtesy Johann König

Andreas **Zybach**

Born 1975
Lives Berlin

Andreas Zybach treats sculpture and exhibition spaces as speculative and self-reflexive models. His *Repetition of Things to Come* (2003) consists of towers assembled from modular elements made from polystyrene, plastic containers and MDF, and looks like the skyline of a retro-futuristic metropolis. The installation *A4/A3* (2003) is in two parts: a dividing wall of cardboard boxes arranged in an irregular grid pattern, and a glass–ceilinged model of the exhibition itself, the two components locked in a formally pleasing if tautological relationship. The artist's interest in perspectives and overviews also finds expression in his series of photographs of the Envisat environmental satellite traversing the night sky. (DE)

Shown by Johann König D2

Contributors

(MA) Max Andrews is a writer based in London and co-founder of Latitudes, Barcelona.

(KB) Kirsty Bell is a writer and curator based in Berlin.

(DE) Dominic Eichler is a writer based in Berlin.

(PE) Peter Eleey is a curator at the public art organization Creative Time in New York.

(DF) Dan Fox is associate editor of *frieze*. He is also a writer and musician.

(JöH) Jörg Heiser is co-editor of *frieze*. He lives in Berlin and writes for *Süddeutsche Zeitung*.

(JH) Jennifer Higgie is co-editor of *frieze* and a writer.

(DJ) Dominic Johnson is a writer and artist based in London.

(KJ) Kristin M. Jones is a writer and editor based in New York.

(SL) Sarah Lowndes is a writer based in Glasgow. She teaches at Glasgow School of Art.

(TM) Tom Morton is contributing editor of *frieze*, and a writer and curator.

(SO'R) Sally O'Reilly is a writer based in London.

(SS) Steven Stern is a writer based in New York.

(JT) James Trainor is US editor of *frieze* and a writer. He lives and works in New York.

(JV) Jan Verwoert is a writer based in Hamburg. He teaches at the Umeå academy.

AUCTIONS

4 DECEMBER 2005

IMPORTANT 20TH
CENTURY DESIGN

6 DECEMBER 2005

ITALIAN 20TH
CENTURY DESIGN

6 DECEMBER 2005

CIRCA 70
A SURVEY OF STYL

1140 West Fulton
Chicago, IL 60607

t 312 563 0020
f 312 563 0040

www.wright20.com
catalogs available

JEAN PROUVÉ
GRANIPOLI TABLE
Saint-Brévin 1939

wright

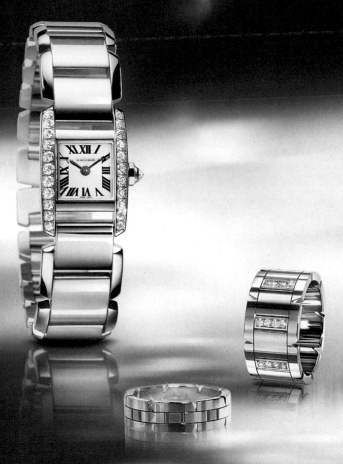

Tankissime watch and Tank Française rings

Cartier

HEMISPHERE

173 FULHAM ROAD, LONDON SW3 6JW
TEL. 020 7581 9800 FAX. 020 7581 9880
rpaynter@btinternet.com

Table-desk by Janette Laverriére, unique piece, 196

Auction
23 October 2005

Viewing
20-23 October

Enquiries
Anthony McNerney
amcnerney@christies.com
+44 (0)207 389 2253

Catalogues
+44 (0)20 7389 2820

London
8 King Street, St. James's
London SW1Y 6QT

View catalogues
and leave bids online at
christies.com

WILHELM SASNAL (b.1972)
Untitled
(Two Men throwing bombs from a Balloon)
signed and dated 'Wilhelm Sasnal 2002' (on the reverse)
oil on canvas
32⅛ x 27¾ in. (81.5 x 70.5 cm)
Painted in 2002
£18,000-22,000

LONDON CONTEMPORARY
23 October 2005

CHRISTIE'S
SINCE 1766

Auction
24 October

Viewing
20 - 24 October (noon)

Enquiries
Olivier Camu
ocamu@christies.com
+44 (0)20 7389 2450

Catalogues
+44 (0)20 7389 2820

London
8 King Street
St. James's
SW1Y 6QT

christies.com

ALIGHIERO BOETTI (1940-1994)

Cubo
mixed media in plexiglass box
90 x 90 x 91 cm.
(35½ x 35½ x 35⅞ in.)
Executed in 1968
£120,000–180,000

LUCIANO FABRO (b. 1936)

Cosa Nostra
glass and metal
107 x 231 cm. (42⅛ x 91 in.)
Conceived in 1968 and
Executed in 1972
£100,000–150,000

THE ITALIAN SALE – 20TH CENTURY ART

London, 24 October 2005

CHRISTIE'S
SINCE 1766

LONDON

NEWYORK

VENICE

CARDIFF

ARTUPDATE.COM/

Bonhams ¹⁷⁹³

Modern and Contemporary Art

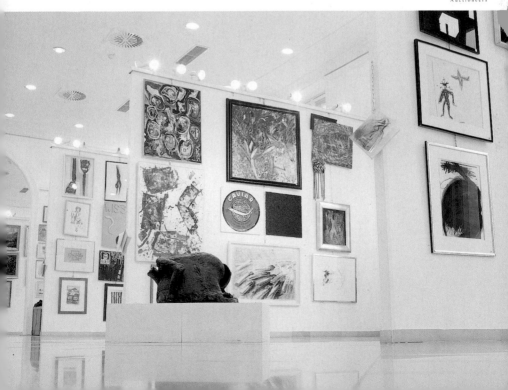

platform art

18 September – 30 October 2005

Richard Wentworth

If London Looked in the Mirror
A commission by Platform for Art and Frieze Projects. Collect yours free from all zone 1 Tube stations and Frieze Art Fair

In collaboration with Frieze Art Fair

October 2005 – January 2006
A new commission
for the ticket hall
Piccadilly Circus station

Shezad Dawood

November 2005 – May 2006
A spectacular new installation
on the District and Circle line
Gloucester Road station

Beatriz Milhazes

Platform for Art is the public art programme
for London Underground

For more information email plat4art@tube.tfl.gov.uk
www.tfl.gov.uk/pfa

MAYOR OF LONDON

Transport for London

The guide

THE ESSENTIAL 7-DAY LISTINGS GUIDE, FREE EVERY SATURDAY *The* **Guardian**

Look at the state you're in

The best and worst accents on film

the art of indulgence

City Inn is proud to support contemporary art in the UK and displays specially commissioned work from selected artists throughout their hotels.

City Inn Westminster: official partner hotel of Frieze Art Fair 2003, 2004 and 2005

CITY INN WESTMINSTER
30 John Islip Street
London SW1P 4DD
tel +44 (0)20 7630 1000
westminster.res@cityinn.com

best rates guaranteed
www.cityinn.com

TANQUERAY, A SUPERB LONDON DRY GIN OF UTTER PURITY

DRINKAWARE.CO.UK

THE ART OF SELF-EXPRESSION

DEPUIS **1812** SINCE

Laurent-Perrier

CHAMPAGNE

Grand Siècle
by Jean–Baptiste Huynh

Stockists: Berry Brothers, Harrods, Selfridges, Majestic,
Sainsbury's Pimlico, Sainsbury's 'Blue Bird Store'
Kings Road, Vintage House, Goedhuis, Wine Bureau
and Oddbins

BEST
KEPT SECRET

THE
ROYAL
PARKS
FOUNDATION

Art for London's Royal Parks

In Summer 2006, leading contemporary artists
will be taking part in a major public art initiative
in support of The Royal Parks. Given a blank
deckchair canvas, artists will capture the spirit
of the Parks in their own personal way, helping
to raise funds for The Royal Parks Foundation.

To find out more about The Royal Parks and this great
art adventure, **come and visit us at stand M26**.

Photograph Giles Barnard

The Royal Parks are the green heart of London.
Your personal space, our natural heritage.
www.royalparksfoundation.org
The Royal Parks Foundation
is a registered charity, number 1097545

DECKCH4IR
dreams

www.domperignon98.com/karllagerfeld

WILD AT HEART

Wild at Heart has a passionate commitment to creating beautiful, stylish, contemporary flowers, ideas that are unconventional and challenge tradition. We believe flowers should enrich our surroundings through colour, texture and scent, drawing inspiration from the worlds of art, architecture, design and fashion. Our flowers are designed to suit their interior, whether classic and traditional or contemporary and modern..

For flower deliveries in London call 0207 727 3095
For special events and contracts call 0207 229 1174
email flowers@wildatheart.com

art press

Biennale de Lyon, Expérience de la durée par Nicolas Bourriaud et Jérôme Sans
Olivier Kaeppelin à la DAP, interview **Jeppe Hein** La peinture aujourd'hui (suite)
Robert Coover Alain Fleischer **Arthur Koestler** À bas le sexe, vive le sexe !

www.artpress.com

ART HISTORY IN THE MAKING

Art in America

Bright Ideas!

Each month Art in America brings you insightful commentary on major museum events, current exhibition reviews, revealing interviews, exciting cutting-edge artists and news from the art world. There is simply no better source of information that covers the international art scene.

Subscribe: call 515.246.6952 worldwide or 800.925.8059 in the U.S.

Advertise: call 212.941.2854

Art in America
JANUARY 2005

DAN FLAVIN
HELEN CHADWICK
ANT FARM
ANSEL ADAMS
MONOCHROMES

Germany Calling
Axel Lapp

Abstraction Appropriated
Vincent Pécoil

Giovanni Anselmo
Reviewed by Ian Hunt

Joseph Beuys
Reviewed by Deborah Schultz

Size Matters
Art and the spectacle

On Sculpture
And its reinvention

The Last Painting
circa 1966

The Flick Collection Berlin
What's in a name?

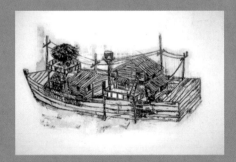

BLUEPRINT

Subscribe and get three issues free
£39.95 for 15 issues instead of 12

STEVE SPELLER

- Unrivalled coverage and analysis of contemporary architecture and design

- Unique large format, high-quality original writing, photography and illustrations

- A forum for provocative ideas and debate on issues in architecture and design

SUBSCRIBER BENEFITS:

Every issue direct to your doorstep
Discounted admission to events
Free Blueprint Broadsides

I would like to subscribe to Blueprint

- 15 issues for the price of 12 (UK, £39.95) – three issues free
- 15 issues for the price of 12 (rest of world, £74.95)

Title: _____ First name: _____
Surname: _____
Company name: _____
Job title: _____
Address: _____

_____ Postcode: _____
Telephone: _____
e-mail: _____

- **Direct debit** (UK subs only): please complete the form below
- **Credit card:** please charge my Mastercard/Visa £ _____
- **Invoice:** please invoice my company at the above address

CARD N°
EXPIRY DATE ⬜⬜ - ⬜⬜

- **Cheque** for £ _____ (Payable to Blueprint)

Signature: _____ Date: _____

- Wilmington Group may occasionally pass your details to other reputable organisations whose products and services may be of interest. Please tick this box if you are prepared to receive such offers.
- This information may be sent by e-mail. Please tick this box if you are prepared to receive e-mail from such organisations.
- Wilmington Group companies may write to you about your renewals and our other services, events or products which may be of interest. Please tick this box if you are prepared to receive such information from us.
- Wilmington Group companies may send you this information by e-mail. Please tick this box if you are prepared to receive e-mail from us.

Please fax this order on 020 8606 7301 or ring 020 8606 7549 (credit card orders only) or return to Blueprint, c/o WDIS, Units 12 &13, Cranleigh Gardens Ind Estate, Southall UB1 2DB, or subscribe on-line at **www.blueprintmagazine.co.uk**

FAF05

1980 1981 1982 1983 1984

1985 1986 1987 1988 1989

1990 1991 1992 1993 1994

1995 1996 1997 1998 1999

2000 2001 2002 2003 2004

EVERY MONTH A NEW IDEA. EVERY YEAR A NEW RESOLUTION. EVERY 25 YEARS A GREAT PARTY. i-D EST 1980

Buy the art of the future 23-27 November

ART*futures* 2005
at Bloomberg SPACE

Contemporary Art Society

Join the Contemporary Art Society and get an invitation to the Opening of ART*futures*

www.contempart.org.uk

Purchasing and commissioning art for private and corporate clients

Projects Art Consultancy
26 Binney Street
London W1K 5BH
Tel + 44 (0)20 7355 3222
Fax + 44 (0)20 7355 3444
info@projectsartconsultancy.com
www.projectsartconsultancy.com

Stephan Balkenhol 'Scottish Aboriginal Woman' 2003
Julian Opie 'Bob, gallerist' 2002

Audiovisual made simple

ADi Audiovisual
Technical Expertise
Hires, Sales, Installation

+44 (0) 207 729 8085

ADi Solutions
Art & Design Installation
Design, Build, Hang.

+44 (0) 207 729 8073

1st Floor, 6-8 Standard Place, Rivington St, London, EC2A 3BE

www.groupadi.com

The Japanese hinge

Made from the inner bark of native Japanese plants, traditional Japanese Washi paper has long fibres which make it light and flexible, yet deceptively strong. The paper's soft, subtle textures and natural feel are said to echo the warm heart of the papermaker who makes each sheet with devotion.

The combination of delicacy and strength make Washi the perfect paper for our art presentation team to use in the skilled technique of Japanese hinging artwork to mounts and support surfaces.

For more information on our protective and preventative approach to contemporary picture framing, call us for a copy of our new brochure.

John Jones

Stroud Green Road (corner of Morris Place)
London N4 3JG
Telephone +44(0)20 7281 5439
info@johnjones.co.uk www.johnjones.co.uk

Koenig Books Ltd.

at the Serpentine Gallery

Edited by Nationalgalerie Berlin, published by Verlag der Buchhandlung Walther König, Köln · **Jörg Immendorff, Male Lago** · Essays English/German by Anette Hüsch, Pamela Kort, Peter-Klaus Schuster, Robert Storr. Interview by Hans Ulrich Obrist. Size 28,5 x 21 cm. 700 pages with 148 colour plates and hundreds of illustrations, Paperback € 39,80

Kensington Gardens, London W2 3XA
Tel.: 020 7706 4907, Fax: 020 7706 4911
e-mail: info@koenigbooks.co.uk
order at: www.koenigbooks.co.uk

Insightful, intelligent and exquisitely designed, frieze covers all that is vital in contemporary art and culture. Read it to find out first about emerging artists, to discover new currents in art and to gain a fresh perspective on more established artists. frieze looks beyond what's hot and what's not and places the fast-moving world of contemporary art in a wider context, demystifying and making it more accessible.

Including exhibition reviews and worldwide listings, frieze is invaluable reading both for art insiders and anyone wishing to learn more about contemporary art.

FRIEZE ART FAIR

Index

Gallery Index

1301PE

Stand B8
Tel +1 323 938 5822

6150 Wilshire Blvd
Los Angeles CA 90048
USA
Tel +1 323 938 5822
Fax +1 323 938 6106
info@1301PE.com
www.1301PE .com

Contact
Brian Butler
Alexis Johnson

Gallery artists
John Baldessari
Fiona Banner
AA Bronson
Angela Bulloch
Meg Cranston
Kate Ericson & Mel Ziegler
Kirsten Everberg
General Idea
Jack Goldstein
Ann Veronica Janssens
Mike Kelley
Rachel Khedoori
Martin Kippenberger
Judy Ledgerwood
Paul McCarthy
Liliana Moro
Jorge Pardo
Jason Rhoades
Katy Schimert
Diana Thater
Rirkrit Tiravanija
Pae White
Paul Winstanley

303 Gallery

Stand C13
Tel +1 917 660 7332

525 West 22nd Street
New York NY 10011
USA
Tel +1 212 255 1121
Fax +1 212 255 0024
info@303gallery.com
www.303gallery.com

Contact
Lisa Spellman
Mari Spirito

Gallery artists
Doug Aitken
Laylah Ali
Edgar Bryan
Anne Chu
Thomas Demand
Inka Essenhigh
Hans-Peter Feldmann
Ceal Floyer
Karel Funk
Maureen Gallace
Tim Gardner
Rodney Graham
Mary Heilmann
Karen Kilimnik
Liz Larner
Florian Maier-Aichen
Kristin Oppenheim
Collier Schorr
Stephen Shore
David Thorpe
Sue Williams
Jane & Louise Wilson

ACME.

Stand D15
Tel +1 323 857 5942

6150 Wilshire Blvd
Los Angeles CA 90048
USA
Tel +1 323 857 5942
Fax +1 323 857 5864
info@acmelosangeles.com
www.acmelosangeles.com

Contact
Bob Gunderman
Randy Sommer
Dean Anes

Gallery artists
Amy Adler
Kristin Baker
Uta Barth
Miles Coolidge
Tomory Dodge
Tony Feher
Chris Finley
Katie Grinnan
Kevin Hanley
Kurt Kauper
Martin Kersels
Aaron Morse
Laura Owens
Monique Prieto
Stephanie Pryor
Dario Robleto
John Sonsini
Jennifer Steinkamp

Air de Paris

Stand A4
Tel +33 6 6250 2084

32 rue Louise Weiss
Paris 75013
France
Tel +33 1 44 23 02 77
Fax +33 1 53 61 22 84
fan@airdeparis.com
www.airdeparis.com

Contact
Florence Bonnefous
Edouard Merino

Gallery artists
Olaf Breuning
Guy de Cointet
François Curlet
Stéphane Dafflon
Brice Dellsperger
Trisha Donnelly
Liam Gillick
Joseph Grigely
Annika von Hauswolff
Carsten Höller
Pierre Joseph
Inez van Lamsweerde &
Vinoodh Matadin
M/M Paris
Sarah Morris
Petra Mrzyk &
Jean-François Moriceau
Philippe Parreno
Bruno Pelassy
Rob Pruitt
Navin Rawanchaikul
Allen Ruppersberg
Torbjørn Rødland
Bruno Serralongue
Shimabuku
Lily van der Stokker
Jean-Luc Verna

Galería Juana de Aizpuru

Stand C17
Tel +44 20 7935 0752

Barquillo 44–1°
Madrid 280040
Spain
Tel +34 91 310 5561
Fax +34 91 319 5286
aizpuru@galeríajuanadeaizpuru.
com

Contact
Juana de Aizpuru

Gallery artists
Rafael Agredano
Art & Language
Miroslaw Balka
Tania Bruguera
Miguel Ángel Campano
Rui Chafes
Luis Claramunt
Jordi Colomer
Jonas Dahlberg
Sandra Gamarra
Carmela García
Dora García
Alberto García Alix
Cristina García Rodero
Ferrán García Sevilla
Pierre Gonnord
Federico Herrero
Georg Herold
Aitor Lara
Sol LeWitt
Rogelio Lopez Cuenca
Cristina Lucas
Ingeborg Lüscher
Sigfrido Martín Begué
Priscilla Monge
Yasumasa Morimura
Albert Oehlen
Markus Oehlen
Fernando Sánchez Castillo
Andres Serrano
Wolfgang Tillmans
Franz West

The
Approach

Stand G3
Tel +44 20 8983 3878

1st Floor, 47 Approach Road
London E2 9LY
UK
Tel +44 20 8983 3878
Fax +44 20 8983 3919
info@theapproach.co.uk
www.theapproach.co.uk

Contact
Jake Miller
Emma Robertson
Mike Allen

Gallery artists
Haluk Akakçe
Phillip Allen
Dan Coombs
Evan Holloway
Inventory
Rezi van Lankveld
Dave Muller
Jacques Nimki
Michael Raedecker
John Stezaker
Mari Sunna
Gary Webb
Martin Westwood
Shizuka Yokomizo

Arndt &
Partner

Stand D21
Tel +41 79 440 4966

Zimmerstrasse 90-91
Berlin 10117
Germany
Tel +49 30 280 8123
Fax +49 30 283 3738

Lessingstrasse 5
Zurich 8002
Switzerland
+41 43 817 6780/81
+41 43 817 6782
arndt@arndt-partner.com
www.arndt-partner.com

Contact
Matthias Arndt
Anna Lemke Duque
René Lahn

Gallery artists
Adam Adach
Olaf Breuning
Sophie Calle
Yannick Demmerle
Torben Giehler
Gabi Hamm
Rachel Harrison
Anton Henning
Mathilde ter Heijne
Thomas Hirschhorn
Henning Kles
Douglas Kolk
Claude Lévêque
Muntean/Rosenblum
Tam Ochiai
Christopher Orr
Erik Parker
Julian Rosefeldt
Lisa Ruyter
Charles Sandison

Nedko Solakov
Hiroshi Sugito
Miroslav Tichý
Susan Turcot
Keith Tyson
Massimo Vitali

Art & Public – Cabinet P.H.

Stand B20
Tel +41 79 202 6908

37 rue des Bains
Geneva 1205
Switzerland
Tel +41 22 781 4666/78
Fax +41 22 781 4715
art@artpublic.ch
www.artpublic.ch

Contact
Pierre Huber
Roberto Gomez-Godoy
Celine Fressart

Gallery artists
John Armleder
John Coplans
Sylvie Fleury
Subodh Gupta
On Kawara
Martin Kippenberger
Louise Lawler
Ken Lum
Esko Männikkö
Frank Nitsche
Albert Oehlen
Raymond Pettibon
Thomas Ruff
Lisa Ruyter
Sam Samore
Jim Shaw
Cindy Sherman
Frank Thiel
Franz West
Christopher Wool
Erwin Wurm
Yan Pei Ming

Art : Concept

Stand E2
Tel +33 1 5360 9030

16 rue Duchefdelaville
Paris 75013
France
Tel +33 1 53 60 90 30
Fax +33 1 53 60 90 31
info@galerieartconcept.com
www.galerieartconcept.com

Contact
Olivier Antoine
Daniele Balice
Caroline Maestrali

Gallery artists
Martine Aballea
Francis Baudevin
Whitney Bedford
Jean-Luc Blanc
Michel Blazy
Jeremy Deller
Richard Fauguet
Vidya Gastaldon
Geert Goiris
Lothar Hempel
Andrew Lewis
Jacques Lizène
Philippe Perrot
Michael Sailstorfer
Roman Signer

Galerie Catherine Bastide

Stand E16
Tel +32 2 646 2971

62 rue Chaussée de Forest
Brussels 1060
Belgium
Tel +32 2 646 2971
Fax +32 2 640 0694
c.bastide@online.be
www.catherinebastide.com

Contact
Catherine Bastide
Lilou Vidal

Gallery artists
Jacques André
Patrick Vanden Eynde
Jean-Pascal Flavien
Josh Smith
Catherine Sullivan
Janaina Tschäpe
Kelley Walker

Guido W. **Baudach**

Stand H10
Tel +49 30 2804 7727

Oudenarderstrasse 16-20
Berlin 13347
Germany
Tel +49 30 2804 7727
Fax +49 30 2804 7727
galerie@guidowbaudach.com
www.guidowbaudach.com

Contact
Guido W. Baudach
Heike Tosun

Gallery artists
André Butzer
Björn Dahlem
Thilo Heinzmann
Thomas Helbig
Andreas Hofer
Erwin Kneihsl
Markus Selg
Thomas Zipp

Bernier/ Eliades

Stand F17
Tel +30 210 341 3935

11 Eptachalkou Street
Athens 11851
Greece
Tel +30 210 341 3935
Fax +30 210 341 3938
bernier@bernier-eliades.gr
www.bernier-eliades.gr

Contact
Jean Bernier
Barbara Kouzelis
Marina Eliades
Lina Markopoulou

Gallery artists
Haluk Akakçe
John Baldessari
Dirk Braeckman
Giuseppe Caccavale
Alan Charlton
Tony Cragg
Lionel Estève
Gilbert & George
George Hatzimichalis
Cameron Jamie
Moshekwa Langa
George Lappas
Richard Long
Florian Maier-Aichen
Tony Oursler
Daniel Richter
Charles Sandison
Thomas Schütte
Jim Shaw
Boyd Webb
Franz West
Sue Williams
Yan Pei Ming

Blum & Poe

Stand G6
Tel +1 310 836 2062

2754 S. La Cienega Blvd
Los Angeles 90034
USA
Tel +1 310 836 2062
Fax +1 310 836 2104
info@blumandpoe.com
www.blumandpoe.com

Contact
Tim Blum
Jeff Poe
Silke Taprogge

Gallery artists
Aya Takano
Chiho Aoshima
Tatsurou Bashi
Jennifer Bornstein
Slater Bradley
Nigel Cooke
Sam Durant
Anya Gallaccio
Mark Grotjahn
Julian Hoeber
Matt Johnson
Friedrich Kunath
Sharon Lockhart
Florian Maier-Aichen
Daniel Marlos
Dave Muller
Takashi Murakami
Yoshitomo Nara
Hirsch Perlman
Dirk Skreber
Chris Vasell
Bruce Yonemoto

Marianne **Boesky** Gallery

Stand E5
Tel +1 212 680 9889

535 West 22nd Street
New York NY 10011
USA
Tel +1 212 680 9889
Fax +1 212 680 9897
info@marianneboeskygallery.com
www.marianneboeskygallery.com

Contact
Marianne Boesky
Elisabeth Ivers
Jay Sanders

Gallery artists
Kevin Appel
Chinatsu Ban
Hannah van Bart
Sue de Beer
Liz Craft
Rachel Feinstein
Angelo Filomeno
Thomas Flechtner
Barnaby Furnas
Francesca Gabbiani
Mary Ellen Mark
Donald Moffett
Takashi Murakami
Yoshitomo Nara
Jacco Olivier
Annèe Olofsson
Sarah Sze
John Waters
Yi Chen
Lisa Yuskavage

Tanya **Bonakdar** Gallery

Stand E9
Tel +1 917 783 5849

521 West 21st Street
New York NY 10011
USA
Tel +1 212 414 4144
Fax +1 212 414 1535
mail@tanyabonakdargallery.com
www.tanyabonakdargallery.com

Contact
Tanya Bonakdar
Ethan Sklar
James Lavender

Gallery artists
Uta Barth
Sandra Cinto
Mat Collishaw
Mark Dion
Olafur Eliasson
Michael Elmgreen &
Ingar Dragset
Siobhán Hapaska
Sabine Hornig
Teresa Hubbard &
Alexander Birchler
Ian Kiaer
Carla Klein
Atelier van Lieshout
Charles Long
Jason Meadows
Ernesto Neto
Rivane Neuenschwander
Peggy Preheim
Thomas Scheibitz

Niels **Borch** Jensen Gallery

Stand H2
Tel +49 170 2862 974

Naunynstrasse 38
Berlin 10999
Germany
Tel +49 30 6150 7448
Fax +49 30 6150 7449
mail@berlin-kopenhagen.de
www.berlin-kopenhagen.de

Contact
Isabelle Gräfin Du Moulin
Niels Borch Jensen

Gallery artists
Lewis Baltz
Georg Baselitz
Tacita Dean
Thomas Demand
AK Dolven
Olafur Eliasson
Stephen Ellis
Michael Elmgreen &
Ingar Dragset
Jeffrey Eugenides
Ceal Floyer
Rodney Graham
Jeppe Hein
Damien Hirst
Carsten Höller
Olav Christopher Jenssen
Eske Kath
Clay Ketter
Martin Kippenberger
Per Kirkeby
Takehito Koganezawa
Katrin von Maltzahn
Boris Mikhailov
Albert Oehlen
Tal R
Tom Sandberg
Jan Svenungsson
Al Taylor
Rosemarie Trockel
Alan Uglow
Mark Wallinger
Rachel Whiteread
Karen Yama

Gavin **Brown's** enterprise

Stand D7
Tel +1 212·627 5258

620 Greenwich Street
New York NY 10014
USA
Tel +1 212 627 5258
Fax +1 212 627 5261
gallery@gavinbrown.biz
www.gavinbrown.biz

Contact
Gavin Brown
Laura Mitterrand

Gallery artists
Franz Ackermann
James Angus
Dirk Bell
Martin Creed
Verne Dawson
Jeremy Deller
Peter Doig
Urs Fischer
Mark Handforth
Jonathan Horowitz
Tony Just
Udomsak Krisanamis
Mark Leckey
Victoria Morton
Chris Ofili
Laura Owens
Oliver Payne & Nick Relph
Elizabeth Peyton
Steven Pippin
Rob Pruitt
Anselm Reyle
Katja Strunz
Spencer Sweeney
Rirkrit Tiravanija
Piotr Uklanski

Galerie Daniel **Buchholz**

Stand D14
Tel +49 17 0430 0153

Neven-DuMont-Strasse 17
Cologne 50667
Germany
Tel +49 221 257 4946
Fax +49 221 253 351
post@galeriebuchholz.de
www.galeriebuchholz.de

Contact
Daniel Buchholz
Christopher Müller

Gallery artists
Tomma Abts
Henning Bohl
Enrico David
Lukas Duwenhögger
Thomas Eggerer
Vincent Fecteau
Morgan Fisher
Isa Genzken
Jack Goldstein
Julian Göthe
Richard Hawkins
Jochen Klein
Jutta Koether
Mark Leckey
David Lieske
Lucy McKenzie
Henrik Olesen
Paulina Olowska
Silke Otto-Knapp
Mathias Poledna
Florian Pumhösl
Jeroen de Rijke &
Willem de Rooij
Frances Stark
Stefan Thater
Cheyney Thompson
Wolfgang Tillmans
Rebecca Warren
T.J. Wilcox
Katharina Wulff
Cerith Wyn Evans

Cabinet

Stand E12
Tel +44 20 7251 6114

Apartment 6
49-59 Old Street
London EC1V 9HX
UK
Tel +44 20 7251 6114
Fax +44 20 7608 2414
art@cabinetltd.demon.co.uk

Contact
Martin McGeown
Andrew Wheatley

Gallery artists
Tariq Alvi
Gillian Carnegie
Bonnie Camplin
Marc Camille Chaimowicz
Cosey Fanni Tutti
Enrico David
Julian Göthe
Mark Leckey
Lucy McKenzie
Paulina Olowska
James Pyman
Lily van der Stokker
J.D. Williams

Rebecca
Camhi

Stand E22
Tel +30 210 383 7030

Themistokleous 80
Athens 10681
Greece
Tel +30 210 383 7030
Fax +30 210 383 7030
gallery@rebeccacamhi.com
www.rebeccacamhi.com

Contact
Rebecca Camhi
Angelica Papavasiliou

Gallery artists
Rita Ackermann
Nobuyoshi Araki
Ross Bleckner
Sylvie Fleury
Nan Goldin
Konstantin Kakanias
Karen Kilimnik
Sean Landers
Guy Limone
DeAnna Maganias
Miltos Manetas
Tracey Moffatt
Julian Opie
Bill Owens
Mantalina Psoma
Phillip Taaffe
Takis

Luis
Campaña
Galerie

Stand G16
Tel +49 173 539 3838

An der Schanz 1a
Cologne 50735
Germany
Tel +49 221 256 712
Fax +49 221 256 213
info@luis-campana.de
www.luiscampana.de

Contact
Luis Campaña
Annette Völker

Gallery artists
Kati Barath
Tatsurou Bashi
Ralf Berger
Jan de Cock
Björn Dahlem
Kendell Geers
Seb Koberstädt
Takeshi Makishima
Lisa Milroy
Wilhelm Mundt
Gregor Schneider
Qiu Shi-Hua
Dirk Skreber
Jörg Wagner

Galerie
Gisela
Capitain

Stand D12
Tel +49 221 256 676

Aachener Strasse 5
Cologne 50674
Germany
Tel +49 221 256 676
Fax +49 221 256 593
info@galeriecapitain.com
www.galeriecapitain.de

Contact
Gisela Capitain
Regina Fiorito
Nina Kretzschmar

Gallery artists
Maria Brunner
Gillian Carnegie
Günther Förg
Uwe Henneken
Georg Herold
Charline von Heyl
Margarete Jakschik
Rachel Khedoori
Martin Kippenberger
Zoe Leonard
Albert Oehlen
Laura Owens
Jorge Pardo
Stephen Prina
Sam Samore
Monika Sosnowska
Franz West
Christopher Williams
Johannes Wohnseifer
Christopher Wool

carlier |
gebauer

Stand F12
Tel +49 171 857 1158

Holzmarktstrasse 15–18
Bogen 51/52
Berlin 10179
Germany
Tel +49 30 280 8110
Fax +49 30 280 8109
office@carliergebauer.com
www.carliergebauer.com

Contact
Ulrich Gebauer
Marie–Blanche Carlier
Philipp Selzer
Beatrice Dallot

Gallery artists
Ernesto Caivano
Sebastian Diaz Morales
AK Dolven
Michel François
Paul Graham
Hans Hemmert
Marko Lehanka
Julie Mehretu
Aernout Mik
Santu Mofokeng
Jean–Luc Moulène
Paul Pfeiffer
Peter Pommerer
Bojan Sarcevic
Erik Schmidt
Christian Schumann
Thomas Schütte
Fred Tomaselli
Sophie Tottie
Janaina Tschäpe
Luc Tuymans
Mark Wallinger

Galleria
Massimo de
Carlo

Stand E10
Tel +39 02 7000 3987

Via Ventura 5
Milan 20134
Italy
Tel +39 02 7000 3987
Fax +39 02 7492 135
admin@massimodecarlo.it
www.massimodecarlo.it

Contact
Massimo de Carlo
Ludovica Barbieri
Paola Clerico

Gallery artists
Amy Adler
Mario Airò
Haluk Akakçe
John Armleder
Massimo Bartolini
Simone Berti
Maurizio Cattelan
Roberto Cuoghi
Jason Dodge
Jeanne Dunning
Michael Elmgreen &
Ingar Dragset
gelatin
Felix Gonzalez-Torres
Thomas Grünfeld
Carsten Höller
Christian Holstad
Gary Hume
Ian Kiaer
Annika Larsson
Eva Marisaldi
Aernout Mik
Olivier Mosset
Luigi Ontani
Steven Parrino
Diego Perrone
Paola Pivi
Jonathan Pylypchuk
Sam Samore
Gregor Schneider

Tino Sehgal
Jim Shaw
Ettore Spalletti
Rudolf Stingel
Piotr Uklanski
Lawrence Weiner
Franz West
Yan Pei Ming

China Art Objects Galleries

Stand F13
Tel +1 213 613 0384

933 Chung King Road
Los Angeles CA 90012
USA
Tel +1 213 613 0384
Fax +1 213 613 0363
info@chinaartobjects.com
www.chinaartobjects.com

Contact
Steve Hanson
Erica Redling

Gallery artists
Andy Alexander
Walead Beshty
Mason Cooley
Kim Fisher
Morgan Fisher
David Korty
Sean Landers
JP Munro
Ruby Neri
Andy Ouchi
Oliver Payne & Nick Relph
Jonathan Pylypchuk
Eric Wesley
Pae White
T.J. Wilcox

Galería Pepe Cobo

Stand E24
Tel +34 91 319 0683

Fortuny, 39
Madrid 28010
Spain
Tel +34 91 319 0683
Fax +34 91 308 3190
info@pepecobo.com
www.pepecobo.com

Contact
Pepe Cobo

Gallery artists
John Baldessari
Stephan Balkenhol
Joan Brossa
Willie Doherty
Pepe Espaliú
Federico Guzmán
Diango Hernández
Cristina Iglesias
Zoe Leonard
Juan Muñoz
Augustina von Nagel
Gonzalo Puch
MP & MP Rosado
Glen Rubsamen
Julião Sarmento
Ann-Sofi Sidén

James Cohan Gallery

Stand B9
Tel +1 212 714 9500

533 West 26th Street
New York NY 10001
USA
Tel +1 212 714 9500
Fax +1 212 714 9510
info@jamescohan.com
www.jamescohan.com

Contact
Jim Cohan
Elyse Goldberg
Arthur Solway

Gallery artists
Manfredi Beninati
Ingrid Calame
Ian Dawson
Trenton Doyle Hancock
Yun-Fei Ji
Richard Long
Beatriz Milhazes
Ron Mueck
Roxy Paine
Richard Patterson
Hiraki Sawa
Yinka Shonibare
Robert Smithson
Erick Swenson
Tabaimo
Fred Tomaselli
Bill Viola
Wim Wenders

Sadie **Coles** HQ

Stand C10
Tel +44 20 7434 2227

35 Heddon Street
London W1B 4BP
UK
Tel +44 20 7434 2227
Fax +44 20 7434 2228
sadie@sadiecoles.com
www.sadiecoles.com

Contact
Sadie Coles
Pauline Daly

Gallery artists
Carl Andre
Avner Ben-Gal
John Bock
Don Brown
Jeff Burton
John Currin
Angus Fairhurst
Urs Fischer
Jonathan Horowitz
David Korty
Jim Lambie
Sarah Lucas
Hellen van Meene
Victoria Morton
JP Munro
Laura Owens
Simon Periton
Raymond Pettibon
Elizabeth Peyton
Richard Prince
Ugo Rondinone
Wilhelm Sasnal
Gregor Schneider
Daniel Sinsel
Andreas Slominski
Rudolf Stingel
Nicola Tyson
Paloma Varga Weisz
T.J. Wilcox
Andrea Zittel

John **Connelly** Presents

Stand A12
Tel +1 212 337 9563

526 West 26th Street, Suite 1003
New York NY 10001
USA
Tel +1 212 337 9563
Fax +1 212 337 9613
info@johnconnellypresents.com
www.johnconnellypresents.com

Contact
John Connelly
Alexandra Tuttle

Gallery artists
assume vivid astro focus
Marco Boggio Sella
Matthew Brannon
AA Bronson
Kaye Donachie
Kim Fisher
Freeman & Phelan
Kent Henricksen
Scott Hug
Sissel Kardel
Alexander Kwartler
Nick Lowe
Michael Magnan
Andrew Mania
Philippe Perrot
Ara Peterson
Michael Phelan
Justin Samson
Mungo Thomson
Scott Treleaven
Michael Wetzel
Grant Worth

Corvi-Mora

Stand E7
Tel +44 20 7840 9111

1a Kempsford Road
London SE11 4NU
UK
Tel +44 20 7840 9111
Fax +44 20 7840 9112
tcm@corvi-mora.com
www.corvi-mora.com

Contact
Tommaso Corvi-Mora
Tabitha Langton-Lockton

Gallery artists
Kai Althoff
Abel Auer
Brian Calvin
Pierpaolo Campanini
Anne Collier
Andy Collins
Robert Elfgen
Rachel Feinstein
Dee Ferris
Liam Gillick
Richard Hawkins
Roger Hiorns
Jim Isermann
Dorota Jurczak
Aisha Khalid
Armin Krämer
Eva Marisaldi
Jason Meadows
Monique Prieto
Muhammad Imran Qureshi
Andrea Salvino
Glenn Sorensen
Tomoaki Suzuki

Counter Gallery

Stand E20
Tel +44 77 208 7243

44a Charlotte Road
London EC2A 3PD
UK
Tel +44 20 7684 8888
Fax +44 20 7684 8889
jo@countergallery.com
www.countergallery.com

Contact
Carl Freedman
Joanna Stella-Sawicka

Gallery artists
Armando Andrade Tudela
Michael Fullerton
Simon Martin
Gareth McConnell
Rosalind Nashashibi
Peter Peri
Lucy Skaer
Fergal Stapleton

CourtYard Gallery

Stand H13
Tel +86 10 6526 8882

95 Donghuamen Da Jie
Dongcheng District
Beijing 100006
China

CourtYard Gallery Annex
155 Nangao Road
Cao Chang Di Village
Chaoyang District
Beijing 100015
China
courtart@cinet.com.cn
www.courtyard-gallery.com

Contact
Meg Maggio
Jeremy Wingfield

Gallery artists
Aniwar
Cao Fei
Zhang Dali
Song Dong
Weng Fen
Wang Gongxin
Hong Hao
Zhuang Hui
Zhu Jia
Ling Jian
Guo Jin
Li Jin
Yan Lei
Ma Liuming
Luo Brothers
Wang Qingsong
Chen Shaoxiong
Lin Tianmiao
Zhan Wang
Guo Wei
Liu Wei
Chen Wenbo
Chen Wenji
Yang Yong
Song Yongping
Liu Zheng
Qiu Zhijie

CRG Gallery

Stand C23
Tel +1 212 229 2766

535 West 22nd Street
Third Floor
New York NY 10011
USA
Tel +1 212 229 2766
Fax +1 212 229 2788
mail@crggallery.com
www.crggallery.com

Contact
Carla Chammas
Richard Desroche
Glenn McMillan
Glen Baldridge

Gallery artists
Robert Beck
Russell Crotty
Tomory Dodge
Robert Feintuch
Pia Fries
Ori Gersht
Lyle Ashton Harris
Jim Hodges
Siobhan Liddell
Melissa McGill
Kelly McLane
Stephanie Pryor
Sam Reveles
Jeffrey Saldinger
Lisa Sanditz
Sandra Scolnik
Mindy Shapero
Frances Stark

Galerie Chantal **Crousel**

Stand D10
Tel +33 1 42 77 38 87

10 rue Charlot
Paris 75003
France
Tel +33 1 42 77 38 87
Fax +33 1 42 77 59 00
galerie@crousel.com
www.crousel.com

Contact
Chantal Crousel
Niklas Svennung

Gallery artists
Allora & Calzadilla
Darren Almond
Fikret Atay
Tony Cragg
Alberto Garcia-Alix
Fabrice Gygi
Mona Hatoum
Thomas Hirschhorn
Hassan Khan
Jean-Luc Moulène
Melik Ohanian
Gabriel Orozco
Anri Sala
Sean Snyder
Rirkrit Tiravanija

D'Amelio Terras

Stand G14
Tel +1 917 513 2577

525 West 22nd Street
New York NY 10011
USA
Tel +1 212 352 9460
Fax +1 212 352 9464
gallery@damelioterras.com
www.damelioterras.com

Contact
Christopher D'Amelio
Lucien Terras

Gallery artists
Adam Adach
Polly Apfelbaum
Erica Baum
Whitney Bedford
Delia Brown
Tony Feher
Amy Globus
Joanne Greenbaum
John Morris
Rei Naito
Cornelia Parker
Noguchi Rika
Dario Robleto
Karin Sander
Yoshihiro Suda

Sorcha **Dallas**

Stand A14
Tel +44 78 1260 5745

5–9 St Margaret's Place
Glasgow G1 5JY
UK
Tel +44 78 1260 5745
Fax +44 141 553 2662
info@sorchadallas.com
www.sorchadallas.com

Contact
Sorcha Dallas

Gallery artists
Henry Coombes
Kate Davis
Alex Frost
Sophie Macpherson
Alan Michael
Craig Mulholland
Alex Pollard
Gary Rough
Clare Stephenson
Michael Stumpf

Thomas Dane

Stand D23
Tel +44 20 7925 2505

11 Duke Street St James's
London SW1Y 6BN
UK
Tel +44 20 7925 2505
Fax +44 20 7925 2506
info@thomasdane.com
www.thomasdane.com

Contact
Thomas Dane
Martine d'Anglejan-Chatilllon
François Chantala

Gallery artists
Hurvin Anderson
Anya Gallaccio
Stefan Kürten
Michael Landy
Steve McQueen
Albert Oehlen
Paul Pfeiffer

doggerfisher

Stand A10
Tel +44 77 7908 5750

11 Gayfield Square
Edinburgh EH1 3NT
UK
Tel +44 131 558 7110
Fax +44 131 558 7179
mail@doggerfisher.com
www.doggerfisher.com

Contact
Susanna Beaumont
Ruth Beale

Gallery artists
Charles Avery
Claire Barclay
Nathan Coley
Graham Fagen
Moyna Flannigan
Franziska Furter
Ilana Halperin
Louise Hopkins
Janice McNab
Rosalind Nashashibi
Sally Osborn
Jonathan Owen
Lucy Skaer
Hanneline Visnes

Galerie EIGEN + ART Leipzig/Berlin

Stand B17
Tel +49 30 280 6605

Auguststrasse 26
Berlin 10117
Germany
Tel +49 30 280 6605
Fax +49 30 280 6616
berlin@eigen-art.com

Spinnereistrasse 7, Halle 5
Leipzig 04179
Germany
Tel +49 341 960 7886
Fax +49 341 225 4214
leipzig@eigen-art.com
www.eigen-art.com

Contact
Gerd Harry Lybke
Kerstin Wahala
Birte Kleemann
Elke Hannemann

Gallery artists
Akos Birkas
Birgit Brenner
Martin Eder
Tim Eitel
Nina Fischer &
Maroan el Sani
Jörg Herold
Christine Hill
Uwe Kowski
Rémy Markowitsch
Maix Mayer
Carsten Nicolai
Olaf Nicolai
Neo Rauch
Ricarda Roggan
Yehudit Sasportas
David Schnell
Annelies Strba
Matthias Weischer

Foksal Gallery Foundation

Stand C14
Tel +48 504 268 910

Górskiego 1A
Warsaw 00-033
Poland
Tel +48 22 826 5081
Fax +48 22 826 5081
mail@fgf.com.pl
www.fgf.com.pl

Contact
Joanna Mytkowska
Andrzej Przywara

Gallery artists
Paweł Althamer
Cezary Bodzianowski
Piotr Janas
Katarzyna Józefowicz
Edward Krasinski
Robert Kusmirowski
Anna Niesterowicz
Wilhelm Sasnal
Monika Sosnowska
Jakub Julian Ziółkowski
Artur Żmijewski

Galeria Fortes Vilaça

Stand C15
Tel +44 20 7486 2576

Rua Fradique Coutinho 1500
São Paulo SP 05416-001
Brazil
Tel +55 11 3032 7066
Fax +55 11 3097 0384
galería@fortesvilaca.com.br
www.fortesvilaca.com.br

Contact
Cristiana Thompson

Gallery artists
Franz Ackermann
Efrain Almeida
John Bock
Los Carpinteros
Leda Catunda
Gil Heitor Cortesão
Tiago Carneiro da Cunha
José Damasceno
Iran Do Espírito Santo
José Antonio Hernandez-Diez
Alejandra Icaza
Fabian Marcaccio
Beatriz Milhazes
Gerben Mulder
Viz Muniz
Ernesto Neto
Rivane Neuenschwander
Hélio Oiticica &
Neville D'Almeida
Damián Ortega
Mauro Piva
Sara Ramo
Nuno Ramos
Julie Roberts
Julião Sarmento
Valeska Soares
Hiroshi Sugito
Janaina Tschäpe
Adriana Varejão
Erika Verzutti
Luiz Zerbini

Marc Foxx

Stand C18
Tel +44 79 6085 0762

6150 Wilshire Blvd
Los Angeles CA 90048
USA
Tel +1 323 857 5571
Fax +1 323 857 5573
gallery@marcfoxx.com
www.marcfoxx.com

Contact
Marc Foxx
Rodney Hill

Gallery artists
Ryoko Aoki
Cris Brodahl
Brian Calvin
Jay Chung
Anne Collier
Andy Collins
Martin Creed
William Daniels
Stef Driesen
Olafur Eliasson
Vincent Fecteau
Sophie von Hellermann
Roger Hiorns
Jim Hodges
Evan Holloway
Makiko Kudo
Luisa Lambri
Marcin Maciejowski
Jason Meadows
Hellen van Meene
David Musgrave
Philippe Perrot
Alessandro Pessoli
Richard Rezac
Matthew Ronay
Sterling Ruby
Dana Schutz
Hiroshi Sugito
Frances Stark
Karlheinz Weinberger

Stephen **Friedman** Gallery

Stand D11
Tel +44 20 7486 2965

25-28 Old Burlington Street
London W1S 3AN
UK
Tel +44 20 7494 1434
Fax +44 20 7494 1431
info@stephenfriedman.com
www.stephenfriedman.com

Contact
David Hubbard
Kirsten Sampson

Gallery artists
Mamma Andersson
Stephen Balkenhol
Claire Barclay
Robert Beck
Tom Friedman
Kendell Geers
Dryden Goodwin
Mark Grotjahn
Thomas Hirschhorn
Jim Hodges
Corey McCorkle
Paul McDevitt
Beatriz Milhazes
Donald Moffett
Yoshitomo Nara
Rivane Neuenschwander
Catherine Opie
Yinka Shonibare
David Shrigley

Frith Street Gallery

Stand C1
Tel +44 20 7494 1550

59-60 Frith Street
London W1D 3JJ
UK
Tel +44 20 7494 1550
Fax +44 20 7287 3733
info@frithstreetgallery.com
www.frithstreetgallery.com

Contact
Jane Hamlyn
Charlotte Schepke

Gallery artists
Chantal Akerman
Fiona Banner
Massimo Bartolini
Anna Barriball
Dorothy Cross
Tacita Dean
Marlene Dumas
Bernard Frize
Craigie Horsfield
Callum Innes
Jaki Irvine
Cornelia Parker
Giuseppe Penone
John Riddy
Thomas Schütte
Dayanita Singh
Annelies Strba
Bridget Smith
Fiona Tan
Daphne Wright
Juan Uslé

Gagosian Gallery

Stand D9
Tel +44 20 7486 0848

6-24 Britannia Street
London WC1X 9JD
UK
Tel +44 20 7841 9960
Fax +44 20 7841 9961

555 West 24th Street
New York NY 10011
USA
Tel +1 212 741 1111

980 Madison Avenue
New York NY 10021
USA
Tel +1 212 744 2313

456 North Camden Drive
Beverly Hills CA 90210
USA
Tel +1 310 271 9400
info@gagosian.com
www.gagosian.com

Contact
Mollie Dent-Brocklehurst
Millicent Wilner
Stefan Ratibor
Robin Vousden

Gallery artists
Ghada Amer
Richard Artschwager
Georg Baselitz
Cecily Brown
Glenn Brown
Chris Burden
Francesco Clemente
Michael Craig-Martin
John Currin
Dexter Dalwood
Peter Davies
Ellen Gallagher
gelatin
Douglas Gordon
Arshile Gorky

Galerist

Damien Hirst
Sir Howard Hodgkin
Carsten Höller
Mike Kelley
Anselm Kiefer
Martin Kippenberger
Willem de Kooning
Jeff Koons
Vera Lutter
Walter de Maria
Ed Ruscha
Jenny Saville
Richard Serra
Elisa Sighicelli
David Smith
Hiroshi Sugimoto
Philip Taaffe
Mark Tansey
Robert Therrien
Cy Twombly
Andy Warhol
Franz West
Rachel Whiteread
Richard Wright
Elyn Zimmerman

Stand G18
Tel +90 532 356 8297

Istiklal Cad. Misir Apt. 311/4
Beyoglu/Istanbul 34340
Turkey
Tel +90 212 244 8230
Fax +90 212 244 8229
info@galerist.com.tr
www.galerist.com.tr

Contact
Murat Pilevneli
Ebru Algim
Defne Katherina Mizanoglu
Sedat Oztürk

Gallery artists
Haluk Akakçe
Taner Ceylan
Hussein Chalayan
Ayse Erkmen
Leyla Gediz
Yesim Akdeniz Graf
Seza Paker
Murat Sahinler
Erinc Seymen
Evren Tekinoktay
Elif Uras

Klemens Gasser & Tanja Grunert, Inc.

Stand C21
Tel +44 20 7935 2569

524 West 19th Street
New York NY 10011
USA
Tel +1 212 807 9494
Fax +1 212 807 6594
info@gassergrunert.net

Contact
Klemens Gasser
Tanja Grunert
Ashley Ludwig
Tim Hawkinson

Gallery artists
Eija-Liisa Ahtila
Knut Åsdam
Robert Barry
Benjamin Cottam
Ann Craven
Bart Domburg
Jitka Hanslová
Gustav Kluge
Peter Land
Olivier Mosset
Elizabeth Neel
Chloe Piene
Will Ryman
Smith/Stewart
Ena Swansea

Gladstone Gallery

Stand C6
Tel +44 20 7935 1676

515 West 24th Street
New York NY 10011
USA
Tel +1 212 206 9300
Fax +1 212 206 9301
info@gladstonegallery.com
www.gladstonegallery.com

Contact
Barbara Gladstone
Rosalie Benitez
Maxime Falkenstein

Gallery artists
Vito Acconci
Miroslaw Balka
Stephan Balkenhol
Matthew Barney
Robert Bechtle
Bruce Conner
Jan Dibbets
Carroll Dunham
Luciano Fabro
Gary Hill
Thomas Hirschhorn
Anish Kapoor
Sharon Lockhart
Sarah Lucas
Mario Merz
Marisa Merz
Dave Muller
Jean-Luc Mylayne
Shirin Neshat
Catherine Opie
Walter Pichler
Lari Pittman
Magnus von Plessen
Richard Prince
Gregor Schneider
Rosemarie Trockel
Paloma Varga Weisz

Marian Goodman Gallery

Stand F9
Tel +44 20 7486 2559

24 West 57th Street
New York NY 10019
USA
Tel +1 212 977 7160
Fax +1 212 581 5187

79 rue du Temple
Paris 75003
France
Tel +33 1 48 04 70 52
Fax +33 1 40 27 81 37
goodman@mariangoodman.
com
www.mariangoodman.com

Contact
Jeannie Freilich
Agnes Fierobe
Andrew Richards
Rose Lord

Gallery artists
Eija-Liisa Ahtila
Chantal Akerman
Giovanni Anselmo
John Baldessari
Lothar Baumgarten
Dara Birnbaum
Christian Boltanski
Marcel Broodthaers
Daniel Buren
Maurizio Cattelan
James Coleman
Tony Cragg
Thierry de Cordier
Richard Deacon
Tacita Dean
Rineke Dijkstra
David Goldblatt
Dan Graham
Pierre Huyghe
Cristina Iglesias
William Kentridge
Steve McQueen
Marisa Merz
Annette Messager
Juan Muñoz
Maria Nordman
Gabriel Orozco
Giulio Paolini
Giuseppe Penone
Gerhard Richter
Anri Sala
Thomas Schütte
Thomas Struth
Niele Toroni
Jeff Wall
Lawrence Weiner
Francesco Woodman
Yang Fudong

Greene
Naftali

Stand G5
Tel +1 917 374 4745

516 West 26th Street, 8th Floor
New York NY 10001
USA
Tel +1 212 463 7770
Fax +1 212 463 0890
info@greenenaftaligallery.com
www.greenenaftaligallery.com

Contact
Carol Greene
Kathleen Eagan
Ben Carlson

Gallery artists
Julie Becker
Paul Chan
Jim Drain
Harun Farocki
Guyton\Walker
Rachel Harrison
Sophie von Hellermann
Jacqueline Humphries
Joachim Koester
David Korty
Michael Krebber
Mark Manders
Daniel Pflumm
Blake Rayne
Daniela Rossell
Amelie von Wulffen

greengrassi

Stand C4
Tel +44 20 7840 9101

1a Kempsford Road
London SE11 4NU
UK
Tel +44 20 7840 9101
Fax +44 20 7840 9102
info@greengrassi.com
www.greengrassi.com

Contact
Cornelia Grassi
Holly Walsh
Megan O'Shea

Gallery artists
Tomma Abts
Stefano Arienti
Jennifer Bornstein
Henry Coleman
Roe Ethridge
Gretchen Faust
Vincent Fecteau
Giuseppe Gabellone
Joanne Greenbaum
Sean Landers
Simon Ling
Margherita Manzelli
Aleksandra Mir
David Musgrave
Kristin Oppenheim
Silke Otto-Knapp
Alessandro Pessoli
Lari Pittman
Charles Ray
Karin Ruggaber
Allen Ruppersberg
Anne Ryan
Frances Stark
Jennifer Steinkamp
Pae White
Lisa Yuskavage

Galerie Karin
Guenther
Nina
Borgmann

Stand B7
Tel +49 170 556 6994

Admiralitätstrasse 71
Hamburg 20459
Germany
Tel +49 40 3750 3450
Fax +49 40 3750 3451
k.guenther.galerie@gmx.de

Contact
Karin Guenther
Nina Borgmann

Gallery artists
Markus Amm
Henning Bohl
Friederike Clever
Jeanne Faust
Ellen Gronemeyer
Michael Hakimi
Kerstin Kartscher
Janice Kerbel
Stefan Kern
Nina Könnemann
Silke Otto-Knapp
Gunter Reski
Allen Ruppersberg
Markus Schinwald
Stefan Thater

Studio **Guenzani**

Stand E13
Tel +39 02 2940 9251

Via Eustachi 10
Milan 20129
Italy
Tel +39 02 2940 9251
Fax +39 02 2940 8080
info@studioguenzani.it

Contact
Claudio Guenzani
Luciana Rappo

Gallery artists
Nobuyoshi Araki
Stefano Arienti
Gabriele Basilico
Ginny Bishton
Jennifer Bornstein
Giuseppe Gabellone
Jim Isermann
Kcho
Yayoi Kusama
Luisa Lambri
Sean Landers
Lisa Lapinski
Louise Lawler
Margherita Manzelli
Paul McCharty
Jason Meadows
Yasumasa Morimura
Catherine Opie
Laura Owens
Alessandro Pessoli
Lari Pittman
Stephanie Pryor
Jorge Queiroz
Allen Ruppersberg
Salvatore Scarpitta
Cindy Sherman
Dayanita Singh
Hiroshi Sugimoto
Patrick Tuttofuoco
Marcella Vanzo
Lisa Yuskavage

Galería Enrique **Guerrero**

Stand B10
Tel +52 55 5280 2941

Horacio 1549
Mexico D.F. 11540
Mexico
Tel +52 55 5280 2941
Fax +52 55 5280 3283
info@galeríaenriqueguerrero.
com
www.arte-mexico.com/
eguerrero

Contact
Enrique Guerrero
Elizabeth Diaz

Gallery artists
Olga Adelantado
Manuel Cerda
Jose Dávila
Alejandra Echeverria
Hector Falcon
Enrique Jezik
Guillermo Kuitca
Miguel Angel Madrigal
Teresa Margolles
Yoshua Okon
Pedro Reyes
Luis Miguel Suro

Jack **Hanley** Gallery

Stand E11
Tel +1 415 522 1623

389 & 395 Valencia Street
San Francisco CA 94103
USA
Tel +1 415 522 1623
Fax +1 415 522 1631
info@jackhanley.com

945 Sun Mun Way
Los Angeles CA 90012
USA
Tel +1 213 626 0403
jhgla@jackhanley.com
www.jackhanley.com

Contact
Jack Hanley
Liz Mulholland
Ava Jancar
Lucy Spriggs

Gallery artists
Anne Collier
Simon Evans
Harrell Fletcher
Christopher Garrett
Joseph Grigely
Jo Jackson
Xylor Jane
Piotr Janas
Chris Johanson
Jim Lambie
Euan Macdonald
Alicia McCarthy
Keegan McHargue
Mathieu Mercier
Jonathon Monk
Muntean/Rosenblum
Scott Myles
Shaun O'Dell
Bill Owens
Will Rogan
Michael Sailstorfer
Peter Saul
Leslie Shows
Hayley Tompkins
Chris Ware
Erwin Wurm

Haunch of Venison

Stand F16
Tel +44 20 7486 1798

6 Haunch of Venison Yard
off Brook Street
London W1K 5ES
UK
Tel +44 20 7495 5050
Fax +44 20 7495 4050
london@haunchofvenison.com

Lessingstrasse 5
Zurich 8002
Switzerland
Tel + 41 43 422 8888
Fax +41 43 422 8889
zurich@haunchofvenison.com
www.haunchofvenison.com

Contact
Harry Blain
Pilar Corrias
Graham Southern
Adrian Sutton

Gallery artists
Mark Alexander
Skyler Brickley
Pedro Cabrita Reis
Ergin Cavusoglu
Nathan Coley
Thomas Joshua Cooper
Dan Flavin
Bill Fontana
Anton Henning
Ed & Nancy Kienholz
Richard Long
Ian Monroe
Thomas Nozkowski
Robert Overby
Jorge Pardo
Tobias Rehberger
Robert Ryman
Diana Thater
Patrick Tuttofuoco
Keith Tyson
Bill Viola
Wim Wenders

Hauser & Wirth Zürich London

Stand C9
Tel +41 14 468 050

Limmatstrasse 270
Zurich 8031
Switzerland
Tel +41 44 446 8050
Fax +41 44 446 8055
zurich@hauserwirth.com

196A Piccadilly
London W1J 9DY
UK
Tel +44 20 7287 2300
Fax +44 20 7287 6600
london@hauserwirth.com
www.hauserwirth.com

Contact
Iwan Wirth
Marc Payot
Gregor Muir
Florian Berktold

Gallery artists
Louise Bourgeois
Berlinde De Bruyckere
Christoph Büchel
David Claerbout
Martin Creed
Ellen Gallagher
Isa Genzken
Dan Graham
Rodney Graham
David Hammons
Mary Heilmann
Eva Hesse
Roni Horn
Richard Jackson
Allan Kaprow
On Kawara
Rachel Khedoori
Guillermo Kuitca
Maria Lassnig

Lee Lozano
Paul McCarthy
John McCracken
Caro Niederer
Raymond Pettibon
Michael Raedecker
Jason Rhoades
Pipilotti Rist
Anri Sala
Wilhelm Sasnal
Christoph Schlingensief
Roman Signer
André Thomkins
David Zink Yi

Herald St

Stand A8
Tel +44 20 7168 2566

2 Herald Street
London E2 6JT
UK
Tel +44 20 7168 2566
Fax +44 20 7168 2566
mail@heraldst.com
www.heraldst.com

Contact
Nicky Verber
Ash Lange

Gallery artists
Markus Amm
Alex Bircken
Pablo Bronstein
Lali Chetwynd
Scott King
Cary Kwok
Christina Mackie
Djordje Ozbolt
Oliver Payne & Nick Relph
Donald Urquhart
Nicole Wermers

Hotel

Stand H5
Tel +44 79 6678 2040

53A Old Bethnal Green Road
London E2 6QA
UK
Tel +44 20 7729 3122
email@generalhotel.org
www.generalhotel.org

Contact
Darren Flook
Christabel Stewart

Gallery artists
Michael Bauer
Carol Bove
Carter
Steven Claydon
Luke Dowd
Richard Kern
Alan Michael
David Noonan
Peter Saville
Alexis Marguerite Teplin

Taka Ishii Gallery

Stand F4
Tel +81 80 3084 3358

1-31-6 1F Shinkawa Chuo-Ku
Tokyo 104-0033
Japan
Tel +81 3 5542 3615
Fax +01 3 3552 3363
tig@takaishiigallery.com
www.takaishiigallery.com

Contact
Takayuki Ishii
Jeffrey Ian Rosen
Nahoko Yamaguchi
Elisa Uematsu

Gallery artists
Amy Adler
Doug Aitken
Nobuyoshi Araki
Slater Bradley
Jeff Burton
Thomas Demand
Jason Dodge
Michael Elmgreen & Ingar Dragset
Kevin Hanley
Naoya Hatakeyama
Tomoki Imai
Naoto Kawahara
Yuki Kimura
Sean Landers
Daido Moriyama
Kyoko Murase
Jorge Pardo
Erik Parker
Jack Pierson
Hiroe Saeki
Dean Sameshima
Kei Takemura
Kara Walker
Christopher Wool

Jablonka
Galerie

Stand C16
Tel +44 20 7224 0972

Hahnenstrasse 37
Cologne 50667
Germany
Tel +49 221 240 3426
Fax +49 221 240 8132
info@jablonkagalerie.com
www.jablonkagalerie.com

Contact
Rafael Jablonka
Julia Garnatz
Birgit Müller
Christian Schmidt

Gallery artists
Nobuyoshi Araki
Miquel Barceló
Francesco Clemente
Eric Fischl
Roni Horn
Alex Katz
Mike Kelley
Matthias Lahme
Sherrie Levine
Richard Prince
Andreas Slominski
Philip Taaffe
Andy Warhol

Jablonka
Lühn

Stand C16
Tel +44 20 7224 0972

Lindenstrasse 19
Cologne 50674
Germany
Tel +49 221 397 6900
Fax +49 221 397 6907
ll@jablonkaluehn.com
www.jablonkaluehn.com

Contact
Linn Lühn
Julia Macke
Uta Ruhkamp

Gallery artists
Francesco Gennari
Sophie von Hellermann
Alexej Koschkarow
Matthias Lahme
Sebastian Ludwig
Christoph Schellberg
Daniela Steinfeld
Constantin Wallhäuser
Kevin Zucker

Alison
Jacques
Gallery

Stand D17
Tel +44 77 9865 3428

4 Clifford Street
London W1X 1RB
UK
Tel +44 20 7287 7675
Fax +44 20 7287 7674
info@alisonjacquesgallery.com
www.alisonjacquesgallery.com

Contact
Alison Jacques
Laura Lord
Luke Morgan

Gallery artists
Uta Barth
Christian Flamm
Ian Kiaer
Graham Little
Robert Mapplethorpe
Paul Morrison
Jack Pierson
Jonathan Pylypchuk
Alessandro Raho
Sam Salisbury
Catherine Yass
Thomas Zipp

Galerie
Martin
Janda

Stand A13
Tel +43 664 233 5429

Eschenbachgasse 11
Vienna 1010
Austria
Tel +43 1 585 7371
Fax +43 1 585 7372
galerie@martinjanda.at
www.martinjanda.at

Contact
Martin Janda
Elisabeth Konrath

Gallery artists
Martin Arnold
Manon de Boer
Adriana Czernin
Milena Dragicevic
Werner Feiersinger
Giuseppe Gabellone
Asta Gröting
Christine & Irene Hohenbüchler
Carsten Höller
Jun Yang
Raoul de Keyser
Jakob Kolding
Raimund Märzinger
Rupprecht Matthies
Gregor Neuerer
Roman Ondák
Peter Pommerer
Allen Ruppersberg
Joe Scanlan
Lara Schnitger
ManfreDu Schu
Andreas Schulze
Ene-Liis Semper
Roman Signer
Xavier Veilhan
Maja Vukoje
Corinne Wasmuht
Lois & Franziska Weinberger
Gregor Zivic

Johnen +
Schöttle

Stand D16
Tel +49 177 686 5970

Maria-Hilf-Strasse 17
Cologne 50677
Germany
Tel +49 221 310 270
Fax +49 221 310 2727
mail@johnen-schoettle.de
www.johnen-schoettle.de

Schillingstrasse 31
10179 Berlin
Tel +49 30 2758 3030
Fax +49 30 2758 3050
mail@johnengalerie.de
www.johnengalerie.de

Amalienstrasse 41
Munich 80799
Germany
Tel +49 89 33 3686
Fax +49 89 34 2296

Contact
Jörg Johnen
Markus Lüttgen

Gallery artists
Janis Avotins
Stephan Balkenhol
Armin Boehm
Martin Boyce
Michal Budny
Rafal Bujnowski
David Claerbout
James Coleman
Martin Creed
Slawomir Elsner
Elger Esser
Hans-Peter Feldmann
Katharina Fritsch
Dan Graham
Rodney Graham
Stefan Hablützel
Eberhard Havekost
Candida Höfer
Olaf Holzapfel
Martin Honert
Robert Kusmirowski
Marko Lulic
Jan Merta
Yoshitomo Nara
Frank Nitsche
Michael van Ofen
Richard Phillips
Zbigniew Rogalski
Thomas Ruff
Anri Sala
Wilhelm Sasnal
Tino Sehgal
Florian Süssmayr
Jeff Wall

Annely **Juda** Fine Art

Stand F1
Tel +44 20 7629 7578

23 Dering Street
London W1S 1AW
UK
Tel +44 20 7629 7578
Fax +44 20 7491 2139
ajfa@annelyjudafineart.co.uk
www.annelyjudafineart.co.uk

Contact
David Juda

Gallery artists
Roger Ackling
Anthony Caro
Alan Charlton
Eduardo Chillida
Christo & Jeanne-Claude
Prunella Clough
Nathan Cohen
Gloria Friedmann
Katsura Funakoshi
Alan Green
Nigel Hall
Werner Haypeter
David Hockney
Peter Kalkhof
Tadashi Kawamata
Leon Kossoff
Darren Lago
Edwina Leapman
Kenneth & Mary Martin
Michael Michaeledes
David Nash
Alan Reynolds
Yuko Shiraishi
Suzanne Treister
Graham Williams

Iris **Kadel**

Stand A9
Tel +49 179 115 1268

Viktoriastrasse 3–5
Karlsruhe 76133
Germany
Tel +49 721 909 16 72
Fax +49 721 467 28 00
info@iris-kadel.de
www.iris-kadel.de

Contact
Iris Kadel

Gallery artists
Matthias Bitzer
Shannon Bool
Katja Davar
Henry VIII's Wives
Myriam Holme
Skafte Kuhn
Olaf Quantius
Mathilde Rosier
Karoline Walther

Georg **Kargl**

Stand G9
Tel +43 676 624 5490

Schleifmühlgasse 5
Vienna 1040
Austria
Tel +43 1 585 4199
Fax +43 1 585 41999
georg.kargl@sil.at

Contact
Georg Kargl
Evelyn Appinger
Pilar Alcala
Fiona Liewehr

Gallery artists
Carol Bove
Clegg & Guttmann
Martin Dammann
Mark Dion
Angus Fairhurst
Herbert Hinteregger
Chris Johanson
Elke Krystufek
Thomas Locher
Inés Lombardi
Matt Mullican
Muntean/Rosenblum
Gerwald Rockenschaub
Lisa Ruyter
Markus Schinwald
Rudolf Stingel
John Waters
Ina Weber
Cerith Wyn Evans

Galleri Magnus **Karlsson**

Stand B2
Tel +46 708 106 906

Fredsgatan 12
111 52 Stockholm
Sweden
Tel +46 8 660 43 53
m.karlsson@telia.com
www.gallerimagnuskarlsson.com

Contact
Magnus Karlsson

Gallery artists
Mamma Andersson
Roger Andersson
Lars Arrhenius
Bianca Maria Barmen
Mette Björnberg
Marcel Dzama
Niklas Eneblom
Carl Hammoud
Tommy Hilding
Kent Iwemyr
Richard Johansson
Johanna Karlsson
Klara Kristalova
Petra Lindholm
Ulf Lundin
Jockum Nordström
Susanne Simonson
Per Wennerstrand

Paul **Kasmin** Gallery

Stand G12
Tel +1 212 563 4474

293 Tenth Avenue
New York NY 10001
USA
Tel +1 212 563 4474
Fax +1 212 563 4494

511 West 27th Street
New York, NY 10001
USA
Tel + 1 212 563 4474
Fax +1 212 563 4494
inquiry@paulkasmingallery.com
www.paulkasmingallery.com

Contact
Paul Kasmin
Clara Ha

Gallery artists
Xu Bing
Christopher Bucklow
Leo De Goede
Susan Derges
Angus Fairhurst
Barry Flanagan
Caio Fonseca
Walton Ford
Ron Galella
David Hockney
Robert Indiana
Mark Innerst
Morris Louis
Santi Moix
James Nares
Elliott Puckette
Aaron Rose
Nancy Rubins
Kenny Scharf
Frank Stella
Andy Warhol
Joe Zucker

galleria francesca **kaufmann**

Stand C19
Tel +39 33 5627 1373

Via dell'Orso 16
Milan 20121
Italy
Tel +39 02 7209 4331
Fax +39 02 7209 6873
info@galleriafrancesca
kaufmann.com
www.galleriafrancesca
kaufmann.com

Contact
Francesca Kaufmann
Alessio delli Castelli
Daphné Valroff
Emanuela Mazzonis

Gallery artists
Candice Breitz
Pierpaolo Campanini
Gianni Caravaggio
Maggie Cardelùs
Naomi Fisher
Brad Kahlhamer
Helen Mirra
Kori Newkirk
Kelly Nipper
Tam Ochiai
Yoshua Okon
Adrian Paci
Eva Rothschild
Roberta Silva
Lily van der Stokker
Billy Sullivan
Pae White

Kerlin
Gallery

Stand E14
Tel +35 38 7988 0362

Anne's Lane
South Anne Street
Dublin D2
Ireland
Tel +353 1 670 90 93
Fax +353 1 670 90 96
gallery@kerlin.ie
www.kerlin.ie

Contact
David Fitzgerald
Darragh Hogan
John Kennedy
Brid McCarthy

Gallery artists
Phillip Allen
Chung Eun-Mo
Phil Collins
Barrie Cooke
Dorothy Cross
Willie Doherty
Felim Egan
Mark Francis
Maureen Gallace
David Godbold
Richard Gorman
Siobhán Hapaska
Callum Innes
Jaki Irvine
Merlin James
Elizabeth Magill
Brian Maguire
Stephen McKenna
William McKeown
Fionnuala Ní Chiosáin
Kathy Prendergast
Sean Scully
Paul Seawright
Seán Shanahan
Tony Swain
Paul Winstanley

Anton **Kern**
Gallery

Stand D6
Tel +1 212 367 9663

532 West 20th Street
New York NY 10011
USA
Tel +1 212 367 9663
Fax +1 212 367 8135
info@antonkerngallery.com
www.antonkerngallery.com

Contact
Anton Kern
Christoph Gerozissis
Michael Clifton

Gallery artists
Kai Althoff
Ellen Berkenblit
John Bock
Brian Calvin
Saul Fletcher
Mark Grotjahn
Bendix Harms
Eberhard Havekost
Lothar Hempel
Jörg Immendorff
Sergej Jensen
Sarah Jones
Michael Joo
Edward Krasinski
Jim Lambie
Marepe
Dan McCarthy
Matthew Monahan
Marcel Odenbach
Manfred Pernice
Alessandro Pessoli
Wilhelm Sasnal
Lara Schnitger
David Shrigley

Peter
Kilchmann

Stand C22
Tel +41 79 205 5286

Limmatstrasse 270
Zurich 8005
Switzerland
Tel +41 44 440 3931
Fax +41 44 440 3932
info@peterkilchmann.com
www.peterkilchmann.com

Contact
Peter Kilchmann
Claudia Friedli
Alessandro Pascarella
Cynthia Krell

Gallery artists
Rita Ackermann
Francis Alÿs
Maja Bajevic
John Coplans
Willie Doherty
Zilla Leutenegger
Jorge Macchi
Teresa Margolles
Claudia & Julia Müller
Adrian Paci
Santiago Sierra
Melanie Smith
Costa Vece
Andro Wekua
Artur Zmijewski

Nicole
Klagsbrun
Gallery

Stand G17
Tel +1 212 243 3335

526 West 26th Street, No. 213
New York 10001
USA
Tel +1 212 243 3335
Fax +1 212 243 1059
gallery@nicoleklagsbrun.com
www.nicoleklagsbrun.com

Contact
Nicole Klagsbrun
Lisa Cooley
Carolyn Ramo

Gallery artists
Hans Op De Beeck
Sheila Berger
Jonathan Callan
Beth Campbell
Nancy Davenport
Shoshana Dentz
Robert Devriendt
Jacob El Hanani
Dennis Hollingsworth
Adam McEwen
John Pilson
Elaine Reichek
Mika Rottenberg
Dylan Stone
Hiroshi Sugito
Billy Sullivan

Klosterfelde

Stand A7
Tel +49 30 283 5305

Zimmerstrasse 90/91
Berlin 10117
Germany
Tel +49 30 283 53 05
Fax +49 30 283 53 06
office@klosterfelde.de
www.klosterfelde.de

Contact
Martin Klosterfelde
Lena Kiessler
Bettina Klein

Gallery artists
Nader Ahriman
Matthew Antezzo
John Bock
Tobias Buche
Hanne Darboven
Michael Elmgreen &
Ingar Dragset
Stefan Hirsig
Christian Jankowski
Edward Krasinski
Ulrike Kuschel
Peter Land
Armin Linke
Jonas Lipps
Matt Mullican
Rivane Neuenschwander
Dan Peterman
Kirsten Pieroth
Steven Pippin
Michael Snow
Lily van der Stokker
Vibeke Tandberg

Leo Koenig
Inc.

Stand E25
Tel +1 212 334 9255

545 West 23rd Street
New York NY 10011
USA
Tel +1 212 334 9255
Fax +1 212 334 9304
www.leokoenig@hotmail.com
www.leokoenig.com

Contact
Leo Koenig
Elizabeth Balogh
Kai Heinze
Shella Robinson

Gallery artists
Aidas Bareikas
Norbert Bisky
Kristin Calabrese
Nicole Eisenman
Justin Faunce
gelatin
Torben Giehler
Brandon Lattu
Tony Matelli
Jonathan Meese
Frank Nitsche
Erik Parker
Alexis Rockman
Les Rogers
Tom Sanford
Bill Saylor
David Scher
Christian Schumann
Kelli Williams

Johann
König

Stand D2
Tel +49 173 617 8740

Weydinger Strasse 10
Berlin 10178
Germany
Tel +49 30 3088 2688
Fax +49 30 3088 2690
info@johannkoenig.de
www.johannkoenig.de

Contact
Kirsa Geiser
Johann König
Timo Kappeller

Gallery artists
Micol Assaël
Tue Greenfort
Jeppe Hein
Michaela Meise
Natascha Sadr Haghighian
Johannes Wohnseifer
David Zink Yi
Andreas Zybach

Tomio
Koyama
Gallery

Stand B6
Tel +81 3 6222 1006

Shinkawa 1-31-6-1F Chuo-ku
Tokyo 104-0033
Japan
Tel +81 3 6222 1006
Fax +81 3 3551 2615
info@tomiokoyamagallery.com
www.tomiokoyamagallery.com

Contact
Tomio Koyama
Tomoko Omori

Gallery artists
Masako Ando
Benjamin Butler
Gianni Caravaggio
Jeremy Dickinson
Jeanne Dunning
Sam Durant
Tom Friedman
Atsushi Fukui
Rieko Hidaka
Satoshi Hirose
Tamami Hitsuda
Dennis Hollingsworth
Mika Kato
Hideaki Kawashima
Naoki Koide
Makiko Kudo
Masahiko Kuwahara
Toru Kuwakubo
Sharon Lockhart
Mitsue Makitani
Paul McCarthy
Shintaro Miyake
Takashi Murakami
Mr.
Yoshitomo Nara
Mika Ninagawa
Tam Ochiai
Jonathan Pylypchuk

Tom Sachs
Yoshie Sakai
Hiroshi Sugito
Ricky Swallow
Atsuko Tanaka
Vibeke Tandberg
Mamoru Tsukada
Richard Tuttle
John Wesley
Liu Ye
Keisuke Yamamoto

Gallery Koyanagi

Stand E6
Tel +81 33 561 1896

8F 1-7-5, Ginza Chou-Ku
Tokyo 104-0061
Japan
Tel +81 3 3561 1896
Fax +81 3 3563 3236
mail@gallerykoyanagi.com

Contact
Atsuko Koyanagi
Kaori Hashiguchi
Chie Fukasawa

Gallery artists
Sophie Calle
Janet Cardiff
Ólafur Eliasson
Dominique Gonzalez-Foerster
Antony Gormley
Hanayo
Federico Herrero
Kengo Kito
Luisa Lambri
Christian Marclay
Kae Masuda
Hellen van Meene
Mariko Mori
Rei Naito
Tetsuya Nakamura
Walter Niedermayr
Noguchi Rika
Yuri Ogawa
Thomas Ruff
Hedi Slimane
Yoshihiro Suda
Hiroshi Sugimoto
Tabaimo

Andrew Kreps Gallery

Stand B14
Tel +1 212 741 8849

516A West 20th Street
New York NY 10011
USA
Tel +1 212 741 8849
Fax +1 212 741 8163
contact@andrewkreps.com
www.andrewkreps.com

Contact
Andrew Kreps
Stephanie Jeanroy
Ezra Rubin

Gallery artists
Ricci Albenda
Daniel Bozhkov
Juan Cespedes
Peter Coffin
Meredith Danluck
Liz Deschenes
Roe Ethridge
Jonah Freeman
Jamie Isenstein
Cary Leibowitz
Jan Mancuska
Robert Melee
Ruth Root
Lawrence Seward
Cheyney Thompson
Hayley Tompkins
Klaus Weber

Galerie Krinzinger

Stand F15
Tel +43 676 324 8385

Seilerstätte 16
Vienna 1010
Austria
Tel +43 1 513 30 06
Fax +43 1 513 30 06 33

Krinzinger Projekte
Schottenfeldgasse 45
Vienna 1070
Austria
Tel +43 1 512 81 42
galeriekrinzinger@chello.at
www.galerie-krinzinger.at

Contact
Ursula Krinzinger
Thomas Krinzinger

Gallery artists
Siegfried Anzinger
Chris Burden
Günter Brus
Angela de la Cruz
Dubossarsky & Vinogradov
Angelika Krinzinger
Oleg Kulik
Ulrike Lienbacher
Atelier van Lieshout
Erik van Lieshout
Jonathan Meese
Bjarne Melgaard
Shintaro Miyake
Alois Mosbacher
Otto Muehl
Hermann Nitsch
Sigmar Polke
Werner Reiterer
Eva Schlegel
Rudolf Schwarzkogler
Frank Thiel
Gavin Turk
Martin Walde
Erwin Wurm

Galerie **Krobath** Wimmer

Stand H7
Tel +43 676 566 8644

Eschenbachgasse 9
Vienna 1010
Austria
Tel +43 1 585 7470
Fax +43 1 585 7472
galerie@krobathwimmer.at
www.krobathwimmer.at

Contact
Helga Krobath
Barbara Wimmer

Gallery artists
Thomas Baumann
Monica Bonvicini
Hannah Dougherty
Judith Eisler
Martin Eiter
Maria Hahnenkamp
Isabell Heimerdinger
Brigitte Kowanz
Robert Lucander
Dorit Margreiter
Anna Meyer
Julian Opie
Fritz Panzer
Florian Pumhösl
Ugo Rondinone
Esther Stocker
Octavian Trauttmansdorff
Otto Zitko

kurimanzutto

Stand B11
Tel +52 55 5286 3059

Mazatlan 5 Depto.
T-6 Col. Condesa
Mexico D.F. 06140
Mexico
Tel +52 55 5286 3059
Fax +52 55 5256 2408
info@kurimanzutto.com
www.kurimanzutto.com

Contact
Monica Manzutto
Jose Kuri

Gallery artists
Eduardo Abaroa
Carlos Amorales
Miguel Calderón
Abraham Cruzvillegas
Minerva Cuevas
Daniel Guzman
Jonathan Hernandez
Gabriel Kuri
Dr Lakra
Enrique Metinides
Gabriel Orozco
Damian Ortega
Fernando Ortega
Luis Felipe Ortega
Monika Sosnowska
Sofia Taboas
Rirkrit Tiravanija

Yvon **Lambert**

Stand F6
Tel +33 1 42 71 09 33

564 West 25th Street
New York NY 10001
USA
Tel +1 212 242 3611
Fax +1 212 242 3920
newyork@yvon-lambert.com

108 rue Vieille du Temple
Paris 75003
France
Tel +33 1 42 71 09 33
Fax +33 1 42 71 87 47
paris@yvonlambert.com
www.yvon-lambert.com

Contact
Yvon Lambert
Olivier Belot
Denis Gaudel
Patricia Martin

Gallery artists
Francis Alÿs
Carlos Amorales
Alice Anderson
Carl Andre
Miquel Barceló
Robert Barry
Slater Bradley
Pavel Braila
Berlinde de Bruyckere
Stanley Brouwn
Mircea Cantor
David Claerbout
Spencer Finch
Anna Gaskell
Nan Goldin
Douglas Gordon
Jeppe Hein
Jenny Holzer
Roni Horn
Jonathan Horowitz
Koo Jeong-A
Joan Jonas
Isaac Julien
On Kawara
Anselm Kiefer

Barbara Kruger
Thierry Kuntzel
Matthieu Laurette
Bertrand Lavier
Louise Lawler
Zoe Leonard
Claude Lévêque
Sol LeWitt
Glenn Ligon
Christian Marclay
Jonathan Monk
Ernesto Neto
Melik Ohanian
Tsuyoshi Ozawa
Guilio Paolini
Adam Pendleton
Pedro Reyes
Charles Sandison
Andres Serrano
David Shrigley
Vibeke Tandberg
Niele Toroni
Richard Tuttle
Cy Twombly
Salla Tykkä
Lawrence Weiner
Ian Wilson
Johannes Wohnseifer
Cerith Wyn Evans
Sislej Xhafa

Galerie Gebr. Lehmann

Stand G10
Tel +49 17 3371 9710

Görlitzer Strasse 16
Dresden 01099
Germany
Tel +49 351 801 1783
Fax +49 351 801 4908
info@galerie-gebr-lehmann.de
www.galerie-gebr-lehmann.de

Contact
Frank Lehmann
Ralf Lehmann
Karola Matschke
Grit Dora von Zeschau

Gallery artists
Tatjana Doll
Markus Draper
Slawomir Elsner
Eberhard Havekost
Olaf Holzapfel
Thoralf Knobloch
Frank Nitsche
Suse Weber

Lehmann Maupin

Stand F18
Tel +44 20 7224 1869

540 West 26th Street
New York NY 10001
USA
Tel +1 212 255 2923
Fax +1 212 255 2924
info@lehmannmaupin.com
www.lehmannmaupin.com

Contact
David Maupin
Rachel Lehmann
Jan Endlich
Courtney Plummer

Gallery artists
Stefano Arienti
Kutlug Ataman
Pedro Barbeito
Ross Bleckner
Marie Josè Burki
Casey Cook
Bryan Crockett
Tracey Emin
Teresita Fernández
Anya Gallaccio
Gilbert & George
Shirazeh Houshiary
Julian LaVerdiere
Jun Nguyen-Hatsushiba
Tony Oursler
Jennifer Steinkamp
Do-Ho Suh
Juergen Teller
Adriana Varejão
Suling Wang

Lisson
Gallery

Stand D8
Tel +44 20 7724 2739

52–54 Bell Street
London NW1 5DA
UK
Tel +44 20 7724 2739
Fax +44 20 7724 7124

29 Bell Street
London NW1 5BY
UK
Tel +44 20 7535 7350
Tel +44 20 7723 5513
contact@lisson.co.uk
www.lisson.co.uk

Contact
Nicholas Logsdail
Elly Ketsea
Lisa Rosendahl
Clare Coombes

Gallery artists
Allora & Calzadilla
Francis Alÿs
Art & Language
Pierre Bismuth
Christine Borland
Roderick Buchanan
James Casebere
Tony Cragg
Angela de la Cruz
Grenville Davey
Richard Deacon
Spencer Finch
Ceal Floyer
Douglas Gordon
Rodney Graham
Dan Graham
Graham Gussin
Mark Hosking
Shirazeh Houshiary
Christian Jankowski
Peter Joseph
Anish Kapoor
On Kawara
Igor & Svetlana Kopystiansky
John Latham

Sol LeWitt
Robert Mangold
Jason Martin
Tatsuo Miyajima
Jonathan Monk
John Murphy
Max Neuhaus
Avis Newman
Julian Opie
Fernando Ortega
Tony Oursler
Giulio Paolini
Daniele Puppi
Charles Sandison
Julião Sarmento
Santiago Sierra
Jemima Stehli
Lee Ufan
Marijke van Warmerdam
Lawrence Weiner
Richard Wentworth
Jane & Louise Wilson
Sharon Ya'ari

Luhring
Augustine

Stand B12
Tel +1 212 206 9100

531 West 24th Street
New York NY 10011
USA
Tel +1 212 206 9100
Fax +1 212 206 9055
info@luhringaugustine.com
www.luhringaugustine.com

Contact
Roland Augustine
Lawrence Luhring
Claudia Altman-Siegel
Natalia Mager Sacasa

Gallery artists
Janine Antoni
Cardiff & Miller
Larry Clark
George Condo
Gregory Crewdson
Gunther Forg
Paul McCarthy
Yasumasa Morimura
Reinhard Mucha
Albert Oehlen
Pipilotti Rist
Joel Sternfeld
Antonio Tunga
Rachel Whiteread
Steve Wolfe
Christoper Wool

maccarone inc.

Stand B3
Tel +1 212 431 4977

45 Canal Street
New York NY 10002
USA
Tel +1 212 431 4977
Fax +1 212 965 5262
kitchen@maccarone.net
www.maccarone.net

Contact
Michele Maccarone
Blair Taylor
Ellen Langan

Gallery artists
Mike Bouchet
Carol Bove
Christoph Büchel
Anthony Burdin
Chivas Clem
Roberto Cuoghi
Felix Gmelin
Christian Jankowski
Nate Lowman
Corey McCorkle
Claudia & Julia Mueller
Daniel Roth
Olav Westphalen

Kate MacGarry

Stand H8
Tel +44 20 7613 3909

95-97 Redchurch Street
London E2 7DJ
UK
Tel +44 207 613 3909
Fax +44 207 613 5405
mail@katemacgarry.com
www.katemacgarry.com

Contact
Kate MacGarry
Fabio Altamura

Gallery artists
Tasha Amini
Josh Blackwell
Matt Bryans
Stuart Cumberland
Luke Gottelier
Dr Lakra
Goshka Macuga
Peter McDonald
Stefan Saffer
Francis Upritchard

Mai 36 Galerie

Stand D19
Tel +41 76 322 5024

Rämistrasse 37
Zurich 8001
Switzerland
Tel +41 44 261 6880
Fax +41 44 261 6881
mail@mai36.com
www.mai36.com

Contact
Victor Gisler
Luigi Kurmann
Gabriela Walther

Gallery artists
Franz Ackermann
Ian Anüll
John Baldessari
Stephan Balkenhol
Matthew Benedict
Troy Brauntuch
Pedro Cabrita Reis
Anke Doberauer
Pia Fries
Rita McBride
Matt Mullican
Manfred Pernice
Magnus von Plessen
Glen Rubsamen
Thomas Ruff
Christoph Rütimann
Jörg Sasse
Paul Thek
Stefan Thiel
Lawrence Weiner
Rémy Zaugg

Galerie Maisonneuve

Stand H9
Tel +33 6 6287 3818

24–32 rue des Amandiers
5th floor
Paris 75020
France
Tel +33 1 43 66 23 99
Fax +33 1 43 66 23 99
contact@galerie-maisonneuve.com
www.galerie-maisonneuve.com

Contact
Grégoire Maisonneuve
Joanna Cohen

Gallery artists
Patrick Bernier
Martin Le Chevallier
Rainer Ganahl
Jan Kopp
Olive Martin
Alexandre Perigot
Alberto Sorbelli
Lincoln Tobier

Giò Marconi

Stand F10
Tel +39 02 2940 4373

Via Tadino 15
Milan 20124
Italy
Tel +39 02 29 40 43 73
Fax +39 02 29 40 55 73
info@giomarconi.com
www.giomarconi.com

Contact
Giò Marconi
Giorgio Marconi
Carlotta Arlango
Nadia Forloni

Gallery artists
Franz Ackermann
John Bock
Christian Jankowski
Jukka Korkeila
Atelier van Lieshout
Sharon Lockhart
Maurizio Mochetti
Jorge Pardo
Paul Pfeiffer
Tobias Rehberger
Markus Schinwald
Elisa Sighicelli
Thaddeus Strode
Catherine Sullivan
Vibeke Tandberg
Grazia Toderi
Francesco Vezzoli
Christopher Wool

Matthew Marks Gallery

Stand C8
Tel +44 20 7935 7725

523 West 24th Street
522 West 22nd Street
529 West 21st Street
New York NY 10011
USA
Tel +1 212 243 0200
Fax +1 212 243 0047
info@matthewmarks.com
www.matthewmarks.com

Contact
Jeffrey Peabody
Jill Sussman
James Kelly
Stephanie Dorsey

Gallery artists
Robert Adams
Darren Almond
David Armstrong
Nayland Blake
Peter Cain
Peter Fischli & David Weiss
Lucian Freud
Katharina Fritsch
Robert Gober
Nan Goldin
Andreas Gursky
Jonathan Hammer
Martin Honert
Roni Horn
Peter Hujar
Gary Hume
Jasper Johns
Ellsworth Kelly
Willem de Kooning
Inez van Lamsweerde &
Vinoodh Matadin
Brice Marden
Roy McMakin
Ken Price
Ugo Rondinone
Tony Smith
Sam Taylor-Wood
Rebecca Warren
Terry Winters

Galerie Meyer Kainer

Stand G2
Tel +43 664 233 1049

Eschenbachgasse 9
Vienna 1010
Austria
Tel +43 1 585 7277
Fax +43 1 585 7539
info@meyerkainer.com
www.meyerkainer.com

Contact
Renate Kainer
Christian Meyer

Gallery artists
Vanessa Beecroft
John Bock
Olaf Breuning
Plamen Dejanoff
Liam Gillick
Dan Graham
Mary Heilmann
Christian Jankowski
Michael Krebber
Marcin Maciejowski
Sarah Morris
Yoshitomo Nara
Walter Niedermayr
Walter Obholzer
Jorge Pardo
Raymond Pettibon
Mathias Poledna
Martina Steckholzer
Beat Streuli
Wolfgang Tillmans
Franz West
T. J. Wilcox
Heimo Zobernig

Meyer Riegger

Stand C5
Tel +49 172 678 2262

Klauprechtstrasse 22
Karlsruhe 76137
Germany
Tel +49 721 821 292
Fax +49 721 982 2141
info@meyer-riegger.de
www.meyer-riegger.com

Contact
Jochen Meyer
Thomas Riegger
Julia Hólz

Gallery artists
Franz Ackermann
Heike Aumüller
Jeanne Faust
Sebastian Hammwöhner
Isabell Heimerdinger
Uwe Henneken
Dani Jakob
Korpys/Löffler
Kalin Lindena
Meuser
John Miller
Helen Mirra
Jonathan Monk
Peter Pommerer
Daniel Roth
Glen Rubsamen
Silke Schatz
David Thorpe
Gabriel Vormstein
Corinne Wasmuht
Eric Wesley

Massimo Minini

Stand E4
Tel +39 335 233 817

Via Apollonio 68
Brescia 25128
Italy
Tel +39 030 38 3034
Fax +39 030 39 2446
info@galleriaminini.it
www.galleriaminini.it

Contact
Massimo Minini
Francesca Minini
Daniella Minini

Gallery artists
Mario Airò
Ghada Amer
Stefano Arienti
Robert Barry
Vanessa Beecroft
Daniel Buren
Jota Castro
Paolo Chiasera
Jan Fabre
Dan Graham
Peter Halley
Anish Kapoor
Bertrand Lavier
Sol LeWitt
Eva Marisaldi
Ryan Mendoza
Mathieu Mercier
Sabrina Mezzaqui
Giulio Paolini
Riccardo Previdi
Francesco Simeti
Ettore Spalletti
Beat Streuli
Sabrina Torelli

Victoria Miro Gallery

Stand F7
Tel +44 20 7336 8109

16 Wharf Road
London N1 7RW
UK
Tel +44 20 7336 8109
Fax +44 20 7251 5596
info@victoria-miro.com
www.victoria-miro.com

Contact
Victoria Miro
Glenn Scott Wright
Andrew Silewicz

Gallery artists
Doug Aitken
Hernan Bas
Varda Caivano
Anne Chu
Verne Dawson
Thomas Demand
Peter Doig
William Eggleston
Inka Essenhigh
Ian Hamilton Finlay
Alex Hartley
Chantal Joffe
Isaac Julien
Idris Khan
Udomsak Krisanamis
Yayoi Kusama
Dawn Mellor
Tracey Moffatt
Hiroko Nakao
Alice Neel
Chris Ofili
Jacco Olivier
Grayson Perry
Tal R
Raqib Shaw
Adriana Varejão
Suling Wang
Stephen Willats
Francesca Woodman

The Modern Institute / Toby Webster Ltd

Stand B15
Tel +44 141 248 3711

Suite 6, 73 Robertson Street
Glasgow G2 8QD
UK
Tel +44 141 248 3711
Fax +44 141 248 3280
mail@themoderninstitute.com
www.themoderninstitute.com

Contact
Toby Webster

Gallery artists
Dirk Bell
Martin Boyce
Björn Dahlem
Jeremy Deller
Urs Fischer
Kim Fisher
Luke Fowler
Henrik Håkansson
Mark Handforth
Richard Hughes
Chris Johanson
Andrew Kerr
Jim Lambie
Duncan MacQuarrie
Victoria Morton
Scott Myles
Toby Paterson
Simon Periton
Mary Redmond
Anselm Reyle
Eva Rothschild
Monika Sosnowska
Simon Starling
Katja Strunz
Tony Swain
Spencer Sweeney

Pádraig Timoney
Joanne Tatham &
Tom O'Sullivan
Hayley Tompkins
Sue Tompkins
Cathy Wilkes
Michael Wilkinson
Richard Wright

Jan **Mot**

Stand B16
Tel +32 475 56 30 71

rue Antoine Dansaertstraat 190
Brussels 1000
Belgium
Tel +32 2 514 10 10
Fax +32 2 514 14 46
janmot@skynet.be
www.galeriejanmot.com

Contact
Jan Mot

Gallery artists
Sven Augustijnen
Pierre Bismuth
Manon de Boer
Rineke Dijkstra
Honoré d'O
Dora García
Mario Garcia Torres
Dominique Gonzalez-Foerster
Douglas Gordon
Joachim Koester
Sharon Lockhart
Deimantas Narkevicius
Tino Sehgal
Ian Wilson

Galerie Michael **Neff**

Stand A15
Tel +49 177 533 8144

Hanauer Landstrasse 52
Frankfurt am Main 60314
Germany
Tel +49 69 9043 1467
Fax +49 69 4908 4345
galerieneff@t-online.de
www.galerieneff.com

Contact
Michael Neff
Juliane von Herz

Gallery artists
Michael Beutler
John Bock
Mike Bouchet
Sunah Choi
Hansjörg Dobliar
Susann Gassen
Thilo Heinzmann
Stefan Kern
Thoralf Knobloch
Manuel Ocampo
Paola Pivi
Anselm Reyle
Michael S. Riedel
Katharina Sieverding
Olav Westphalen
Phillip Zaiser
Thomas Zipp

Galerie **Neu**

Stand F11
Tel +49 30 285 7550

Philippstrasse 13
Berlin 10115
Germany
Tel +49 30 285 7550
Fax +49 30 281 0085
galerie.neu@snafu.de
www.galerieneu.com

Contact
Thilo Wermke
Alexander Schroeder
Sasha Rossman
Lara Breckenfeld

Gallery artists
Kai Althoff
Tom Burr
Keith Farquhar
Christian Flamm
Sergej Jensen
Thomas Kiesewetter
Birgit Megerle
Manfred Pernice
Daniel Pflumm
Josephine Pryde
Andreas Slominski
Sean Snyder
Francesco Vezzoli
Katharina Wulff
Cerith Wyn Evans

Galleria Franco **Noero**

Stand E8
Tel +39 011 88 2208

Via Giolitti 52A
Turin 10123
Italy
Tel +39 011 88 2208
Fax +39 011 1970 3024
info@franconoero.com
www.franconoero.com

Contact
Franco Noero
Luisa Salvi Del Pero

Gallery artists
Tom Burr
Jeff Burton
Adam Chodzko
Lara Favaretto
Henrik Håkansson
Arturo Herrera
Gabriel Kuri
Jim Lambie
Paul Morrison
Muntean/Rosenblum
Henrik Olesen
Rob Pruitt
Steven Shearer
Simon Starling
Costa Vece
Francesco Vezzoli
Eric Wesley

Galerie Giti **Nourbakhsch**

Stand D4
Tel +49 30 4404 6781

Rosenthaler Strasse 72
Berlin 10119
Germany
Tel +49 30 4404 6781
Fax +49 30 4404 6782
info@nourbakhsch.de
www.nourbakhsch.de

Contact
Giti Nourbakhsch
Sandra Bürgel

Gallery artists
Tomma Abts
Susanne Bürner
Marc Camille Chaimowicz
Berta Fischer
Simone Gilges
Uwe Henneken
Piotr Janas
Kerstin Kartscher
Bernd Krauss
Udomsak Krisanamis
Sean Landers
Anselm Reyle
Katja Strunz
Vincent Tavenne
Hayley Tompkins
Cathy Wilkes

Galerie Nathalie **Obadia**

Stand E23
Tel +33 1 4274 6768

3 rue du Cloître St Merri
Paris 75004
France
Tel +33 1 42 74 67 68
Fax +33 1 42 74 68 66
info@galerie-obadia.com
www.galerie-obadia.com

Contact
Nathalie Obadia
Corinne Prat
Céline Cléron
Latifa Echakhch-Pluot

Gallery artists
Carole Benzaken
Jedediah Caesar
Liz Craft
Rosson Crow
Wim Delvoye
Valérie Favre
Cameron Jamie
Ana Mendieta
Beatriz Milhazes
Frank Nitsche
Manuel Ocampo
Albert Oehlen
Chloe Piene
Bernard Piffaretti
Pascal Pinaud
Jorge Queiroz
Fiona Rae
James Rielly
Lorna Simpson
Eliezer Sonnenschein
Jessica Stockholder
Nicola Tyson
Paul Winstanley

galerie bob van **orsouw**

Stand D19
Tel +41 79 402 7629

Limmatstrasse 270
Zurich 8005
Switzerland
Tel +41 44 273 1100
Fax +41 44 273 1102
mail@bobvanorsouw.ch
www.bobvanorsouw.ch

Contact
Bob Van Orsouw
Birgid Uccia
Tal Trost
Ulrich Meinherz

Gallery artists
Philip Akkerman
Nobuyoshi Araki
Paul Graham
Fabrice Gygi
Anton Henning
Lori Hersberger
Teresa Hubbard &
Alexander Birchler
Olav Christopher Jenssen
Hans Josephsohn
Karin Kneffel
Atelier van Lieshout
Erik van Lieshout
Urs Lüthi
Bjørn Melhus
Claudio Moser
Walter Niedermayr
Julian Opie
Erik Parker
David Reed
Albrecht Schnider
Shirana Shahbazi
Juan Uslé
Bernard Voïta

Patrick **Painter**, Inc.

Stand C2
Tel +44 20 7486 1775

2525 Michigan Avenue, B2
Santa Monica CA 90404
USA
Tel +1 310 264 5988
Fax +1 310 264 5998
info@patrickpainter.com
www.patrickpainter.com

Contact
Patrick Painter
Sachiyo Yoshimoto
Daniel Congdon

Gallery artists
Bas Jan Ader
Hope Atherton
Glenn Brown
André Butzer
Valie Export
Bernard Frize
Larry Johnson
Mike Kelley
Won Ju Lim
Sebastian Ludwig
Ivan Morley
Albert Oehlen
Ed Ruscha
Kenny Scharf
Christian Schumann
Jim Shaw
Meyer Vaisman
Peter Wu
Thomas Zipp

Maureen **Paley**

Stand C12
Tel +44 20 7729 4112

21 Herald Street
London E2 6JT
UK
Tel +44 20 7729 4112
Fax +44 20 7729 4113
info@maureenpaley.com

Contact
Maureen Paley
Dan Gunn
Maximilian Mugler

Gallery artists
Kaye Donachie
Dick Evans
Hamish Fulton
Maureen Gallace
Andrew Grassie
Anne Hardy
Sarah Jones
Michael Krebber
Malerie Marder
Muntean/Rosenblum
Paul Noble
Saskia Olde Wolbers
Seb Patane
Ruth Root
Maaike Schoorel
Hannah Starkey
David Thorpe
Wolfgang Tillmans
Donald Urquhart
Banks Violette
Rebecca Warren
Gillian Wearing
James Welling

Paragon
Press

Stand A1
Tel +44 20 7224 1859

108c Warner Road
London SE5 9HQ
UK
Tel +44 20 7370 1200
Fax +44 20 7370 1229
info@paragonpress.co.uk
www.paragonpress.co.uk

Contact
Charles Booth-Clibborn
Etienne Lullin
Florian Oliver Simm

Gallery artists
Hurvin Anderson
Gillian Carnegie
Jake & Dinos Chapman
Alan Davie
Richard Deacon
Peter Doig
Terry Frost
Hamish Fulton
Damien Hirst
Gary Hume
Anish Kapoor
Michael Landy
Christopher Le Brun
Sarah Morris
Paul Morrison
Marc Quinn
George Shaw
Bill Woodrow

Parkett
Editions

Stand H6
Tel +44 20 7486 0698

Quellenstrasse 27
Zurich 8031
Switzerland
Tel +41 44 271 8140
Fax +41 44 272 4301

155 Sixth Avenue
New York NY 10013
USA
Tel +212 673 2660
Fax +212 271 0704
info@parkettart.com
www.parkettart.com

Contact
Dieter von Graffenried
Beatrice Faessler

Gallery artists
Franz Ackermann
John Bock
Monica Bonvicini
Olaf Breuning
Angela Bulloch
Daniel Buren
Peter Doig
Bernard Frize
Katharina Grosse
Pierre Huyghe
Jeff Koons
Sarah Morris
Richard Phillips
Pipilotti Rist
Anri Sala
Wilhelm Sasnal
Richard Serra
Luc Tuymans
Keith Tyson
Franz West

Peres
Projects
Los Angeles
Berlin

Stand E21
Tel +49 176 2460 1985

969 Chung King Road
Los Angeles CA 90012
USA
Tel +1 213 617 1100
Fax +1 213 617 1141

Schlesische Strasse 26
Berlin 10997
Germany
Tel +49 30 6162 6962
Fax +49 30 6162 7066
info@peresprojects.com
www.peresprojects.com

Contact
Javier Peres
Andrea Cherkerzian
Scott Weaver

Gallery artists
assume vivid astro focus
Dan Attoe
Chris Ballantyne
Dan Colen
Liz Craft
Amie Dicke
Kaye Donachie
Jim Drain
Matthew Greene
Folkert de Jong
John Kleckner
Terence Koh
Bruce La Bruce
Kirstine Roepstorff
Dean Sameshima
Mark Titchner

Galerie
Emmanuel
Perrotin

Stand D3
Tel +33 1 42 16 79 79

76 rue de Turenne
Paris 75003
France
Tel +33 1 42 16 79 79
Fax +33 1 42 16 79 74
info-paris@galerieperrotin.com
www.galerieperrotin.com

Contact
Emmanuel Perrotin
Peggy Leboeuf
Nathalie Brambilla
Etsuko Nakajima

Gallery artists
Aya Takano
Chiho Aoshima
Daniel Arsham
Bhakti Baxter
Sophie Calle
Maurizio Cattelan
Eric Duyckaerts
Michael Elmgreen &
Ingar Dragset
Lionel Estève
Naomi Fisher
Bernard Frize
Giuseppe Gabellone
gelatin
Jean-Pierre Khazem
Kolkoz
Guy Limone
Tony Matelli
Keegen McHargue
Jin Meyerson
Mariko Mori
Mr.
Takashi Murakami
Martin Oppel
Jean-Michel Othoniel

Paola Pivi
Terry Richardson
Piotr Uklanski
Chris Vasell
Xavier Veilhan
John Waters
Jeff Zimmerman
Peter Zimmermann

Galerie
Francesca
Pia

Stand C20
Tel +41 79 247 5752

Münstergasse 6
Bern 3011
Switzerland
Tel +41 31 311 7302
Fax +41 31 311 7302
francesca.pia@bluewin.ch
www.galeriefrancescapia.ch

Contact
Francesca Pia

Gallery artists
Thomas Bayrle
Valentin Carron
Philippe Decrauzat
Hans-Peter Feldmann
Vidya Gastaldon
Joseph Grigely
Wade Guyton
Mai-Thu Perret
David Shrigley
Joanne Tatham &
Tom O'Sullivan
John Tremblay

pkm
Gallery

Stand G4
Tel +44 20 7486 4082

137-1 Hwa-dong
Chongro-ku Seoul 110-210
Korea
Tel +82 2 734 9467/8
Fax +82 2 734 9469
suh@pkmgallery.com
www.pkmgallery.com

Contact
Kyung Mee Park
Shi-ne Oh
Hwa. J. Suh

Gallery artists
Joonsung Bae
Bernd & Hilla Becher
Moon Beom
Lee Bul
Cody Choi
Ham Jin
Hyungtae Gim
Michael Joo
Jiwon Kim
Sang Gil Kim
Sang Nam Lee
Noori Lee
Bruce Nauman
Jorge Pardo
Sejin Park
Stephen Prina
Yoo Seung-Ho

Postmasters
Gallery

Stand H12
Tel +1 917 400 5473

459 West 19th Street
New York NY 10011
USA
Tel +1 212 727 3323
Fax +1 212 229 2829
postmasters@thing.net
www.postmastersart.com

Contact
Magdalena Sawon
Tamas Banovich

Gallery artists
Guy Ben-Ner
Diana Cooper
David Diao
Omer Fast
Spencer Finch
Anthony Goicolea
Perry Hoberman
Natalie Jeremijenko
Paul Johnson
Mary Kelly
John Klima
Katarzyna Kozyra
Kristin Lucas
Jennifer & Kevin McCoy
Steve Mumford
Wolfgang Staehle
Eddo Stern
Claude Wampler

Galerie Eva
Presenhuber

Stand C7
Tel +41 78 836 1048

Limmatstrasse 270
Postfach 1517
Zurich 8031
Switzerland
Tel +41 43 444 7050
Fax +41 43 444 7060
info@presenhuber.com
www.presenhuber.com

Contact
Eva Presenhuber
Markus Rischgasser
Anna Caruso
Angelika Hunziker

Gallery artists
Doug Aitken
Emmanuelle Antille
Monika Baer
Martin Boyce
Angela Bulloch
Valentin Carron
Verne Dawson
Trisha Donnelly
Maria Eichhorn
Urs Fischer
Peter Fischli & David Weiss
Sylvie Fleury
Liam Gillick
Mark Handforth
Siggi Hofer
Candida Höfer
Karen Kilimnik
Richard Prince
Gerwald Rockenschaub
Ugo Rondinone
Dieter Roth
Jean-Frédéric Schnyder
Steven Shearer
Beat Streuli
Franz West
Sue Williams

Produzenten-galerie Hamburg

Stand E18
Tel +49 171 838 3851

Admiralitätstrasse 71
Hamburg 20459
Germany
Tel +49 40 37 82 32
Fax +49 40 36 33 04
info@produzentengalerie.com
www.produzentengalerie.com

Contact
Jürgen Vorrath
Anna-Catharina Gebbers
Kerstin Niemann

Gallery artists
Tjorg Beer
Ulla von Brandenburg
Gisela Bullacher
Stephan Craig
Beate Gütschow
Bethan Huws
Hubert Kiecol
Astrid Klein
Gustav Kluge
Rupprecht Matthies
Manfred Pernice
Hermann Pitz
Norbert Prangenberg
Bernhard Prinz
Thomas Scheibitz
Thomas Schütte
Norbert Schwontkowski
Andreas Slominski
Henk Visch
Nicole Wermers

Projectile Gallery

Stand E15
Tel +1 212 688 4673

37 West 57th Street
3rd Floor
New York NY 10019
USA
Tel +1 212 688 1585
Fax +1 212 688 1589
mail@projectilegallery.com
www.projectilegallery.com

Contact
Christian Haye
Jenny Liu
Simon Preston

Gallery artists
José Damasceno
Coco Fusco
Maria Elena González
Nic Hess
Glenn Kaino
Daniel Joseph Martinez
Julie Mehretu
Aernout Mik
Kori Newkirk
Yoshua Okon
Geof Oppenheimer
Paul Pfeiffer
William Pope.L
Jessica Rankin
Tracey Rose
Peter Rostovsky
Jason Salavon
Cristián Silva
Kim Sooja
Stephen Vitiello
Martín Weber

Raucci/ Santamaria Gallery

Stand A5
Tel +39 081 744 3645

Corso Amedeo di Savoia 190
Naples 80136
Italy
Tel +39 081 7443645
Fax +39 081 7442407
raucciesantamaria@interfree.it

Contact
Umberto Raucci
Carlo Santamaria

Gallery artists
Miriam Bäckström
Mat Collishaw
Evan Holloway
Hervé Ingrand
Ann Lislegaard
John Pilson
Frédéric Pradeau
Tim Rollins & K.O.S.
Ugo Rondinone
Glenn Sorensen
Cheyney Thompson
Pádraig Timoney
Torbjörn Vejvi
Cathy Wilkes
James Yamada
Yang Fudong

Galerie Almine **Rech**

Stand G1
Tel +33 1 45 83 71 90

127 rue du Chevaleret
Paris 75013
France
Tel +33 1 45 83 71 90
Fax +33 1 45 70 91 30
a.rech@galeriealminerech.com
www.galeriealminerech.com

Contact
Almine Rech
Thomas Dryll
Nicolas Zahler
Marie-Laure Gilles

Gallery artists
Rita Ackermann
Nobuyoshi Araki
Damien Cadio
Philip-Lorca diCorcia
Mark Handforth
Johannes Kahrs
Ange Leccia
John McCracken
Anselm Reyle
Ugo Rondinone
Bruno Rousseaud
Hedi Slimane
Annelies Strba
Vincent Szarek
John Tremblay
Gavin Turk
James Turrell
Vincent Szarek
Stephen Vitiello

Daniel **Reich** Gallery

Stand B5
Tel +1 917 923 9374

537A West 23rd Street
New York NY 10011
USA
Tel +1 212 924 4949
Fax +1 212 924 6224
gallery@danielreichgallery.com
www.danielreichgallery.com

Contact
Daniel Reich
Meredith Darrow
Ashley Reid
John McCord

Gallery artists
Black Leotard Front
Scoli Acosta
Hernan Bas
Michael Cline
Bjorn Copeland
Sean Dack
Amy Gartrell
Delia Gonzalez &
Gavin Russom
Christian Holstad
Anya Kielar
Nick Mauss
Paul P
Tyson Reeder

Anthony **Reynolds** Gallery

Stand D18
Tel +44 20 7439 2201

60 Great Marlborourgh Street
London W1F 7BG
UK
Tel +44 20 7439 2201
Fax +44 20 7439 1869
info@anthonyreynolds.com
www.anthonyreynolds.com

Contact
Anthony Reynolds
Costanza Mazzonis

Gallery artists
Eija-Liisa Ahtila
The Atlas Group/Walid Raad
David Austen
Richard Billingham
Ian Breakwell
Erik Dietman
Keith Farquhar
Rudolf Fila
Leon Golub
Paul Graham
Lucy Harvey
Georg Herold
Emily Jacir
Kai Kaljo
Andrew Mansfield
Alain Miller
Lucia Nogueira
Nancy Spero
Jon Thompson
Amikam Toren
Nobuko Tsuchiya
Mark Wallinger

Galerie Thaddaeus Ropac

Stand F14
Tel +43 662 881 393

Mirabellplatz 2
Salzburg 5020
Austria
Tel +43 662 881 393
Fax +43 662 881 3939

7 rue Debelleyme
Paris 75003
France
Tel +33 1 42 72 99 00
Fax +33 1 42 72 61 66
office@ropac.at
www.ropac.net

Contact
Thaddaeus Ropac
Arne Ehmann
Bénédicte Burrus

Gallery artists
Donald Baechler
Stephan Balkenhol
Georg Baselitz
Jean-Marc Bustamante
Maggie Cardelùs
Francesco Clemente
Tony Cragg
Elger Esser
Sylvie Fleury
Gilbert & George
Antony Gormley
Peter Halley
Lori Hersberger
Ilya Kabakov
Alex Katz
Anselm Kiefer
Imi Knoebel
Jonathan Lasker
Robert Mapplethorpe
Fabian Marcaccio
Bernhard Martin
Jason Martin
Yasumasa Morimura
Not Vital

Paul P.
Mimmo Paladino
Jack Pierson
Gerwald Rockenschaub
Lisa Ruyter
Tom Sachs
David Salle
Philip Taaffe
Andy Warhol

Andrea Rosen Gallery

Stand C3
Tel +44 20 7224 0654

525 West 24th Street
New York NY 10011
USA
Tel +1 212 627 6000
Fax +1 212 627 5450
Andrea@rosengallery.com
www.andrearosengallery.com

Contact
Andrea Rosen
Jordan Bastian
Susanna Greeves
Laura Mackall

Gallery artists
Rita Ackermann
David Altmejd
Michael Ashkin
Miguel Calderón
Gillian Carnegie
Nigel Cooke
John Coplans
John Currin
Walker Evans
Felix Gonzalez-Torres
Craig Kalpakjian
Friedrich Kunath
Sean Landers
Annika Larsson
José Lerma
Ken Lum
Joshiah McElheny
László Moholy-Nagy
Dan Peterman
Michael Raedecker
Matthew Ritchie
Matthew Ronay
Julia Scher
Ricky Swallow
Wolfgang Tillmans
Francis Upritchard
Charlie White
Andrea Zittel
Heimo Zobernig

Galleria Sonia **Rosso**

Stand A6
Tel +39 33 5614 2071

Via Giulia di Barolo 11/H
Turin 10124
Italy
Tel +39 011 817 2478
Fax +39 011 817 2478
info@soniarosso.com
www.soniarosso.com

Contact
Sonia Rosso
Valentina Sina

Gallery artists
Charles Avery
Pierre Bismuth
Massimiliano Buvoli
Scott King
Jim Lambie
Peter Land
Jonathan Monk
Scott Myles
Mathew Sawyer
Annika Strom

Salon 94

Stand B18
Tel +1 917 496 3746

12 East 94th Street
New York NY 10128
USA
Tel +1 646 672 9212
Fax +1 646 672 9214
info@salon94.com
www.salon94.com

Contact
Jeanne Greenberg Rohatyn
Carmen Hammons
Fabienne Stephan

Gallery artists
Barry X Ball
Iris van Dongen
Kendell Geers
Paul Graham
Katy Grannan
Paula Hayes
Laleh Khorramian
Malerie Marder
Marilyn Minter
Carlo Mollino
Aïda Rúilova
Shirana Shahbazi

Galerie Aurel **Scheibler**

Stand G15
Tel +49 177 311 0011

St.Apern-Strasse 20–26
Cologne 50667
Germany
Tel +49 221 311 011
Fax +49 221 331 9615
office@aurelscheibler.com
www.aurelscheibler.com

Contact
Aurel Scheibler
Brigitte Schlüter
Daniel Schmidt

Gallery artists
Sam Crabtree
Öyvind Fahlström
Anthony Goicolea
Christian Holstad
Stefan Löffelhardt
Sarah Morris
Ernst Wilhelm Nay
Jack Pierson
Bridget Riley
Peter Saul
Claudia Schink
Rachel Selekman
Boy & Erik Stappaerts
Peter Stauss
Billy Sullivan
Hideo Togawa
Alessandro Twombly
Christoph Wedding
Erwin Wurm
Joe Zucker

Esther Schipper

Stand F5
Tel +49 172 167 0994

Linienstrasse 85
Berlin 10119
Germany
Tel +49 30 2839 0139
Fax +49 30 2839 0140
office@estherschipper.com
www.estherschipper.com

Contact
Esther Schipper

Gallery artists
Matti Braun
Angela Bulloch
Nathan Carter
Thomas Demand
Ceal Floyer
General Idea
Liam Gillick
Dominique Gonzalez-Foerster
Grönlund\Nisunen
Carsten Höller
Pierre Huyghe
Ann Veronica Janssens
Christoph Keller
Philippe Parreno
Ugo Rondinone
Roth Stauffenberg
Julia Scher

Anna Schwartz Gallery

Stand B1
Tel +11 61 423 768 928

185 Flinders Lane
Melbourne 3000
Australia
Tel +613 9654 6131
Fax +613 9650 5418
mail@annaschwartzgallery.com
www.annaschwartzgallery.com

Contact
Anna Schwartz
Ruth Bain
Tomislav Nikolic

Gallery artists
Peter Booth
Christine Borland
Polly Borland
Stephen Bram
Philip Brophy
Louisa Bufardeci
Janet Burchill &
Jennifer McCamley
Mutlu Çerkez
Tony Clark
Susan Cohn
Peter Cripps
Angela de la Cruz
Mikala Dwyer
Emily Floyd
Dale Frank
Marco Fusinato
Melinda Harper
Robert Hunter
Lyndal Jones
Maria Kozic
Shelley Lasica
Akio Makigawa
Clement Meadmore
Callum Morton
Jan Nelson
John Nixon
Rose Nolan
Mike Parr
Stieg Persson
Kerrie Poliness
Vivienne Shark LeWitt
Kathy Temin
Peter Tyndall
Daniel von Sturmer
Jenny Watson
Gary Wilson
John Young

Gabriele Senn Galerie

Stand H4
Tel +43 1 585 2580

Schleifmühlgasse 1A
Vienna 1040
Austria
Tel +43 1 585 2580
Fax +43 1 585 2606
galerie.senn@aon.at
www.galeriesenn.at

Contact
Gabriele Senn

Gallery artists
Kai Althoff
Cosima von Bonin
Norbert Brunner
André Butzer
Bernhard Fruehwirth
Martin Gostner
Georg Herold
Richard Jackson
Dennis Loesch
Marko Lulic
Hans–Jörg Mayer
Barbara Mungenast
Josephine Pryde
Michael S. Riedel
Hans Weigand
Amelie von Wulffen

Stuart **Shave** | Modern Art

Stand D13
Tel +44 78 8455 6818

10 Vyner Street
London E2 9DG
UK
Tel +44 20 8980 7742
Fax +44 20 8980 7743
info@modernartinc.com
www.modernartinc.com

Contact
Stuart Shave
Jimi Lee

Gallery artists
Bas Jan Ader
David Altmejd
Kenneth Anger
Mat Collishaw
Nigel Cooke
Barnaby Furnas
Tim Gardner
Matthew Greene
Brad Kahlhamer
Barry McGee
Jonathan Meese
Alan Michael
Tim Noble & Sue Webster
Eva Rothschild
Collier Schorr
D.J. Simpson
Ricky Swallow
Juergen Teller
Sue Williams
Clare Woods

Galeria Filomena **Soares**

Stand E1
Tel +35 1 96 237 3956

Rua da Manutenção 80
Lisbon 1900–321
Portugal
Tel +35 1 21 862 4122
Fax +35 1 21 862 4124
gfilomenasoares@mail.telepac.pt
www.gfilomenasoares.com

Contact
Filomena Soares
Manuel Santos

Gallery artists
Pilar Albarracín
Helena Almeida
Ghada Amer
Vasco Araújo
Art & Language
Daniel Canogar
Pedro Casqueiro
Ângela Ferreira
Joan Fontcuberta
Günther Förg
Pia Fries
Renée Green
Katharina Grosse
Oleg Kulik
Ma Liuming
Jason Martin
Tracey Moffatt
Paul Morrison
Shirin Neshat
Markus Oehlen
Rodrigo Oliveira
João Penalva
Francisco Queirós
Ana Luísa Ribeiro
Allan Sekula
Nancy Spero
João Pedro Vale
Júlia Ventura
Luiz Zerbini
Peter Zimmermann

Sommer Contemporary Art

Stand A2
Tel +972 3 560 0630

13 Rothschild Blvd
Tel Aviv 66881
Israel
Tel +972 3 560 0630
Fax +972 3 566 5501
iritms@netvision.net.il
www.sommergallery.com

Contact
Irit Mayer-Sommer

Gallery artists
Darren Almond
Yuel Burtana
Avner Ben Gal
Rineke Dijkstra
Ofir Dor
Alona Harpaz
Michal Helfman
Yitzhak Livneh
Boyan Lozanov
Muntean/Rosenblum
Ugo Rondinone
Wilhelm Sasnal
Yehudit Sasportas
Netaly Schlosser
Ahlam Shibli
Efrat Shvily
Doron Solomons
Eliezer Sonnenschein
Wolfgang Tillmans
Uri Tzaig
Sharon Ya'ari
Rona Yefman
Guy Zagursky
Shai Zurim

Galerie Pietro Spartà

Stand G13
Tel +33 3 8587 2782

6 rue de Beaune/
30 rue de Chaudenay
Chagny 71150
France
Tel +33 3 85 87 27 82
Fax +33 3 85 87 10 48
galeriepietrosparta@wanadoo.fr

Contact
Pietro Spartà

Gallery artists
Daniel Buren
Gerard Collin-Thiebaut
Pascal Convert
Peter Downsbrough
Luciano Fabro
Lee Friedlander
Jannis Kounellis
Bertrand Lavier
Sol LeWitt
Richard Long
Grout Mazeas
Mario Merz
François Morellet
Robert Morris
Olivier Mosset
Eric Poitevin
Alain Sechas
Niele Toroni
Ida Tursic & Wilfried Mille
Didier Vermeiren
Lawrence Weiner
Gilberto Zorio

Sperone Westwater

Stand B19
Tel +44 20 7224 1746

415 West 13th Street
New York NY 10014
USA
Tel +1 212 999 7337
Fax +1 212 999 7338
info@speronewestwater.com
www.speronewestwater.com

Contact
Gian Enzo Sperone
Angela Westwater
David Leiber
Michael Short

Gallery artists
Carla Accardi
Alighiero e Boetti
Giorgio De Chirico
Greg Colson
Wim Delvoye
Kim Dingle
Lucio Fontana
Guillermo Kuitca
Wolfgang Laib
Jonathan Lasker
Charles LeDray
Piero Manzoni
Mario Merz
Frank Moore
Malcolm Morley
Nabil Nahas
Bruce Nauman
Not Vital
Evan Penny
Francis Picabia
Susan Rothenberg
Tom Sachs
Laurie Simmons
Richard Tuttle
Andy Warhol
William Wegman
Jan Worst

Sprüth
Magers Lee

Stand B13
Tel +44 20 7491 0100

12 Berkeley Street
London W1J 8DT
UK
Tel +44 20 7491 0100
Fax +44 20 7491 0200

Wormer Strasse 23
Cologne 50677
Germany
Tel +49 221 380 415/16
Fax +49 221 380 417

Schellingstrasse 48
Munich 80799
Germany
Tel +49 893 304 0600
Fax +49 893 973 02
info@spruethmagerslee.com
www.spruethmagerslee.com

Contact
Simon Lee
Monika Sprüth
Philomene Magers

Gallery artists
John Baldessari
Alighiero e Boetti
George Condo
Peter Fischli & David Weiss
Andreas Gursky
Jenny Holzer
Donald Judd
Joseph Kosuth
Barbara Kruger
Louise Lawler
Cindy Sherman
Stephen Shore
Robert Therrien
Rosemarie Trockel
Christopher Wool
Toby Ziegler

Diana
Stigter

Stand H14
Tel +31 2 0624 2361

Elandsstraat 90
Amsterdam 1016 SH
The Netherlands
Tel +31 20 624 2361
Fax +31 20 624 2362
mail@dianastigter.nl
www.dianastigter.nl

Contact
Diana Stigter
David van Doesburg
Leen Bedaux

Gallery artists
Tariq Alvi
Pierre Bismuth
Nina Bovasso
Amie Dicke
Elspeth Diederix
Berta Fischer
Henrik Hakansson
Cees Krijnen
Andrew Mania
Alisa Margolis
Jonathan Monk
Fortuyn O'Brien
Saskia Olde Wolbers
Jimmy Robert
Julika Rudelius
Maaike Schoorel
Iris van Dongen
Rezi van Lankveld
Roman Wolgin

Galeria
Luisa Strina

Stand G7
Tel +55 11 30 88 24 71

Rua Oscar Freire 502
São Paulo 01426
Brazil
Tel +55 11 30 88 24 71
Fax +55 11 30 64 63 91
info@galerialuisastrina.com.br
www.galerialuisastrina.com.br

Contact
Luisa Malzoni Strina
Cristina Candeloro
Gabriela Inui

Gallery artists
Keila Alaver
Caetano de Almeida
Tonico Lemos Auad
Franklin Cassaro
Alexandre da Cunha
Wim Delvoye
Antonio Dias
Valdirlei Dias Nunes
Marcius Galan
Carlos Garaicoa
Brian Griffiths
Fernanda Gomes
Jenny Holzer
Luisa Lambri
Dora Longo Bahia
Jorge Macchi
Marepe
Gilberto Mariotti
Cildo Meireles
Tracey Moffatt
Antoni Muntadas
Adriano Pedrosa
Marina Saleme
Edgard de Souza
Sandra Tucci
Tunga

Sutton Lane

Stand H3
Tel +44 20 7253 8580

1 Sutton Lane
London EC1M 5PU
UK
Tel +44 20 7253 8580
Fax +44 20 7253 6580
info@suttonlane.com
www.suttonlane.com

Contact
Gil Presti
Sabine Spahn

Gallery artists
Henriette Grahnert
Justin Lieberman
Camilla Løw
Yuri Masnyj
Robert Melee
Toby Paterson
Sean Paul
Pavel Pepperstein
Eileen Quinlan
Blake Rayne
Christoph Ruckhäberle
Joanne Tatham &
Tom O'Sullivan
Cheyney Thompson
Eric Wesley
Michael Wilkinson

Galerie Micheline **Szwajcer**

Stand D5
Tel +32 3237 1127

Verlatstraat 14
Antwerp B-2000
Belgium
Tel +32 3 237 1127
Fax +32 3 238 9819
info@gms.be
www.gms.be

Contact
Micheline Szwajcer
Elisa Platteau

Gallery artists
Angela Bulloch
David Claerbout
Wim Delvoye
Bernard Frize
Daan van Golden
Dan Graham
Rodney Graham
Ann Veronica Janssens
On Kawara
Tobias Rehberger
Joe Scanlan
Christopher Wool

Timothy **Taylor** Gallery

Stand F2
Tel +44 20 7224 1758

24 Dering Street
London W1S 1TT
UK
Tel +44 20 7409 3344
Fax +44 20 7409 1316
mail@timothytaylorgallery.com
www.timothytaylorgallery.com

Contact
Tim Taylor
Joel Yoss
Faye Fleming
Joanna Thornberry

Gallery artists
Craigie Aitchison
Miquel Barceló
Tim Braden
Jean-Marc Bustamante
Marcel Dzama
Adam Fuss
Philip Guston
Susan Hiller
Alex Katz
Jonathan Lasker
Matthias Müller
Richard Patterson
Fiona Rae
James Rielly
Sean Scully
Tony Smith
Mario Testino

Emily **Tsingou** Gallery

Stand E3
Tel +44 79 6826 2234

10 Charles II Street
London SW1Y 4AA
UK
Tel +44 20 7839 5320
Fax +44 20 7839 5321
info@emilytsingougallery.com
www.emilytsingougallery.com

Contact
Emily Tsingou
Gina Buenfeld
Francesca Anfossi
Tobias Wagner

Gallery artists
Michael Ashkin
Henry Bond
Kate Bright
Peter Callesen
Lukas Duwenhögger
Paula Kane
Karen Kilimnik
Justine Kurland
Won Ju Lim
Dietmar Lutz
Daniel Pflumm
Sophy Rickett
Jim Shaw
Georgina Starr
Marnie Weber
Mathew Weir

Two Palms

Stand H11
Tel +1 212 965 8598

476 Broadway, 3rd floor
New York 10013
USA
Tel +1 212 965 8598
Fax +1 212 965 8067
info@twopalmspress.com
www.twopalmspress.com

Contact
Evelyn Day Lasry
David Lasry

Gallery artists
Mel Bochner
Cecily Brown
Chuck Close
Carroll Dunham
Ellen Gallagher
Elizabeth Peyton
Matthew Ritchie
Jessica Stockholder
Terry Winters

Galerie Anne de **Villepoix**

Stand D1
Tel +33 1 42 78 32 24

43 rue de Montmorency
Paris 75003
France
Tel +33 1 42 78 32 24
Fax +33 1 42 78 32 16
info@annedevillepoix.com
www.annedevillepoix.com

Contact
Anne de Villepoix
Anna Antoine
Florence Pallot

Gallery artists
Vito Acconci
Chris Burden
Changha Hwang
John Coplans
Christoph Draeger
Angelo Filomeno
Luigi Ghirri
Craigie Horsfield
Satch Hoyt
Huang Yong Ping
Sven Kroner
Suzanne Lafont
Anna Maria Maiolino
Julie Mehretu
Wangechi Mutu
Ingrid Mwangi
Stéphane Pencréac'h
Joyce Pensato
Carol Rama
Fabien Rigobert
Martha Rosler
Pucci de Rossi
Sara Rossi
Sam Samore
Franck Scurti
James Siena
Ettore Spalletti
Beat Streuli
Barthélémy Toguo
Fred Tomaselli
Rosemarie Trockel
Erwin Wurm
Yan Pei-Ming

Vilma Gold

Stand D20
Tel +44 20 8981 3344

25B Vyner Street
London E2 9DG
UK
Tel +44 20 8981 3344
Fax +44 20 8981 3355
mail@vilmagold.com
www.vilmagold.com

Contact
Rachel Williams
Mark Dickenson

Gallery artists
Shahin Afrassiabi
Dan Attoe
Alexandre da Cunha
William Daniels
Dubossarsky & Vinogradov
Brock Enright
Brian Griffiths
Daniel Guzman
Sophie von Hellermann
hobbypopMUSEUM
Ben Judd
Colin Lowe
Andrew Mania
Alisa Margolis
Ilias Papailiakis
Aïda Ruilova
Michael Stevenson
Mark Titchner

Waddington Galleries

Stand F3
Tel +44 20 7851 2200

11 Cork Street
London W1S 3LT
UK
Tel +44 20 7851 2200
Fax +44 20 7734 4146
mail@waddington-galleries.com
www.waddington-galleries.com

Contact
Leslie Waddington
Thomas Lighton
Phillida Reid
Ales Ortuzar

Gallery artists
Craigie Aitchison
Josef Albers
Milton Avery
Peter Blake
Patrick Caulfield
John Chamberlain
Giorgio De Chirico
Ian Davenport
Jean Dubuffet
Barry Flanagan
Peter Halley
Barbara Hepworth
Patrick Heron
Robert Indiana
Ellsworth Kelly
Morris Louis
Agnes Martin
Henri Matisse
Joan Miró
Henry Moore
Ben Nicholson
Mimmo Paladino
Francis Picabia
Pablo Picasso
Robert Rauschenberg
Susan Rothenberg
David Salle
Lucas Samaras
Antoni Tàpies
William Turnbull
Cy Twombly
Andy Warhol
Bill Woodrow
Jack B. Yeats

Galleri Nicolai Wallner

Stand A3
Tel +45 32 57 09 70

Njalsgade 21, building 15
Copenhagen 2300
Denmark
Tel +45 32 57 09 70
Fax +45 32 57 09 71
nw@nicolaiwallner.com
www.nicolaiwallner.com

Contact
Nicolai Wallner
Claus Robenhagen

Gallery artists
Mari Eastman
Michael Elmgreen &
Ingar Dragset
Douglas Gordon
Jens Haaning
Jeppe Hein
Joachim Koester
Jakob Kolding
Peter Land
Jonathan Monk
Henrik Plenge Jakobsen
Tal R
Christoph Ruckhäberle
Christian Schmidt-Rasmussen
David Shrigley
Glenn Sorensen
Gitte Villesen

Galerie Barbara Weiss

Stand C20
Tel +49 30 262 4284

Zimmerstrasse 88–89
Berlin 10117
Germany
Tel +49 30 262 4284
Fax +49 30 265 1652
mail@galeriebarbaraweiss.de
www.galeriebarbaraweiss.de

Contact
Barbara Weiss
Luise Essen
Birgit Szepanski

Gallery artists
Monika Baer
Heike Baranowsky
Thomas Bayrle
Janet Cardiff &
George Bures Miller
Raoul De Keyser
Maria Eichhorn
Nicole Eisenman
Ayse Erkmen
Friederike Feldmann
Christine & Irene Hohenbüchler
Laura Horelli
Jonathan Horowitz
Boris Mikhailov
John Miller
Jean-Frédéric Schnyder
Andreas Siekmann
Roman Signer
Erik Steinbrecher
Niele Toroni
Marijke van Warmerdam

Galerie Fons Welters

Stand E19
Tel +31 20 423 3046

Bloemstraat 140
Amsterdam 1016 LJ
The Netherlands
Tel +31 20 423 3046
Fax +31 20 620 8433
mail@fonswelters.nl
www.fonswelters.nl

Contact
Fons Welters
Xander Karskens
Corine Lindenbergh

Gallery artists
Yesim Akdeniz Graf
Eylem Aladogan
Rob Birza
Merijn Bolink
Tom Claassen
Jan de Cock
Claire Harvey
Sara van der Heide
Thomas Houseago
Job Koelewijn
Sven Kroner
Gabriel Lester
Atelier van Lieshout
Matthew Monahan
Maria Roosen
Daniel Roth
Gé Karel van der Sterren
Berend Strik
Jennifer Tee
Monika Wiechowska

White Cube/ Jay Jopling

Stand F8
Tel +44 20 7486 2676

48 Hoxton Square
London N1 6PB
UK
Tel +44 20 7930 5373
Fax +44 20 7749 7460
enquiries@whitecube.com
www.whitecube.com

Contact
Jay Jopling
Daniela Gareh
Tim Marlow

Gallery artists
Franz Ackermann
Darren Almond
Miroslaw Balka
Koen van den Broek
Jake & Dinos Chapman
Chuck Close
Gregory Crewdson
Raoul de Keyser
Anselm Kiefer
Carroll Dunham
Tracey Emin
Katharina Fritsch
Anna Gaskell
Gilbert & George
Nan Goldin
Steven Gontarski
Antony Gormley
Marcus Harvey
Mona Hatoum
Eberhard Havekost
Damien Hirst
Gary Hume
Tom Hunter
Runa Islam
Ellsworth Kelly
Clay Ketter
Martin Kobe
Julie Mehretu
Harland Miller
Sarah Morris
Frank Nitsche
Richard Phillips
Marc Quinn

Clare Richardson
Doris Salcedo
Andreas Slominski
Hiroshi Sugimoto
Neal Tait
Sam Taylor-Wood
Fred Tomaselli
Gavin Turk
Luc Tuymans
Jeff Wall
Cerith Wyn Evans

Galerie Barbara Wien

Stand C20
Tel +49 173 615 6996

Linienstrasse 158
Berlin 10115
Germany
Tel +49 30 2838 5352
Fax +49 30 2838 5350
info@barbarawien.de
www.barbarawien.de

Contact
Barbara Wien
Wilma Lukatsch

Gallery artists
Michael Beutler
Ernst Caramelle
Antje Dorn
Jimmie Durham
Hans-Peter Feldmann
Peter Fischli
Arthur Köpcke
Alexandra Leykauf
Isa Melsheimer
Nanne Meyer
Peter Piller
Eva von Platen
Thomas Ravens
Dieter Roth
Tomas Schmit
Michael Snow
David Weiss
Haegue Yang

Max
Wigram
Gallery

Stand G11
Tel +44 20 7935 2412

43b Mitchell Street
London EC1V 3QD
UK
Tel +44 20 7251 3194
Fax +44 20 7689 3194
info@maxwigram.com
www.maxwigram.com

Contact
Max Wigram
Michael Briggs

Gallery artists
Cory Arcangel
Michael Ashcroft
Anna Bjerger
Slater Bradley
Jason Brooks
FOS (Thomas Poulsen)
James Hopkins
Barnaby Hosking
Pearl C. Hsiung
Marine Hugonnier
Mustafa Hulusi
Alastair Mackie
Alison Moffett
Xiomara de Oliver
John Pilson
Julian Rosefeldt
Nigel Shafran
Joel Tomlin
Christian Ward
Richard Wathen
James White

Wilkinson
Gallery

Stand D22
Tel +44 7980 892 851

242 Cambridge Heath Road
London E2 9DA
UK
Tel +44 20 8980 2662
Fax +44 20 8980 0028
info@wilkinsongallery.com
www.wilkinsongallery.com

Contact
Amanda Wilkinson
Anthony Wilkinson

Gallery artists
Kevin Appel
Kamrooz Aram
David Batchelor
Tilo Baumgartel
AK Dolven
Geraint Evans
Julie Henry
Matthew Higgs
Nicky Hirst
Paul Housley
Olav Christopher Jenssen
Joan Jonas
Thoralf Knobloch
Liisa Lounila
Elizabeth Magill
Robert Orchardson
Ged Quinn
Silke Schatz
George Shaw
Shimabuku
Mike Silva
Johnny Spencer
Martina Steckholzer
Matthias Weischer
Olav Westphalen

Galleri
Christina
Wilson

Stand B4
Tel +45 2839 7160

Sturlasgade 12H
Copenhagen 2300
Denmark
Tel +45 32 54 52 06
Fax +45 32 54 52 04
gcw@christinawilson.net
www.christinawilson.net

Contact
Christina Wilson
Sara Krogsgaard

Gallery artists
Kaspar Bonnén
Jesper Dalgaard
FOS (Thomas Poulsen)
Piero Golia
Jesper Just
John Kørner
Ulrik Møller
Jonathan Pylypchuk
Kirstine Roepstorff
Les Rogers
Mette Winckelmann

The **Wrong** Gallery

Stand H1

516A1/2 West 20th Street
New York NY 10011
USA
thewronggallery@googlemail.com

Contact
Maurizio Cattelan
Massimiliano Gioni
Lisa Ivorian Gray
Ali Subotnick

Gallery artists
Peter Coffin
Roberto Cuoghi
Trisha Donnelly
Michael Elmgreen &
Ingar Dragset
Harrell Fletcher
Dara Friedman
Delia R. Gonzalez &
Gavin R. Russom
Mark Handforth
Noritoshi Hirakawa
Piotr Janas
On Kawara
Justin Lowe
Keegan McHargue
Dave Muller
Laura Owens
Richard Prince
Carol Riot Kane
Shirana Shahbazi
Gedi Sibony
Andreas Slominski
Tommy White
Michael Wilkinson
Christopher Wool

XL Gallery

Stand E17
Tel +7 916 125 0995

Podkolokolny Per. 16/2
Moscow 109028
Russia
Tel +7 095 917 8508
mail@xlgallery.ru
www.xlgallery.ru

Contact
Elina Selina
Sergey Khripun

Gallery artists
Aristarkh Chernyshov &
Vladislav Efimov
Dubossarsky & Vinogradov
Lyudmila Gorlova
Irina Korina
Oley Kulik
Tanya Lieberman
Igor Makarevich
Vladislav Mamyshev-Monroe
Boris Mikhailov
Igor Moukhin
Boris Orlov
Konstantin Zvezdochetov

Donald **Young** Gallery

Stand G8
Tel +1 773 209 7183

933 W. Washington Blvd
Chicago IL 60607
USA
Tel +1 312 455 0100
Fax +1 312 455 0101
gallery@donaldyoung.com
www.donaldyoung.com

Contact
Donald Young
Emily Letourneau

Gallery artists
Anne Chu
Rodney Graham
Gary Hill
Cristina Iglesias
Sol LeWitt
Andrew Lord
Robert Mangold
Josiah McElheny
Helen Mirra
Joshua Mosley
Bruce Nauman
Martin Puryear
Charles Ray
Daniel Roth
Ulrich Rückriem
Richard Serra
Rosemarie Trockel
Rebecca Warren
James Welling

Zero

Stand A11
Tel +39 349 6044136

Via Ventura 5
Milan 20134
Italy
Tel +39 02 3651 4283
Fax +39 02 9998 2731
info@galleriazero.it
www.galleriazero.it

Contact
Paolo Zani
Claudia Ciaccio
Jennifer Chert

Gallery artists
Micol Assaël
Hubert Duprat
Christian Frosi
Francesco Gennari
Tue Greenfort
Massimo Grimaldi
Diego Perrone
Pietro Roccasalva
Michael Sailstorfer
Hans Schabus
Shimabuku

David Zwirner

Stand C11
Tel +1 917 213 1926

525 West 19th Street
New York NY 11201
USA
Tel +1 212 727 2070
Fax +1 212 727 2072
information@davidzwirner.com
www.davidzwirner.com

Contact
David Zwirner
Angela Choon
Bellatrix Hubert
Hanna Schouwink

Gallery artists
Francis Alÿs
Mamma Andersson
Michaël Borremans
Raoul De Keyser
Stan Douglas
Marcel Dzama
Isa Genzken
On Kawara
Rachel Khedoori
Toba Khedoori
Gordon Matta-Clark
John McCracken
Jockum Nordström
Chris Ofili
Raymond Pettibon
Neo Rauch
Jason Rhoades
Daniel Richter
Michael S. Riedel
Thomas Ruff
Katy Schimert
Yutaka Sone
Diana Thater
Luc Tuymans
James Welling
Christopher Williams

Magazine Index

Afterall

Stand M3

Central St Martins
College of Art and Design
107–109 Charing Cross Road
London WC2H 0DU
UK
Tel +44 20 7514 7212
Fax +44 20 7514 7166
london@afterall.org
www.afterall.org

California Institute of the Arts
24700 McBean Parkway
Valencia, CA 91355
USA
Tel +1 661 253 7722
Fax +1 661 253 7738
losangeles@afterall.org
www.afterall.org

a–n The Artists Information Company

Stand M14

1st Floor, 7-15 Pink Lane
Newcastle upon Tyne
NE1 5DW
UK
Tel +44 191 241 8000
Fax +44 191 241 8001
info@a–n.co.uk
www.a–n.co.uk

Art AsiaPacific

Stand M12

245 Eighth Avenue, #247
New York NY 10011
USA
Tel +1 212 255 6003
Fax +1 212 255 6004
info@aapmag.com
www.aapmag.com

Art + Auction

Stand M7

11 East 36th Street
Floor 9
New York NY 10016
USA
Tel +1 212 447 9555
Fax +1 212 447 5221
dgursky@artandauction.com
www.artandauction.com

Art in America

Stand M22

575 Broadway
New York NY 10012
USA
Tel +1 212 941 2800
Fax +1 212 941 2870
www.artinamericamagazine.com

Artforum

Stand M4

350 7th Avenue
New York NY 10001
USA
Tel +1 212 475 4000
Fax+1 212 529 1257
generalinfo@artforum.com
www.artforum.com

Art Monthly

Stand M17

4th Floor
28 Charing Cross Road
London WC2H 0DB
UK
Tel +44 20 7240 0389
Fax +44 20 7497 0726
info@artmonthly.co.uk
www.artmonthly.co.uk

The Art Newspaper

Stand M13

70 South Lambeth Road
London SW8 1RL
UK
Tel +44 20 7735 3331
Fax +44 20 7735 3332
contact@theartnewspaper.com
www.theartnewspaper.com

Art Nexus

Stand M9

12955 Biscayne Blvd
Suite 410
Miami FL 33181
USA
Tel +1 305 891 7270
Fax +1 305 891 6408
zroca@artnexus.com
www.artnexus.com

Art Press

Stand M6

8 rue François Villon
Paris 75015
France
Tel +33 1 53 68 65 65
Fax +33 1 53 68 65 77
servicelecteurs@artpress.fr
www.artpress.com

ArtReview

Stand M18

Hereford House
23–24 Smithfield Street
London EC1A 9LF
UK
Tel +44 20 7236 4880
Fax +44 20 7246 3351
info@art-review.co.uk
www.art-review.com

Cabinet

Stand M2

55 Washington Street, #327
Brooklyn, NY 11201
USA
Tel +1 718 222 8434
Fax +1 718 222 3700
info@cabinetmagazine.org
www.cabinetmagazine.org

Flash Art International/ Art Diary International

Stand M19

68 Via Carlo Farini
Milan 20159
Italy
Tel +39 02 688 7341
Fax +39 02 6680 1290
info@flashartonline.com
www.flashartonline.com

frieze

Stand M16

5–9 Hatton Wall
London EC1N 8HX
UK
Tel +44 20 7025 3970
Fax +44 20 7025 3971
admin@frieze.com
www.frieze.com

Guardian Newspapers Limited

Stand M25

119 Farringdon Road
London EC1R 3ER
UK
Tel +44 20 7278 2332
www.guardian.co.uk

International Herald Tribune

Stand M10

40 Marsh Wall
London E14 9TP
UK
Tel +44 20 7510 5727
Fax +44 20 7987 3462
jwhite@iht.com
www.iht.com

Springerin

Stand M8

Museumplatz 1
Vienna 1070
Austria
Tel +43 15 22 91 24
Fax +43 15 22 91 25
springerin@springerin.at
www.springerin.at

spike Art Quarterly

Stand M20

Sportmagazin Verlag
Heiligenstädter Lände 29
1190 Vienna
Austria
Tel +43 13 6085 168
Fax +43 13 6085 200
spike@spike.at
www.spikeart.at

TATE ETC.

Stand M5

20 John Islip Street
London SW1P 4RG
UK
Tel +44 20 7887 8606
Fax +44 20 7887 8729
tateetc@tate.org.uk
www.tate.org.uk/tateetc

tema celeste

Stand M15

Piazza Borromeo 10
Milan 20123
Italy
Tel +39 02 8901 3359
Fax +39 02 9801 5546
ad@temaceleste.com
subscription@temaceleste.com
www.temaceleste.com

Texte zur Kunst

Stand M11

Torstrasse 141
D–10119 Berlin
Germany
Tel +49 30 280 47 910
Fax +49 30 280 47 912
verlag@textezurkunst.de
www.textezurkunst.de

V&A Magazine

Stand M21

Victoria & Albert Museum
Cromwell Road
London SW7 2RL
UK
Tel +44 20 7942 2271
Fax +44 20 7942 2275
c.burnett@vam.ac.uk
www.vam.ac.uk

Artists Index

Artists Index

Artists Index

Artists Index

Artists Index

Yvon Lambert F6
Lester Gabriel
Galerie Fons Welters E19
Leutenegger Zilla
Peter Kilchmann C22
Lévêque Claude
Arndt & Partner D21
Yvon Lambert F6
Levine Sherrie
Jablonka Galerie C16
Lewis Andrew
Art : Concept E2
LeWitt Sol
Galería Juana de Aizpuru C17
Yvon Lambert F6
Lisson Gallery D8
Massimo Minini E4
Galerie Pietro Spartà G13
Donald Young Gallery G8
Leykauf Alexandra
Galerie Barbara Wien C20
Liddell Siobhan
CRG Gallery C23
Lieberman Justin
Sutton Lane H3
Lieberman Tanya
XL Gallery E17
Lienbacher Ulrike
Galerie Krinzinger F15
van Lieshout Atelier
Tanya Bonakdar Gallery E9
Galerie Krinzinger F15
Giò Marconi F10
galerie bob van orsouw D19
Galerie Fons Welters E19
van Lieshout Erik
Galerie Krinzinger F15
galerie bob van orsouw D19
Lieske David
Galerie Daniel Buchholz D14
Ligon Glenn
Yvon Lambert F6
Lim Won Ju
Patrick Painter, Inc. C2
Emily Tsingou Gallery E3
Limone Guy
Rebecca Camhi E22
Galerie Emmanuel Perrotin D3
Lindena Kalin
Meyer Riegger C5
Lindholm Petra
Galleri Magnus Karlsson B2
Ling Simon
greengrassi C4
Linke Armin

Klosterfelde A7
Lipps Jonas
Klosterfelde A7
Lislegaard Ann
Raucci/Santamaria Gallery A5
Little Graham
Alison Jacques Gallery D17
Liuming Ma
CourtYard Gallery H13
Galeria Filomena Soares E1
Livneh Yitzhak
Sommer Contemporary Art A2
Lizène Jacques
Art : Concept E2
Locher Thomas
Georg Kargl G9
Lockhart Sharon
Blum & Poe G6
Gladstone Gallery C6
Tomio Koyama Gallery B6
Giò Marconi F10
Jan Mot B16
Loesch Dennis
Gabriele Senn Galerie H4
Löffelhardt Stefan
Galerie Aurel Scheibler G15
Lombardi Inés
Georg Kargl G9
Long Charles
Tanya Bonakdar Gallery E9
Long Richard
Bernier/Eliades F17
James Cohan Gallery B9
Haunch of Venison F16
Galerie Pietro Spartà G13
López Cuenca Rogelio
Galería Juana de Aizpuru C17
Lord Andrew
Donald Young Gallery G8
Louis Morris
Paul Kasmin Gallery G12
Waddington Galleries F3
Lounila Liisa
Wilkinson Gallery D22
Løw Camilla
Sutton Lane H3
Lowe Colin
Vilma Gold D20
Lowe Justin
Galleri Christina Wilson H1
Lowe Nick
John Connelly Presents A12
Lowman Nate
maccarone inc. B3
Lozano Lee

Hauser & Wirth
Zürich London C9
Lozanov Boyan
Sommer Contemporary Art A2
Lucander Robert
Galerie Krobath Wimmer H7
Lucas Cristina
Galería Juana de Aizpuru C17
Lucas Kristin
Postmasters Gallery H12
Lucas Sarah
Sadie Coles HQ C10
Gladstone Gallery C6
Ludwig Sebastian
Jablonka Lühn C16
Patrick Painter, Inc. C2
Lulic Marko
Johnen + Schöttle D16
Gabriele Senn Galerie H4
Lum Ken
Andrea Rosen Gallery C3
Art & Public – Cabinet P.H. B20
Lundin Ulf
Galleri Magnus Karlsson D2
Lüscher Ingeborg
Galería Juana de Aizpuru C17
Lüthi Urs
galerie bob van orsouw D19
Lutter Vera
Gagosian Gallery D9
Lutz Dietmar
Emily Tsingou Gallery E3
M/M (Paris)
Air de Paris A4
Macchi Jorge
Peter Kilchmann C22
Galeria Luisa Strina G7
Macdonald Euan
Jack Hanley Gallery E11
Maciejowski Marcin
Marc Foxx C18
Galerie Meyer Kainer G2
Mackie Alastair
Max Wigram Gallery G11
Mackie Christina
Herald St A8
Macpherson Sophie
Sorcha Dallas A14
Macquarrie Duncan
The Modern Institute /
Toby Webster Ltd B15
Macuga Goshka
Kate MacGarry H8
Madrigal Miguel Angel
Galería Enrique Guerrero B10

Artists Index

Artists Index

Artists Index

Artists Index

Artists Index

Artists Index

Galerie Aurel Scheibler G15
galleria francesca kaufmann C19
Nicole Klagsbrun Gallery G17
Sullivan Catherine
Galerie Catherine Bastide E16
Giò Marconi F10
Sunna Mari
The Approach G3
Suro Luis Miguel
Galería Enrique Guerrero B10
Süssmayr Florian
Johnen + Schöttle D16
Suzuki Tomoaki
Corvi-Mora E7
Svenungsson Jan
Niels Borch Jensen Gallery H2
Swain Tony
Kerlin Gallery E14
The Modern Institute /
Toby Webster Ltd B15
Swallow Ricky
Tomio Koyama Gallery B6
Andrea Rosen Gallery C3
Stuart Shave | Modern Art D13
Swansea Ena
Klemens Gasser &
Tanja Grunert, Inc. C21
Sweeney Spencer
Gavin Brown's enterprise D7
The Modern Institute /
Toby Webster Ltd B15
Swenson Erick
James Cohan Gallery B9
Szarek Vincent
Galerie Almine Rech G1
Sze Sarah
Marianne Boesky Gallery E5
Taaffe Philip
Rebecca Camhi E22
Gagosian Gallery D9
Jablonka Galerie C16
Galerie Thaddaeus Ropac F14
Tabaimo
James Cohan Gallery B9
Gallery Koyanagi E6
Taboas Sofia
kurimanzutto B11
Tait Neal
White Cube/Jay Jopling F8
Takano Aya
Blum & Poe G6
Galerie Emmanuel Perrotin D3
Takemura Kei
Taka Ishii Gallery F4
Takis

Rebecca Camhi E22
Tan Fiona
Frith Street Gallery C1
Tanaka Atsuko
Tomio Koyama Gallery B6
Tandberg Vibeke
Klosterfelde A7
Tomio Koyama Gallery B6
Yvon Lambert F6
Giò Marconi F10
Tansey Mark
Gagosian Gallery D9
Tàpies Antoni
Waddington Galleries F3
Tatham Joanne &
Tom O'Sullivan
The Modern Institute /
Toby Webster Ltd B15
Galerie Francesca Pia C20
Sutton Lane H3
Tavenne Vincent
Galerie Giti Nourbakhsch D4
Taylor Al
Niels Borch Jensen Gallery H2
Taylor-Wood Sam
Matthew Marks Gallery C8
White Cube/Jay Jopling F8
Tee Jennifer
Galerie Fons Welters E19
Tekinoktay Evren
Galerist G18
Teller Juergen
Lehmann Maupin F18
Stuart Shave | Modern Art D13
Temin Kathy
Anna Schwartz Gallery B1
Teplin Alexis Marguerite
Hotel H5
Testino Mario
Timothy Taylor Gallery F2
Thater Diana
1301PE B8
Haunch of Venison F16
David Zwirner C11
Thater Stefan
Galerie Daniel Buchholz D14
Galerie Karin Guenther
Nina Borgmann B7
greengrassi C4
Thek Paul
Mai 36 Galerie D19
Therrien Robert
Gagosian Gallery D9
Sprüth Magers Lee B13
Thiel Frank

Art & Public – Cabinet P.H. B20
Galerie Krinzinger F15
Thiel Stefan
Mai 36 Galerie D19
Thomkins André
Hauser & Wirth
Zürich London C9
Thompson Cheyney
Galerie Daniel Buchholz D14
Andrew Kreps Gallery B14
Raucci/Santamaria Gallery A5
Sutton Lane H3
Thompson Jon
Anthony Reynolds Gallery D18
Thomson Mungo
John Connelly Presents A12
Thorpe David
303 Gallery C13
Maureen Paley C12
Meyer Riegger C5
Tianmiao Lin
CourtYard Gallery H13
Tichý Miroslav
Arndt & Partner D21
Tillmans Wolfgang
Galería Juana de Aizpuru C17
Galerie Daniel Buchholz D14
Galerie Meyer Kainer G2
Maureen Paley C12
Andrea Rosen Gallery C3
Sommer Contemporary Art A2
Timoney Padraig
The Modern Institute /
Toby Webster Ltd B15
Raucci/Santamaria Gallery A5
Tiravanija Rirkrit
1301PE B8
Gavin Brown's enterprise D7
Galerie Chantal Crousel D10
kurimanzutto B11
Titchner Mark
Peres Projects
Los Angeles Berlin E21
Vilma Gold D20
Tobier Lincoln
Galerie Maisonneuve H9
Toderi Grazia
Giò Marconi F10
Togawa Hideo
Galerie Aurel Scheibler G15
Toguo Barthélémy
Galerie Anne de Villepoix D1
Tomaselli Fred
carlier | gebauer F12
James Cohan Gallery B9

Artists Index

Artists Index

Zimmerman Elyn
Gagosian Gallery D9
Zimmermann Jeff
Galerie Emmanuel Perrotin D3
Zimmermann Peter
Galeria Filomena Soares E1
Zink Yi David
Hauser & Wirth
Zürich London C9
Johann König D2
Ziółkowski Jakub Julian
Foksal Gallery Foundation C14
Zipp Thomas
Guido W. Baudach H10
Alison Jacques Gallery D17
Galerie Michael Neff A15
Patrick Painter, Inc. C2
Zitko Otto
Galerie Krobath Wimmer H7
Zittel Andrea
Sadie Coles HQ C10
Andrea Rosen Gallery C3
Zivic Gregor
Galerie Martin Janda A13
Žmijewski Artur
Foksal Gallery Foundation C14
Peter Kilchmann C22
Zobernig Heimo
Galerie Meyer Kainer G2
Andrea Rosen Gallery C3
Zorio Gilberto
Galerie Pietro Spartà G13
Zucker Kevin
Jablonka Lühn C16
Zucker Joe
Paul Kasmin Gallery G12
Galerie Aurel Scheibler G15
Zurim Shai
Sommer Contemporary Art A2
Zvezdochetov Konstantin
XL Gallery E17
Zybach Andreas
Johann König D2